Feeling
Media

Feeling Media

Potentiality and
the Afterlife of Art

MIRYAM SAS

Duke University Press
Durham and London
2022

Cover designed by Matt Tauch
Typeset in Degular and Arno Pro by Westchester Publishing Services

Library of Congress Cataloging-in-Publication Data
Names: Sas, Miryam, author.
Title: Feeling media : potentiality and the afterlife of art / Miryam Sas.
Description: Durham : Duke University Press, 2022. | Includes
bibliographical references and index.
Identifiers: LCCN 2021054874 (print)
LCCN 2021054875 (ebook)
ISBN 9781478015857 (hardcover)
ISBN 9781478018490 (paperback)
ISBN 9781478023098 (ebook)
Subjects: LCSH: Mass media—Philosophy. | Mass media—Social
aspects—Japan—History—20th century. | Mass media—Political
aspects—Japan—History—20th century. | Popular culture—Japan—
History—20th century. | Affect (Psychology)—Social aspects. | Arts,
Japanese—20th century. | BISAC: SOCIAL SCIENCE / Media Studies |
HISTORY / Asia / Japan
Classification: LCC P92.J3 S26 2022 (print) | LCC P92.J3 (ebook) |
DDC 302.230952—dc23/eng20220504
LC record available at https://lccn.loc.gov/2021054874
LC ebook record available at https://lccn.loc.gov/2021054875

Cover art: Kobayashi Fumiko, *1000 Feet and the Fruit of Beginning*
(2013; also sometimes translated *1000 Legs, Cultivating Fruits*),
installation detail. Photo by the author. Courtesy of the artist's estate.

Contents

Acknowledgments

This book has emerged over many years with the help of too many individuals and collectives to enumerate here. So many friends and colleagues have provided inspiration, prodding, distraction, material comfort, and brilliant conversation. I am deeply grateful to UC Berkeley's Department of Comparative Literature for providing a long-term home for my research, and Film and Media for pushing my thinking in new directions. Berkeley's Center for Japanese Studies, the UC President's Fellowship in the Humanities (2017–18), and Berkeley's Humanities Research Fellowship and Mellon Project Grant have provided generous support for my research and allowed me time to write this book. The CJS and the Japan Society for the Promotion of Science (JSPS) funded two conferences, "Cultural Geographies of 1960s Japan" and "Media Histories/Media Theories and East Asia," that helped to seed this project.

An earlier version of chapter 1 was published in *The Oxford Handbook of Japanese Cinema*, edited by Daisuke Miyao. I am grateful to him for the invitation and to Oxford University Press for publishing that essay. Thanks to Doryun Chong and Nancy Lim of the Museum of Modern Art (New York) for supporting my investigation of intermedia in the context of the exhibition and catalog *Tokyo 1955–1970: A New Avant-Garde*, where I also published an early exploration of this material. An earlier version of chapter 3 was published in *Media Theory in Japan*, edited by Alexander Zahlten and Marc Steinberg. I am grateful to Alex, Marc, and Duke University Press for including me in that collaborative work. A prior version of a part of chapter 2 was included in *Mechademia* vol. 7, *Lines of Sight*. I am grateful to the editors for kick-starting my thinking about alternative horizon lines in animation. Thanks to Amanda Maddox at the Getty Museum for engaging me with the work of Ishiuchi Miyako; an earlier version of a part of chapter 4 appeared in *Ishiuchi Miyako: Postwar Shadows*. The curators of *Roppongi Crossing 2013* at the Mori Art Museum invited me to write about contemporary Japanese art and gave me early access and introduction to many contemporary artists' works. Roger and Karen Reynolds kindly opened their archives to me once again for this project. John Solt and Sawako Nakayasu kept me connected

to the poetic and earlier visual avant-gardes. I received much helpful feedback on portions of this research from thoughtful audiences at the Sainsbury Institute for Japanese Studies, SOAS, INALCO, University of Copenhagen, Bombas Gens Centre d'Art, Stanford, Yale, Cambridge, Oxford, Seikei University, Harvard, University of Michigan, McGill, UCLA, University of Chicago, Kinema Club, and SCMS. Thank you so much to all my amazing colleagues at those places.

For their permission to use the images of their work, I thank all of the artists and their families: Nakahira Gen (for his father), Nakamura Hiroshi, Ishiuchi Miyako, Asakai Yōko, Kazama Sachiko, the family of Kobayashi Fumiko, Arai Takashi, Minamigawa Kenji and Masui Hirofumi (WAH Project, now 目 [mé] art collective). For catalyzing a performance event and clarifying Ichiyanagi's graphic score, including the caption included here, credit to Yayoi Uno Everett. For helping me connect with those artists and families, my appreciation to Sawada Yōko (Osiris Press) for her tireless work in the field of Japanese photography, Hatta Naoko from the Isozaki Arata office, Mizuya Tomoyo (of 目 [mé]), Akaaka Publishing's Editor in Chief Himeno Kimi, Kakiuchi Yukiko of MUJIN-TŌ Productions, and Aya Tomoka from Third Gallery Aya (for Ishiuchi).

Maiko Morimoto Tomita is the most brilliant collaborator anyone could ever wish for. Takako Fukasawa was a key member of our team, and Yui Hayakawa and Matthew MacLellan joined in the end. Dan O'Neill helped me navigate the rapids. Sophie Rabau gave me a place to land in Paris and sushi picnics by the Seine. Kimber Simpkins, Liz Thurber, Michael Allen, and Greg Cason kept me writing in many genres. The magical Barri Malek held space for many metamorphoses. Yariv Rabinovitch remembered it all when I forgot. Coriander Reisbord, Rachel Mercy-Simpson, Racheli Perl and Gilad Buchman and Boaz, Tom Rockwell, Alice, Michiko Tsushima and her family, Miriam Bartha, Kimura Saeko in the 3ème, Sumi Shin, Mia Fineman, Neil Mayle and Sara Wolfensohn, Josine Shapiro, Melissa Milgram, 57, and many other friends and colleagues kept me laughing and stood by me through everything. Anne Bayard-Sakai and Michael Lucken were so welcoming. The late Takeyoshi Nishiuchi wandered with me through the city. The moms and dads of the boys' pod kept the kids happy. Sherri Wizard taught me a new meaning of sister. Rabbi Chai, Renna, and Elizheva expertly navigated the bar mitzvah with us. My brother Jon showed me that it's not only about words. Dorothy Rubin up the hill radiated light and painted it. The Wednesday women talked it through. Higashi Yoshizumi and Shōta Kanoko lightened the weight of it all.

Deep thanks to Anitra Grisales for careful editing and suggestions about how better to weave the threads together, and to Elizabeth Ault, Benjamin Kossak, and Ihsan Taylor at Duke University Press for welcoming this work into the world and ongoing encouragement and practical help.

In loving memory of my aunt Harriet Smith, whose creativity with everyday objects and poems was a model for the artistic life, and my kindhearted uncle Alex Sussman, forthright when the occasion demanded, whom we were so sad to lose to this pandemic. Thanks to my parents, Drs. Nira and Joel Silverman, my first sister Sharon Shepard, and my whole extended family, present and past, for always having my back.

Biggest thanks to Paul, Beckett, and Yair for being there and teaching me about feeling as well as media, and for infusing the nonwriting times with so many cuddles and so much play.

Japanese names here are given in the Japanese order, surname first, unless I have known the person primarily in a US context.

Introduction

The day I began revising the introduction to this book, Berkeley was experiencing a sudden, intense heat wave. In the thick and sticky air, all the plants in my garden immediately drooped. Inside, the best I could manage was a small electric fan. The kids were about to leave for summer camp, and the night before, drenched in sweat and unable to sleep, I had watched an addictive TV series until too late. My brain could not quite pull together anything that could map the contours of this book. I had to let it go.

Later, on a cooler day, I realized that the very things that had been blocking me were integral to the book's through-lines. The air—the larger atmosphere, including the global warming that led to this heat wave, and the industrial, cultural, imaginative, and technological structures around it—that air, that atmosphere, holds within it a complex history. Air has a history. It sounds strange. Not just the scientific sense of molecules of oxygen, carbon dioxide, and nitrogen in space, but atmosphere in the sense that Virginia Woolf meant when she wrote—when Clarissa Dalloway thought—"It will be a solemn sky . . . it will be a dusky sky, turning away its cheek in beauty." She evoked the sky, the air, not literally but infused with social meaning and intimate feelings. "There it was—ashen pale, raced over quickly by tapering vast clouds."[1] The history of wars, personal memories, and loss infuse Woolf's famous tactile and sonic refrains: "Fear no more the heat of the sun. . . . Leaden circles dissolve in air."[2] In the words of this most precise theorist of the movements of feeling, air becomes a medium for sensory experience and

encompasses the multiple meanings of its fading, like the dissipating sound of Big Ben across the urban landscape.

Sometimes spoken of as atmosphere or environment, or in terms of ecology, talk of something like air in recent theoretical writings has brought with it a shift in scales of focus in the humanities from talking mainly about works and their contexts to larger distributive systems and aspects of the life of tone and feeling that are harder to name or narrate. The sense of connection to a larger picture opened again in a new way in the current pandemic, where we wear our masks to protect ourselves and others from airborne viral contagions, where political movements and their fore- and backlashes ripple the sociopolitical climate, and where, as one journalist put it, from well before this moment we have been subject to "the buffeting emotional weather of everyday life . . . our Twitter-fed swings of anger and mirth."[3] Such tonalities often turn up under the names of affect or emotion; they designate feeling tones not located in or limited to a single individual, and they allow for mappings and analyses that do not require reifying boundaries (like the bounds of nation, relevant for a book like this that takes up works done in and around the Japanese language).

These approaches allow us to analyze the fact that it is not only my heat wave, my spacy mind, my internet, or my TV series. Affect has allowed us to see the ways that my personal world is toned—or by turns atonal or out of tune—with local and broader national and global shifts. While structuralist and post-structuralist theories allow us to understand the symbolic formation of our subjectivities in and through language and its limits, with important attention to the workings of power across social systems, affect theory brought in some new questions and new approaches, taking place around and between larger structures (language, capitalism) and the smaller, seemingly individual but also highly structured and overdetermined worlds ("my" self, my body, sounds and words resonating inside my mind—like the little name labels I pressed onto the summer-camp clothes, the sadness and joy of beginnings and departures).

This book argues that by perceiving the world on the level of air or atmosphere, through studies that engage with the idea of affect and look among and between the larger systems, we can locate a realm of potentiality that relies neither on outmoded or utopian models of individual agency nor on pessimistic or paranoid frameworks of critical late-capitalist overwhelm. The larger systems that this book takes up in a series of related forms are sometimes perceptible under the frameworks we could call infrastructure—meaning not just technological apparatus or physical built environments but

also the movements, flows, and social conventions that condition them and make them work. The thinkers and artists I take up in this book, whose work centers in the 1960s–70s and in the earlier years of the twenty-first century, sometimes name those larger systems "totality" to designate precisely what is beyond the power of the individual to grasp. Yet certain rhetorical and artistic practices can begin to give a handhold, reinterpret, or reframe those totalities in a way that helps them become newly perceptible and thinkable. These practices shape an altered form of attention and analysis that highlights the space between individual as well as collective acts and those larger structures.

This book teases out the places where artists and critics grappled directly with a problem that we continue to feel strongly now: how to maneuver or put together a life, to create or simply survive within bigger structures that may overwhelm and that clearly take place at a level or scale beyond the individual, and also beyond local community. Some of what we feel as overwhelming today—aspects of the world changing too quickly and in ways too large to understand or perceive fully—happen in the realms of the internet and electronic media, via the little phones and thin computers that have almost come to feel like parts of our bodies. Some artists and critics lament the loss of an analog emotional terrain, or wonder if something very important is being lost; others reframe "lossiness" itself as a matter of digital depixelation, a structural side effect of reproduction and compression within new media.[4] Yet those feelings of something new and overpowering happening in the world are not in themselves new. They have echoes in the writings of the critics of early modernity, and again in early twentieth-century urban life and avant-gardes; and then again, in something like what Hal Foster termed "retroaction," around the time of the postwar burgeoning of electronic media that the first part of this book focuses on.[5] Doubts about the powers of art and imagination are a recurrent refrain; the sense of larger uncertainties today thus doubles and echoes representations of past losses and experiences of technological overwhelm.

In this book, through six chapters on intermedia art, experimental animation, postwar media theory, photography, and contemporary visual art, I evoke both the potentialities and the limits of working at what I call the scale of affect—that ambivalent scale or space that both traces and blurs the boundaries between individuals, collectives, and systemic structures. It is an honest space: it pretends neither to be able to change the world nor to claim that such a change is impossible. Instead, and with a sustained interest in media as a realm for working out these potentialities, it aims to draw out

the reframing and shifts in both perception and action that become possible when grappling and perceiving at that affective scale.

In 1960s–70s Tokyo, an era of massive rebuilding and technological transformation, as well as more recently in the aftermath of the 2011 triple disaster of Tōhoku and Fukushima (tsunami, earthquake, nuclear meltdown), we find a particularly strong need, in both imaginative and concrete forms, to grapple with the sense of being caught up in and vulnerable to a larger set of structures and systems. By the end of the 1960s, Japan was internationally known for its massive export of high-quality, inexpensive technology and electronics—radios, televisions, music players, and more—and thus had a key role in transforming the media landscape globally. The governing bodies had made an immense commitment to economic growth, and the vision of the salaryman on his long commute and the housewife in the apartment block (*danchi*) or company dormitory played a decisive role in cultural representations of the time.

For example, in the 1963 film *The Elegant Life of Mr. Everyman* (*Eburiman-shi no yūgana seikatsu*), by Okamoto Kihachi, it is precisely the boring cookie-cutter life of the salaryman as a cog in the machine that gets turned humorously on its head (figure 1.1). The life of Everyman represents the Showa era up to that point, through the war years and into the postwar economic boom.[6] The affective boredom of his life (*omoshiroku-nai*, boring) transforms into shame (*hazukashī*) as the film mediates, through multiple cinematic genres, the reflections on history and larger systems—wartime business, the gender-family system, the corporate salaryman culture—that condition his and the

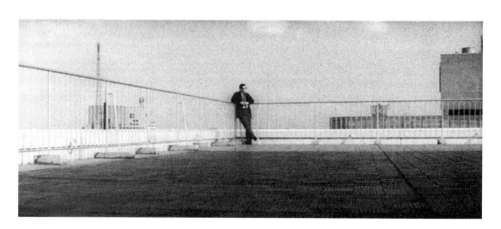

FIGURE I.1 *The Elegant Life of Mr. Everyman* (dir. Okamoto Kihachi, 1963), film still.

audience's present life. In one of the closing images of the film, after watching his coworkers boogie on the rooftop, we see Everyman himself at the vanishing point of the larger infrastructure of the company in the line of sight, as the larger film frames for us through multiple vantage points the intersection of (premediated, genre-bound) subjective and objective perspectives on that Showa-era life. This image can thus provide one possible figure to evoke that larger range of complex relations—positioning of the subject/artist within larger total structures—that part I of this book focuses on through examples drawn from intermedia art, experimental animation, and theories of the culture industry from the late 1950s to the 1970s.

In the post–triple disaster era (referred to as 3–11 because the triple disaster occurred on March 11, 2011), artists have often mediated their approaches through older technologies and media forms. Arai Takashi, for example, took daguerreotypes of survivors in the Minami-Sōma area (near Fukushima), with their animals, and displayed them in dark museum rooms alongside images of the *Daigo fukuryū-maru*, the *Lucky Dragon* boat that was damaged in the nuclear testing outside Bikini Atoll, and juxtaposed these with images of the Nevada test site as well as from Hiroshima. The layers of mediation of histories of disaster become a crucial element of the negotiation of scales of approach in the aftermath of 3–11, and by allowing the skin of the film to show its damage along with evoking the vulnerability to nuclear threat, he creates a layering of media and historical times. Other photographers and visual artists take this layering and emphasis on skin even further in attempting to grapple with the affective and mediatic resonances of both the losses and the ongoing infrastructural (and sometimes invisible) presences that condition Japan and the world today. The efforts of these more recent artists, which I draw into relation with the earlier intermedia arts to develop a language for theorizing them, emerge as the central subject of part II of this book.

The Affective Scale

The scale of affect is a way of describing something all the artists and theorists in this book navigate at a practical level, in which certain feeling tones emerge, or happen, in large and small ways at once, pulling on what Lauren Berlant perhaps tries to evoke with the term "economo-affective"[7]—that is, seeing big systems in small ways, but also allowing the larger picture to come into view through the pulling of small strings in a line of text, a turn of a ring modulator (chapter 1), a wrinkle of toes in a photograph (chapter 4). When social theorists map big epistemological regimes across centuries, while telling

us that the century marks do not necessarily delimit the ending of a particular discursive logic but its recession from dominance, or when literary critics mark a historiographic overlap between modernist and postmodernist logics, they are limning sensibilities marked within micro-instances but read for larger waves, tendencies, or fields. Mapping the affective scale might involve a new little key at the corner of the map that brings to bear both size in space (larger structures, small instances) and temporal flexibility—reading those feeling tones as they transform across a broader historical horizon from the 1950s to the early twenty-first century.

The aim here is to use the term *affective scale* to account for a functioning system of relays between larger infrastructures (social and technological) and the subjects who constitute and are constituted by them. These modes of relay happen sometimes explicitly in the works' own moment, and at other times as part of a media field that later works and times make perceptible in a transhistorical and transcultural perspective. Small and big, micro- and macrotemporal, these relays get articulated when we attend to the movements of atmospheres, what some others might call ecologies (including media ecologies), letting our focus shift from close to far without losing sight of the close.[8] Scales may be forms of genre—in the sense of framing existing forms for understanding or grasping the world—and reading affect across scales may be a form of genre-flailing.[9] But I would like to think that as the affective scale, which has intimately to do with media and mediation, traverses this book, it picks up meanings and clarities and also may become useful for the work of others.

I have leaned toward defining infrastructure as a mode of attending to the larger systems of technology, capital, and governance while keeping at front of mind the social and embodied frameworks and modes of movement that condition them and that they condition. My definition of the infrastructural thus inclines toward the social and affective. When Lisa Parks outlines a mode of considering affect together with infrastructure, she writes, "A phenomenology of infrastructure and affect might begin by excavating the various dispositions, feelings, moods, or sensations people experience during encounters with infrastructural objects, sites, and processes." In her articulation there, considering the theme of affect in relation to problems of infrastructure would primarily mean bringing to bear a frame/phenomenology of the personal, embodied, psychological ("dispositions, feelings, moods, or sensations people experience").[10] Yet that is not the main meaning of the work on the scale of affect as I mobilize it in this book. Instead, in the lineage of Sianne Ngai and other feminist critics following Eve Sedgwick (to some degree Sara Ahmed

as well), I don't lean hard on the differentiation between affect and emotion, but place affect on a continuum—and here was the original inspiration for the term *affective scale*—between subjective/personal and larger structures, attempting to account for tones and modalities that give access to places of relay and intermediate spaces in perfect continuity with neither imagined pole, that work to destabilize fixed polarities and open to a different kind of vista. As studies of scale have pointed out, moving from smaller/closer (i.e., individual, subjective) to larger/farther (social/infrastructural) does not just yield something like higher- and lower-resolution views of the same terrain, but in fact opens the purview of a different terrain altogether and a different vantage point. The affective scale aims to trace moments when such an alternative terrain comes to be perceptible, as well as to map moments when its imperceptibilities can begin to be grasped.

Focusing on artists from the 1950s to the present, mostly from Japan, this book also takes on a specific methodological task. While many excellent colleagues have shown the relevance of theoretical writings in Japanese, there remains a marked tendency to reduce, if ever so slightly, those writings to something comparable, something already recognizable or known, rather than taking the time to grant them, like all good theoretical writing, their full complexity and open-ended nuance. Within discussions of Japanese media, cultural, and film theory, mere mention of prominent Euro-American (usually white male) theorists has a tendency to overwrite, and thus reduce, the impact of any Japanese theorist's formulations. Writing about theory is an act of translation and imagination: I have attempted as much as I can (though somewhat imperfectly, especially in chapter 3) to avoid superimposing or citing those famous names in order, in the best case, to open these specific theorists' thoughts to more of their provocative possibility. I want them to function in an open-ended manner as working thought—that is, as their own form of praxis, along the lines articulated by the writers themselves.

Yet I would also want to avoid imagining Japan as a hermetic space. Indeed a fault of the long tradition of orientalist readings of Japan for what it can offer "us" as a counter to "our" entrenched tendencies mirrors another tendency in recent media theory: to read the digital datascape as a new apparition of the inapprehensible (and often feminine-gendered and racialized) unknown. Japanese theorists and artists, especially in the periods I discuss in this book, are part of a global landscape traversed by blockbuster Disney animations, Hollywood films, and the French nouvelle vague, as well as by the translated theories of Benjamin, Adorno, Barthes, Senghor, and Marx, among so many others. The artists participate in global contemporary art

circulations—though their textual interventions often remain untranslated and unheard. It poses a challenge for both area studies disciplines and area-based art exhibitions to define the limits and parameters of their objects without flattening them, to account for their varying resonances at the global and local levels.[11] Perhaps one approach to this problem becomes listening to theory as a decentered and decentering practice, as I try to do in this book (so that theory slowly ceases to mean Euro-America).

While I thus avoid depending too heavily on the abundant wave of Euro-American theories on affect, allowing the Japanese artists to articulate their own speculative interventions, I have been inspired by some specific American writings in ways worth mentioning here. For affect, I do not press in the direction of those theoretical interventions that set themselves against structuralist/post-structuralist thinking to emphasize and reify the body, sensibility, or materialities. My version of affect integrates textual structures (with and as material forms) with aspects dealing with the difficult-to-grasp spaces of material objects, embodied labors, and metainstitutional systems. Affect and emotion, terms often opposed to one another, exist on a continuum in this book. Prior theorists identify *emotion* with the subjective or narratable, related to the first person; *affect* evoked the more objective or third person (as in the role of the analyst's feelings in psychoanalysis), or what was less organized, structured, or narratable. Affect was not constrained by the bounds of an individual subject. An influential articulation, such as that of Sianne Ngai, takes the difference between emotion and affect instead as "a modal difference . . . rather than a formal difference of quality or kind."[12] Ngai argues that this changed emphasis allows "an analysis of the transitions from one pole to the other," and she highlights productive moments when "we are most uncertain if the 'field' of [feelings'] emergence is subjective or objective."[13] My own version of affect here is inspired by these blurrings of the distinction between the localized and ambient, between first and third person, or individual and larger fields for the play of feeling; such spaces of transition are key markers that characterize the "affective scale" in art, critique, and analysis. Thus, I work in opposition to those versions of affect theory that have been accused of abandoning close reading or larger structural problems for the sake of a focus on the personal, embodied spectator. Instead, my interest focuses on and aims at the place where attention to infrastructures and transpersonal feeling comes into contact with specific subjective investments, and more narratable or formed, familiar emotions.[14]

Yet for thinkers like filmmaker Matsumoto Toshio, as we shall see in this book, the problems of intrapsychic and extrapsychic structures refracting

one another already formed a fundamental part of his theoretical frame. Writing about avant-garde work, he brings the experimental, antinarrative, or antilogical visions one would associate with experimental filmmaking—sometimes said to reflect the workings of the interior of the psyche, the unconscious, and so on—together with the documentary impulse, as the necessity to see and refract the real or larger world. Both terrains are crucial for the filmmaker's search, and they have a necessary relation to one another. His theories of the avant-garde documentary interest me here because of how they presuppose an integral relation between the intrapsychic and the document of the world. In this sense, they theorize the space of that blurred line between the extra- and intrapsychic as a necessary field for artistic and mediatic practice. His mid- to late-1950s experiments draw on earlier intermedial sculptural works that recognize the interlocking gazes of multiple spectators beyond the grasp of any one individual. Aiming to totalize the relations between that subject-exceeding set of gazes, Matsumoto is a creative theorist of that space and scale of artistic/mediatic potentiality located above the individual and below the larger system (whether the latter is conceived, as it might be today, as infrastructure or platform). Or if the metaphor of a horizon line with an above and a below fails, perhaps we may imagine this intermediate scale as an interlocking in-between. Whatever metaphor we land on, and the artists of this book have been prolific in visualizing and theorizing this terrain, we find that language, film, and visual arts hold a privileged place in articulating, reframing, and grappling with the realm that opens—that we find ourselves in—between and among larger systems that work beyond our grasp.

In reading these approaches, the grapplings, the inventiveness of the artists and critics both of the 1960s–70s and of more recent contemporary art in Japan, especially those engaging with the larger systems and structures of media and social institutions, I have found helpful Eve Sedgwick's influential articulations of what she (following Melanie Klein) terms the "paranoid" and the "reparative" (or "depressive") positions.[15] Something along the lines of these positions offers seemingly contradictory yet simultaneously plausible interpretations of these works and ideas. As with emotion and affect, it can be more useful to attend to slippages and shadings, and to the transitions where one yields to another and back again, so the seemingly contradictory frames of interpretation do not land in a fixed binary or mark correct or inaccurate views, but instead open to a range of interpretative possibilities that can be more or less convincing or generative at different moments.

The paranoid position in recent theory (say of the last forty years) is, for Sedgwick, the gesture of (Marxist) unmasking, in which the theorist or

interpreter reveals the workings of power (gender, hierarchy, class, race, heteronormativity) in a text where it was otherwise hidden or invisible: it is the gesture she calls the "topos of depth or hiddenness, typically followed by a drama of exposure."[16] She offers as an alternative the Kleinian depressive/reparative position as one that is attuned to the "heartbeat of contingency" (147), and that entails a "middle range of agency," neither simply accepting or refusing what is (13). Rather than being attached unwaveringly to specific individuals, Sedgwick's queer-affiliated version of the reparative involves "mutable positions [or] practices," which are "additive and accretive," a practice of "assembling" that has deeply to do with loss and survival (149–50). What one stands to gain from attending to the reparative practices are "the many ways selves and communities succeed in extracting sustenance from the objects of a culture" (150–51).

This accretive art, and the attempt to grapple with and survive the overwhelm (or downturn), is an evocative description that aligns well with what the artists and critics of this book continually take up. The inspiration that the shift between paranoid and reparative has given me here, like the shift between Ngai's emotion and affect, is that they have regranted me a freedom—already conferred in advance by Matsumoto's theories and those of many other artists in this book—to engage with an intermediate realm of interlocking gazes and relationships with agency, to see how the potentialities evoked in these artworks and theories manage somehow both to engage critically and to be part of larger and sometimes damaging systems and structures (global capital, media systems, art markets). They open an intermediate range of agency where the imbrication of personal subjectivity in these larger structures becomes visible, and where, as Matsumoto put it, one can grapple with and potentially countervail the "feeling of Being in the contemporary age."[17] That is, on the one hand, one can engage alternately in a paranoid/critical/exposing view of the larger social structures and infrastructures and one's own part within them, exposing the complicities of artists and critical frames even beyond their own view.[18] On the other hand, one can also switch into a mode of seeing where the grappling with and survival among the structures and frameworks provide a space or scale, if not precisely of sustenance, then a praxis/practice of acting at that middle range of agency—one that does not invalidate the critical/paranoid frame but rejiggers it in some special and unexpected way. The middle range of agency aligns with the affective scale of practice, a practical navigation that has to do with ways of seeing as well as making, interventions within larger sociocultural genres and infrastructures.

This kind of action, this rejiggering, in its many kinds and methods, is the focus of all the chapters of this book.

Protest and Artistic Practice

The early to late 1960s in Japan is often also known as the era of protests—against the renewal of the Japan-US Security Treaty and the hegemonic Cold War control over the East Asian security sphere in 1960, and against the Vietnam War and the presence of US military bases in Japan, such as the one in Yokosuka that forms a key site of postwar Japanese photography that I discuss in chapter 4 of this book. While May 1968 is the date for the best-known Berkeley-Paris-Tokyo-Berlin protests and the center of gravity for international memory of the 1960s—as revealed in the spate of commemorations of the fiftieth anniversary of that date in 2018—a key date for Japan is actually 1960, when one of the most prominent rounds of worker and student protests took place. Other moments also figure prominently in historical memory, like 1952, 1968–70, the continued protests against the renewal of the Japan-US Security Treaty taking a recursive structure thematized by filmmakers like Ōshima Nagisa (in chapter 2).

Though women photographers had a significant role in the emergence of photography movements in Japan, they have been largely ignored in the wave of recent international attention to postwar Japanese photography in the era of the protests. "At times carrying the camera and at times wooden staves," as the afterword of one protest book proclaimed, photographers like Shinkai (possible pseudonym of Sasaki Michiko), for example, may have taken images like figure I.2 for the photo book of the Nihon University Struggle (*Nichidai tōsō*, one major site of the late 1960s Japanese student protest movements), a book aiming to inspire and provoke solidarity with other potential participants among the local public and abroad.[19] In this shot, the space of the protesters' tiny white shirts and black hair recedes like (in my analogy) an abstract Kusama Yayoi dot painting among the dominating diagonal lines of the university building, symbol of the larger institutional infrastructures against which the students mounted their resistance. The image shows the intricate attention and emergent media practices through which Shinkai and her comrades took up the challenge of grasping and visualizing the place of individuals within the larger system—though this photo does manage to frame an overview of it. Yet Sasaki herself, who was certainly present with her camera at these events, is now owner of a bar in the famous Tokyo nightlife

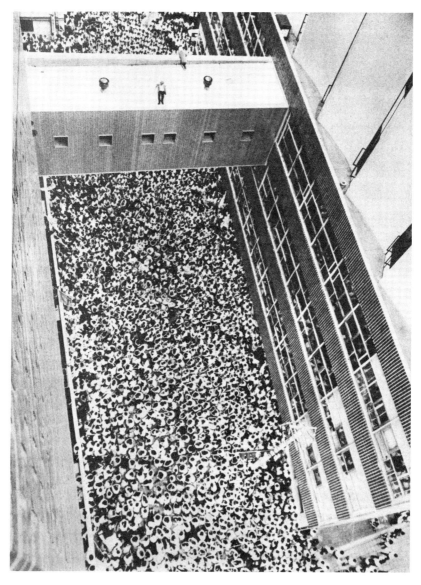

FIGURE 1.2 *Nichidai tōsō* photo book (1969), image of student protest at Nihon University.

district of Golden-gai (Golden Street) in Shinjuku 2-chōme, and attends also to the importance of individual acts, activist lives, and personal connections in her reminiscences on this era, as in her recent book *Shinjuku gōruden-gai no hitobito* (The people of Shinjuku Golden-gai).[20] The stated reason for the 1969 protest book's "revelation of the imperfection and incompletion" of the student protests, the provisional positions revealed through these photographs, is to solicit the participation and support of others. The book pictures the infrastructural work of protest, the practicalities of how it's done, from within the politics of direct action and resistance characterizing that early period.

Bridging these various waves of protest, around the period of the 1964 Tokyo Olympics, when the massive cleanup of Tokyo for that purpose was deeply underway, the sense of being engulfed in enormous logics and institutional configurations and the necessity of contending with these processes through art and criticism were central cultural preoccupations. Here, it was a matter not only of technological changes or physical infrastructures but also how social systems and regulations/surveillance worked within them. One paradigmatic event that highlights these elements is the Hi Red Center Shelter Plan, documented in Jōnouchi Motoharu's film of the same name. In this event the artist group Hi Red Center rented a room at Tokyo's Imperial Hotel (a famous building by Frank Lloyd Wright that was demolished a few years later). They invited guests to undergo convoluted body measurements and offered them the opportunity to buy personally fitted bomb shelters. Because artist Akasegawa Genpei was already under surveillance for what would evolve into the 1000-Yen Note incident, throughout the event a policeman was stationed in the lobby (in a sense, becoming part of the happening); artist Nakanishi Natsuyuki describes the event as an "infiltration" of the hotel that was "part art and part crime."[21]

Importantly, *Shelter Plan* focused attention on what Akasegawa called the "*sōchi*" (device or apparatus) of social space. Arguably, the term *sōchi*, as artists used it in this period, traverses the terrain covered in concurrent and later Euro-American debates around apparatus theory, with the term French term *dispositif* (translated into English as *apparatus* or left untranslated) now spanning the structural/technological/built environments as well as the social structures and lived uses and regulatory regimes of those spaces.[22] Japanese theorists sometimes invoke *dispositif* (now the term *technics* in US media studies sometimes fills that oppositional space alongside *dispositif* in relation to the more technologically determinist, older readings of the term *apparatus*). Yet *sōchi* as space, in the perception of Akasegawa and others deeply embedded in critical performative practices like *Shelter Plan*, fully encompassed

both the social and architectural/architectonic. The artists' use of the term and concept of *sōchi* contains a trenchant and humorous critique of imperial/nuclear discourse planted within a historically overdetermined space. Device/apparatus/*sōchi* thus became an approach to that intermediate scale of analysis where the individual, the collective/group, and the larger systems interface. Artistic worlds found there an ironic yet solemn "*moderato cantabile*," as Nam Jun Paik called it: Yōko Ono lies on the hotel bed to be measured from above and below for her personal shelter.[23] This 1964 event and other associated works and artists around the Sōgetsu Art Center in Tokyo presaged and participated in the broader frame of the movement that came to be called intermedia in the late 1960s.

A central concern of this book revolves around this intermedia art, introduced in chapter 1, a form or movement intimately related to (and sometimes referred to interchangeably with) happenings, performance art, and the emergence of 1960s electronic music. Key to the lead-in or context of intermedia are the practices of expanded cinema (cinema shown on more than one screen or on alternative spaces/forms of projection) and Matsumoto Toshio's theories mentioned above, which led him in that direction. The terms *intermedia* and *environmental art* are also often used in close relation to one another. Emergent artists and designers were becoming exposed to trends in pop art, op art, minimalism, intermedia, and happenings both in Tokyo and internationally, particularly through the journal *Bijutsu techō* (Art notebook) and other media venues as well as traveling programs generated from Sōgetsu Art Center and Shinjuku Bunka Theater. Avant-garde ideas were reaching those outside traditional disciplinary educational systems and were being implemented in actions and performances that never entered the mainstream of the avant-garde canon. Higashi Yoshizumi, for example, an important artist and illustrator still active today in Chigasaki (though still mostly undiscovered in the art world), left behind the world of formal artistic training and moved to Tokyo to start out as a sign painter, and later to join the ad agency Young and Rubicon before going freelance. Higashi kicked off his journey to Tokyo by staging an event in 1969 on the Asagiri plateau, at the base of Mount Fuji: he flew a single giant paper airplane across the open landscape and photographed it during its flight.[24] Such a conception of the artist outside of Japan's traditional training and media boundaries, inspired by a discursive critical/conceptual network that framed a critique of artistic infrastructure, was made possible in and around the framework of art linked to these intermedia experiments.

A key introductory event for proto-intermedia artworks arrives with the event *From Space to Environment* (*Kūkan kara kankyō e*) presented by the Kankyō no kai (Environment society) at Tokyo's Matsuya department store in 1966, which included a night of happenings at the Sōgetsu Art Center. "The many genres of art," wrote the organizers of the exhibition, "must destroy themselves in order to be reorganized under new systems," while viewers, "in the face of unavoidable self-dissolution, are either boldly or passively whirled into, or swallowed by, and cannot but participate in the 'place' created by the work of art."[25] For the show, intermedia sound engineer Okuyama Jūnosuke pioneered light and sound contraptions that, as critic Tōno Yoshiaki put it, were realizations of "structures and systems" conceived by given artists but realized by "other hands" (often Okuyama's), and highlighted the place of apparatus and infrastructure in framing the human body in relation to the urban environment.[26]

Expanded cinema practices were especially prominent in the events leading up to the 1970s Osaka International Exposition (Expo '70) as well as in the expo itself. A rapid montage of three projections—two side by side and a third on top—Matsumoto's film *For My Crushed Right Eye* (*Tsuburekakatta migime no tame ni*) was shown at *Expose '68*, at the Sōgetsu Art Center. In an environment saturated with technologically reproduced images, works of expanded cinema such as *For My Crushed Right Eye* proposed a version of film that was performative and contingent, and thus corresponded with a reality that appeared at the time to consist of fragments and images violently colliding with one another. The film incorporates images taken from popular television shows, scenes of student protests and clashes of Japan's radical New Left group at Haneda and Sasebo, go-go dancers, graphic arts, the pop music scene, and images from Shinjuku's gay-boy culture. Matsumoto described the reality that consisted of these fragmented and colliding images—in parallel with what has been characterized as the "cinema mosaic" of his films—as "a mosaic in a complex state of flux, apparently lacking in logical connection . . . a disordered and chaotic *totality* [whose] overcrowded and congested experience is only multiplied by the infinite influx of news and information items."[27] For Matsumoto, multiprojection in an intermedia context was a way to create an art that could contend with the disordered totality of the contemporary mediatized world.

A reevaluation of the works and practices of the late 1950s to early 1970s in Japan gives us a more historicized, and perhaps less parochial, perspective on contemporary works of environment-based and site-specific art, works

that critique systems and infrastructures, and new media art more broadly. Central issues of mediation and digitization that today's artists confront have roots and parallels in the media practices of postwar artists in Japan and elsewhere. Though these issues are not unique to Japanese art, their manifestations and the critical discourses of intermedia in Japan continue to resonate forcefully as we consider the role of medium in art practice today, and as we come to grips with parallel dilemmas of navigating technological transformations in an increasingly globalized and mediatized environment.

Shelter Plan worked through infrastructural questions (imperiality, the nuclear threat) that also impinge on personal, embodied vulnerability (the shelter) and consumer capital (the ironic sale of shelters and postnuclear canned food). Intermedia art, with its technological obsessions, also engaged deeply with the vulnerability of the human sensorium in relation to larger-scale structures, and hence with the possibility (and inevitability) of loss. Concurrently with *Shelter Plan*, many of the same artists who participated in intermedia art also became involved with animation experiments at the Sōgetsu Art Center. Through the stretch and plasticity of animation's lines, its perspectival shifts, they aimed for a *dépaysement* (disorientation, dislocation), an unsettling of the overarching rhythms of the everyday. They mobilized what they saw as animation's unique potentialities in relation to the media system, including television's regulated temporalities. Working both from within and parallel to commercial media, these animation practitioners at times evoke a lassitude that flies in the face, or just steps to the side, of the regulated temporalities of Olympic preparedness. Their odd interest in things like recursively bouncing balls, teardrops, and ink on skin opens an alternative space in which those larger structures and systems may shift their meaning. Yet the artists are not outside the systems of commercial culture. From within experiments in the medium, they model a space of permeable boundaries of cultural fields, an intermediate scale of vacillating folds within larger systems. Here, this exploration takes the form of an intimate yet technologically mediated relation with objects in their materiality, and the interlocking relations of subjects and objects in their gazes. While paranoid readings of overwhelming structures have a tendency to place critical hope either in acts of unveiling or in the discovery of cracks and fissures in an otherwise unbending rigidity of frame, animation offers a sometimes ambivalent emphasis on the arts of the stretch, extension, the plastic and plasmatic for a practice of potentiality as metamorphosis.

In the later 1960s, these artistic experiments in animation, which I discuss in chapter 2, came into direct relation with the political problems of violence

and revolution, figuring a sort of anonymous (*quelconque*) figure of revolt and attempting to theorize what kind of violence might bring about a truly effective and meaningful shift in the political, social, and class hierarchies.[28] Working within a celebrity culture, the experimental animation of Ōshima Nagisa becomes one notable example where the layering of time, the recursive, repetitive structure both of repressive hierarchy and rebellious protest, come into focus through the specific formal strategies of a *gekiga* (long-form dramatic popular manga) reframed and remediated into a work of what I am calling experimental animation. The workings of the affective scale, the scale where the individual is both present and multiplied, where the perspective fragments into a view of insurgence, creates a framework for thinking about the potentiality of animation and violence in relation to revolution.

Using the term *potentiality* in a Marxist sense might bring to mind the series of Euro-American debates on the terms *dunamis* (potentiality) and *energeia* (act) in the Italian Marxist–lineage of interpretation of Aristotle.[29] Views of the specific potentiality for revolution of the workers, the relations between potentiality (*potenza*) and realization in acts (*l'atto*), accompany a substrate of (disagreement) about *impotenza* (*adunaton*, im-potentiality)—that is, the question of what happens, in the passage from potentiality to realization, with the capacity not-to-do, to the withholding? In other words, is it not the case that what distinguishes potentiality from realization is potentiality's capacity also to fail to be realized, to not-be or not-to-be? While the debates around these subjects have occupied Marxist critical theorists extensively, an important strand of artists and critics in Japan directly engaged in Marxist thought were also divided around the questions of doing or not-doing, or speech (*parole*) and silence, the capacity or incapacity of larger media systems and the masses—the latter in many ways formed by or in relation to those systems—to act, self-organize, and mobilize. The depth of the theories of culture industries on these questions is striking, and specific formulations of the Japanese theorists open out nuances not available in other languages, which I explore in chapter 3.

These theoretical questions took center stage against a backdrop of dramatic shifts in the media cultural landscape. In summer 1966 it was the Beatles; in September 1966 it was Sartre and Beauvoir. Throughout the 1960s a parade of European celebrity cultural figures passed through and created memorable media events in Japan.[30] (The year 1970 is often limned as the end of the era of meaningful political revolt, with the securitization of urban space and the palpable atmosphere of defeat of the student movements, followed by the rise of Red Army radicalism and televised hostage crises.) In

1973, the optimistic cultural/media theorist Hans Magnus Enzensberger visited Japan, and his visit became a fulcrum for the critical and art worlds to gather and articulate their own readings and understandings of the potentialities and limits of media and the culture industries. It was a moment when cybernetics and information studies had begun to circulate in Japan, when computer art and video art came into being. Critics understood deeply that the infrastructures and social uses of media and information also included the movements of labor and labor unions, architectural spaces, and many other aspects that could be conceived within the imaginative frame of feedback loops, or in relation to the workings of the *dispositif* understood in terms of social/cultural movement. While many Japanese theorists had a hard time connecting or relating to their German colleague's perceived optimism, this case and moment provide a revealing opportunity to understand where contemporary theorists thought media's potentialities (and its silences) could lead, as I explore in chapter 3. The early 1970s culture industry debates give us a snapshot of Japanese media theory at a moment when the strategies of direct protest and the idealization of certain kinds of direct violence began to give way to a war of tactics to be fought on the level of representations and cultural structures; rather than fighting with staves, activists now focused more on reevaluating the semiotics of race, gender, and class. A stark division arose between those who thought that working for change within the system was most productive, and those who believed in complete refusal of the system. The former attempted to access an intermediate scale of agency by maneuvering within current structures and media systems in self-reflexive ways; the latter felt only full refusal—negation of these overarching structures and frameworks via language and artistic projects—could lead to an activation of change, a facing up to possibility as well as loss in the affective realm.

These refusals often took shape in an ambivalent practice of photography, the most famous of which today is the *Provoke* photography movement. Nakahira Takuma (1938–2015) and Taki Kōji, as key theorists of that moment, write of the paradoxical quest to reach or at least theorize the totality that is beyond what is possible to grasp, and how to live within that impossibility as a mode of existential praxis. Taki writes, "In the process of trying to theorize what we 'cannot see,' we try to decide 'toward what' we want to exist."[31] The idea of reaching toward a negation via a photographic and fragmented collective experiment took shape in the short-lived *Provoke* journal and other media venues that extended from it into the early 1970s, which work within yet also aim to negate the existing media cultural sphere. "The sphere that we are aiming to provoke goes beyond politics, toward a deeper realm of negation.

Or we even think that our provocation can happen in such a way that we ourselves become something utterly negative," wrote Taki in his "Memorandum" in the first issue of *Provoke*.[32]

The related landscape theory (*fūkeiron*) of the late 1960s and early '70s aimed to reveal the invisible workings of power within seemingly empty landscapes, often through film or photography.[33] In the wake of *fūkeiron* and the *Provoke* movement, many artists experimented with photography, emptiness, and negation that could nonetheless make the infrastructure of the social perceptible. Mobilizing textures, surfaces, ruptures, and seams, photographer Ishiuchi Miyako began her career by photographing the spaces of Yokosuka where she grew up, around the US military bases. Her approach departed obliquely from the ways those spaces had previously been photographed. Earlier versions of Yokosuka had framed it first as part of a documentary project for the occupying military. Later, it provided for a countervailing realist postoccupation critique that emphasized the abjection of the war orphans and prostitutes (*pan-pan*) who congregated around the bases and became symbolic snapshot representatives and allegories of the geopolitical incline. That is, those earlier forms of snapshot realism are often interpreted as directly visualizing US power over Japan, the perceived (gender-inflected) disempowerment of Japan.[34] Unlike those versions of Yokosuka, Ishiuchi's late 1970s photographs present the haunting surfaces of the abandoned brothels and bars whose crumbling paint and cracked tile evoke a present absence of female bodies, a more uncertain relationship with their suffering and their agency within those larger spaces. In her 1970s views of those same spaces, Ishiuchi weaves in another dimension that resonates with what the landscape theorists had asserted as well—by showing the empty yet fissured landscapes and walls of Yokosuka and mostly absent human subjects, and also by entering the forbidden spaces (to her, as a child), she braves facing a transpersonal history whose traces and scars still require her working through. Ishiuchi's photographs thus take on that intermediate scale between affect and emotion, between larger structures and the personal, between stories and histories that can and have been narrated and those that have not.

From Postwar to Contemporary Art

Because Yokosuka is nothing if not a paradigmatically infrastructural space, reflecting on the military, governmentality, and international power relations—"Hello, Sacramento!" shout the now-abandoned signs in English from the base-serving town—Ishiuchi's works also resonate with the on-

going debates and violences of the 1970s around the reversion of Okinawa to Japan, a space and event with which all the important photographers of the 1960s–70s had to grapple. Yet for Ishiuchi it is not only the military base town as an infrastructure of national/class/gender inequities, nor the more historically laden *dispositif*/apparatus of sexual exploitation, but also that level of eventually interchangeable yet anonymous subject positions—at an intermediate scale—that are at issue in her photographic series of Yokosuka, especially when read in relation to her following series of photographs of the textured surfaces of the bodies of women of her generation, discussed in chapter 4. Later she moves on to capture her mother's billowing, luminous clothing hanging in the window, as well as the clothing left behind in the ひろしま/*hiroshima* archive, to frame and refract a new meditation on potentiality and affect in direct relation to loss. Thus, her work both transcends and vacillates among other competing sets of binaries (particular/concrete, historical/timeless, philosophical/phenomenological versus nonlocalizable), locating among them an engaging but nonfinal take on gender as social apparatus. From emotion to affect, between personal and infrastructural, Ishiuchi works in transitional and liminal spaces, creating an oeuvre that rewrites itself with each subsequent contribution, so that the Yokosuka works can only be fully understood or realized in relation to her 2005 *mother's* series and revived/reinstituted again after ひろしま/*hiroshima*. Here I argue that the infrastructures of gender come into focus beside or within the historical layering, so that her practice frames a nonverbal space where that intermediate potentiality of grappling and rejiggering the materiality of the social has been mobilized in a provocative way. Her work, imagining a plural I/me in her photographs, aligns Ishiuchi across a paradoxical spectrum of critical exposures and reparative solidarities.

Ishiuchi, as an artist whose work bridges the two central periods under discussion in this book—and whose earlier work came to broad recognition during the later period—makes us want to reflect on the dynamics and methodological consequences of examining works from the 1950s–70s in relation to the early decades of the twenty-first century. Both at the level of the exhibition and the individual artists' works, this book opens possibilities for reflecting on perceived similarities and differences in these periods, and for thinking critically about how that discursive and affective relationship gets constructed and used (by artists, curators, collectors, viewers). One can think through this problem via the modes of insertion/assertion of the work within international arts scenes, where they are frequently juxtaposed or linked; or one can consider the two periods of Olympic urban renewal (post-1964 and,

more recently, toward intended 2020 then 2021 Olympics); or one can high-light the sense of being in some kind of postdisaster/crisis moment, either in more recent memory (for post 3–11) or at some remove (for the '60s) that involves a crucial trope of reconstruction/renewal, along with ongoing is-sues of contamination and decontamination (traffic wars, Minamata disease, nuclear energy politics).

Even with the great differences also apparent between these times (neo-liberal deregulation, the rise of freeters and the precariat, among many other differences), both eras considered themselves as eras of the rise and estab-lishment of varying new media, meaning that rapid media transformations arose and eventually settled into a new normalcy within an expanded image-media ecology, entailing unprecedented early or late stages of transnational circulation and globalization. All of these factors work to allow some sense of a pattern of recurrence, a kind of circularity or feedback loop to be constructed, or become visible, across these moments. This feedback loop can then evoke an imagination or reflection on the very systematicity and process-oriented functioning of cultural work (meta- and local/global) as well as arts and media in "these (strange) times." The system of high growth consumption and metaphors of Olympic cleanup and renewal are again deployed—in a relay of historical moments between 1960s–70s frames of the *gendai* (con-temporary) and the newer *kontenporarī*, where we see the return of a media-saturated attempt of art to grapple with the impossible situation of being spoken through and infused by larger systems.

The aftermath of 3–11 has become a central thematic for Japanese stud-ies, and the works either produced or newly reinterpreted in this aftermath illuminate media studies and leftist critical theory in unanticipated ways. While some works continue to speak garrulously (and accurately) about the continuities between prewar fascisms and contemporary populisms/nation-alisms, the works' relationships with 1960s–70s media theories give a more layered view of the power of recent visual arts. In the legacy of the reportage painters of the 1950s, Kazama Sachiko questions visual media's potential to frame and refract political events.[35] Bringing to mind also the animetic line's stretch and the remediated manga as political shifting of the horizon that I discuss in chapter 2, my discussion of Kazama in chapter 5 shows how she brings back the slow, analog frames of the woodblock carving to create large-scale works that reflect on new social media, government surveillance and censorship, and the information overload in which her own online presence and hypertextual process notes also participate. The affective scale for Ka-zama is both historical (having to do with the layering of repressions across

histories and across visual representational forms) and mediatic—the interstice between the textural specificity and material one-timeness of black ink on paper and the infinite reproducible pixels of online informational supplementation. Thus, a new and contemporary version of that intermediate scale of potentiality emerges here through a citational yet innovative practice of assemblage.

Other artists practicing in the wake of 3–11 move toward the pole of *impotenza*/silences in their mediatic reflections on materialities, infrastructures, and personal loss. The massive scale of the installation work by artist Kobayashi Fumiko at Roppongi Crossing in 2013 rose before the exhibition viewers as if her career were only just beginning, and her powers of collection/assemblage/accretion were unstoppable—though that was to become one of her last works. The vacillation between the emphatically reparative and the paranoid positions allows us to better understand her assemblage works, including the six-meter wall of abandoned chairs and clothing she constructed temporarily in the Mori Art Museum at the very top of Tokyo. Her gathering of stray objects, clothing, and the cast-off shells of urban life as a performative act presses against the infrastructural and institutional regulations of the Mori's solid walls and building safety rules, as she constructs a supplementary wall directly in the museum space. The silences of her work allow many viewers' perspectives to emerge, while they also create imaginings of the absent lives of those who lived with those objects.

In the context of the global contemporary art world, in which the Roppongi Crossing exhibition self-consciously intervenes (chapter 5), the transnational operations of Japanese art markets make it less useful to delineate who is and is not a Japanese artist. Younger artists like Asakai Yōko move between Rhode Island School of Design, Europe, and Tokyo, among the landscapes and infrastructures of air, weather, wind, and their electronic mediations, providing us with an updated and yet more enigmatic evocation of what cannot be seen, whether nuclear fallout, the movement of tides, or the layering of time that materializes affect in the form of a photograph. In Asakai's photograph series *sight* (2006–11), ambivalent communities and families hover over their small screens watching Hollywood blockbusters, refracting an oddly beautiful global intimacy, as in an example from the series, *Bambi, Berlin* (figure 1.3). In the spaces of silence between these untalkative photographic works, tentative and strange spaces of commonality may be imagined. The potentiality here may have yet to be fully palpable; yet by theorizing these photographs and installations in relation to the transitions at the affective scale, via the work of intermedia artists and cultural theorists, we can begin

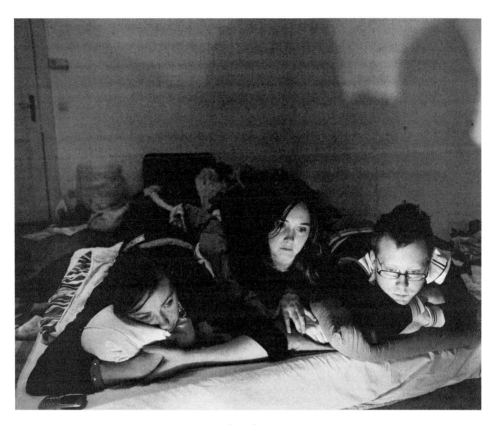

FIGURE I.3 Asakai Yōko, *Bambi, Berlin* (2006), type-c print, 453 × 560 mm, from the series *sight*, © Asakai Yōko. Courtesy of the artist.

to gain a meaningful sense of the grappling these recent photos demand of us in disaster's aftermath, and in the ecological spaces of today's disaster-infused, foreboding infrastructural everydayness.

While in some parts of recent photography, collectivities are dispersed into lonely solitudes or empty landscapes across distant rural roads, in other parts of the contemporary arts scene, especially before the pandemic, the ideas of community and collaboration have taken an unprecedented centrality—whether because of the emphasis on social interventions and participation or precisely because of the sense of existing in an aftermath of disaster, as in the Japanese case, or on the cusp of ecological disaster in the global case. Many artists focus on the idea of community participation, where the boundaries have become blurred between art happening, religious/spiritual/new wave ritual, and social-environmental movement (organic farming event, etc.). This

emphasis on participation can lead to a utopian-romantic presupposition about the reinforcement of community through art as a form of reparative practice. Yet in some cases this set of assumptions loses sight of the critical potential of engagement with infrastructures, those modes of grappling with the larger frameworks with which intermedia arts and earlier media theories so articulately struggled. Where has that struggle gone?

Chapter 6 works toward reinfusing the current discourse on community with the theoretical complexity of these earlier thinkers. Could one find a way, at the middle range of agency, to grapple with the actual and potential assemblages of relations that exist between institutions, individuals, objects, and social structures, including structures of feeling, movement, and directions of energy? In the 1950s, Marxist theorists articulated theories of media and mass-energy within a complex imagining of materialist dialectics. Infused with such theoretical insights, we can look at intermedia musical compositions, 1970s media theory, and contemporary visual art for important models and correctives to these simpler, more idealistic notions of community formation, and thus find new perspectives on the relations between artistic interventions and larger infrastructural forms. Artists make important conceptual leaps via infrastructural material, as individuals and systems interact along a series of complex vectors at the affective scale. Grappling with breakages in the potentialities of interactive conceptual art, photographers move beyond the intervention of the individual artist as they practice instead an art of circulation and slight delay, such that waves and ripples of just-printed photographs might rise up to challenge any preconceived understandings of what constitutes the real. More recently, the sculptural walls of contemporary installations, silent but imbricated in a complex semiotics, reframe the idea of community into a resonant infrastructure as citation of what remains behind. The works of photographers and sculptors from both periods thus yield a transformed relation to community, counterposing collectivity and assemblage as modes of pressing against and into the overwhelm of Being in the contemporary age. They model ways of opening a paradoxical model of futurity that has already been, or that engages dialectically with a multitude of material pasts.

From intermedia experiments to animation's plasmatic stretch, from trenchantly embedded media theories to multilayered textural practices of photography, artists in the 1950s–70s and the contemporary visual artists who "retroact" and revive their critiques operate at the affective scale to reveal unexpected possibilities for media practice. Beginning in the 1950s, the relationship between media in a moment of profound technological and cultural

change allowed artistic works to focus on apparatus and environment and to operate at an alternate scale of perception and technologically self-reflexive construction. With the high-growth economy of the 1960s, such an exploration became even more deeply necessary to reactivate artistic practice against and within the regulated temporalities of the booming corporate world. In chapter 1, beginning with the 1950s experiments of Jikken Kōbo (Experimental Workshop) and the media theories of Matsumoto Toshio, we trace the emergence of new potentialities of media theory and praxis (vacillating between paranoid and reparative positions) in paradigmatic works of the intermedia movement.

Part I

Intermedia and Its Potentialities

The Feeling of Being
in the Contemporary Age

The Rise of Intermedia

When 1960s Tokyo was being rebuilt on a massive scale, when memories of the "city of ruins" were close at hand—in ways resonant with what we have seen recently after the events of Tōhoku-Fukushima—the sense of being enveloped in a larger network of structures and in an emergent technological landscape developed in increasingly palpable and imaginative forms.[1] Technological changes in urban space affected daily life, and artists worked to invent forms and construct media that could address this altered sensibility. Even something as simple as the construction of ever-taller buildings and underground passageways, as in Shinjuku in the 1960s, undeniably changed the experience of space and dimensionality. As architect Isozaki Arata put it, "Up until the nineteenth century, it was all one could do to feel the city by walking in a straight line. But in contemporary cities, because one can walk not only left and right, but also climb up and dive down, an extremely three-dimensional frame has been generated for the first time as a structure through which one can apprehend the city. Through these conditions, systems of space have been transformed."[2]

In this era of explosive urban growth, the Tokyo sky was dark with chemical smog, cars pushed through intersections in accident-ridden "traffic wars," and waste-disposal systems could not keep up with the rate of expansion.[3] Japanese artists responded by focusing on three key areas of art and the world

around them: infrastructure, environment, and what I am calling apparatus. Intermedia events made an impact not merely in showcasing particular works and artists, but in terms of the concatenation of elements, central and peripheral, that culminate in an art event. These elements could include engagements with the wider urban environment and the barrage of mass-media images; networks of corporate and other supporters; the regulation of urban space; the flux of art venues and institutions; human and economic relationships within transforming media and technological systems; and, depending on the particular event, alternative engagements with everyday objects and sensory perceptions in aleatory relationship.[4] The protagonists of intermedia perceived that the changing environment demanded nothing less than a reinvention of art itself, a mode of action (with or without the label *art* attached) that would be commensurate with what Matsumoto had called the "feeling of Being in the contemporary age."[5]

As the scale of environmental and technological transformations reached a peak in the 1960s, intermedia art in Japan reflected on the experiential dimension of this changing urban space in the age of information. By framing this description around the term *experiential*, I am addressing, along the vacillating relays of what I have termed the affective scale, the complex imbrication of larger systems and perceptual frames that play themselves out through these works. I also focus on how each of these pieces and events theoretically shifts the terms for grasping (or failing to grasp) the potential for interventions within the shifting infrastructural frames of their time. The works I discuss in this chapter attempt to cope with and respond to large transformations, each confronting in its own way aspects of the changing systems of space in the mediated environment.

Artistic work between and across technological media began in Japan well before the term *intermedia* came to prominence and was theorized as such, at least as early as the advent of cinema in Japan.[6] Yet the rise of what came to be called intermedia in the 1960s can contribute to the understanding of both historical and contemporary media practices. These artists' nuanced understandings of environment and apparatus became key to their grappling with the broader totality of the systems and structures of high-growth capitalism, and with its effects on what was once known as or thought to define the human, in ways that have important implications for contemporary thinking about capitalism and techno-social forms today. Intermedia art is often interpreted as complicit with Japan's pronationalist, techno-utopian, commercialist agendas. By emphasizing intermedia's concern with infrastructure and systems in this chapter, I show how intermedia and artists tactically

intervened in such agendas, but without pegging their work to one side or the other of the binary opposition of collusion and resistance/reflection. Intermedia work brings elements usually relegated to the backstage to the forefront of events; the work, in short, is crucially about conditioning structures. And though at times its moves and gestures may seem to be "partial," "interrupted," fraught with "disheartening breakdowns," the attempt to intervene at the level of infrastructures models tactics of moving through the complex negotiations required in a late-capitalist environment.[7] Though not everyone would agree that intermedia was an effectual intervention, I argue that it produces shifted frames for meaning-making that are in themselves not only symptoms of the transformations of their times (though they are that) but also models contingent on tactics of frame-shifting, parallax-viewing, and even aggressive overwhelm-boxing (confronting that very overwhelm). Read in relation to Matsumoto's formulation of a materialist dialectics, they also push us up against our limited frames for understanding what and how art makes a difference, and on what scale(s) of perception and recognition its interventions take place.

Intermedia art in Japan emerged in direct relationship and dialogue with late-1950s debates about the ways disparate art disciplines and mediums could be conjoined into a composite totality, a multivalent concept known as composite or synthetic art, *sōgō geijutsu*. In the prewar period, this term frequently described the organic synthesis of the efforts of various participants in cinema and theater projects, or the organic synthesis of distinct art forms and their relations.[8] In 1955, film critic Satō Tadao used the term in reference to the multifaceted realm of filmmaking and its synthesis of high art and popular performing arts.[9] Marxist critic Hanada Kiyoteru criticized such interpretations in 1957, saying that the "first task of avant-garde art is the bringing-together of media/genres [*janru no sōgō*]," but also urging that the future of film as *sōgō geijutsu* should be grasped as a continual dialectical tension among media and between avant-garde and mass art.[10] In this Marxist-based view of *sōgō geijutsu*, art forms retain their distinctiveness, coexisting in tense dialectical relationship with one another, and the complex links between popular/mass-media culture and high/avant-garde art are acknowledged. Ideas of intermedia art developed from this latter articulation of the term.

Cross-media experiments in the late 1950s formed important precursors to intermedia work and are vital to understanding a wide range of trends in postwar Japanese art. While intermedia had particularly close links to expanded cinema and electronic music, taken more broadly it touched on a diversity

of modes—performance art, happenings, events, dance, painting, theater, architecture[11]—that developed over the course of decades, from the proto-intermedia work of the collective Jikken Kōbō (Experimental Workshop) starting in the 1950s, before the term itself was in usage, to the happenings and performance pieces by *butō* dancers to the animation/music/film/stage experiments that took place at Tokyo's Sōgetsu Art Center until 1972.[12]

In English, the term *intermedia* became pertinent to the art world in the mid-1960s: American artist Dick Higgins and the Fluxus group are credited with popularizing it, and it wasn't long before it took on institutional importance in the United States as well as in Europe.[13] Around the same time, *intermedia*—*intāmedia* in transliterated Japanese—entered the lexicon of Japan's art world.[14] One paradigmatic, though little-known, performance that came under the explicit heading *intāmedia* took place at Runami (Lunami) Gallery in Tokyo's Ginza in 1966. The event, organized by art critic Ishizaki Kōichirō and film critic and editor Satō Shigechika, involved screening experimental films with multiple projectors at night.[15] To critic Ishiko Junzō, the evening's activities seemed more aligned with "Happenings" (in his words) and experimental film than with intermedia, though the critical discussions that followed the event provided a vital start to the evolution of intermedia theory, as artists collaborated in pushing beyond earlier concepts of *sōgō geijutsu*.[16]

Thus, by the late 1960s, when the terms *intermedia* and *environmental art* (*kankyō geijutsu*) came into frequent use in Japan, artists harnessed these cross-media possibilities to respond to the country's changing technological and urban environment, as well as to the dissolution of the boundaries between media and a newly activated interrogation of spectator subjectivity. Reflecting on the 1966 Runami Gallery experience three years later, Ishiko articulated this new conception of intermedia: "I understood that the composite term *intermedia*—unlike the idea of addition of different genres represented by the old idea of composite art [*sōgō geijutsu*]—designated an AND [「と, or transliterated, *to*], not only between one genre of art and another but across various conjunctions, for example, between art AND technology, or environment AND art, everyday life AND art, medium AND message, *aspiring to totalize the relational structure of perception and cognition*."[17] Ishiko envisioned intermedia as a kind of multidimensional space that would allow for a "relational structure" (*kankei kōzō*) that accommodated multiple combinations of concepts. In practice, the resulting art explored and exposed structuring configurations of environment, technology, and institutional networks.

Importantly, the term *totality* (*zentaisei*) connoted not a grandiose, organically unified whole, but a chaotic multiplicity beyond the experiential limits of human perception. For example, when critic Taki Kōji (associated with the *Provoke* photography group) wrote of "totality" in *Provoke* journal's first issue (1968), he was interested in aspects of reality that transcend or escape subjective experience and perception. So when Ishiko refers to "totalizing the relational structure," he is also framing a vision of how these larger structures, ungraspable at the level of individual perception, might be nonetheless grappled with or through the frameworks of intermedia. As in the definitions of affect that place it between an ungraspable larger structure and a subjective perception, intermedia would attempt to find a way to operate at that liminal scale between what could and could not be grasped subjectively or located in language or visual perception. The *Provoke* photographers asked, could photography, as a document and fragment of that reality, capture or record something of those phenomena that would be outside the grasp of the photographing subject? Matsumoto similarly wrote of totality as a flux that exists on the "other side of the self," conditioning the experience of the individual but hard to grasp "as it is."[18] He wondered if expanded cinema might offer a means to grasp the ungraspable nature of that relationship between the totality and the perceiver. These theories also relate to the experimental visual arts group Mono-ha's explorations of materiality and their emphasis on the attempt to frame reality "as it is."[19] Within the broader systems and structures of high-growth capitalism, which dwarf the individual, these theorists attempted to understand how the fragmented, overwhelmed individual, whose gaze is riddled with blind spots, might create (or at least catalyze) an art or expressive form capable of contending with the reality and speed of this engulfing environment.

Matsumoto Toshio's theoretical work and film practice contain important thinking about this potentiality of cinema to contend with the engulfing transformations in the urban media environment that led to intermedia works. Matsumoto's work appears in several events connected to the emergence of intermedia art in Japan; his and his collaborators' proto-intermedial experiments began with his very earliest film, *Ginrin* (*Silver Wheels*, 1955–56), a color PR film commissioned by a division of JETRO to advertise Japanese bicycles abroad, with special effects by Tsuburaya Eiji.[20] The revised version of *Ginrin* was relatively recently found, carefully restored, and screened in festivals, marking a renewed interest in PR and educational films, including those of Iwanami Productions and their important contribution to postwar

Japanese film.[21] *Ginrin* was a "cinema poem," in Matsumoto's words, made of images and music with no narration; it features composer Takemitsu Tōru's first film soundtrack. As a moment of close collaboration between corporate-government institutions and avant-garde aesthetic experiments, *Ginrin* destabilizes or cracks the binary logic that (in paranoid position) would frame an either-or rhetoric of resistance (critical distance) and co-optation (complicity, collusion, incorporation into corporate culture), which often constrains understandings of experimental works up to and including the 1970 Osaka Expo. This film negotiates its own embeddedness in larger historical and economic structures, with some room for its slippages to become visible. *Ginrin*, in a way that later, explicitly intermedial events extend and develop, takes the constraints of its situation and, one might even suggest, frames an allegorical reading of this situation within the work itself.

Ginrin's use of superimposition and its fascination with the mechanism of the bicycle wheel emerges out of a long history of earlier explorations of the dissolution of unified perspective and the fragmentation of viewer experience. From the focus on mechanisms in futurism and cubism to the fragmentation of narrative views in Shinkankaku-ha, in association with French symbolist film theory, many examples in the prewar avant-gardes evoke the rise of modern urban space through a decentralization and fragmentation of visual perspectives. In *Ginrin*, isolated handlebars whirl through space; geometric forms configure and break off. The gear wheel turns and animates in a geometric abstraction as the screen divides into four, then two. Metal wheels whirl and shimmer in the light, flying through a space made to feel expansive, to extend beyond the screen, by the metallic plinks and high reverberations of Takemitsu's score. Multiple riderless bicycles float through the air, unconnected with any ground. The visual perspective refracts into vertical bars of light, only some of which are connected to any object. When the boy who opens the frame narrative reappears (at the opening of the film he was seen reading a book about bicycles, which launches this more abstract segment), he sees women collecting bicycle wheel rims from a white expanse where they lie like abandoned hula hoops, in an abstract pattern. Cyclists appear, some showing only their legs at the top of the frame, the light shimmering on the spokes—in a range of scales, some smaller, some bigger. The boy walks among them, before them (figure 1.1). These multiple and repeated figures of bikers crossing the screen call to mind most strongly the image of a zoetrope, from the "gadget-and-apparatus" phase at the origins of cinema's illusion of movement.

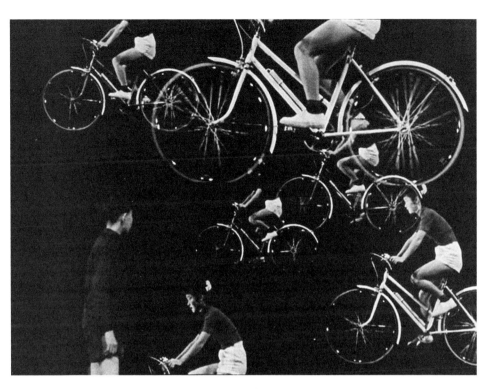

FIGURE 1.1 From Matsumoto Toshio, *Ginrin* (*Silver Wheels*, 1955).

The wonders of the bicycle (and its associated relaxed lifestyle) come to be equated here—for foreign consumption—with the wonders, pleasures, and leisure of cinema itself. As the panoramic landscape passes by—the lateral movement across surfaces rather than movement into depth—one follows the view from the camera as if mounted on a moving bicycle. The foreground blurs. The transition from color to grayer tones and then to more vibrant greens and cerulean blues, and the refraction of light through the trees as the camera moves from sky to ground, all become part of *Ginrin*'s meditation on the visual experience of cycling: the diffraction of the light becomes an extension of the work of art director Yamaguchi Katsuhiro's *Vitrine* series in his Jikken Kōbō exhibitions. The distinctive pigment scheme of this early Japanese color film—on a version of Eastman Kodak color film stock that would be discontinued in 1959—becomes part of the lasting effects of this narratively simple film with its ultimately sappy ending, augmented by the sponsors' later addition of footage of Mount Fuji.[22]

From the sponsors' viewpoint, *Ginrin* showcases the simple pleasures of color cinema and the cycling apparatus, both as ways of experiencing/mediating selected elements of the (in this case) natural environment, the "beauty of nature." Yet at another level, the effects of scale here parallel the effects of speed: with the parallax view, with mechanical objects whirling in space, the film reflects on the experience of the technologically mediated environment. Yamaguchi's *Vitrine* glass appears again just before the film closes down its poetics (in the revised version of the film) with the narrative shutdown of the boy waking up from his dream on his cycling book, fantastically titled in English, *Bicycle of Japan*.

Ginrin represents a historically significant moment of innovation, framing collaborations between artists across media with an interest in how the apparatus and mechanism affect the physical experience of the environment. Like later intermedia art, the making of *Ginrin* was enabled by an alliance serving the disparate interests of industry, government, and the arts, as JETRO provided an opportunity for avant-garde artists to deepen their experiments with mechanism, color, and light, lovingly preserved in the National Film Center's recent restoration. *Ginrin* thus opens some central themes and perspectives that become crucial for later works of intermedia. At a further remove, it also marks a key step in Matsumoto's influential and complex theories of subject-object relations and projection in expanded cinema, in which interior and exterior exist in constant tension and "the totality of the experiences of continuity of seeing by the viewer are themselves the work."[23] His description of the fragmented totality, the gaze in motion that creates a series of experiences to create a composite work (in writing about the kinetic qualities of Yamaguchi's *Vitrine* series), prefigures his own interrogation of the relation of cinema to its object in his famous theories of documentary and avant-garde cinema, a key influence on a generation of upcoming directors, artists, and cinephiles.

Matsumoto along with his collaborators and associated critics in the early 1960s, through their experimental documentary works and theories of subject-object relations, opened the way to later artistic movements and events that directly addressed the problem of the technological transformations in urban space and art's responses to the experience of these broader totalities and dynamic systems. Works that take on material and informational landscapes, the repurposing of the visual forms, cast-off detritus, and overflow of information in contemporary urban environments, as we shall see, take new form in post-3–11 works and experiments. Yet Matsumoto's work, in his experimental documentary, expanded cinema work, and the CROSS

TALK Intermedia event I will detail in this chapter, begins to address the problem of the phenomenological experience of "being" in the age of information and mass-mediated images. As these events work toward a grappling and perceptibility at the affective scale, their potentiality emerges in their coming to terms with larger information and media environments (or ecologies) while accounting for the necessary failure to grapple with them fully. They find a paradoxical way of picturing (and rolling up their sleeves, tangling in the dusty electric wires of) the dialectic thus created. Other artists, connected to Matsumoto through a web of artistic associations and venues (including Akiyama Kuniharu, Yuasa Jōji, and Ichiyanagi Toshi), further theorize this line of thought and push its central problems in new directions through their discussions of environment and intermedia experiments.[24] After delineating a fuller understanding of Matsumoto's theoretical vision, the following pages thus delve more fully into two key events—*From Space to Environment* and CROSS TALK Intermedia—that addressed the problems of intermedia and environment, events that in their larger structure (not just through individual artworks or theories) aimed to generate collectives of artistic activity commensurate with the expansive totality of systems and infrastructures beyond the individual artist or viewer's grasp. Although they did not specifically aim to critique collectivity, the massive scale of the events they created and the way they constructed a broad infrastructural meditation on the making and viewing of art managed to open both paranoid and reparative modes of understanding for their contemporary moment, thus enacting and embodying the potentialities of intermedia artistic practice.

Visualizing the Dialectic: Matsumoto's *The Song of Stone* and Theories of the Image

Matsumoto's remediated photographic work *Ishi no uta* (*The Song of Stone*, 1963) and his contemporaneous theories of *eizō* (mechanically reproduced image) embody his emergent theories of the subject's (and by extension the filmmaker's) relation with objects and show how those theories connect to a growing interest in environment, landscape, and apparatus, as well as cinematic form. By the time the Osaka Expo occurred in 1970, the centrality of environment and apparatus in his ideas and those of artists more broadly had transformed understandings of both art and cinema.

In postwar Japanese cinema and art theory, the artist/subject's relation to objects and their mutism was a central question. Nakahira writes about the magnetic field created by the object that gazes back upon the self; film

director Yoshida Kijū also posits the returned gaze of the object as a key image for his film theory.[25] For Matsumoto, the term *eizō* opens a space of mediation in his theoretical writings between inner and outer world; subjectivity and objectivity are not separate spheres but in dialectical relation. I argue that in the film *Ishi no uta*, stones come to signify or symbolize this relation to the image, to embody figuratively the object-relation problem of cinematic praxis. In "Zen'ei kiroku eiga-ron" (On avant-garde documentary film), Matsumoto points to the limitations in 1920s avant-garde cinema's excessive focus on the inner world: "They are lacking the toughness [*kibishisa*] to bring the inner and outer worlds into relation, unceasingly and subjectively."[26] This relation must be framed subjectively: avant-garde documentary films, according to Matsumoto, need to document not only the object outside themselves but also the process of searching for a methodology to frame a relation to that object. Most simply, he puts it this way: "To capture the so-called outer world without leaving anything out, one must capture the inner world without leaving anything out, and to accurately grasp the inner world, one must accurately grasp the outer world; therefore, in order to document as a whole the relation between the two, one must *logically process their dialectical relation in detail* as a truly new method of documentary."[27]

For the making of the film *Ishi no uta*, Matsumoto shot *Life* photographer Ernest Satow's original photographs frame by frame to animate, agitate, and place them in ghostly superimposition. The ostensible narrative of the film, conveyed via voice-over, intertitles, and images, shows us the creative work of the 1,200 laborers in a granite quarry in the mountains of the southern island of Shikoku, meditating on the birth, life, and death of the workers in this world of stones (for example, how in death they "make their own tombstones and sleep under them"). The work has an intermedial relation through Akiyama Kuniharu's soundtrack with the broader *musique concrète* movement at Sōgetsu Art Center: Akiyama uses the sound of the quarry as well as instrumental sounds to punctuate the concrete construction of this work. Yet, with the help of this soundtrack's resonances, one is struck by the architectonics of these images, their muteness (in Francis Ponge's sense) but also their symbolic resonance: making what cannot speak be nonetheless alive, and yet also resistant to capture either by language's significations or by human consciousness.

At many points in the film, the sound of hammers on stones accompanies the quick montage of black-and-white images of the stonecutters doing their labor. Zooms and pans show the work of the camera as if it, too, were a method of slicing stones in the photographic image. Hands become a central

focus, as Matsumoto repeatedly gives close-up shots of the hands working on the stone. The hands might return one to a sense of the artisanal, the romanticized laborer, except that these are relentlessly mediated hands, black-and-white photographed hands, shifting in a rhythm that transcends their human, fleshly quality, like *Ginrin*'s legs on bicycles. Here, cinematic viewing's haptic qualities come to the fore: the experience of apprehending these hands and pulsing black-and-white images and sounds in rhythmic superimposition highlights the embodied perception of the viewer touched by cinema at the intersection between subject and object.[28] Meanwhile, the stones are every bit as corporeal as the hands, in a way all the more emphasized by the voice-over descriptions of the stones' life. Like Takemitsu's music in *Ginrin*, Akiyama Kuniharu's soundtrack here gives a sense of an expansive space beyond the screen, with its open and resonating chimes and echoing hammer blows. Intense staccato movements of montage alternate with other slower, more meditative and silent pans across the scene around the quarry, as the voice-over tells of the anthropomorphic language the quarry workers use—"killing" the stones, letting them "live," the "warmth" of their forms, so that when a stone form is complete, the locals would say, "It has come to life." Matsumoto is performing a cinematic exploration into a problem Marx formulated on the issue of "relation between things" (including *eizō*) or object-relations as "fantastic[ally]" and dialectically infused with social forms.[29] An alternative reading of this idea of the stones' life could evoke questions around the Anthropocene; rather than objectifying the human, Matsumoto highlights a discourse that vivifies the organicity of the (feeling) stone.

In "Eiga geijutsu no gendai-teki shiza" (Contemporary perspectives on the art of film), Matsumoto writes:

> A superior documentary image [*kiroku-teki eizō*] does not stop at simply recording the object, but it also records the very process of searching into/toward the object. (That is where its secret lies.) In the same sense, the drama (of their own production) revealed by excellent documentary images is not the same as the dramatic quality that belongs to the object. It is clearly the "drama of searching" for the drama of the object, and is thus always a "subjectified drama," an "expressed drama." However, this is none other than the drama of "*eizō*" [the image] and cannot be expressed by literature or theater.[30]

Many artists questioned what constitutes a subject and what constitutes an object in the changing frame of the 1960s discursive milieu.[31] Isozaki Arata calls the environment itself a "subject" (*shutai*, in the sense of the subject in

the term *subjectivity*). For Matsumoto, the stones in *Ishi no uta* develop into a crucial figure for the dialectical relation between photography and moving image (between media), and for the relation between subject and object mediated by the image (*eizō*). Dialectics, as a form of montage construction that also illuminates contradictions and sets up colliding elements—overcoming each side of the contradiction while preserving what is overcome—comes to be figured most concretely in the hacking and sculpting of the living stones themselves.[32] Thinking back on *Ginrin* in light of this later formulation, it is clear that the handlebars, gears, and wheel rims are, at the imaginative limit, themselves animated into a kind of subjectivity that is visualized most clearly in the play of light and color; or, speaking more modestly, one can say that they are a concretized image of a realm of projected sensorial fantasy (and perhaps even, in the sponsors' intention, with the aim of infusing these partial objects with fetishistic powers). In the face of this subjectivized environment, the human bodies in *Ginrin* seem to be themselves mechanized objects in varying scales, fit to the structure and motion of the gear wheels. These unnamed people in the film do not smile as they ride; rather, one might almost say the bicycle parts are the ones at play.

As we have seen, Matsumoto rejects the distinction between the cinematic document as record of the object in reality and the interpretation of aesthetic experiments as inherently about the (psyche's) interior. This relationship is expressed visually in heightened moments of *Ishi no uta*. In the ending of the film, Matsumoto shows Satow's photographs of a man on the grid of stones, zooming out, changing angles, flipping and superimposing, like positive and negative or reversed versions of the same image, a crucial symbolic moment expressing this dialectical relationship. Yet what does Matsumoto figure in the idea of this positive and negative dialectic? In the essay cited above, Matsumoto writes, "While it may seem on first glance that documentaristic films that try to sharply cut out [*kiritoru*] the exterior world and avant-gardistic films that try to delve deeply to pull out [*hikizuridasu*] the inner world are absolutely different kinds of film, in fact they overlap *like positive and negative images*. . . . Or rather, they are in the kind of relationship where the more one tries to grasp and think about one, the more one has to direct one's eyes toward the other."[33] Elsewhere, he takes it a step further: "We need to aim for the negation of negation [*hitei no hitei*], or the sublation [*Aufheben*] of existing documentary film and avant-garde film; in other words, to grasp the outer and inner worlds as a whole in their conflicts and coherences, and aim for the possibility of a new film that would be the synthesis of both sides."[34] The relationships in the film could be a visual analogue to the workings of the

affective scale, in which the dynamic relation between elements of the personal/subjective and infrastructural come into a movement—which I earlier called a "relay"—where both are in play, or in intensely dynamic engagement in a way that is newly meaningful here.

The figure of "positive" and "negative" as the poles of relationship—a fully photographic metaphor visualized in shifting, layered images—yields here to a vision of the negation of negation (in other words, a version of Hegelian *Aufheben*), thus taking a philosophical term for a specific dialectical relationship and translating it into visual terms. *Ishi no uta* as a whole has a very contradictory (or palimpsestic) quality, with its humanist, nostalgic voice-over narration (like the frame narrative in *Ginrin*) that works in contrastive parallel with the materiality of the images and the concreteness of the music. Yet if we leave aside for a moment the full significance of the film's humanist/empathic/ethnographic side, with its long shots of the transformations of the landscape by the workers in the quarry and its narration about the hometown, and instead focus most intently on the climax of its most materialist and dialectical moment—when the human figure pulses in photographic reversal—we see it vividly embodies Matsumoto's central question of the complex relation of the subject to the object mapped onto the relation of cinematic documentary and avant-garde.

White-gray stones separated by black cracks shift and fade over one another across the imposing graphic play of the black negative spaces, haunted by the black shadow of the man seen appearing and disappearing from above (figure 1.2). The rectangular forms of the stones project—positive and negative, negation of negation—*Aufheben* in the form of retinal afterimages. A standing figure moves at one-second intervals from one frame of stone to another. The stones concretize the materiality and dialectical searching of Matsumoto's *eizō*. High and low tones in Akiyama's music echo the ghostly mood, not the ghost of tradition or folklore, as some parts of the film and voice-over might imply, but the ghost image burn-in of reproducibility, the materiality of the photographic and cinematic images linking the intrapsychic and the external audiovisual environment.[35]

Through his theories of *eizō* and cinematic praxis in the early 1960s, Matsumoto participates in a broader cultural focus on landscape and environment—subjective and objective, intrapsychic and infrastructural—both of which contain elements of the (Marxist) concrete and that can also become irrational. The multitude of stones can create a figure for the multitude of humans: the humans' combination of plasticity and object-ness in capital's use of them.[36] The architectonics of *Ishi no uta*'s landscapes, its living stones, allegorize the

FIGURE 1.2 Matsumoto Toshio, *Ishi no uta* (*The Song of Stone*, 1963).

masses of workers but also map the movement of power as imaged within and structuring intrapsychic reality—or as Matsumoto most clearly phrases it, the "umbilical cord between inside and outside." Holding in mind Matsumoto's vision of *eizō*, emblematized in the image-person in negative moving against a background infrastructure of black-and-white stones—itself a powerful visualization of the dynamics of the affective scale—we can now turn to explicit intermedia experiments in the later 1960s that most specifically interrogated the dynamics and impacts of the urban-technological environment and, at times, thrust the products of the environment back on the viewer.

By Other Hands: *From Space to Environment* (1966)

The exhibition *From Space to Environment*—held in 1966 in Ginza's Matsuya department store by the Environment Society—aimed at nothing less than transforming the "concept of place" into a "kinetic, chaotic 'environment' that

incorporates the whole of the viewer and the work" (figure 1.3). In fact, the organizers claimed that the sense of urban space had already been transformed in these ways, and as a result they aimed to search for such a "chaotic place of collisions" for their work that would be commensurate with this new sense of space and environment.[37] Already well analyzed by others, the exhibition posits a "severe self-disintegration [*jiko hōkai*]" that pertains not only to artistic disciplines and media, not only to the works to be shown, but to the visitors/viewers as well.[38] The viewers, too, "in the face of unavoidable self-dissolution, are either boldly or passively whirled into, or swallowed by, and cannot but participate in the 'place' created by artwork."[39] Key to the emergence of intermedia art's readings of infrastructure, this exhibition is worth a more focused look for its intense engagement with rethinking environment and apparatus. Theoretical reflections by media artist Yamaguchi Katsuhiro on the exhibition, and works by Akiyama and others, invent new ways to grapple with the affective experience of the surrounding environment. At times figuring this relationship with the environment in terms of

FIGURE 1.3 *From Space to Environment* (1966), exhibition image.

mimesis, in other moments as metonymy (contingent), and yet others as metaphorical (mirroring), these theories and artistic practices form a key case study for the ways they read social infrastructures at the affective scale. That is, within this exhibition they define unexpected ways of both attending to and intervening within the mutually structuring and interlocking relations between individual subjects, human/technological bodies, and the broader infrastructural mediations of the environment.

The exhibition organizers supplement their vision of the inner collapse of art forms and viewers with their vision of an expansive and encompassing "environment," a "place" intimately linked to concepts of changing urban space. In environmental design, the exhibition manifesto claimed, the city itself is not a sum of fixed parts but, as we have seen, functions as a "subject [*shutai*] called *environment* in which all the parts are organically and dynamically linked." They define this environment-subject here as an "act of surrounding," the "state of being surrounded," with an emphasis on movement, and thus "a set of dynamic relations between human being and surroundings."[40] In this context, the closing layered negative/positive imagery of *Ishi no uta* becomes not only a literalization of Matsumoto's subject-object theory, but also a prescient image for this dynamic relation between human and surroundings—the human figure moving against a subjectivized, shifting plastic and kinetic environment, important as much for its tones as for its technologies.

Springing from an excitement about Marshall McLuhan's theories of the externalization of the sensorium, the artists of the Environment Society showed in quite a different manner what Matsumoto was also so clearly theorizing: a new kind of relationality between humans and their environment, or between subject and object, in which, as Yamaguchi Katsuhiro phrases it,

> If we were to expand our thoughts to the idea that today's human life is built upon going beyond concrete human form and individual functions, we would realize that human beings are already not confined in their consciousness and senses as limited by their physical flesh, nor within the functions of their bodies restricted to a certain number of physical kilograms; instead they are existing and expanding out within the very environment of this contemporary civilization. . . . Human beings themselves transform into a part of the environment, and gradually become homogeneous with it, such that everything that makes up the environment and the environment itself is becoming the bodily, material functions of human beings. By thinking this way, one can grasp

each type of non-personifiable communication [such as even the flashing signal of an airplane's warning light] as the very function of the self.[41]

Yamaguchi takes the interdynamic relation between subject and object and extends it to frame an argument about infrastructure: the opposition between *kankyō* (environment) and humans in its banal form no longer holds, not because of an ambiguity of terms or even a direct application of McLuhan's theory. Rather, Yamaguchi pushes McLuhan's theory into a more intriguing challenge to the bounds of subjectivity: the human expands to the point of an odd exteriorization of scale, such that the "body" of humans no longer is framed in fleshly or sensorial limits—it becomes "signaletic." The "body" of the technologized surroundings becomes the extended realm of the human body, while the human is deeply permeated with and transformed into *kankyō*. The deeply digging externalization of Matsumoto's theories here yields to an image of the technological infrastructure mirrored within (and mirroring) the human body. On one level, it is an image of deathlessness—a powerful extension of the human sensorium, making the environment itself a subject, a communicating signal. Yet this extended definition of the human dramatically evacuates the "person-like-ness" (personifiability, personly verisimilitude) of the person (that is, its mimesis of the human itself), and thus destabilizes the ontological heteromorphism between the machinic/technological and human functions. Yamaguchi envisions a radically continuous space both of contiguity and structural analogy between the newly framed human and the environment, such that even the flashing warning lights of the airplane in the sky overhead are understood as communicative functions of this newly defined self. According to Yamaguchi, human beings already exist in this situation of extension and expansion, a state of projection of human form onto the mechanical surroundings (or the reintrojection—internalization—of that projection), of the image/information age onto/within subjectivity's frame in a way radically different from earlier forms of apostrophe and the Pygmalion-like personification of "nature."[42]

One paradigmatic example of a work displayed at *From Space to Environment* is Akiyama Kuniharu's apparatus *Environmental Mechanical Orchestra No. 1* (figure 1.4). In this sculptural sound-work, a microphone captured the ambient sounds of the exhibition's visitors walking toward the apparatus and put them through an amplifier and a series of oscillators to convert the amplitude of these wave forms to light signals; the lights then flashed toward a fountain, which diffracted them on the surface of water. The bouncing light

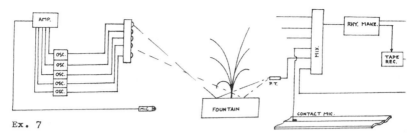

Ex. 7

FIGURE 1.4 Akiyama Kuniharu, *Environmental Mechanical Orchestra No. 1.* Courtesy of Roger and Karen Reynolds.

signals were then picked up by a light sensor (light-sensitive phototransistor, PT) whose signal moved into a mixer, mixed with additional signals from sounds of another contact microphone on the floor, and then transmitted to a "rhythm maker" (the whole constructed by Okuyama Jūnosuke) to structure the emitted sounds. These sounds went into a tape recorder and were projected by a speaker back onto the visitors.[43]

"The important features," as composer and later CROSS TALK Intermedia co-organizer Roger Reynolds phrased it, "are the use of materials produced by the environment and the fact that these products are then *administered, perhaps even flung back* at their makers."[44] While later interactive artworks, such as those displayed at NTT's Inter-Communication Center in the 1990s, or at La Villette in Paris in 2017–18, among many other places, resonate with this description, the emphasis here is on the collective rather than the individual interactive agent, and on the process of envelopment and resonance of the individual within a broader nonhuman environment. The drum-like sounds, bounces, and short gong-like booms and toots have the quality of an electronic heartbeat, a play of rhythms that moves in a steadily flowing yet irregular stream—no long silences, but an odd mix of high and low sounds that do not seem to have any correlation to one another, and that seem, at the risk of personification, not to pay attention to one another.[45] Yet by using terms like *attention* and *heartbeat*, we are already moved into the realm of the listener/viewer's experience, the haptic substitution of the listener's body for the machinic production, that takes the sound from the viewers and passes it through a precisely nonindexical process before sending it back to the viewer for reabsorption.

From start to finish of the 19′40″ recorded version of the piece made at the time, we hear the low, drum-like, irregular drone beat that splits the difference between a machinic low pulse and a more traditional drum sound. In

the upper registers, a sound that resembles a (metal) bow squeaking against and banging on a string enters and asserts itself idiosyncratically, mostly remaining at a single pitch in the first minutes of the piece, eventually sliding up and down slightly, working between traditional pitches in ways that give a sense of texture more than melody. Occasionally an event—the entrance of a sudden punctuation into a duration of relative silence (10′15″), the bounce-pulse of the drone alone (11′08″)—allows the listener to get slowly used to, to accommodate, to navigate within this ambient soundscape, especially thanks to the nonheartbeat's steady-unsteady presence; it creates a field within which, by 11′57″ or 14′45″, when familiar sounds reenter in the higher registers they are old friends, no longer so surprising or grating. In that sense, read as a musical text or piece (though it would have been experienced by walking in and out of the sound field it constructs), the work creates intrinsic norms as a form of structure around variations, a sense of ambient/ambiance, an environment in which chance events intrude. It nudges us to reflect on the tones of the technological, the seeming intentionality of non-human scales—we have a sense that there are sounds here too high or too soft or low to be heard, less of an arc or melodic story than a hum effect and a landscape of controlled noncontrol—ending with something like sirens, what could be a stamp/shuffle of the (electronically modulated) feet of the crowd that in fact contributed to the work, and that steady drone beat that gives a sense that the piece could go on forever.

Environmental Mechanical Orchestra No. 1 foregrounds the largely unconscious, rarely highlighted background of noise—sonic noise, shadow noise—produced by the exhibition visitors' bodies, what they generate differentially by their collective presence and sheer numbers. Even when visitors move politely and relatively quietly (and by all accounts the exhibition was extremely crowded), their existence provokes an oddly abrasive environment, a veritable barrage of light and sounds that this piece captures and amplifies, significantly, with its visible mechanical apparatus. The piece thus mirrors the urban situation and the affective disturbance of the information age, even while modeling this administering back of the crowd upon itself. It pushes a reflection on the structured contingency within which hearers' sensory apparatus is immersed, as well as on the processes of accommodation and modes of intimacy we can take on with these nonhuman objects. Other notable pieces in the exhibition included Ay-O's finger boxes, hung on a wall, which allowed visitors to stick their fingers into dark spaces for unexpected sensations (a sharp nail, a void, or a squishy soft object, among others; figure 1.5). Ichiyanagi Toshi's interactive work emerging from the field of sound

FIGURE 1.5 Ay-O's finger boxes at *From Space to Environment* exhibition (1966).
Courtesy of Roger and Karen Reynolds.

design invited visitors to approach a tall box to peer into its kaleidoscopic and kinetic lights; their spatial proximity was then converted into low, thereminlike sounds through an apparatus also designed by Okuyama.

Events like *From Space to Environment* provoked some criticism in two directions, both related to the problems of environmental design: on the one hand, Haryū Ichirō wrote that the exhibit was too much like a "thronged adult amusement park" (a common critique of interactive art today as well—that it is like an amusement park, but less amusing!) and that the environment of the interior of the department store becomes an "artificial zone" of exhibition that ultimately loses out to the environment of the surrounding reality of "1966 Tokyo Ginza."[46] KuroDalaiJee (Kuroda Raiji) wrote that works of intermedia in events like this one had to lack the "scents [odors] of everyday life" in order to "be tolerated in an exhibition held at a strictly regulated department store," and for him, unlike the atmosphere of Shinjuku, Sōgetsu Art Center (where the performances associated with the exhibition were held) also preserved an atmosphere in which "the political and the fleshly were eliminated [*haijo*, removed, cleaned away]."[47]

Indeed, this criticism does hold true by comparison with the messy/dirty/smelly/sweaty atmosphere of some other contemporary performance practices and street/body art, or with the go-go dancing version of Shinjuku visible in works like Okabe Michio's film *Crazy Love*. (Many expanded cinema events and underground arts events, including the Intermedia Arts Festival, were held in discotheques and go-go snack bars like Killer Joe's, embodying perhaps a less clean version of the potentialities of such performances and experiments.)[48] Yet it is possible to follow this exhibition's alternate emphasis on interaction, materiality (of the machine as well as the viewer), and the bodily apprehensions of the viewer precisely as they provoke us to turn our attention behind the scenes, to the systematicity of the technological infrastructure and its material means, as well as the embodied relations of specifically located viewers to that technological air. In this view, intermedia events provoke a reconsideration of that materiality and its relation to the abstract/conceptual systems: they frame and press on the viewer an awareness of, an attention to, her place in the larger mass of bodies and machines, modeling multiple modes of framing and reinventing the problem of the subject's experience of the mediated urban environment.

Yet one crucial element these intermedia events highlight is that this art is no longer working primarily on the level of the individual viewer or artist; instead, a complex mediation via technology and technological materiality presses one to look at these works at a different level through different analytical tools.

Key to the success of the exhibit *From Space to Environment* and many other sound-based events of the time was the participation of sound engineers like Okuyama Jūnosuke and Satō Shigeru (Mō). Participants describe how composers would come up with an idea, and Okuyama and the other engineers would figure out what equipment they needed and build the circuitry to make it happen, without fail. Art critic Tōno Yoshiaki, in an interview with architect Isozaki Arata, highlights the intense inclusion of technological/engineering components and how they shift the process, temporalities, and ownership of artistic production. Okuyama, Satō, and other engineers become the hands on the work. (We think of the highly mediated hands of the stonecutters spliced together by Matsumoto, but also of today's coders and engineers for current media art like that of Fujihata Masaki. These issues have always been present with assistants, bronze casters, and photo labs, but as with conceptual pieces contemporary to this exhibit, this highly technologized work throws the spotlight on these other hands in a new way.) As Tōno put it, referring also more broadly to the rise of conceptual art in the 1960s:

> Art up until now has been made by the individual artist taking responsibility through to the end and leaving the marks of (the dirt of) his/her own hands; yet here many parts are left to the hands of others. This is not only because the primitive manual labor that has been prevalent up to now does not work with industrial materials, but also because [today the way art works is that] the artist conceives an image strictly in the state of a conceptual plan, and after that leaves the production process to others' hands. In other words, up to now humans and material objects [*buttai*] encountered each other [struck one another, collided] in a kind of emotional, humanistic relation, and from there something was produced. By contrast, [today's artistic productions] interpose a concept [*kannen*] in between [the artist and object, in that relationship] like a transparent film [or screen, *tōmei na maku*].[49]

In this view, something like a transparent film separates the artist from the material objects of the work in today's art world. This means that a deep infrastructural layer of art involves other hands, such as those of Okuyama or Satō, to bring a work into being. Increasingly, the works incorporate questions of infrastructure, supporting environment, and institutions at the center of their aesthetic projects. That is, the use of other hands is not a mere technical assist, which clearly has been going on for a long time, but becomes a key to understanding the thematic and aesthetic projects of the artworks, as they

reflect on issues of infrastructure, environment, and their effects on subjectivity in the contemporary late-capitalist moment. Akiyama's crowd orchestra apparatus; Ay-O's piece that quite literally takes the many other hands of the audience to the center of the experience, in finger boxes; and Ichiyanagi's works with space and surroundings that draw the audience closer with a light apparatus and then make low humming sounds emerge from the work so the sensation of the audience's proximity is converted into an undercurrent of sound—all these art environments center the issue of the dynamics of *kankyō* and reframe it as a problem both of subjective experience and institutional structuration, human sensorial expansiveness and projection of the technological within and without.

For Matsumoto in *Ishi no uta*, the environment as landscape is framed through a dialectical image of *eizō*, living stones, as an interrogation into what he calls the "umbilical" relations (in an oddly biomorphic image) between inner and outer realities. The rhythmic asynchronics Akiyama Kuniharu produced in that film find their way here into a more self-reflexive and technologically mediated form, as what Tōno might call a film or screen—constructed from both sound and concept—between the visitors themselves as audience and as environment. *From Space to Environment*, especially in works like Akiyama's, translates the concrete ambient specificity of the environment at any moment into a newly mediated sensation flung back at the audience. The artists process a set of lights and sounds to offer back to viewers an experience of the atmosphere, the air or resonance that the collective mass of their own bodies produces as they move through the exhibition space.[50] These sounds are passed through an apparatus that strikingly defamiliarizes and makes conspicuous the intensity of impact of that disordered movement, that collective presence. Visitors hear and feel the vibrations in the air of that at first jarring then gradually familiarizing impact: the work models the nonhuman pulse and its own intimate impact on us.

Yet as the concept of intermedia reaches its most explicit manifestation in the late 1960s, the problems of environment come to be articulated even more explicitly in tandem with the infrastructural framing and the transnational migration of the idea of intermedia itself. In another key event, CROSS TALK Intermedia, from 1969, in addition to the exteriorized human sensorium, a dynamic and colliding institutional subjectivity/infrastructure enters the explicit thematics of the work. The importance of incorporating environment into art leads to a new grappling with the social and institutional network as a kind of apparatus. This shift toward the larger sense of apparatus

begins explicitly to open and map yet a new layer or aspect of the larger systems that surround the subject and can frame a distinct entry point into the explorations of affective space and medium that intermedia came to embody.

From Environment to Apparatus: CROSS TALK Intermedia

Intermedia works frequently take larger structures of the environment as their raw material and reexamine the relationship between mechanical reproduction and "liveness" or singularity. They provoke reflection on the expansive scale of urban space that leads to information overload, durational exhaustion, and the colliding chaos of overlapping media images in the contemporary age. Approaching these works and events as transcultural media practices foregrounds the apparatus and social context in which the works are generated. The emphasis shifts away from individual auteurs toward collectives and collaborations, works made by other hands, and complex assemblages of systems, objects, and institutions, an emphasis I reconsider in chapter 6 with the concept of collectivity itself. With intermedia, we get a closer look not only at audiences but also at behind-the-scenes jiggering involving sponsors, engineers, and managers. In looking at a spatial and institutional mapping of culture, the role of the artist changes in a way that parallels shifts in film studies in recent years with the attention to studios, producers, distribution, and circulation.[51] Artists restage individual works in multiple venues to differing effects depending on their contextual networks. The role of nation changes, as the artists commute by airplane from Tokyo to New York, and by *shinkansen* (high-speed bullet train) to and from Osaka and Tokyo and Kyoto, and today Nagoya and Fukuoka and beyond. The *shinkansen*, which began operation in the late 1950s, already held an important role in Gutai art's dissemination and reflections on infrastructure and electric media.[52] What happens when these kinds of infrastructural issues become incorporated, centrally, into the deeper aesthetic projects and the conceptualization of the works, to play a part in reconfiguring art itself and redefining specific media?

The event known as CROSS TALK Intermedia (CTI), organized by Japanese composer Yuasa Jōji, critic Akiyama Kuniharu, American composer Roger Reynolds, and musician and designer Karen Reynolds, was held February 5–7, 1969, at 5:30 each evening, in Yoyogi National Olympic Gymnasium (figure 1.6). CROSS TALK is a good case study for understanding more deeply the relation between technology and art, apparatus and medium, under the rubric of intermedia.

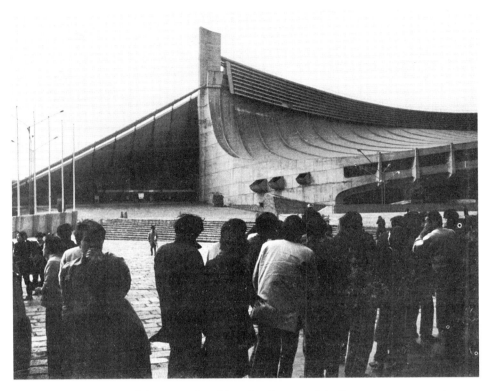

FIGURE 1.6 Crowds line up in the cold on the afternoon of the first CROSS TALK event (February 5, 1969). Courtesy of Roger and Karen Reynolds.

Over time there has even been a territorial squabble over the term *intermedia*, especially in the United States; individual camps manage the threat to individual media's sovereignty by trying to claim intermediality as a specific challenge and therefore expansion of their own particular art, be it music, theater, film, or painting. In the 1968 issue of *Arts in Society: Happenings and Intermedia*, for example, editor Edward Kamarck complains that the 1965 issue of *The Drama Review* on happenings takes them too much as an extension of theater (though happenings can often be "anti-theatrical"); he makes a strong claim for the fairer and more encompassing term *intermedia*. Both terms are often used in conjunction or even, at times, interchangeably, as in the *Bijutsu techō* special issue on CTI. A US journalist in 1969 more pointedly defines intermedia art as another term for what used to be called electronic music.[53] In the well-designed and informative CTI program box set, architect Tange Kenzō proposes the idea of "meta-media" as a counterpart to intermedia.

From an architectural perspective, he is interested in what he calls "meta-disciplinary" work, which leads him to think about environmental design and to envision the "formless monument," in his plans for Expo '70, encompassing both the "physical and non-physical elements of the environment."[54]

The development of the idea of intermedia has intimately to do with the experience and imagination of urban space in the so-called age of information. We can see the centrality of the city space as key player in so many places in the 1960s and beyond, from Nakahira Takuma and *Provoke* photographers' exploration of cityscape and reality as "document" to later projects such as Akasegawa Genpei's *Thomasson* and hyperart.[55] When CTI happened, the fourth and biggest event in the CROSS TALK series, in Yoyogi Olympic Gymnasium, underground arts came emphatically above ground in ways that not everyone found comfortable.[56] Tange, in his conversation with Tōno, put it this way: "Buildings, for a person on the go, can be felt as though they were points in a total environment. Architecture is nothing but a point floating in a whole. This applies to other art forms in which all the components dissolve themselves and become inseparable from a *total environment*."[57] Yet "totality" here, in my view, should not be read holistically or as connoting a unified whole but by taking into account the complex dialectical and sometimes imperceptible relations that the term connoted at the time in relation to Marxist thought. For Expo '70, Tange told Tōno, he wanted to generate not a building or a fixed structure but an "environment that will act as an apparatus, an apparatus that will generate events [*hassei sōchi*]."[58] Here again, Tange mobilizes the idea of *sōchi* (device, apparatus) not only as a technological or spatial object but as one that can generate events through time, can move as a social and interactive working space, a productive frame for generating unexpected happenings.

Totality (*zentaisei*, 全体性) becomes a key word in relation to those environmental art creations: the meaning of this totality, as we have seen, is not a synesthesia or synthesis as in nineteenth-century art theory, nor the *Gesamtkunstwerk*, but implies or requires a certain invisibility, blind spots, speed, and fragmentariness for the subjective structures of perception.[59] *Envelopment* also becomes a key term again, as in *From Space to Environment*: one is enveloped in the environment, the tonal air, but denied a perspective of mastery over it. There is a total reality that inevitably escapes the subject, and the artwork should aim to face this outside of the subject and to orient toward that very situation of being enveloped. Writing on CROSS TALK, Ishizaki Kōichirō uses this idea of totality to describe John Cage's *Winter Music* (1958), performed by Cage and David Tudor along with Takahashi Yūji and Ichiyanagi

Toshi at Sōgetsu Art Center (October 9, 1962, and again without Takahashi on October 12, 1962), in which, he says, Cage, "by stopping at the minimum of the act of composition, revived in the audience the (other) senses that take part in the totality of the world."[60] The piece, with its aggregate of notes to be played in a single beat/"ictus," its silences and small "events" to be overlapped at the performers' will, creates a structure rather than a predetermined piece in which individuals and groups of performers navigate and intervene. Although this is an earlier work before the explicit rise of the concept of intermedia, like the idea of a generative apparatus, it imagines the making of art as the generating of an intermediate space, an affective relationship of interlocking frames between the layer of individual/subjective apprehension, via the larger structures of the artwork, toward the totality of the world beyond the grasp of either audience or composers.

Intermedia, then, becomes part of the lineage of an exploration of this larger sense of environment as apparatus, meaning both social/human and technological apparatus. Intermedia attempts to grapple at that middle level of agency to create a situation where our position within these systems becomes, at least partially, apprehensible, such that we can make practical moves among its structures—and where our failures to grasp the full significance of those systems as they play themselves out both within and outside us develop into yet another explicit layer of the work. While many have read Expo '70 itself as a wholesale moment of co-optation of the avant-gardes by a nationalist narrative of technological progress, and in many ways the endpoint of 1960s avant-gardes, more recent studies have attempted to tease out the ambivalences and more complex meanings in Expo '70 itself. Others have pointed out the productive and generative anti-Expo (*han-paku*) activities. My attempt here is to read the pre-Expo work of CTI, which overall falls in alignment with preparations for Expo '70, to perceive the layer that opens in the reframing of environment as apparatus. CROSS TALK could be thought of as a liminal moment before the true (or further) congealing of intermedia in the Expo, though I do agree that the Expo itself contains complexity and productive paradox as well as banalization/carnivalization of avant-gardes at the scene of their mass consumption. Neither solely paranoid nor reparative, this reading of CTI shows how incorporating infrastructure, including social networks, into the fabric of the work before the showdown of Expo initiates an approach to the fragmentariness, speed, breakdowns, and blind spots of our relation to a larger totality, while reflecting the network of human and institutional forces required to create a site for such a performance. Whether it is a mirror (symbolic) or metonymic relation with the position of subjects

inside larger infrastructures, or whether it involves the folds and complicities of mimesis, the relation between the work and the larger social and cultural assemblages invites us to read at the affective scale, which also means shifting to a broader understanding of apparatus as a social/institutional mode of making.

Multiprojection and Totality

In the politics of intermedia, the apparatus takes the form of a social network. Before examining how that worked in the launching of the CROSS TALK event, I return to the theories of Matsumoto Toshio and his understanding of Stan VanDerBeek's multiple-projection work, which will help us better situate intermedia in its emergence out of and extension beyond multiprojection/expanded cinema. Both VanDerBeek and Matsumoto went on to participate in CTI. After visiting VanDerBeek's Stony Point, New York, Movie Drome in 1968, Matsumoto commented:

> The particularity of the contemporary moment is that various phenomena that at first glance appear overcrowded and lacking connection, parts of a multilayered process of violently changing flux, contribute to the making of one chaotic totality [*konton to shita zentai*]. However, we cannot be the kind of subject [*shutai*] that can fully see through those things that are beyond the self [on the other side of ourselves, *jiko no mukō gawa ni*, like this chaotic whole]. Rather we are limitlessly fragmented, and we are enveloped within that chaotic environment [*kankyō*]. How can we look at such a reality as it is [*aru ga mama*] and from there move toward grasping the connection between self and reality in a *total* way? . . . In fact, as I glimpsed in the Movie Drome, the experience of becoming involved in the complex (composite) aggregate of multiple images that repeatedly permeate and collide with one another oddly can contend with (countervail) the feeling of Being in the contemporary age.[61]

A flux of overcrowded elements beyond the self forms the situation of the contemporary moment. That situation needs to be in some way matched, countervailed, or brought into relation with the subject, perhaps through the experience of cinema. Highlighting this idea of totality, and the aim of art to approach a situation of grasping this reality "as it is" (*aru ga mama*), Matsumoto uses the term *environment* (*kankyō*) as that which envelops the subject and yet is "on the other side of" the subject, beyond the subject. It is

precisely, however, the status of the subject (*shutai*) that comes to be challenged here: the older idea of the subject's ability to actually grasp that reality or "fully see through" it is gone; in its place, we must come to terms with being a subject that is both deeply fragmented—in some ways analogous to that "chaotic totality"—and also "enveloped" within this environment. The permeating and colliding images of expanded cinema offer Matsumoto an enveloping environment as an apparatus for allowing a glimpse of that fragmented subject's situation.

Matsumoto's discourses of this time explore the idea of reproduction and replication (mechanical), and hence the relation between technology and life. For Matsumoto, in VanDerBeek's work the questions of liveness, "one-timeness" (*ikkaisei*), and simultaneity are central: "Up until now film was based on the principle of *fukusei-saisei* [reproduction, duplication] and replaying [bringing back to life], but now, with the birth of expanded cinema, that common sense has been torn apart and a new concept of cinema has been born that is based on the [principle of] one time only [*ikkaisei*]."[62] Here, the characters of *saisei*, reproduction/playback, seem to generate in his sentence more and more "births," so that the issue of life itself in relation to the technological means comes to the fore alongside the issue of projection's singularity. For the fragmented subject, permeated and surrounded by the technological, a key part of glimpsing the contemporary situation comes in the form of a temporal frame, a moment, a one-time event. Yet unable to fetishize the unique temporal frame in his theory, Matsumoto instead finds the idea of birth itself reproducing and doubling in alignment with the cinematic material.

The artists of CTI are similarly haunted in their technological experiments by the idea of life. Tōno talks, in opposition to the old idea of artists as the guardians of the humanistic in the face of technology, of how some artists have "begun to take up *technology* as a new skin."[63] Liveness is at issue in the CTI performances: the live composer stands in the middle of the giant apparatus erected in the Yoyogi stadium, operating the ring modulators, making the sound levels rebalance or sweep around the auditorium.[64] Live performers push the giant balloons around the stage that then become the "screens" for Matsumoto's *Projection for Icon*, in which he takes the idea of multiprojection one step further. Artists Shinohara Ushio and Misawa Kenji (Kenzi) built twenty helium balloons made of vinyl, four meters wide (really huge), not totally filled with helium so that they would float slightly above the floor and move around and bump into each other (figure 1.7). From all around, five film projectors (16 mm), an overhead projector, and colored theater lights were shining and flashing. The projections were of things like large eyeballs

FIGURE 1.7 Matsumoto Toshio, *Projection for Icon* (February 5, 1969). Courtesy of Roger and Karen Reynolds.

in close-up. The work reflects, in a very different mode from *Vitrine*, on gazes, as well as on projection and screening—with eyeballs superimposed on the balloons, and close-ups of lips and hands—that could be seen from any direction. Stagehands moved around the balloons, with the explicit aim of upending the unidirectionality of the one projector, one screen structure.

In Matsumoto's description, this balloon work was intended as a disorienting experience of the image: the movement of balloons could blur the image, or suddenly from the midst of the blur, a giant eye could seem to gaze back at the viewer. The red of lips could be indistinguishable from the red generated by the theater lights, so that it became a meditation on color, on spatial orientation and directionality, multiple images and blocked perception, and most specifically on the mode of the close-up itself, since the viewers can approach these giant screens with their bodies, and others' bodies become shadows blocking the field of projection. No one viewer can encompass the whole; there would be, at least ideally, a multiplication of incomplete visions within a multidirectional soundscape.[65] Yuasa's soundscape for

this event, *Icon for White Noise* (otherwise translated as *"Icon" by White Noise* or *Icon—on the Source of White Noise*), which Yuasa later transposed and reconfigured into Expo '70 with another multiprojection work by Matsumoto, used five tracks distributed among five sound outlets (speaker channels), thus effectively twenty-five channels, moving multiply around the listener, to construct "a new kinetic space created only by sounds," a "jostled silence" in which there was a "horizon of sound that passed out beyond the walls of the studio expanding toward infinity."[66]

Icon for White Noise, which had also been played at the CROSS TALK event the previous year without projection, consisted of a new frequency filter and a control system (an "analog computer" using "punch roll tape") constructed by Satō Shigeru (Mō-san), without which, Yuasa claims, such a complex relationship of the twenty-five channels/five tracks would not have been possible.[67] When listening to the piece today, it is clear why Matsumoto would have envisioned it as an exploration of air. (He originally wanted it to be projected onto fog, but because that was ruled out, he made air visible through the balloons instead.)[68] Making air both audible and visible, the piece thus brings into multiple senses what would usually not be seen; some moments sound like a balloon being inflated, at the upper registers, and then deflated, while in the lower registers a wind-like wave rumbles softly. Abrupt moments interrupt the ongoing "mass sounds," which rotate around the listener through the speaker channels at precise speeds. Specific sounds cast "shadows" by responding at differing volumes from opposite sides of the listener; but what strikes me is how, against a moment that sounds like the inflation of an air bubble in a large, resonant space, or even the HVAC of an enormous building, suddenly a small sound will bring the "pouf" into intimate closeness, like someone puffing a straw in your ear. Thus the piece confuses scales, distributes the very near and the very far; in the auditorium, these sounds would have been traversing the large space of the gymnasium around the audience to bring that set of zones or bands of frequency of sound (and its filters) into a complex motion of encompassing them. At times little high tweets resembling birds or sea creatures (but not quite) rise above the larger crashes and bigger dramas that give the illusion of originating beyond the edges of the theatrical space. Air becomes palpable, the transversal of scales becomes literal, and all the while another invisible element (white light) divides into colored lights and projected images on the balloons in motion.

The theory of the image and cinematic gaze—alongside the conception of sound event here—is both intermedial and transnational (in dialogue with theoretical ideas and experiments going on in the United States and Europe

and traveling to Japan, including the idea of projecting onto balloons). It crosses the layers of the image in a way that is paradoxically mimetic; yet, like Matsumoto's theories of the necessarily experimental process of documentary creation, it pushes toward a theorization of the sociopolitical and moving images that threads the two together in full "cross-violating relation"—a version of mimesis that is not mere imitation but includes the full historical-critical complexity of this term. These works express the overwhelming media-state of experience, creating environments that explore the chaotic political and social situation that might otherwise recede from perceptibility like white light, white noise, or air—not by translating a preexisting grasp of the situation into visual and sonic form, but by showing how that contemporary situation is itself shot through, congested, and overstuffed with image and sonic materiality.[69]

One reviewer wrote that the balloons felt like giant clouds and the *Icon* piece (discussed in more detail below) sounded like a storm. Indeed, it is hard not to hear the carefully balanced five-track dynamics of electronically generated white noise as the buzzes and high chirps of some insect-like creature in a rainstorm or passing by in an oceanic rush. At certain moments its deeply booming low thunderclaps strained the ears of the three thousand people who came to hear it—as did some other pieces on the other two nights, projected through the $41,000 worth of sound equipment donated by Pioneer (about $290,000 in today's dollars): thirty-two speaker enclosures with more than a dozen speakers, ten pairs of them behind the audience; dozens of auxiliary amps and portable tape decks; and a special mixer built by Pioneer engineers. Salvatore Martirano's piece, *L's G.A.*, used helium to alter a voice, and a gas mask; in Robert Ashley's *That Morning Thing*, female singers who were to represent a chorus of frogs wore taillights over their eyes.

Technological art is shot through with the idea of biological life and haunted by the prospect of disaster. The mechanical/mechanized sounds and lights throw the listeners back on their own corporeal and phenomenal experience of duration and the limits of hearing/seeing, as well as the effects of the large crowd's physical presence. Group Ongaku members' piece, *441.4867—0474.82.2603—712.9374* (its title coming from the members' phone numbers), used chance and predetermined rules to transfer light into sound, the electronic into the live.[70] As each player hammered the letters of the title ("amplified dream") in Morse code, performed "heaving glissandi" (long slides between notes of the piano) to represent dashes, or thumped on the piano with elbows and forearms to represent dots, a propeller blown by fans activated control devices that could override the human actions, and five tape recorders

played sounds from record blanks that had been "selectively melted."[71] It is hard not to see and hear overtones of disaster in the melted records, Morse code, and blue-and-white flashing lights. The sounds are loud, painful, siren-like at times; the durations are deliberately designed to tax the performers and the audience, pushing beyond human limits. As we shall see in the later chapters of this book, more recent reflections on infrastructure, mediation, and apparatus draw from the legacies of intermedia in ways that carry similar overtones of disaster, both historical and more contemporary.

Butō dancer Hijikata Tatsumi was supposed to have danced in CTI and did contribute an essay to the program, but backed out at the last minute, so his work ultimately remained underground. His feat had been to get Egawa Saburō, the event manager from Million Concerts, Ltd.—one of those people who engaged in delicate negotiations with corporate, government, journalistic, and artistic interests—to procure a giraffe from the Tokyo Zoo to perform in Hijikata's piece. Both Yuasa and Reynolds recount the details of these negotiations in their writings, focusing on this as much as or more than on the works themselves (which are well documented in the program). The politics of intermedia—as a framework for understanding apparatus—is a key element, as evidenced by all the people involved in these negotiations; and this aspect, when highlighted, also can evoke the ways in which CTI does prefigure the critiques of corporate/governmental collusion that were so strongly leveled at Expo '70. The emphasis on the technological apparatus and environment within the works frames a perspective on, and models a practical rejiggering of negotiations with, the larger sociocultural and institutional network surrounding CTI.

CROSS TALK was funded by United States Information Services (USIS), as Reynolds tells it, essentially a covert propaganda/"public diplomacy" agency founded by the Eisenhower administration during the Cold War. In giving CTI the $7,000 it did (about $49,000 in today's dollars), USIS's intent was to draw in Japanese students and intellectuals, or, as Reynolds put it in his rather clear-eyed confidential memo to the Institute for Current World Affairs, "Foremost on their scale of values was not the furtherance of avant-garde 'art'—needless to say—nor the transmission of American values and ingenuity, but capitalizing on an unusual opportunity for reaching a generally antagonistic segment of the Japanese public: the same young students and intellectuals who, as a matter of habit, demonstrate against American bases, visi[t] Nuclear Ships, and take part in 'Struggle '70.'"[72] Reynolds goes on to mention that, nonetheless, "Interests of very divergent sorts were served to the ample satisfaction of all concerned—the US Government, avant garde

experimentalists, competing electronics firms, foundations, soft-drink man-ufacturers, and air lines."[73] Is this, then, the products (or producers) of the environment "flung back at their makers" and thus, as Reynolds optimisti-cally concludes, the way "individuals can turn the establishment to their own ends"? Or is it simply a dramatic and large-scale prelude to the "sellout" of Expo '70, where, as so many said, avant-garde art (at least for a moment) lost its edge before turning to the more complex negotiations of race, class, and gender that followed in the 1970s? As a skeptical graduate student once put it upon reading this, "I am not convinced," by which she meant that she was not convinced that CTI constituted more than corporate collusion, or that any alternative reading should be emphasized at all. (Julian Ross follows this path as well, remaining more interested in the works that entailed more open improvisation, like those of Iimura Takashi.) Does the paranoid reading—a deflection from collective political struggle—suggested by these facts explain away or void the subtle particularity of the media theories and practices in-vented and developed here? I take a less unilateral or, to quote Matsumoto on *Projection for Icon*, more "one-time"/ex-centric or multidirectional point of view, in which the paranoid reading can remain valid while opening space for it to teach us other modes of perception, especially in relation to the tran-sition from environment to apparatus. Its complicities and folds become a key part of what makes it useful for understanding the position of arts prac-titioners in its (as well as our) moment.

CROSS TALK received ample press coverage in Japan and some abroad. Pan Am waited for their mention in four prominent journals before reimburs-ing event manager Egawa for the American composers' plane tickets. In that sense, it is very much the kind of thing that the anti–Expo '70 factions had been protesting. This collaboration, or rather collusion, or (more sympatheti-cally) tricky set of embedded negotiations between business, government, the mass-media industries, and the avant-gardes was from this perspective just part of the business of artistic creation and distribution in the social sphere. But it also highlights and shines a rather stark spotlight on an aspect of artistic practice that has long played an important role, but in ways the works often do not explicitly address. These works mobilize, model, and manipulate the relations between larger/overwhelming environments and subtle sensory ex-periences of being in and among them. Filmmakers like Ōshima Nagisa, with his independent but cooperative cinema projects, already understood and mastered this mode of working: liminally between and engaging commercial and experimental scenes to get broader distribution. But in Ōshima's debates with Matsumoto at least, Matsumoto overtly eschewed that approach for his

own cinematic practice, aiming instead to critique the "structure of vision" (*shikaku no kōzō*) inherent in the existing systems of production and distribution, with their power structures and concepts of cinema.[74] Meanwhile, Matsumoto, Tange, and others went on to participate fully in Expo '70.

For the purposes of this chapter, though, one can say that the apparatus enabling the festival and the focus on apparatus in the CTI works relate to each other in productive and generative ways, whether as mirror images, metonyms, or contingent relays deeply implicated in the performances. The manipulation and envelopment of the crowd, the "roar of the crowd," becomes one important element of the event—which, according to one newspaper review, included an unusual amount of heckling.[75] The circular seating and the mass audience, as well as the forbidding or emotionally resistant forms of the sounds and performances, or their sheer length (Robert Ashley's *That Morning Thing* segment lasted an hour), created a strong desire to participate—and hence to shout at/react/flow among the performers. The audience for this free event, as another reviewer wrote, was not the typical polite concert audience; many did look more like the kind of students and youth one would see in a demonstration in Shinjuku (figure 1.8).[76] In that sense, it mobilized

FIGURE 1.8 A view of the crowd at the CROSS TALK Intermedia event. Courtesy of Roger and Karen Reynolds.

a crowd to form and flow as a collectivity, a mass, or even a scene, letting them roar in their own version of white noise, even as the compositional innovations of the electronic tracks might have eluded or irritated audience members who may not have invested the time to understand the (accessible) bilingual program. The works performed extended explorations begun at the Montreal World's Fair and responded to intermedia experiments at Sōgetsu Art Center, and thus in some ways encompassed and highlighted a larger framework of flowing and interlocking social, artistic, and cultural scenes within which this particular crowd formed just one particular wave.

CROSS TALK would be oversimplified if one just identified its contribution to media with McLuhan's famous work, which had been translated into Japanese a few years earlier—the idea of its focus on media being itself the message. Instead, it represents a step in the conceptualization of media, highlighted anew in recent disciplinary shifts toward the study of production and distribution, where the apparatuses are not just background support in creating the environment in which the artworks can be made, but are integral to the art and work of intermediality. The apparatus here includes the technology (circuitry, ring modulators, photocells) and the social and managerial apparatus (Olympic stadium managers; Sony; TEAC Corporation; the director of the American Cultural Center, Donald Albright; Porter McCray of the JDR III fund), Pepsi, Pan Am, and the art journal *Bijutsu techō*, as well as numerous Japanese and American artists and critics. Thus, a broader and more ambivalent, multifaceted reading of CTI can help us to evoke the potentialities—as a modeling and reflection on these key matters—as well as the critical view of complicities around media and environment enacted within intermedia events. Thus we have highlighted not only the cinematic visuality through multiprojection, the spatial/architectural framework, and the socio-institutional network, but also the special role of sound media and sound technologies, in that they model a heteroscalar (multiscale) relational structure of perception that makes palpable a movement of air and frequencies, the filtering and differentiation of tones, in a mobile and fragmenting envelopment of the crowd of listeners.

Some of the works created at that time remain and can be seen or heard in some form, like Yuasa's *Icon on the Source of White Noise* piece on CD, or Roger Reynolds's film PING with Beckett's text. PING originally included a simultaneous projection of a 16-mm film with butō dancer Maro Akaji (Sekiji at that time), shot by Katō Kazurō, and a Beckett text projected from multiple slide machines in shifting fonts and positions, in Japanese and English.[77] However, many works, including those later recorded, were nonetheless live

one-time constellations that depended precisely on the space—not just on live performance, but on the configuration of the speakers on Okuyama's fourteen-channel system or Satō's prior constructions and the installation of the speakers and mikes. These works were themselves about sound and relationality, circulating around (and in some ways, indeed, even bypassing or making use of) the crowds of people in spaces that had to be big and loud, with information overload and sometimes durational and sonic burnout. The experience of overstimulation breaks the circuits of the limited humanist frame, and though this can just feel confusing, disorienting, even frustrating, it can also be considered part of the sonic realization of the concept/theory of the information age that this event suggests—within the frames of the meta-media or meta-disciplinarity and the emergence of environmental art, as Tange and others had articulated it.

Indeed, in the Isozaki-Tōno dialogue around *From Space to Environment*, scale and expansiveness were already crucial elements. In the current situation, Isozaki says, "Excessively huge objects are made: the relation between those gigantic things and humans has completely changed our sensibility of scale. Further, the numbers of things manufactured has increased enormously, so that human beings are entirely surrounded by artificial products rather than having a one-to-one relation with objects. . . . The personal, something like the individual constitution [*taishitsu*] or the smell of the body are washed away first, and only the system as abstraction can survive in the end."[78] The huge scale of the events of CTI allowed for a situation of "envelopment" along with a meta-medial reflection on these systems and the bodies that moved among them. Engineer Okuyama and event manager Egawa Saburō became something like the new auteurs of intermedia, as they were key negotiators of the systems and infrastructures that constituted the event (figure 1.9).

Where Matsumoto's earlier theories of the dialectical image concretized his understanding of the inextricable relationship between intrapsychic space and the materiality of the visual and audible world, intermedia works and events open this negotiation to a broader infrastructural and institutional network that decenters both the site and scale of production (making/tinkering/creating) and participant/interaction with artistic practices. Intermedia works move from a focus on environment to an explicit thematization of social and technological apparatus, via an understanding of the chaotic totality that now comes to represent both the world and the fragmented subject within it. Through the totality that is a soundscape, through evocation of vulnerability in the face of engulfing technological modalities and media, intermedia's event-

FIGURE 1.9 Sound engineer Okuyama Jūnosuke. Courtesy of Roger and Karen Reynolds.

fulness requires and in itself theorizes an affective scale of relation between the fragmented subject position and the fragmented surround. Between the mode of reading that sees in it primarily a propaganda site and that which extolls its avant-garde innovations and critiques, this affective scale allows us to grasp an alternate potentiality of intermedia to model ways of grappling with the embedded and rapidly transforming media environment. This set of works, viewed together, perform and model that middle range of agency, a practical navigation that allows both artists and audience to confront a not-

fully-visible set of systemic relations and relays taking place simultaneously on multiple levels.

The Politics of Apparatus and the Feeling of Being

In one telling anecdote about the first of the series of CROSS TALK events, held at Asahi Hall (November 13, 1967, moving back in time), the event happened to take place during a major demonstration and, as a result, the speakers and equipment needed for one of the pieces were "trapped in Ginza" and could not make it to the hall.[79] To cope with this, according to Reynolds, the organizers sent a driver to the American embassy to cut speakers and amplifiers out of the home audio systems of embassy personnel in their apartments just before the show. The composers went crawling around hooking them up at the Asahi Hall, all around the audience. The piece was Yuasa's *Icon*, the same one that later played with Matsumoto's *Projections* at CTI. Key to the piece is that it has two scores, "one specifying pitch, dynamic, and temporal relationships, and in the other, the source of each sound as well as its pattern of movement."[80] As mentioned above, Yuasa had started with "white noise"—that is, "a total sound spectrum including all possible individual frequencies," something like the sound equivalent of a totality, or the light equivalent of white noise. Yuasa writes, "One can filter white noise so as to include certain bands of frequencies, sometimes called 'colored noise.'" In other words, as he puts it, "Members of the audience are surrounded by sounds in the same manner as they are in the actual space of daily living. Individual bands of colored noise shift to the left or right of the viewer. As they shift, band width and dynamic level are slowly reduced or increased so as to create the aural illusion of an expanding (or contracting) spatial horizon." This constant shifting and changing of varying elements could not be done without the proper surrounding speakers: Yuasa gestured with his hands how the individual speakers should be adjusted during the performance for dynamic levels. But some Japanese participants were incensed by the inappropriateness of the Americans having, in effect, overridden a cancellation that was meant to be.

One can read this as a demonstration of the indifference of the CROSS TALK organizers to the political demonstration, which, along with the police barricades it provoked, was primarily a hindrance to their show (this reading would certainly have validity). Yet, interpreted otherwise, it is also a harbinger of a shift in focus for politics itself: an opening to an alternative intervention to remake the apparatus of media, taking the objects and people and insti-

tutions at hand and trying to turn them into something else, reconstructing them for unintended ends. While critics might align with a necessity for total refusal at this point, in ways that are elaborated further in chapter 3, this shift in focus may simultaneously offer an important form of potentiality, a mode of intervention into media ecologies and systems that intermedia events bring into view. Art critic Tōno Yoshiaki, for his part, contrasts leftist radical thought with CTI's optimism about technology in his interview with architect Tange, as they open up a conversation about the political valence of such events: "Seen from the viewpoint of the Zengakuren [the All-Japan Students Self-Government League, key organizers of the student protest movements], technology—as a vehicle of information—is a possession of the establishment."[81] If, as Tōno describes, technology remains in possession of the establishment (and these artists are or eventually become part of another kind of artistic establishment), their practices of taking the media apparatus into their own hands, as an active tinkering with the environment in the name of a totality that transcends the individual, partakes nonetheless in an important transition in discourses and tactics for rethinking the media environment under late capitalism, approaching the remaking of an embedded media environment, and evoking a critical distance from it.[82] Within the shift toward an analysis of systems and socio-affective infrastructures that would gradually supplant the Left's tactics of doing battle in the streets with staves, this kind of alternative analysis bloomed into a multivalent center of debate in the early 1970s, a time when many felt that the direct politics of protest had reached their violent limits (see chapter 3).

Even beyond modeling active tinkering in or on the environment, the confrontation with a media environment that a priori goes beyond the self or individual could be linked from today's perspective to the theories of paranoid knowledge under capitalism in which "the uncertain demarcation of the subject . . . might function as a way of understanding a set of controlling technologies, practices, and ideas."[83] There are many instances in which the relation of the individual to an ungraspable totality or total institutional system gets conceived within the avant-garde under the sign of failures of the subject, as a strand of recent feminist and Marxist critics have explored.[84] At times, the subject's failures also mirror and prefigure larger disruptions or failures within technology and world systems, at the level of technological or ecological disaster, as the artworks in the latter half of this book explore. With the help of this later viewpoint, we can see more clearly the relevance of CTI's environment/apparatus experiments for contemporary criticism on global media practices, and of CTI's multivalent relation to its environment

as part of an attempt to match and contend with the complex historical situation from which it emerged. In the end, I argue that the embeddedness of this event is not merely a symptom of late-capitalist corporatization, but an intervention that allows the relation of the individual to totalizing systems (including its failures in that relation) to be mobilized in a set of affective relays. The works then incite a mode of seeing and hearing in which one comes to traverse or gain a sense of that set of relays and layered scalar models with both articulated and practical (tacit) critical awareness.

Japanese intermedia experiments, from early proto-intermedial experiments like *Ginrin* and *Ishi no uta* to those under the official banner of Intermedia, represent a radical attempt to negotiate the "heteromorphism between human capacities and machinic functions."[85] In discourses of the time, machines, systems, and environments become alive in a complex way, haunted by biomorphic allegories, while the so-called human is overwhelmed, emptied out, destroyed, virtualized, exhausted, and then swirled/overwritten into a "vast chaotic totality" (Matsumoto), which it is oddly nonetheless necessary to confront, "face up to," and even "countervail." Systems, devices, and apparatus appear as elements of a vivified, structured (and sometimes "organic" or "symbiotic") landscape that breathes and becomes "subject," even as artists track, without much lament, the fading out of the "smell of the human" and the mark of "human fingerprints," instead taking on technology as a "new skin." Animation comes to the fore as a key medium in these years, and this may be no surprise. As Nakahara Yūsuke wrote about some early experiments in art animation, the subject of chapter 2, "Through the material imagination" (*busshitsu-teki na sōzōryoku*), technological processes combine with thought, drawing, and line to make something that "flies out or is dashed out of the sensibility of everyday life" into "another dimension" (*nichijōteki na kankaku kara tobidashita ijigen no mono*).[86] A fascination with dimensionality and other-dimensionality comes to the fore. "Animation's true sphere is found in the critical laugh born out of freely breaking everyday time and space," Matsumoto also wrote, noting the "*dépaysement* of illustration" as a part of that potential.[87]

Artists of the 1960s delineate the relation between the technological image and the revised version of the human by layering dimensions, reducing, evacuating, and even eviscerating the realm of dimensionality (Zero Jigen), or by emphasizing *kyo* (virtuality/emptiness), as in Tōno's theories of environment. At times, they propose models of multiplicatory relations, as in Matsumoto's "mutually cross-violating relation" or manga artist and critic Ishiko Junzō's notion of the "multiplicatory 'AND' [*to*]": "I understood that

the composite term intermedia . . . aspired to totalize the relational structure of perception and cognition."[88] To totalize the relational structure of perception and cognition is tantamount to what Tōno and Isozaki articulated in their parallel claim for an externalization of the senses, linked also to the postwar *Provoke* photographers' writing on the systematized aggregate of interlocking gazes that envelop and supplant the photographer.[89] Such an interlocking gaze is already present in prototype form in Yamaguchi's *Vitrine*, here expanded beyond the individual spectator's experience (*taiken*) of fragmentation and disorientation, of multiplicity, to a broader and more massively scaled opening of the technological aesthetic of apparatus/environment.

In intermedia, it is not a single human but human sensorium externalized and multiplied on a grand scale. In Matsumoto and Yuasa's *Projection for Icon*, this scale involved the massive, four-meter balloons being pushed back and forth by performer/operators before over three thousand people, as the tiny Yuasa Jōji, like the Wizard of Oz, managed dynamic levels on a console at the center, fragmenting/reducing the totality of white noise to some of its constituent colors in an apparatus/event generated with the collaboration of dozens of institutions, structures, and collectives of individuals. *Projection for Icon* opens the meaning of projection beyond the main meaning of multiprojection in expanded cinema's "one-timeness" (*ikkaisei*) toward a projection outward as an envisioning of what Matsumoto had theorized as the experience of the chaotic totality that superimposes and collides. As the projective capacities of the human to analogize itself to the technological (sensorium) and of the technological/virtual world to embody the human collide and overlap, Japanese theorists of 1960s intermedia arrive at an idea of the environment that is both mental and material/objective, intrapsychic and sensorially exterior. Through these theories, they map and construct relations to social and cultural transformations to make an art that might be commensurate with the—ambivalent, folded, complicitous—"feeling of Being in the contemporary age."[90]

Intermedia Moments in Japanese Experimental Animation

In the interstices of intermedia works, but in a set of parallel spaces and times, many Japanese artists engaged in a series of experiments under the rubric of the newly (re)named art form "animation." Of course, *manga eiga* (comic films) and other terms had already long existed for the forms of moving pictures incorporating drawing and frame-by-frame movement that we know as animation; by one definition, even the rotating bicycle wheels in *Ginrin*, hovering in air, constitute one stop in the long history of its many-faceted forms, a cross between the Duchampian readymade, a Yamaguchi Katsuhiro multiperspectival *Vitrine*, and the Mickey Mouse–shaped creature called DOB (signature form of today's popular artist Murakami Takashi), with its handlebar-ears suspended between mechanical and organic life.

Nonetheless, for artists affiliated with the Sōgetsu Art Center (SAC) in the late 1950s to early 1960s, animation evoked a particular kind of potentiality, embodied in its elasticity, its morphing, stretching, and undulating lines, which, in combination with the musical experiments being produced at SAC around the same time, could promise to defamiliarize the everyday and produce a transformed relation with the world of materiality and objects. Works of remediation, like Matsumoto Toshio's visualization of dialectic in *Ishi no uta* (*The Song of Stone*, 1963), played with defamiliarization in the context of documentary and photographic practice, filming still photographs with

musique concrète to shape an aesthetic practice that reconsidered the status of the image (*eizō*), the process of its reproduction across various media. At around the same time, minor and outlier animation experiments—low-budget, hand-framed, simple works in terms of their technical accomplishments and cost—created an alternate mode of grappling with materiality and the image. Though far smaller in scale than the lushly infrastructural works discussed so far, these animations are equally concerned with activating a potentiality having to do with objects, materiality, and the interlocking relations of gazes. Through their use of animetic line and movement, these works similarly explore a structure of embedded interactions between externalities and subjectivities, and they take a more ephemeral and micro-mediated approach to the concerns that intermedia events addressed at a broader infrastructural scale. If apprehending the apparatus in intermedia arts soared toward overarching overwhelm, these more minor worlds open an alternative media theoretical space from a broadly defined understanding of animation.

With the plasmatic line and textural stretch, artists evoke a new consciousness via technological processes that they hope would open altered subjective/intrapsychic movements; their work focuses precisely on the skin or screen that joins and separates these two realms. On the one hand, small, ephemeral images frame cute illustrations of the entrapped positions of the subject, infusing humor into intimations of disaster and violence. On the other, through the mobility of objects that perform shifting affective intensities, they imagine ways to stretch beyond the *dispositif* or apparatus of existing social frames, illustrating flexible models of embodiment from within a transforming technological environment.

The broader field of animation in the early 1960s saw the expansion of limited animation forms for television distribution, where cells were reused as much as possible to save costs, in ways that moved along other vectors of spatial imagination. Marc Steinberg and Alexander Zahlten, among others, have written about how limited animation's forms and postwar capitalist structures enabled the rise of the media mix, a popular modality of production, distribution, and consumption that parallels intermedia in being structured around the breakdown of boundaries between different media forms. Imported Disney ("full") animations also held a key role in the landscape of animation at this time. In parallel with those more popular modalities, and in active dialogue with them, early 1960s experimental animation structures its experiments in small-scale avant-garde scenes that remain conversant with, and depend in many ways upon, the mass venues of commercial culture, just as we saw that intermedia/electronic music such as Yuasa Jōji's depended on

his access to NHK studios, which he gained by working on radio dramas and documentaries.[1] These experimental art animation works hold an interval between the newly emergent "white-collar visual cultures,"[2] those striking rhythms of commercial television, and another, slower rhythm that evolves at the pace of a water drop and moves at the scale of a line on skin. That slower evolution shifts things not in reference to a hard-surfaced or rigid symbolic infrastructure but as a newly articulated temporal relationship with the soft, squishy stretch.

The ultimate meaning of moments of stretch, intensity, and plasmatic transformation, which play an important role in Japanese animators' ideas and reflections, does not guarantee a predefined political directionality. From the time of prewar animation, as Ōtsuka Eiji has written (about Tezuka Osamu) and Esther Leslie has discussed in terms of Eisenstein and of Frankfurt School theorists' relation to Disney and Hollywood, stretch and plasmaticity were key to the thinking about the potentiality of animation. Furthermore, as Ōtsuka convincingly argued, that stretch could be (and was) turned to support militarist propaganda as easily as to promote historical materialist revolution. The artist-animators' works in the 1960s participate in the legacy of prewar avant-gardes, as the central participation of (prewar surrealist) Takiguchi Shūzō as a thought leader among them might suggest. These 1960s avant-gardes were thus deeply imbricated in perspectives coming out of prewar modernisms, including Japanese arts movements of the 1920s and '30s as well as translated theories from Europe written in the interwar and early postwar years.[3] Social theorists and critics actively debated the postwar status of the subject (shutaisei ronsō) in Japan and the legacies of wartime violence; and against this backdrop, artists and critics reevaluated the political valence of Japanese prewar avant-garde experiments, some accusing these formal innovations of elitism and of covert (or overt) complicity with national/militarist war efforts. While an emphasis on stretch and transformation held an important place in prewar animation as well, the political implications of that stretch were thus not by definition fixed, either in the pre- or postwar, through the presence of a stretchy line. In the prewar, ideas of ethnicity or nation could be represented as different animal species in ways that supported militarist colonialism; the ability to shape and control forms could represent the creator's "omnipotence" and "fantastic mastery" or, on the other hand, could allow for the world to "elasticate" in dynamic, revolutionary ways—or even at times both at once.[4]

This chapter thus begins with an examination of what artists understood to be the renewed potentiality of the plastic line in some lesser-known works

from the early 1960s, and ends with the more explosively political framing of a shaking, jittering, more masculinist violent revolution in an animation experiment of Ōshima Nagisa, itself also shadowed with a more melancholic relation to time that aligns it with those earlier works. In the context of his New Wave experiments, Ōshima performed a remediation of a visual work of still drawings in *The Band of Ninja* (*Ninja bugeichō*, 1967). The film is based on Shirato Sanpei's popular long-form manga (*gekiga*) about the son of a murdered feudal lord in the Eiroku era (sixteenth-century Japan) who seeks revenge for the death of his father. Its plot has many twists and turns, but centrally evokes the elusive savior figure Kagemaru, who leads starving peasants and farmers to rebel against the oppressive ruling class, and who at times appears in other guises to save the lives of others or to be killed (without truly dying) himself. Constructed of high-speed edits, the film consists of still and panning shots of the original manga drawings, with their speech bubbles, movement lines, and pencil sketch lines still partly visible, along with music, sound effects, and voices by some well-known actors.

Ōshima had formed the independent production company Sōzōsha, and he produced *The Band of Ninja* in collaboration with Art Theater Guild.[5] In general, Ōshima worked in the more commercially linked frame of experimentation of Japanese late 1960s independent cinema—still distributed by the Big 5 studios and partially backed by them financially; he called his work in *Ninja bugeichō* a "*Chōhen manga eiga*" (a feature-length manga film), not an animation, which, as Yuriko Furuhata argues, emphasizes its intermedial qualities.[6] By 1967, he was operating in a milieu where animation and remediated still images could become an intermedial space in which the forms and modes at the boundaries of cinema, visual arts, and sound could reflect on politics, lifelikeness, and changeability. *The Band of Ninja* mobilized these forms to create an explicit meditation on law, state power, and violence.

For the artists of the Sōgetsu Art Center in early animation experiments, the politics are more understated. In that sense, these early animation works presage the leftist struggle over representations and symbolic forms that would take central stage in the culture-industry debates of the 1970s discussed in chapter 3. In Ōshima's episodic and fragmented narrative work, on the other hand, the message was explicitly political, while the audience was more popular. Yet Ōshima's work, too, highlights transformations of substance, as the ninja can manipulate the inanimate world, and the movement line is both absolutely still and relentlessly transforming. Thus, Ōshima's work aims to capture formally and thematically the recursive and unending powers of a more politicized and violently confrontational revolution.

Anime's Material Imagination: The Critical Laugh of the Three Animators' Group

At the Eizō gakkai (Japan Society of Image Arts and Sciences) in 2010, critic Nishimura Tomohiro pointed out that the term *animation*, as it is used today to talk about a particular medium and process of production, only emerged in the postwar period, in the 1960s, with the work of Animēshon Sannin no kai (Three Animators' Group) at the Sōgetsu Art Center and the simultaneous development of the Annécy Animation Film Festival.[7] Before then, various things could be called animation-like, under different names: *kage-e* or shadow pictures (related to *kamishibai* or illustrated narrative plays), puppet films, certain geometrical abstract films under the title *zettai eiga* (absolute films), and then, of course, the term *manga eiga* (comic film). Furthermore, the term *animēshon*, as used in the early 1960s, and in particular in the 1964 Animation Festival at the SAC, still encompassed many possibilities, not all of them necessarily using frame-by-frame shots of moving or changing drawings. The SAC in the 1960s became the center of a lively series of debates and writings on what, precisely, animation should be. My interest here, however, is not so much in the term *animation* but in the effect or impact—the potentialities—people thought certain forms of experiments, which they called animation, might be capable of producing.

Within these works, as I mentioned, the cartoon or plastic line was mobilized to carry a promising form of meaning and potentiality, in ways that found new relevance in the exploding capitalist network, the overwhelming image culture, and the economo-affective air of the high-growth period, where *danchi* (apartment blocks) and salaryman culture burgeoned and commodity forms melded with fantasy/the phantasmatic in ways Marxist thinkers had begun to articulate. What was an object, a subject, and what could the plasmatic line do in their mutually animating projections? At the scale of affect, these works reveal the set of relays that exist between the affective impacts of commercial media on the one hand and, on the other hand, the legacies of avant-garde frameworks, in dialogue with the former, for understanding everyday temporalities, practical pulses of the intrapsychic (both known and unknown), and art's potentialities to intervene in social and political formations.[8] Though in some instances they seem to step in tandem with the development of the new white-collar visual culture of advertising and corporate consumerism, what I am calling minor works (in terms of distribution) enabled the exploration of the slow squish of corporeality and the popped bubbles of raw materials in a framework that sonically and visually

could, at its best, accede to an alternate mode of movement for the everyday, while also allowing space for reflection on the violence and subtle pain (alongside the attractions and pleasures) of commodity culture. In varying ways, the artists of the time articulate how animation might allow them to access an alternative dimension, a transformed quality (*henshitsu*), a placeless place at the limits of critical and sensorial perception.

Sannin no kai (Three Animators' Group) and SAC's animation festival, like the intermedia projects a few years later that are discussed in chapter 1, were structured around scenes—groups of people linked with localities and artistic practices—that focused on the spaces between media, bringing together various artistic forms with a multiply construed notion of animation at their center. Many art critics and film theorists, including Matsumoto, Tōno Yoshiaki, Takiguchi Shūzō, Nakahara Yūsuke, and even Kaikō Takeshi, as well as the artists themselves, registered strong critical and theoretical statements about animation that implicitly or explicitly theorize what animation is, what feeling it should evoke, what would be new for it in these changing times, and what an experimental version of it should and should not do.

Takiguchi Shūzō, for one—as perhaps expected given his catalyzing role in Experimental Workshop (Jikken Kōbō) in the 1950s—focuses on the possibilities of intermediality. He writes of the fact that the three founders of Three Animators' Group—manga artist Kuri Yōji, designer Yanagihara Ryōhei, and painter Manabe Hiroshi—are all crossing media in some way just to do this work, and cites their stated intention to break the frames and forms of current *manga eiga*, to step into what he calls "a different dimension." Animation itself, he says, "very naturally" breaks these disciplinary or "genre" frames, and according to Takiguchi, cannot but do so. Though he expresses some pain at the underdeveloped techniques shown in the 1960 event's first screening, he sees courage and meaning in the artists' attempts at the "breaking of disciplinary frames."[9]

While I appreciate Takiguchi's efforts to define and articulate the qualities of the new dimension that these artists were exploring through their experiments in animation, I would not necessarily take his own formulation of animation's natural breaking of media and genre boundaries at his word. Itō Gō, Steinberg, and Ōtsuka Eiji write about the rise of limited animation's systems of production and distribution through the media mix; and I would agree with them when they argue that these capitalist structures in transformation, these complexes or media ecologies, form key conditions for the new modes of circulation that break through presumed separate media channels. This perspective on media ecologies helped shift film and media

studies into a new emphasis on transmedial circulations: such an approach emphasizes the imagining of worlds, analysis of database structures, and the mobility of game-anime-manga and action figures in their mutual refractions. Nonetheless it is useful to return to the discursive frames in which these artists understood themselves to be working for the definitions of contemporaneity that they draw out, the sense of their own times, and their present moment's affective/expressive forms in relation both to the past and to imagined/potential (or foreclosed) futures.

In their manifesto, the Sannin no kai artists focus not only on the new methods that animation brings but also on what they call a "new consciousness." Their goal is to find new images that can make it possible truly to live (or survive) in the contemporary era (*"gendai" ni ikiteiku tame*).[10] They attempt to redefine *gendai* (contemporaneity) here, this new era (no longer the modern [*kindai*], which is old), in ways parallel to what we see later in Nakahira Takuma's essay "What Is It to Be Contemporary?" or in 1960s–70s dramatic theory: the continual effort to distinguish old thinking or an old vision from a *gendai* (contemporary, present-day) way of living and creating; an old consciousness from a new one; and here, even an old use of technology from one based on this new consciousness.[11] At the heart of this animation theory, as in intermedia, one often finds this question of technology or mechanism in relation to life, now understood to include nuclear threat. The Sannin no kai manifesto states:

> There are so many instances in which people claim to be doing new work but ultimately fail fully to break down the worlds of old consciousness and methods. What is terrifying about the hydrogen bomb or the megaton bomb is that they are [new technologies] riding upon old consciousness.
>
> What we would like to exhibit in Animēshon sannin no kai by means of animation is a strong joining of new methods and techniques with a new consciousness. That is where truly new images will most likely be found.[12]

They explicitly evoke the bomb as the technology of comparison, placing themselves in the (early-ish) postwar landscape, in the set of debates around modernity and subjectivity. In relation to the critics who had claimed that subjectivity in Japan had not yet fully entered *gendai*/modernity, and that subject formation was incomplete, these artists tried to define, as well as to realize in their experiments, a notion of this mediatic contemporaneity.[13] Actual works of animation, which would relentlessly and fetishistically repeat the

spectacle of explosion, the nuclear and postnuclear apocalypse, attempted to catalyze what they understood as an urgently necessary new consciousness in relation to technology and the spectre of immanent and irrecuperable disaster or loss.

In 1961, incisive art critic Nakahara Yūsuke grappled in an alternate vein with the stakes of animation, technology, and aesthetics in the era of the image (*eizō*).[14] For Nakahara, to be animated (*animēto sareru koto*) in the sense shown by *manga eiga* would be a bad thing, because for him it deprived objects of the power precisely of their materiality (*busshitsusei*). He rather appreciated the materiality of things, their thingness, a quality one perhaps had a sense was being lost in the proliferation of images/*eizō* and electronic signals. One can note this interest in matter in his ongoing attention to Mono-ha artists like Lee U-fan, a painter/sculptor/philosopher who centered his work on the encounter with objects to be "left alone," "as they are"—as well as Nakahara's focus, for different reasons, on innovative graphic designer Yokoo Tadanori, who worked with collage and found images to create a metahistorical layering.[15] Having objects "come to life"—and here Nakahara particularly faults Disney—would make them into "organisms" that he calls "dull, closed, familiar, lukewarm." What excites him far more are the early slapstick comedies [*dotabata kigeki*] of Mack Sennett, with early Chaplin, Lloyd, and Keaton, where, he says, a chair, an egg, a barrel, or a bed play as important a role as human actors, if not more, without losing the power of their "object-ness."[16]

Theorists of animation in the early 1960s followed on their prewar forebears in reading transformation or metamorphosis as a crucial potential that animation brings. Like Eisenstein, Nakahara references Disney as a model of this metamorphosis in animation. When Eisenstein writes on Disney, he focuses on the plastic line, its "plasmaticness," evoking the organic.[17] On the surface, Eisenstein's Disney discussion directly contradicts Nakahara's view. For Eisenstein, the bending, warping, curling plastic line, with its "rejection of once and forever allotted form, freedom from ossification, the ability to dynamically assume any form," represents "an essential life force rejecting fixity."[18] It is not just plasticity of line but what gets translated as *plasmaticity* that Eisenstein sees in Disney as representing ecstasy itself: "Ecstasy is a sensing and experiencing of the primal 'omnipotence'—the element of 'coming into being'—the 'plasmaticness' of existence, from which *everything* can arise. And it is *beyond* any image, *without* an image, *beyond* tangibility—like a pure sensation."[19] The mobility, elasticity, fluidity, and diversity of the plastic line gives access to this becoming, to terrains of pure intensity when understood

to embody that which would transcend form. Eisenstein finds this in Disney's cartoon line.

By contrast, in 1961, Nakahara despises what Disney and recent *manga eiga* have become precisely because it is all too organic. He argues that these *manga eiga* work within a mode of transformation of shape (*henkei*) that makes the inorganic into organic substance. The plasmatic is all too tepid (*nama-nurui*), familiar, almost womb-like (with unfortunately gendered implication). He writes instead with fascination for the potential of what he calls "mechanism"—not, he writes, in the form of the geometric abstractions of Fernand Léger in *Musée Mécanique* or Hans Richter in *Rhythms*, but in another sense of transformation he names *henshitsu*. The aesthetic of *henshitsu*, which we could translate as "changing quality," he links to the imaginative power of materiality, what he crucially names the "material imagination" (*busshitsu-teki na sōzōryoku*). Here he names the true potential he sees in animation: the combination of the technological process with materiality, thought, drawing, and line to make something physically (and ideologically) new. "It is not that a human turns into something inhuman [*hi-ningengeki*] nor that the chair or barrel turns into something organic, but that everything changes [*henshitsu*] into things on a different plane that flies out or is *dashed out of the sensibility of everyday life*" (*nichijōteki na kankaku kara tobidashita ijigen no mono*).[20]

Here is the theoretical combination he proposes: whereas for Eisenstein the plastic line is the space of becoming, for Nakahara the best animation that transcends the banal breaks out of given forms—the *tobidashi* (dashed out) as a kind of explosive movement, a paradigm shift—and this breakout takes place precisely on the level of the mechanism, a visual/philosophical machinic potentiality of animation's materiality. Animation works at the intersection of drawn or photographed objects and moving-image technologies. It works precisely because of its placement at the intersection of technology's alternative frames for imaging movement (which we might relate to what Thomas LaMarre termed "the anime machine") and the resistant exteriority of object-ness, which Nakahara captures with the term *materiality*. Both of these edges—potentiality in technological imaginative movement and the plasmatic materiality of objects beyond symbolic grasp—combine to constitute this paradigm shift Nakahara describes. Matsumoto elaborates a related framework: that "animation's true sphere is found in the critical laugh born out of freely breaking everyday time and space."[21] In a later article, Matsumoto criticizes Manabe Hiroshi's *Jikan* (Time, 1963), which has many images

of drawn clocks moving on a black background, for the fact that the hands always go around to the right.[22] Though he likes the work in some ways for seeming to go to the heart of the issue of time and, specifically, the mechanical in animation, why, he seems to ask, is this normal, expected clockwise motion necessary in animation?

Although Nakahara does not comment on the individual animations presented at the screenings, we can begin to see how his aesthetics of animation, his material imaginary, played out in some key works of the following years. Mori Takuya, another critic who wrote extensively on the animation series at SAC, in his essay about limited animation's potential ("Kātōn to gurafikku anime"), goes so far as to call some of these specific works from the 1964 festival "still animation" or "animation that doesn't animate," thus emphasizing that paradoxical overlap between potentiality and what we might call impotentiality, movement and (movement-resistant, materially grounded) stillness.[23] Nonetheless, he says, "they have something that gives the 'feeling of animation,'" and in the end, that is their originality and specialness, though it poses problems of definition. For Mori, in the end, "animation feeling" depends less on the specific technique and more on the synthesis of qualities and affective elements. On Wada Makoto's *Satsujin* / MURDER, for example, a popular success in the 1964 show (in relative terms for this limited audience), Wada had said he used "slides of nothing in particular" and that his work shouldn't even be counted among the works of the show except as a kind of extra or exception. But Mori argues that "through accuracy of pace, we see the thing called the 'animate,' or 'animatedness' [*animēto*]." Wada structured *Satsujin* / MURDER as a humorous pastiche that repeats the same scenario in different cinematic genres to the backdrop of the jazz of Yagi Masao—with, for example, a James Bond 007 version, an Antonioni *L'Avventura* version, a science fiction version, and an art theater version in black and white with vaguely Picasso-esque figures. In many ways it goes nowhere, humorously evoking a repetition of the same, citing the existing visual vocabulary for a looping of time on itself.

Delving more deeply, two other works from the same screening series, Manabe Hiroshi's *Sensuikan Kashiopia* (Submarine Cassiopeia, 1964) and Uno Akira's *Toi et Moi* (You and me, 1964), could "hardly be called anime" in terms of their techniques, according to Uno and Mori.[24] *Sensuikan Kashiopia* takes a drawing of a submarine and films the drawing being submerged in water; but for Mori, this "has a beauty that is really animation-like in terms of light and shining on water."[25] These moments might remind us of some of the works with the auto-slide projector in early Jikken Kōbō like Fukushima

Hideko's *Foam Is Created*, which projected still slides of gradually advancing and moving foam bubbles, with the advancement of the slides triggered in automated response to carbon markings on a soundtrack.[26] In some way, the water drop might be imagined as the prototype for the plasma-like notion of Eisenstein's primordial plasticity, and it recurs in numerous works; however, it is less the lifelikeness and more the textural or tactile grain and material, tensile pull of surfaces that become the focus of interest within these works. Uno's *Toi et Moi*, which I discuss in more detail in a moment, makes a specific and slow use of the graphic line on skin, animating it, as it were, by the plasticity of movements of the body alongside baroque music. This, too, as Uno writes, is hardly animation, but it is a space where the plastic line takes shape: tears and drops here, shown in the moving-image form as they slide down a part of a body, drip down over an illustrated/drawn-on piece of skin, hold in themselves a fundamental substrate of animatedness, via the intersecting plasticity at the interlocking border between life, screen, and skin. But, if we are to follow Nakahara, it is the material imagination of this skin and water, even as it shivers, with ink that could be drawn or filmed, or cut out of paper, that allows animation's full material possibility to emerge.

At other times, it is not by the movement of lines at all but by the rhythm of collaging already existing graphic material made for other purposes (also including photographic elements) that the function of creating the sensibility of animation arises, as Yokoo Tadanori's collage-based contributions to the same series show, including *Anthology No. 1* (figure 2.1), and *Kiss Kiss Kiss* with music by Akiyama Kuniharu. These works are all part of the 1964 "Animation Festival" at SAC by invited artists, and the music included composers who were active in the Sōgetsu Music Inn and the contemporary series of jazz and *musique concrète*–based events taking place at SAC around the same time.[27] For the artists of SAC—which would close down its activities in 1971 partly because of accusations of elitism—the resistance to more overtly commercial venues is explicit: the jazz-based events were specifically interested in the parts of jazz that were not popular. Yet the political structures are more understated, in the form of the psychosexual politics that would come to dominate in the late 1960s–early '70s, with a focus on corporeality, subjection, and gendered/engendering bodies. In Kuri Yōji's *Aos*, for example, where again sound is key, Yōko Ono's voice in wails and nonverbal (slurping) noises overlies an explicit exploration of the precisely not-cute plastic line of the body, the stretch and excess of contour, the agentic squeeze that attempts at least to burst the face (and the mind) into (idealistically) new consciousness—at least we can see this in many moments toward the beginning of the work, before

FIGURES 2.1–2.4 *Top left*, Yokoo Tadanori, *Anthology No. 1*, 1964. *Top right*, Yokoo Tadanori, *Kiss Kiss Kiss*, 1964. *Bottom left*, Kuri Yōji, *Heya/The Room*, 1967. *Bottom right*, Tezuka Osamu, *Omoide (Memory)*, 1964.

the strangely distended tongues give way to a more recognizable cinematic rhythm and configuration of sexualities.

Through varying and sometimes contradictory theoretical renderings of technological possibility and corporeal and linear plastic life, and through the transformations made possible by material imagination, artists from various disciplines and sectors came together to collaborate on the formation of a newly synthesized or reinvented thing that would, for a moment, take them aside from their otherwise active work in publishing, advertising, and television to gather and see what might be possible under the label of "animation." Their collaborative practices should be highlighted, as they pulled together and

created an occasion for questioning the nature and goal of artistic experiments, constructing a happening moment and opening dialogue on how to live in a contemporary way, how to create and improve techniques without losing the fresh edge of the untrained or differently trained hand. Whether still or in motion, whether achieved or not, these works together aimed toward a *dépaysement* of illustration, as Matsumoto puts it, an antirealism or dislocation of the everyday in the midst of a rapidly transforming urban landscape.

Yet the awareness of the pressures of that explosively growing, skyscraper-filling, polluted urban landscape—the dirty air, the accelerated mood of high-growth commerce—remains with them, and the necessity of retheorizing the relations with commodities and objects resonates through the everyday experiences of late-capitalist genres, where the real (documentary, journalism, realist photography) as well as artistic versions of the imaginary have devolved and circulated as just two sets of genres/conventions among others. In some ways these genres seem no longer to hold, or to stick: there is a feeling of being unable to land or articulate precisely what is going on in practice socially, politically, affectively; and yet also a sense that this disjuncture is not individual but involves something larger, that is both local and part of a larger capitalist system/situation. Hence the urgent need to question those forms and genres, the nature of artistic and animated attractions and their limitations, to construct a dialogue and a community—a space where one might breathe a different air—to respond to the barrage of transnationally circulating arts and images of the age.

Works like Uno's *Toi et Moi* move and breathe slowly, remediating soft bodies, while in 1964 Tokyo the preparations for the Olympics proceeded with narratives of speed, cleanliness, and physical triumph. As we shall see, Uno evokes baroque allegory to create a tenuous (tentative) counternarrative to that cleanliness, breaking through that accelerated everyday within the frameworks of 1960s experimental animation. Emergent intermedial experiments of this period (not yet under the term *intermedia*, but already under the framework of exploding the boundaries of media forms and genres) could reframe ideas and theories of media and movement. Focusing on the work of Uno Akira (or Aquirax, as he wrote it) that was shown within the SAC animation series in 1964, I go on to look at the resonances of Uno's variant use of (so-called) animation in relation to the fleshly body, his drawing of lines on skin. Seemingly far from today's globalized production of anime, Uno's work nonetheless partakes in the experimental artistic milieu of the 1960s, whose sensibilities many of today's anime have oddly incorporated or from which they have drawn unexpected echoes.[28]

In 1964–65, the years that Uno Akira participated in Animēshon Sannin no kai (Three Animators' Group) screening, Uno was also involved with Terayama's Tenjō sajiki theater troupe; Yokoo's animations for the animation event included *Kiss Kiss Kiss*, in which he worked with paper collage, taking American comic-book kissing scenes and tearing them in layers to produce the montage of slow, halting movement (figure 2.2). What evokes touch in the latter work is not so much the lips on lips in the pop art–style picture but the invisible action of tearing and ripping of the paper of the comic to reveal an endless series of kisses, always with the emphatic speech bubbles saying, "Kiss! Kiss!" This short work was screened alongside Uno's *Toi et Moi* (*Omae to watashi*).

Other events included in the Contemporary Series of events at Sōgetsu Hall alongside Animēshon Sannin no kai included the jazz study and performance events of Etosetera to Jazz no kai (Jazz etcetera) and Jazz Eiga Jikkenshitsu (Jazz film workshop), cinema and music events that often involved collaborative and improvisatory works, like Takemitsu's *Quiet Design*, created to accompany Italian designer Bruno Munari's *Direct Projection*, or Norman MacLaren's animation *Short and Suite*, shown alongside new works by Wada Makoto or Imai Hisae (the lone woman filmmaker here among many men).[29] Early in 1960, animation was included among the other works, and Wada Makoto aimed to accomplish in animation what the other experiments in cinema in this series also sought to do: bring the improvisational and other aspects of jazz's "action/event" quality into cinema.[30] In *Dōga* (Children's pictures), Wada set the rhythm and theme in advance, but the musicians and he would not know what the others had made until their works "collided" at the moment of performance/screening. Composer Takemitsu Tōru, poet Tanikawa Shuntarō, and photographer (and sometime cinéaste) Hosoe Eikoh were also engaged in bringing jazz's quality as singular event into the medium of cinema, as well as combining improvised jazz performances with the screening of their works. By November 1960, however, the animation events had separated out as their own series, which would continue to run about annually until 1967 under various titles. In 1964 the series came to be called Animation Festival and solicited works from many artists, designers, and illustrators working in other media or realms, including Yokoo Tadanori, Tanaami Keiichi, Tezuka Osamu, and Uno Akira. Tanaami Keiichi's experiments in animation began here, and many of his short works and those of other animators were aired on the TV

program *Jūichi-ji* (Eleven o'clock) from the 1960s through the mid-1970s. Te-zuka Osamu's work was also highly popular on television around the same period. The relation between the advertising interlude and the short experimental film interlude—both with their episodic and sometimes experimental structures aimed at high visual impact—allow us to see these works (at least some of them) not as hermetic forms but as involved in an open-ended relation. They circulated between experimental art scenes (the experimental animation programs also traveled to major Japanese cities after Tokyo), and they participated in what broadcast TV distributed in the larger culture, where they form just one small part of a dominant, generative television structure that accepted them into the late-night (11 p.m.) dreamscape while still, overall, regulating and containing them within a specific, marginal part of the quotidian rhythms.

Yanagihara Ryōhei, one of the founders of the Sannin no kai, was famous for his design of the Suntory "Uncle Torys" character advertising Suntory whiskey in animated TV spots. In one ad, cowboys and Indians shoot at one another until Uncle Torys, as a friendly samurai, offers them both whiskey, does a little dance, and they drink together until they all turn red and find peace. Is this alcohol offered as an antidote to the overly stressful competitive atmosphere of burgeoning salaryman culture, figured in the genre of American-style frontier Western, with the Japanese Uncle Torys mediating? The animated interlude and the short experimental animated film share a certain structural similarity and viewing space, and they often use the same media. The other founders of Animēshon Sannin no kai were illustrator Kuri Yōji and Manabe Hiroshi. Kuri Yōji is well-known internationally for his animations, like *Aos* (1964), with the voice of Yōko Ono, discussed above; his works explore the use of sound, rhythm, and line, the deformations of corporeality, and the salivating, palpitating body. In *Heya/The Room*, Kuri uses the structural line to create a sense of three-dimensional space, but we might also note how the ball inside the room transforms into a piece of a body very quickly and then back again, evoking the stretching, morphing, "deathless" body that Eisenstein wrote of, the eternally springy body of the plastic cartoon line (figure 2.3). The image in that film of female fingers typing on male heads as typewriter keys is another site where commercial culture intervenes for parody, and the sudden appearance of a B-52 bomber brings in a helmeted figure that bounces the head like a ball. Though there are political overtones at play here, the structure is primarily one of fragmented episodes, experiments with line and movement in a way that we see Uno Akira's work take in a very different direction.

Yet before turning to Uno's slow work full of sprouting, transforming lines and water drops, we might also consider the participation of Tezuka Osamu's Mushi Pro in the SAC events, with works that are striking in their playful use of the medium in a more narrative, speedy, and humorous way. At this moment Mushi Pro was also producing popular TV films and, later, TV series like *Tetsuwan Atomu* (Astro boy) and *Ribon no kishi* (Princess knight). Tezuka's Mushi Pro contributed the experimental film *Memory* (1964), which opens with the lines, "Human beings are made to forget things. . . . Everything you see will eventually be forgotten" (figure 2.4). The light atmosphere combines with some interesting use of the sliding plane, photographic images cut out against limited motion. As the work progresses, we find some surprising reflections on animation's obsessive use of apocalyptic imaginings—all in the guise of transformations and reflections on memory. In the end of the short film, Tezuka makes fun of the elitism of high art and modernism, as some future extraterrestrials discover the toilet (in a play on Duchamp) as the highest and most holy achievement of humankind. Nothing is sacred here, except perhaps the visual play and narrative humor of animation itself.

By contrast to this fast-paced and absurdist silliness—shown in the same day and same screening—which uses line and planes in a somewhat more predictable way, Uno's work takes us into a more meditative and ethereal, though still quirkily idiosyncratic, realm. One of Uno's prominent recollections of the original screening of these works is that his date (*abekku*, his *avec*) walked out midway because, unlike Wada's parodic *Satsujin* / MURDER, Uno's work was not funny. Rather than creating an unserious atmosphere about serious subjects like love and war, as Tezuka's charming work does, Uno creates a rather serious atmosphere, a strange and fantastical atmosphere, around what would appear to be rather nonserious or obliquely eroticized subjects: horses, fish, and drops of water (reminiscent of various illustrated renditions of *Alice in Wonderland* circulating at the time). The sensibility moves toward excess, with a nod to melodrama, creating an odd space between the potential invocation of a camp aesthetic and what I am linking with baroque allegory, a very different playfulness from that of Tezuka and an alternate solicitation of the audience.[31]

To read what we might consider Uno's phenomenology of the fragment, here it could be helpful for a moment to dip into Benjamin's theories of allegorical painting in the baroque. For Benjamin, the fragment, magical transformation, and allegory are all linked: "That which lies here in ruins, the highly significant fragment, the remnant, is in fact the finest material in baroque creation. For it is common practice in the literature of the baroque to pile up

fragments ceaselessly, without any strict idea of a goal, and in the unremitting expectation of a miracle, to take the repetition of stereotypes for a process of intensification."[32] Uno works through delicate changes of scale and angle. His camera captures both the highly charged fragment and the rhythms of repetition and intensification. Though Uno's bodies are not in decay, as nature or beauty would be in Benjamin's baroque, Uno's corporeality is too slow, quirky and nonteleological for the atmosphere of Tokyo in the year of the Olympic games—it constructs an offbeat temporality, an off-rhythm quiet.

Like moments in the contemporaneous developments of butō and experimental theater, Uno's work is not afraid of "the repetition of stereotypes," even clichés, for the sake of such a "process of intensification." Still, for Uno, this intensification leads not so much to depth and strength but to an emphasis on surfaces, on a sheer closeness of attention—a potential squishiness, and even listlessness, that lingers on subtleties of texture. While for Tezuka in his Mushi Pro piece, *Shizuku* (The drop), a longed-for water drop readily transforms into a familiar and expected hallucination of the female figure, for Uno the teardrop beads up on skin in a shivering moment—more reminiscent of the incessant quivering of the animated medium itself in Kuri Yōji's tongue animations. In his writings, Uno highlights the (queer or at least nonuniform/misfit) sexualization of this water drop and shivering on skin; it both quotes emotional intensity, the animation of the reacting skin (sweat, or teardrop from an eye), and at the same time distances us from any content or emotion, leaving the viewer to sense mainly the water drop's tensile strength on the skin/screen's surface.[33]

Line and skin's surfaces become the main medium for Uno's reflection on love, exaggeration, and time; and these themes and forms bring us back to Benjamin's emblem and "irresistible decay."[34] The omnipresent *shōjo* (preadolescent girl figure) in Uno's illustrations—*shōjo* and horses, like the repeated subjects in the work of France's media celebrity Foujita Tsuguharu in the 1920s—could be thought of in today's anime theory terms as *moe* objects (of intensification) within the rhetorics of *kawaii*. But, following the poetic text by Paul Géraldy that flashes at times almost subliminally illegible on the screen between Uno's images, we have here a love poem about the vicissitudes of love itself as a kind of fetish image—distancing both the usual effects and sometimes heteronormative overtones of *moe*'s partial objects. Géraldy's is instead an excessive text about intoxication and indolence, about the rise of intensities and their inevitable fall: "But one gets drunk on words, one exaggerates the importance of it all, and then, one suddenly notices that the reality does not hold up. I beg you, let's leave my heart, let's leave your

heart."[35] The poem, which flashes by early on and then comes back to close *Toi et Moi*, explores the relation or lack of relation between the *you* and the *I*.[36] Reality may not be up to the exaggerations, the intoxications, the grandiloquent overstatements of language. "What you love," says another line of the text in a more familiar phrasing, "is not so much me but love itself."

If reality does not hold up to imagined feeling in Géraldy's poem, or if feeling itself is an effect of mediated tensile surfaces, Uno explores and explodes that potentiality of surfaces through his mobile yet static, captive ink drawings on skin in a way that gives unexpected access, in a different way than we have seen, to the intermediate, affective space between subjective and nonsubjective/materialized forms. The tension between the imprisoned, motionless figures he draws and the lithe, elastic substrate of skin on which he draws them can accommodate that affective scale of analysis/perception and play on it in new ways. Beyond any capacity for narration, the materiality of these lines on skin traces a process that hovers between an intrapsychic intensity and a tonal beyond, a third-person intimacy that partakes in a broader field of sexual genres and forms. In this way, without necessarily bringing it into language, the leaving of the hearts in the poem, the fleeting insight (*fui to ki ga tsuku/on s'aperçoit*) found in the cited poetic fragment takes place between the subjective and a more externalized touchstone of reality (*genjitsu/la réalité*) that is not sufficient, does not hold up (*sore hodo made de wa nai/n'est pas à la hauteur*). In this case, it is not the subject that fails as it is overwhelmed by totality beyond its bounds but the reality that disappoints, that fails. Thus, Uno's work invites a navigation across the first, here second, and third person of the tactile gaze, and he models that mode of framing through an emphasis on the materialities of line.

We have seen drawings on skin in this era: Jōnouchi Motoharu's short film *Gewaltopia Trailer* starts with the title written on an opening and closing eyelid; Nakanishi Natsuyuki paints a vulva on the back of Tamano Kōichi for a butō performance with Hijikata; Kara Jūrō's rose tattoo appears in the opening street scene of Ōshima's *Shinjuku dorobō nikki* (Diary of a Shinjuku thief).[37] But these calligraphics are mostly not tensile reflections on the animetic medium in relation to skin itself, like Uno's hand-drawn line then drawn back on the hand itself.[38] Even the lines of a made-up eye or black hair in *Toi et Moi* come to be seen so emphatically in their textural specificity, as lines and frames within the screen.

Uno emphasizes the tactility even of white paper, book paper, against cloth, against skin; the eye seeing/touching skin and the eyelid touching eyelid; the touch of the drawing hand that made this image, the touch of one hand on

another. His gradual metamorphoses challenge the solidity of the illusion of form; they press against the more structural line of the bouncing ball of Kuri Yōji's ping-ponging three-dimensional box in *Aos*, where the flexibility and spring may appear (at least at first) through the nonverbal vicissitudes of the voice. In Uno's work things change, but not so much by quick montage. They move slowly: one fish eats another; an imaginary woman is made to move by pulling the skin surface she is drawn on, by the breathing of the body she is drawn on; made to cry by the sprinkling of water drops over that skin (figure 2.5). The horse drawn on a leg raises its head with the (silly, yet moving) straightening of a knee, in an anti-Olympic softness of (strong, yet relaxed) muscle, and the evocative presence of the baroque organ music is not to be underestimated.

On his creative process, Uno writes:

In my pictures, fragments change their form [*henshin*, metamorphose] into various things. . . . When I want to make an illustration with a strong impact, for example, in the motif of a hand, first I open a true-to-life hand on the canvas of my mind and for a while I just gaze at it.

FIGURE 2.5 Still from Uno Akira, *Toi et Moi*, 1964. Drawing on skin.

When I do that, at some point, one finger becomes a butterfly, or a vein becomes the tail of an amphibian.

There is always the time while I wait for the change in the true-to-life thing inside myself, and at the moment the change takes form and floats up, I try to grasp it as if it were a living thing, so I can fix it on the white paper. The work is like that of a medium/spiritualist [*kōreijutsu*].[39]

Uno emphasizes the need for letting go of any story, or letting the non-story emerge, as it were, out of the movement of the line against the white page—the imagination already figured as a canvas. The hand is already an illustration (or an animation) in the mind, ready to transform even before he begins to draw. The movement from imagination to physical act as spirit evocation resonates (among others)[40] with Ohno Kazuo's rhetoric on his nonrepresentational dance practices and form. He cautions not to decide the form and then make the body follow, nor to follow the music directly; instead, he asks one to "wait for the spirit to appear and only then let the body follow," or not to move at all.[41] Today, on Uno's Twitter page, young people find a fascination precisely with this movement from imagination to material act. Over and over they watch videos of Uno drawing, watching the organic forms emerge onto paper out of his body, hand, pen, and imagination as if by magic, in a twenty-first-century refraction of the fascination with that liminal space between intrapsychic and material structures.

In Uno's films, the legacy of the jazz film improvisations meets the presence of sensual extravagance; while Moriyasu Toshihisa writes of Yokoo Tadanori in terms of (Benjamin's) baroque, Uno explicitly evokes the baroque in the music and the images he quotes.[42] We think of Benjamin's piling up of fragments without a goal, his "unremitting expectation of a miracle," as the intensification in this film meets the simple gaze: the eye of the young woman in profile, the eye of a horse drawn on skin, fragments and fish scales, and we imagine in advance the necessary sloughing off of these drawings and the future aging, decay, and disappearance of this all-too-smooth skin.

We watch the slow movement, the wiggling and the shiver of surfaces. Uno is not beyond sheer silliness: a man's arm bends—and it seems this is the arm of film director Higashi Yōichi, who is listed as appearing in and collaborating on the film—bringing a drawn gun on the forearm to point at a male head drawn on the biceps. A cat runs through a flip book at the corner of a page. Fingers with paper taped to them at one point dance a jig. The fragments pile on one another in a play of surfaces and scale (close-ups and fragments of the same image placed differently in the frame) that revises our perspective

on the transforming bodies in Kuri Yōji's animations, the faster and more rhythmic tic-tac of his body-like ball, his ball-like bodies. Having watched Uno, we see Tezuka's narratives of the water drop and animated atom-bomb memory a little differently, too, and even the Uncle Torys advertisements appear light, in an upbeat kind of way that reveals a darker, more idiosyncratic and contingent kind of lightness/play, a much heavier and even melancholic lightness here in Uno's work.

In his next animated work, *La Fête Blanche*, Uno explored the explicitly theatrical or performative sexuality as well as the skull-of-death figure from the baroque; and in *Don* (1965) he experiments with laterally moving planes, as odd, changing figures move by two open architectural windows that function as miniscreens.[43] In *Don*, Uno also experiments with figures in a chain of subjection: in a large drawing slowly revealed part by part through the lateral motion of the camera, we see a lion girl on a chain held by a little girl on a plate, but the little girl's hair is in a huge fork, and the fork is in a hand of a figure that also spears a lizard. This is a kind of visual *kakekotoba* (pivot-word/pivot-image) of capture that echoes Uno's own words about the "spearing" or chaining down of his "living" imaginings on paper while hinting at more liminal intrapsychic realms. We hear the words of Géraldy: "One can become intoxicated with words [and images]," as Uncle Torys' whisky fuels the avant-garde. Here we again sense a tipsy slowness, a stretch and pull like the elasticity of skin in the animation and illustration line itself.

The violent spring of Disney's undying cartoon body is absent here; in its place is an unfolding and distending of time. Uno Akira's experiments are thus of a piece with the antilinear experiments going on in both animation and other arts at this time, but they take things in their own direction. These works of animation perform an exploration of the borders between (solid) form and (plastic) stretch, with a quietly unfolding drama of tensile surfaces. Uno's works thus make us reflect again on the networks and lines of connection, elasticities, and reverberations among the intermedia spaces (and illustrated surfaces) of 1960s experimental arts, and the contingent intensities also expressed, in other ways, by the experiments with infrastructure.

By contrast with the big avant-gardes leading to Expo '70 in the later years of the 1960s, with their corporate worlds, in the early '60s we encounter the smaller avant-gardes of these animated fragments, the most innovative of them not framing an overt politics, yet opening political subjectivities in pointedly affective ways alongside the more explicit political polemics of auteurs like Ōshima and others who participated in the Art Theater Guild. Larger discourses of intermedia frame broader technological and infrastructural

inquiries, beyond any individual's grasp, while flashing back to these earlier and more liminal spaces of intermediality, themselves traversing corporate structures and mediated temporalities (like the TV show *Jūichi-ji*) as they, in part, participate in generating the characteristically quirky visual mass culture of the period. With Uno we find a particularly generative space to explore minor affects and unexpected quivers, plasmatic intersections of body and line.

It is useful to pause for a moment to ask why animation becomes the site of such a discourse of potentiality, why the elasticity of animation's lines, and its sheer plasticity, evoke for an analytics of media theory a hope for a parallel, if bounded, elasticity of cultural forms and norms. Rather than the rhetoric of fissures and cracks in what is imagined or figured as a hard and rigid wall, system, or infrastructure of the sociocultural sphere, animation makes us want to pull out images of stretching, overturning, somersaulting, leaping—images that can excite us with hopes of transformation. In place of a vision of rigidity—linked to economic hierarchies, governmental policies, unbending formal and symbolic worlds and codes—animation seems to offer an alternative, tactile potentiality. Not that in normal times, normative genres don't contain and bring with them a "good deal of wobble" and in that sense often fail at the points where they are expected to hold or contain amorphous experience.[44] But in this instance, the specific affective intensities of animation partake not of the crack or fault line in a rigid system, nor even the wobble between set categories, but of the magical, supernatural stretch.

Rhetorics of flexibility, adaptability, and reformability, however, with their positive valence as aspects of the post-Fordist information worker in the global system—transnationality, mobility, the infinitely malleable—have led us to be suspicious of any revolutionary potential that used to be attributed to the merely plasmatic/elastic capacity of the stretch/flex/adapt. In spite of what Eisenstein wrote on the matter, we cannot automatically go utopian anytime something gets visually bent out of shape. We have seen how stretch could be used at times to abet hegemonic power. Nonetheless, delving back into these early 1960s moments of animetic experimentation allows a case study of a moment when the plasmatic line seemed to work at the affective interstice to afford a promising aesthetic potentiality prefiguring, in a different mode, the larger project proffered by intermedial experiments. As another handhold in the field of limning the boundary between subjective/intrapsychic processes, corporeal movements, and material objects, these animations of the early to mid-1960s at SAC offer one key space that can lead us toward our exploration of theoretical debates around the political potentialities of media—as well as affording some historical perspectives on the theories

of manga/animation (the ambivalent politics of *moe*, *kawaii*, the database) circulating so widely today.

In the later 1960s, the well-known director Ōshima Nagisa put forward a view of revolution that also evoked the potentialities of the animated line in a very different dramatic mode from Uno's evocative baroque quivers. Ōshima's *Night and Fog in Japan* (1960) took up the subjects of the student organizations and political movements directly, and consequently was censored and pulled after four nights of screenings; yet that work frames those protests themselves as a recursive and cyclical movement, one in which some characters look back to the "real" revolutionary spirit in the earlier moments of protest (1952). Even and already in 1960, the remembered heyday of student protests, Ōshima's depiction of these tense times shows them already infused with a sense of loss and disorientation. A few years later, still against the backdrop of the student protest movements, Ōshima's ongoing works evoke a power politics that differs quite strikingly in emphasis and form from what we saw in Matsumoto's (perhaps deeper, or more indirect) reflections on medium and mediation, and from Nakahira's equally trenchant but more embedded practices of photographic critique. Ōshima's remediation of the long-format comic *Ninja bugeichō* in the heyday of Art Theater Guild's productions centers on the themes of violence and revolution while also innovating a different kind of potentiality that it launches through the unexpected movement of its animetic forms.

Violence and Cinematic Revolution (Ōshima Nagisa's *Ninja bugeichō*, 1967)

Ōshima's film, distributed by Art Theater Guild and first shown in its flagship Art Theater Shinjuku Bunka in Tokyo, entered a milieu where the student and other left-wing protest coalitions were gaining new and significant force: various fragmented left-wing factions of the student movement had united in opposition to the Communist Party–affiliated groups the year before, and later in the same year the militant Haneda struggles against Japan's collaborative participation in the Vietnam War would bring new violent tactics and mass media attention to these radical struggles.[45] The question of revolutionary violence was rarely far from younger activists' minds; many raised questions of violence in relation to Japan's economic growth, the security treaty, and Japan's support role in the Vietnam War, yet they wondered what kind of violent tactics would be productive, and how intensely to mobilize *jitsuryoku soshi* (obstruction by direct force). The German term for power,

Gewalt, came into usage to mark or imagine a violence that would differ from the repressive powers of the police and governing institutional forces. Ōshima had long explored corporeal and sexual violence in cinema in relation to social revolution, from his *Nihon no yoru to kiri* (*Night and Fog in Japan*, 1960)—which most explicitly evoked debates and factional politics in the student movements—through 1970's *Tokyo sensō sengo hiwa* (*The Man Who Left His Will on Film*), about which he wrote that he was trying to discover in that film "whether one can engage in terror against oneself" (*mizukara no teroru suru koto ga dekiru ka*), in relation to the Red Army Faction's so-called Tokyo War.[46]

Ninja bugeichō, the 1967 direct adaptation of Shirato Sanpei's hit *gekiga*, which appeared in seventeen volumes from 1959 to 1962, played for a long run at Shinjuku Bunka Theater under the genre title *Chōhen firumu gekiga* (feature-length film *gekiga*). Ōshima's film functions well within its commercial milieu; for example, he uses recognizable star voices, such as Tōra Rokko for the savior figure of Kagemaru, who had also starred in *Night and Fog in Japan* and in TV dramas, with music composed by the well-known Hayashi Hikaru.[47] By using Shirato's (and his rarely mentioned shadow coartist on this work, his younger sister Okamoto Satsuko's) drawings as is, without making the drawings move in the conventional animated sense, Ōshima makes the film materially possible in terms of costs. Yuriko Furuhata has written about the film's place in a discourse that holds to cinema's specificity while also marking cinema's loss of its privileged place (cinema's crisis) within the broader realm of image-based media such as television. The film performs an appealing condensation of a must-know *gekiga* precisely on the subject of revolution, a revolution of the sixteenth century (1570s, Eiroku era) that mapped in an interesting way onto contemporary theories and media representations of violent uprisings. It evoked the interest of those engaged in contemporary student protests, antiwar movements, and critiques of high-growth capitalism.

This is both a popular work on the one hand—Ōshima wanted to reach as wide an audience as possible—and an avant-garde or experimental work. Speaking about violence and revolution, the work shows its awareness that perceptions of violence in this historical moment are conditioned by the forms and consumption practices of image-based media, including manga, cinema, and television. Long and epic, the film can feel overwhelming at 131 minutes, though contemporary audiences could follow the plot more easily because of their familiarity with the original manga. Shōchiku offered to distribute it only if Ōshima made significant cuts; ultimately, only Art Theater

Guild and Shinjuku Bunka Theater's director Kusui Kinshirō supported the work in its rapid-fire, visually overloading form. Ōshima had come upon the structure of using stills with voice-over and sound effects in *Yunbogi no nikki* (*Diary of Yunbogi*) two years before, following works such as Matsumoto Toshio's *Ishi no uta* (*The Song of Stone*, 1963); yet the narrative and visual overload of this film far exceeds the more bounded ambitions of these prior works. The script of *Ninja bugeichō* was published in the leading film journal *Eiga hihyō* (Film criticism) in the same issue with Chris Marker's *La Jettée* (1962), another film that had inspired Ōshima with its structure of filming still images. While the work highlights its status as an experiment, and reflects on visual temporality and memory like Marker's, it also thematizes the problem of reaching a wide audience: complicity with capital, reaching the masses, and, more significantly for its political reflections, what kind of leadership is necessary for a popular revolution to be truly popular. Matsumoto Toshio criticized Ōshima in their famous 1968 debates for being too interested in drawing in a large audience and continuing to work with the distribution networks of the large studios to gain a broad viewership. Matsumoto argued that cinema could not be fundamentally transformed from within its existing structures. But in *Ninja bugeichō*, clearly Ōshima's stance on this issue is not fully one-sided: the problem of the relationship to the public remains an open question.

While *Ninja bugeichō* and Walter Benjamin's 1921 "Critique of Violence" participate in two very different historical horizons of the theorization of violence, they have something structurally in common: both envision or imagine an "other form" of violence that would interrupt the naturalized continuities of time and would challenge the current orders of law and state power. Both interrupt a temporal horizon, layering and challenging the perspectives of linear historiography with an altered trajectory of time; but in Ōshima's case, this vision of a violent disturbance to the current order of law is performed through a literal movement of lines, the curving and curling, crossing and swirling of Shirato Sanpei and his sister's drawings, which Ōshima films directly into a rapid-fire and extended montage.

Benjamin's ideas of violence, though obscure, were already present in the philosophical apparatus of late 1960s–early '70s Japan. Iconically, in Higashi Yōichi's slightly later film *Yasashī nipponjin* (Gentle Japanese, 1971), a politically engaged character working at a motorcycle repair shop reads out an excerpt from Benjamin's "Critique of Violence," while another character says bluntly that he has no idea what it means, no idea what such philosophical discourse has to do with the day-to-day reality of the political struggle at

hand.[48] The position Ōshima takes in his writings on this film draws in both poles of their debate: he argues that the "spirit of revolution" (political struggle) and the "spirit of experimentation" (philosophically, and formally, in relation to the medium) are both crucial to the "leap" that is *Ninja bugeichō*, a leap he asserts—in a rhetoric that in many ways parallels the discourses of Matsumoto (and Nakahira)—is necessary to challenge commonsense frames of cinema and social forms more broadly.[49]

In the essay "Critique of Violence," Benjamin defines a contrast between lawmaking (mythic) and law-destroying (divine) violence: "If mythic violence is lawmaking, divine violence is law-destroying; if the former sets boundaries, the latter boundlessly destroys them. If mythic violence brings at once guilt and retribution, divine power only expiates; if the former threatens, the latter strikes; if the former is bloody, the latter is lethal without spilling blood."[50] On the surface, the image of a bloodless violence—like the classic character of Wile E. Coyote who falls and falls but never dies—would appear to be fully aligned with animation's plasticity. So-called divine violence, which for Benjamin is a saving form of violence, "destroys boundaries" and, as such, moves edges, switches the lines around, changes fixed frames and perspectives. In Ōshima's writings on this film, it is true that he is boundlessly interested in blood, "how people shed blood in order to change situations (*jōkyō*), and how history is moved by that blood."[51] Yet the blood thematized here is a form of line—a line drawn in black on a white background, then filmed—in a structure of perception as well as narrative arc that generates a perpetual, nonfinal, endlessly successive subjectivity of revolution.[52] In other words, what is important in *Ninja bugeichō* is not so much the individual death, the individual's blood, as the continual revival of what the film and original manga series envision as the energy and power of revolution from one generation and historical moment to another: a violence not bounded but boundless, and in that sense aligned with Benjamin's "other" (which he calls divine) form of violence.

Kagemaru, the hero of *Ninja bugeichō*, represents a force of violence outside the law, like that which Benjamin theorizes. For Benjamin, it is "pure, immediate violence," and he describes this "highest manifestation of unalloyed violence" to have been proved to be possible, but Benjamin writes that it is nonetheless difficult to determine exactly when or whether this more "pure" form of violence has been realized "in particular cases" in the real world.[53] For Benjamin, though he is also interested in the possibilities of nonviolence, there is an interruption or breach, a caesura that he calls *Gewalt* (a term that also means *power*) that would be law-destroying, breaking the

naturalized continuity of time and fate. Rather than "mythic violence," which for Benjamin constitutes a pernicious equivalent of lawmaking and the semi-invisible law-sustaining violence, this other kind of somewhat messianic violence is a saving violence associated with life and with happiness (and in Ōshima's film, that messianic force takes the name and form of the saving figure of the character Kagemaru). Benjamin calls it "pure power over all life for the sake of the living."[54] Though many scholars have commented on Benjamin's provocative declaration about the fundamentally brutal under-pinnings of state military and legal sovereignty, in looking at the horizon of 1960s Japanese film, the so-called divine violence side of his formulation be-comes most relevant. Activists and those interested in revolution during the 1960s were also interested in visualizing a kind of violence of revolution that would have a saving power and in creating the conditions of possibility—a kind of potentiality—for challenging that other more pernicious kind of violence. For these reasons, several cultural commentators (Terayama Shūji, Akasegawa Genpei) had already openly associated the figure of Shirato's Kagemaru in the original manga with the student movements, as Abe Kashō points out, and Ōshima's film formed a key and popularizing impetus in that lineage. That said, the place of the activist is complicated in Benjamin's ar-ticulation by the assertion that it is not possible from a human perspective to know for certain when this saving violence of *Gewalt* has in fact been re-alized in particular instances. This may be because there is no human posi-tion fully outside the law; or, in any case, for Benjamin even to imagine such a position requires the invocation of the divine or the "soul of the living."[55] A parallel complexity shows itself in the specific actions of Kagemaru and the swordspeople's and ninjas' shifting alliances.

The narrator of Ōshima's film asks over and over about the film's hero, Kagemaru, "What are you?" In the opening of the film, the hero supports and provokes the rebelling peasants as they attack Fushikage castle, but he also does not hesitate to save the life of Sakagami Shuzen, the resident lord, giving him a horse to escape the peasants' attack. His *Gewalt* (power/violence) and provocation have an enigmatic and anonymous quality, com-ing from the terrain of the beyond, where we can no longer judge in simple moralistic terms of good and evil.

In one utopian moment, when the young swordsman Jūtarō (son of the murdered overlord, rightful inheritor of the castle) interrogates Kagemaru about his seemingly fruitless fight, Kagemaru replies, "People believe I am manipulating the peasants, but if they don't have me, someone like me will come into being. . . . Even if I die, someone will follow." Kagemaru's battle

cry describes a continual violence, an unending struggle of revolution whose agency is ultimately located outside himself. Throughout the film he is both a catalyst of peasant revolts against power and a mysterious figure with unpredictable allegiances. He also never seems to die. His undeath is perfectly suited to the still drawings with voice-over form of the work, in a way that lifts this aspect to our attention as a reflection on the structure of animation itself, its deathless bodies. Like Benjamin, Kagemaru (in the low, resonantly booming voice of Tōra Rokko) invokes "happiness": "Even if they are torn or ragged, people will aim for their goal. . . . Until the day comes when the majority of people are equal and happy, they will keep fighting." Ōshima echoes Kagemaru's utopian closing statement in his writings on the film as if it were also his own motto in making the work.

Like Benjamin's idea of immediate, unalloyed violence in its highest manifestation, the character Kagemaru describes an unending but violent struggle that is posited as a saving form of violence. Is this a cruel optimism, a cruel and ultimately crushing utopia? Even while the film ends with almost all the characters dead, it is presumed that the few who live on, or the spirit they carry, will be revived in a later historical moment. Death is contingent here, and at least sometimes bloodless; and the emergent violence is undergirded with histories of loss and grieving. Kagemaru's (and elsewhere his teacher Muhū Dōjin's) refusal to die and refusal to rot emblematize this bloodless loss, the living on beyond death, the spiritual survival of the fight for a more just world. Whether framed in terms of plasticity or remediation, this survival finds ways formally to extend and interrupt the terminality of the moment and the horizon of singular perspective within a space of surprise.

In a key scene, Muhū Dōjin brings Kagemaru's head to the powerful lord Oda Nobunaga, who has to pay Muhū Dōjin five thousand gold sticks for it. Still, the detached head speaks, and after its arrival (without the body) Nobunaga throws one more sword at it, to no effect. The smiling head laughs (figure 2.6); and in the end it does not rot but just disappears mysteriously from the gate where it is hung.[56] Questions of the medium come to the fore in the structural choices: the abrupt cuts, sometimes called aspect-to-aspect or affective transitions, reveal the *gekiga*/cinema interface. Is it the spirit of peasant revolt as mapped onto antiwar protests, the spirit of violent rebellion that will not die? If so, the structure of this interruptive power is one that embraces both (law-destroying) caesura and (revolutionary) continuity. If in chapter 1 we saw the affective scale at work in a maneuvering between the subjective and larger systems in a relatively constrained temporal frame, here, as in this book more broadly, that navigation works in a way that draws

FIGURE 2.6 The severed head of Kagemaru laughs. From Ōshima Nagisa's *Ninja bugeichō*, 1967.

parallels across the structures of feeling of a broader historical horizon. That wider time frame and the intermedial/remediated form open an additional perspective on the workings of the affective scale that traverses micro- and macro-systems, and that generates relays between and among them across time. That would be an addition to or a reframing of our analytic model made visible by Ōshima's works, as well as perhaps by Uno's through its Benjaminian invocation of the baroque.

Ōshima finds that Shirato's *gekiga* has been seen as "nearly impossible" to adapt for the screen, except by the method he arrives at, of using the drawings as "material," "as they are."[57] A hit TV show of the same year, *Naite tamaru ka: Manga jinsei* (Crying, can you stand it: A manga life, March 1967) also uses live action mixed with drawn stills to show ninja magic. In Ōshima, generic expectations of the ninja genre and epic ninja genre music on the one hand make possible the consumption of this story, with its gorgeous reflections on the relations between *gekiga* and cinema, the deep intertwining of these media, and its exploration of the graphic force of both the moving and still image in a kind of unlayered, hyperlimited animation. (If limited animation in television involves the reuse of the same cells or moving one drawing against

a fixed background to save labor, the hyperlimited would be the use without intervening drawings of the original manga, photographed in high-key lighting against Ōshima's living room wall.) The incitement to the "right kind" of violence here collides with, traverses, and complicates issues of commodification (with its phantasms) and/or spectacularization. The force of the moving image is partly directed/redirected into the interests of consumption, issues thematized in this work when the magic of ninja techniques becomes an allegory for cinema's magic. Yet the film asks the question: for whose benefit is this magic, are these techniques? The thrill of watching the ninjas' magic fighting is mobilized (and also immobilized) as a mode of cinematic pleasure and through that, collectively and individually, as a call to revive revolutionary energy.

Through the doubling and multiplication of identities and false faces or heads, the film questions what the real identity and goals of the savior figure are, and what would be or how to determine the right direction for this vital revolutionary energy. What form of violence, breach, or rupture is the saving kind? Is it possible from a human perspective, an agentic perspective—or even the spectatorial perspective—to stand even for a provisional, imaginative moment outside the law, outside these power structures that at the very least constitute the conditions for, if not perniciously suppress, revolutionary hopes for historical change? How can one distinguish the saving kind of violence? What is the law of perspective, what mode of vision beyond the linear would make it possible to envision this suspension, or freeze-frame, or shifting beyond known perspectives (into the virtual/future constructed out of remediations/residues of the past)?

Affective identification with the characters and visual regimes is continually interrupted, one might say forcibly, by the constant cutting, lateral movement of the camera, and the excessive epic complexity—with the sheer number of characters, the sometimes shaky camera, and the rapid-fire montage of these drawn image materials "as they are." There is some degree of visual violence here: treading a fine line—allowing or tempting entry and then, by continual switching, exceeding the boundaries of one's grasp. Even the celebrity system comes up for thematization, with the crowd's *ah*s and *oh*s at Kagemaru's appearance.

Returning to Benjamin's kinds of violence, then, we recall how Japanese student movements used the term *Gewalt* to distinguish their forms of violence from repressive police violence—for example, with their *geba-bō* sticks, named for the German term. Viewers and critics sometimes (and rightly) think of Ōshima as idealizing or even romanticizing violence, as a means

of revolution—without regard for gender constraints, which his vision often leaves unquestioned or even pushes further into a masculinist frame—that is, as an imagined way outside the frames of the social, as opposed to Matsumoto's critiques of subjectivity "always already embedded in capital." But this work reminds us that in this moment of crisis for cinema as a whole—when television and other media seem to be taking over the central place that cinema held for artistic production and popular culture—and at this moment of rising power but also some confusion about the directionality of the student movements, Ōshima formulates a critique very much enmeshed in questions of capital, power struggles, problems of violence, and (capitalist, cinematic/spiritual, and technological) reproducibility. Through this one-time technical exploration and adventure, he participates in a larger milieu of animetic experiments that foreground key questions of violence allegorically, thematically, and formally.

Some aspects of the belief in violent revolution were already being critiqued by factions of the student and radical political movements in the very moment others were formulating them. In 1969, Sunada Ichirō found that the factions' distinct forms of leftist thought and their views on violence could best be distinguished from one another less by their stated beliefs or tenets and more by what he calls their "ideo-affective" stances.[58] Specifically, then, Ōshima's work performs that intermediate space in the ideo-affective stance of certain New Left student radicals, which encourages radical individual autonomy and flexible alliances while aiming forms of violence at dominating power through the work of a collective. Such a stance envisions that their tactics and strategies may live on beyond the individual or group of the moment. The aspiration toward violent revolution may seem naive or dangerously co-optable in the present moment (or any time after the early 1970s). Still, this work raises many questions relevant for considerations of intermedia in relation to anime and manga, and for studies of more recent animation. Animation in the 1960s and its variations, which feed directly into more contemporary representations of violence in animation and limited animation forms, here reveal and reflect in their complicities and critiques of the orders of late-capitalist culture a position parallel to the large intermedia events discussed in chapter 1. Yet, beyond that revealing reflection, the work tests out and experiments with modes of framing the potential horizons for an intervention, thinking through and modeling practical or tacit modes of working, practicing, and galvanizing movement in the face of such an overarching situation. When we understand the historical stakes in conjunction with the visual horizons for imagining the meanings of violence and

revolution, we can see how these works operate at the affective scale, that is, in this case, theorizing an altered and deepened view of the relation between experimentality and commercialism, between representational violence and globalized media networks, as well as between transmedial practices and varying kinds of violent social forms.

Already in the early 1960s, the force of animation's moving image, and animation's specific uses of perspective, were catalyzing reflective (and in Ōshima's terms, revolutionary) thought, while forwarding the production, circulation, and consumption of media itself. Recent thinking on animation has continued to try to understand how limited animation's critical and generative potential comes to flow (or get redirected) into channels of flatness (sometimes linked to market globalization). Yet problems crucial to understanding this set of inquiries are already seen here in an intricate way, so intimately a part of the struggle Ōshima and his collaborators open through the film *Ninja bugeichō*.

Moving the Horizon

Like all *gekiga* of this time, Shirato Sanpei's manga is already cinematic. The structure of its framing follows and is inspired by film editing; as in Tezuka Osamu's works, which also inspired Shirato's art, this is a crucial part of the form that allows them to open out and spin long stories for volumes upon volumes. In this sense, *gekiga* is already an intermedial medium. Now that cinema studies focuses increasingly on new media, frequently alluding to or debating questions of the end of cinema and the mobility of platforms, we see a structurally parallel set of discourses animating the earlier theorizations of intermedia and the kinds of experiments being performed across media.[59]

Writer, director, and manga critic Takatori Ei claims that Shirato's *gekiga* was in some sense an underground work. Takatori writes that though Shirato at the time was publishing his serial stories in *Shōnen* (Boys) magazine and was a successful manga artist, *Ninja bugeichō* was published as a *kashihon gekiga*, which meant that it was not sold in bookstores. To read it, one had to go to rental book shops (*kashihonya*) located in small alleys. While the *gekiga* series was published from 1959 to 1962 in seventeen volumes and was a big hit, "no adolescent magazine that existed at the time would publish *Ninja bugeichō*."[60] Ōshima writes that he read Shirato's work at the suggestion of Sasaki Mamoru, Abe Susumu, and Sano Mitsuo in the fall of 1962; Sasaki later wrote the screenplay.[61] Ōshima claims that it was he who decided to cinematize Shirato's work "as it is," using the original drawings Shirato and his sister made:

The original drawings were 1.2 times as large as the published *kashi-honya* (rental book) version, which is not very large. We shot these drawings with a close-up lens called Macro Kilar. The original drawings had some dirty spots and grids on them, so we lit them with a very bold light and used Eastman Plus X film to emphasize whiteness. In the book version, besides black and white there were grey parts called *hosome* (shading) that are not on the original drawing but are put in during printing, so here, without those, the black and white are accentuated even more.[62]

When one looks at the lines and shapes of Shirato's original drawings, they are already full of movement in the curves and lines of the landscape and figures. When we study Ōshima's film frames, what is striking is both the immense flatness of using a drawing—like the visions of Resnais' *Guernica* (1950) made famous in Japanese film theory by Matsumoto Toshio—and at the same time the gentle sense of depth and shadow introduced by those gray lines, grids, and erasures on the original drawing, which Ōshima's overexposure almost but not completely effaces (figures 2.7 and 2.8).[63] Is this the moment of moral ambiguity, the layers of history of the image reminding us of the imperfect distinctions of black and white, of shadow and layers of gray?

The Kage (shadow) clan are at the center of the story, a band of ninja mostly not related by blood but styled as a family. They come to their warrior arts through a history of devastation, sorrow, and loss during times of war. The image's layers might recall for today's viewers William Kentridge's drawn films on South African apartheid, where the previous layers of the drawing remain visible under erasure, as a link to loss and a visualization of its potential generativity.[64] The underlayers of the drawings by Shirato and his sister give a sense of temporal strata in a story that is very much about the superimposition of historical moments. This layering takes place on several levels. First, as I have noted, the time of the student protest movements of the late 1960s is paralleled with the sixteenth-century peasant revolts against the aristocracy; but beyond this, within the extremely recursive drama itself, one sees the continual reappearance (and disappearance) of Kagemaru as he provokes yet one more round of revolt and rebellion for the oppressed.

Further yet, the Kage family's layers of identity work such that each is a *bunshin*, a potential substitute, for the others.[65] They are not just contractually linked, for, as Ōshima says, being merely "unionized" or organized does not suffice; they are intimately linked not just as a family but as alter egos for one another. And last, among the characters, it is not always clear who is who.

FIGURES 2.7 and 2.8 Lines of landscape in Shirato's drawings, from the opening scenes of Ōshima Nagisa's *Ninja bugeichō*, 1967.

Clearly, the making of the *gekiga* itself involved thousands of replicated drawings, hundreds of each character, but at times, within the narrative, the plot turns on the fact that identical characters are indistinguishable from one another. This element comes to prominence especially around moments of beheading—of determining who is killed or not. The character Onikichi, when beheaded, splits into eight identical copies of himself, and he asks his son to help him find his real head. At one point, Onikichi peels off his face and reveals Kagemaru underneath (figures 2.9–2.12). The shadow, the replication, the layers all thematize the layered quality of time itself: how the very idea of revolution and its formal process, the "spirit of the will of the people" as Ōshima idealistically puts it, is infused with shadow—or in this case, one might also say the echo—and the voices and images of the people that come before.[66]

One might draw a link to the distributions of the sensible theorized more recently in writings on the coming into visibility or audibility of a particular world of phenomena that would be otherwise imperceptible—as linked to the *quelconque*, the anonymous. Kagemaru masquerades as a figure of centrality yet at his base he is an icon, holding the iconicity of animated figures' plastic lines and the plasticity or replaceability of that icon. On the one hand, Kagemaru has a distinct and recognizable, even beautiful, face; his is a divine or ideal figure, and his smile embodies hope. Ōshima said he wanted to make an "ideal immortal, ideal figure."[67] On the other hand, he holds a certain anonymous quality, a quality of the *quelconque* (the "any whatsoever"). In his inimitable voice, he paradoxically declares his dispensability, his ultimate

FIGURES 2.9–2.12 *Top left*, Onikichi splits into identical copies. *Top right*, Onikichi beheaded—his son's surprise as Onikichi asks the son to look for his head. *Bottom left*, Onikichi removes his face to reveal . . . Kagemaru underneath, *bottom right*. From Ōshima Nagisa's *Ninja bugeichō*, 1967.

anonymity: "If I were not here, someone would always come in my place." Ōshima puts it this way: "Kagemaru does not symbolize a self-proclaimed revolutionary party or a group. He symbolizes the will and the power of the people who aim for change."[68] In the logic of the narrative, Kagemaru can show up at any time, at any place. His shadow lurks under every line. His life lurks under every shape. Ninja magic and heroic inspiration are inherently possible at every moment of devastating loss, as a new life that can spring up and become part of the power of the shadow, the shadow that moves the horizon line of power, that overturns the hierarchies of class and time.

Ōshima elaborates his view of the political aims of the *gekiga* and film: "The [Kage family's] strange ways of fighting are acquired in the course of the struggles of an alienated and excluded life. These are the 'weapons' of life. They become arms for the struggle against the enemy in a class battle. Has there yet been a work that grasps the link between the life of the oppressed class and their struggle so clearly? Has there yet been a work that captured in such decisive images what arms are for the oppressed classes?"[69]

What happens when one takes these images and combines them into a film? Ōshima alludes to Eisensteinian montage as yet one more layer.[70] While the editing is extravagant in some ways, otherwise Ōshima severely limits his options, using cuts, pans, tilts, and close-ups with voice-over, sound, and music only with a direct appropriation of Shirato's original drawings. Abe Kashō calls the feeling of the editing "gasping breath," an "absence of margins," and points out that Ōshima may be influenced by the work of Masumura Yasuzō and Nakahira Kō, creating a sense of speed. Ōshima explicitly experiments with overturning the expected rhythms of cuts in live-action films. The effect of the editing in *Ninja bugeichō* is one of intense density. After completing the film, while recovering in the hospital, Ōshima wrote the following note: "Edit based on the rhythm of the images themselves. . . . All current films are based on dialogue. Destroy this," meaning, destroy the dependence on dialogue for editing's rhythm in favor of following the flow of the image.[71]

This rhythm has intimately to do not only with shot duration, but also with the movement within images and hence with the structures of visual form within individual frames. A moment in the film that sums up this perspectival shift is the scene of *jibashiri* (literally, "running earth"), when a violent conflict between characters is arrested by an inexplicable wave, something coming from the distance, that turns out to be an unstoppable swarm of (lemming-like) mice, devastating everything in their wake until they reach the sea (figures 2.13–2.15). The drawings show the skeletons they have picked over as they flatten the landscape. The lines of their approach shake as the camera shakes. "It is as if the horizon were moving," intones the deep voice of the narrator. The *jibashiri* sequence carries an allegory for the masses of starving peasants and children we have seen rise up behind or under Kagemaru's subtle provocation to try to defeat and lay waste to oppressive regimes. But what is most striking in this scene is the quality of the line, the shaking horizon, the sense that the film itself might come undone at any moment. It is the *n*th degree of movement: the already vibrant and plastic movement of Shirato's *gekiga*, itself an echo of the crosscuts and motion forms of live-action cinema, now cited back into a series of rapid-fire montages, camera stills, and

FIGURE 2.13 The horizon moves—

FIGURE 2.14 It is a swarm of mice approaching.

FIGURE 2.15 Close-up of swarms of mice. From Ōshima Nagisa's *Ninja bugeichō*, 1967.

movement, visualizing a kind of insurgence (*ran*, 乱) of social forces almost as if they were (the ghostly echo of) the forces of nature, and also, an insurgence, a saving violence, of the cinematic realm itself.

One might hesitate to be too optimistic. People went to Shinjuku Bunka late at night and they came home. Perhaps they came home even more enamored of their favorite stars and composers, even more ready to participate in the commercial culture of their time, even more ready to watch more movies. The flatness of the landscapes of this film, along with their motion, point the way for Ōshima's participation in the landscape theory debates with his film *Tokyo sensō sengo hiwa* (1970). By the 1970s, he had come to recognize that it was no longer a question of shedding blood: "In spite of the promise that each sect would fight with the determination to die, no one

died. The battle of the 1960s came to an end. How can I die [in] the 1970s?"[72] The understandings of violence and the explorations did not end, but they did shift in form as the (long) 1960s closed. The belief in a saving form of violence, the force of that belief and its visual and rhetorical discourses, was redirected—without exactly being lost—into other horizons of movement. Some of these movements had to do with critiques of sexuality—as we see the movement of beheading and refusal to die shift to encompass a critique of race/ethnic discrimination and sexuality in works like Ōshima's *Kōshikei* (*Death by Hanging*, 1970), in which the character who refuses to die is alternately identified and erotically entwined with the figure of his Korean sister.

The 1970 Anpo generation, the generation of student and radical protesters who opposed the re-signing of the Japan-US Security Treaty in 1970, nonetheless took one of Kagemaru's lines as a slogan for their struggle, a slogan that can itself crystallize the repetitive motion involved in pushing back the horizon of a political movement that has already been (and already, according to many, failed): "We have come a long way; and we have a long way to go."[73] Abe calls this citational structure, the repetition inside the slogan and the reiteration of the slogan itself, a form for the "infinite succession of the revolutionary subject."[74] And yet, it should not be an infinite repetition without difference: the movement of lines and faces, the layers of shadow filmed by Ōshima in Shirato's images show that the shadow of what came before lingers within or alongside the force of each new round of motion, each fresh and intimately present line—like Shirato's sister's hand alongside his more famous one, like the tracing paper they each must have used to trace the lines and ninja arts/techniques of the other. And then, like Benjamin says, an uncertainty remains: it is not possible to ascertain whether that kind of "pure violence" has been attained in an individual case, or in Ōshima's questioning terms, "For an age of change to move in a direction that can truly serve the people's happiness, what must we do?"[75] While it experiments with specific techniques of pure, hyperlimited animation, Ōshima's *Ninja bugeichō* is also a film that draws together, in exemplary ways for its era, how the problems of cultural transformations of thought ally with a horizon of linear movement framed and reframed on the boundaries of media.

Though its overall effect may exhaust, our minds can nonetheless hold, however briefly, these constellations or specific moments, freeze-frames when, already ejected from Cartesian perspectivism, we can synthesize an alternative visual horizon with the actively changing social process that Shirato and Ōshima put forward in this foundational work. Beyond the capacity or point of view of a single mind, we may be able to envision or imagine its

expiating and boundary-destroying path, its proposal of an animetic violence that could possibly be productive, lethal without spilling blood.

Shirato and Ōshima's expiatory violence and alternate horizons bring us to one of the most energized articulations of hope and potentiality in the book thus far. The more quivering, tensile surfaces of Uno Akira's *Toi et Moi* enact a quieter, off-kiltered, slower way of visualizing an intermediate space of affective potential of plasticity, the potential for a stretch beyond the everyday. Ōshima's more aggressive yet still layered framing of an agency toward transformation approaches the larger class struggle within a newly energized mediatic frame. His work refracts the imagining of a larger overthrow of existing sociopolitical structures while understanding that the smaller shadows of a drawn line may be the most inventive or emergent scale on which that possibility may find material form. This is not to claim potentiality for avant-garde experiments only, nor primarily to find optimisms in the creative reinventions of mainstream culture, but rather, through the conceptual lens of the affective scale, to grasp how specific works intervene in, traverse, and shift that very horizon theoretically and visually, allowing a series of shadows, microlayerings, and gray scales to reinflect the mapping of change and violence across those larger systems.

Let these visions of animated possibility, then, open a space for further considerations of media's potentialities in chapter 3, where we transition to explicitly New Left discourses of corporeality, mediation, and mobilization at a moment when media's commercial/consumer culture and regulatory regimes seemed almost unshakably dominant—when the questions of media's forms and impacts in a frame of transnational media theory arose again for reevaluation. Holding to a moment of (minor) optimism, we turn now to a later time in which the paranoid position or incisively negative media theoretical critique seemed the most apt modality for getting a handhold on the overwhelming media environment of that moment.

The Culture Industries and Media Theory in Japan

Transformations in Leftist Thought

The previous two chapters, on intermedia and experimental animation, introduced key works in which the potentiality of art practices came to the fore at what I call the affective scale, limning the complex relationships between the personal, embodied experience of the media environment and the larger social and political infrastructures beyond the individual's grasp. Beyond fairy tales of good and evil, the stretch of lines and the shaking horizons of animation give a more capacious picture of the world of 1960s media ecologies, precursors to our own, in which individual actors, artists, and critics deal with a changing world at that liminal scale: critical distances and reparative modes of assemblage alternately or even simultaneously afford potential modes of relationship with that world and help us to understand anew the force of the media explorations of that time. The ninja and heroes of Shirato's and Ōshima's world, as we saw, live in a threshold space where they are neither necessarily only good guys or bad guys but have shifting alliances in the arts of working and fighting; yet that ambivalence opens a space of possibility for hopeful metamorphosis alongside a coming to terms with loss. Similarly, the violent tactics of revolution in 1960s Japan had ambivalent effects that could not be anticipated. The division between the push for yet more violent tactics and the attempts to work within and among systems of representation and media found one of its most revealing articulations in the

realm of theoretical writings on media in that era: critical theorists grappled with how these new media ecologies and infrastructures were remaking the sense of time, the experience of embodiment, and modes of thought and feeling. Theoretical writing and artistic practices sought to find a way of relating to and within—or breaking relation with—these bigger structures, and to encompass both the capacities and vulnerabilities of individuals and the mobile collectivities they might form or organize.

Literary and cultural critic Suga Hidemi describes the situation in Japan around 1970, a time when in the broader culture the strategies of protest were seen to have failed, in the following terms:

> Prior to [1970], Japan's "1968" movement was caught up in a kind of "resolution-ism" [determinism, *ketsudan-shugi*: wanting to escalate violence to achieve a decisive result]. With the "defeat" of January 18–19, 1969, at Tokyo University's Yasuda Auditorium, the new leftists were driven into a corner, realizing that there was nothing more that could be done with staves, thrown rocks, and fire bottles. In such a context, there began to be talk in the Bund [the Communist Party alliance, established in 1958 among New Left groups] about the establishment of an "army," and the Red Army came on the scene. . . . Each party began escalating their armed fights on the streets. There were already visions of fights with bombs as well. This impetus, today, is critically reflected as a [problematic] "weaponism" [唯武器主義, parody-word on 唯物主義, "materialism"] that dreams about revolution by means of escalated armament.[1]

On the one hand, in the late 1960s, many leftists both in Japan and internationally argued that the struggle had to be pushed further in the direction of radical violence. Others felt that the struggle should be shifted to a more symbolic level, fought more in terms of cultural values and discursive power structures, with particular focus on immigration control, discrimination, and minority issues. A crucial intertext for these articulations was Gramsci's reading of Machiavelli's *Art of War*. Following Machiavelli, Gramsci outlined an opposition between (1) a "war of maneuver" (*kidōsen* in Japanese, a mobile war)—the war of "staves, thrown rocks, and fire bottles" mentioned above, or of even more explosive arms—and (2) a "war of position" (*jinchisen*, a positional war, war of encampment) or "protracted war" (*jikyūsen*, a contest of endurance) to be fought on the terrain of culture, thought, law, and power, the terrain of "brute semiosis."[2]

My argument here maps how, along with these shifting strategies, new critical understandings of both media and theory emerged, in their relation

and nonrelation, as depicted by practitioners who had a deep stake in both terms. These thinkers' work reflects a highly dense notion of the connection between theory and practice, and the potentialities of each, an investment that conditions their writings on media and theory. They ask: Is media always already complicit with capital? What is the potentiality of theory to mobilize, and on what scale? These critics in 1973 Japan called for a deep deconstruction of the systems and structures of media as currently constituted, and in the process a rethinking and restructuring of theory as a critical act as well.

The thinkers who emerged at the center of the late 1960s–early '70s culture-industry debates that are the subject of this chapter can be understood as part of a much wider network of leftist artists/intellectuals who first participated in the late 1960s protest movements and, when such protests were seen to be over, catalyzed the shifting modes of critique in the early 1970s. Deeply interested in new theorizations of the third world and emergent postcolonial thought, these theorists were part of a historic shift in strategies and tactics of the left in the wake of the perceived failure of the violent confrontations of the protest movements. Each engaged in a form of activism and media practice (art, organizing, photography, filmmaking) that informed and responded to the pressing theoretical articulations of the day; each held a lasting commitment to the question of the relation between language (critical writing, theory) and other forms of making or acting in the sphere of media.[3]

If globalization, for many critics, marked a direction of homogenization and an infrastructurally conditioned reduction of specificity/difference, the well-known *fūkeiron* (landscape theory) discourse developed in Japan was a trenchant critique of this overriding vector toward flatness and uniformity and a careful analysis of infrastructural manifestations of power. The critics around *fūkeiron* were important media theorists who played a crucial role in late 1960s–early '70s culture-industry debates. Matsuda Masao, born in 1933, was a key theorist of *fūkeiron*, a set of discourses that emerged out of and in conjunction with the work of filmmakers such as Ōshima Nagisa, director of *Ninja bugeichō* (discussed in chapter 2), and director Adachi Masao, as well as in the essays and photographic practices of Nakahira Takuma.[4] The work of Matsuda and Nakahira around 1970 forms part of a web of leftist and radical leftist thought and artistic work that encompassed the pioneering, provocative theories of Tsumura Takashi, known for his work on internalized discrimination, and critic Taki Kōji, the art critic who early on was a member of the photography collective *Provoke*.

It is notable that each of the four main theorists considered here subsequently ran aground or shifted approaches radically in some part of their

media and political practices. Nakahira suffered an attack of illness and apha-sia in 1977 and stopped writing and photography for a significant number of years. He only returned to his photography and writing practice again much later. Tsumura shifted to a qigong practice and ceased explicit leftist political journalism in the early 1980s (though he gave talks about that political work and the relation between the two pursuits in the last years of his life). Mat-suda lived in France in 1973 but was detained and deported in 1974 on suspi-cion of planning international guerilla activities with Japan's Red Army and after that was confined to Japan (though he continued to write and support Red Army activities and the East Asia Anti-Japan Armed Front, and con-tinued to work on films such as 2007's *Yūheisha*). Taki's work as a practicing photographer in the usual sense was confined to the groundbreaking *Provoke* journal, though he went on to be a celebrated critic of photography, paint-ing, and architecture and was posthumously given the lifetime achievement award for criticism from the Photographic Society of Japan. Both Tsumura and Matsuda were still living and working when this chapter was first writ-ten, but both died of respiratory ailments in 2020 during the first months of the pandemic.

This chapter begins with the premise that media critical discourses have a transnational/transcultural (though often unequal and intermittent) circu-lation and that the dynamics of these flows of ideas are themselves mediated through journalism, television, and corporate networks, the very infrastruc-tures and technologies of media that they tend to theorize. Media theorists in Japan are self-reflexive on their position within the media; transcultur-ated media theories connect with one another not by correspondence but rather, to use landscape theorist Matsuda Masao's figures, through relays, resonances, gestures, and subterranean moves. In other words, media the-ory in Japan is neither united nor particularly Japanese (and certainly not *particularly* Japanese); even the discourses around Japan's and East Asia's marginalized position (after media, as it were) as they emerged in the 1960s–70s are wrapped in other transnational circuits of emergent postcolonial and Marxist thought that analyze the workings of capital and the culture industry. The transculturation of media theory, not to mention of philosophy, social sci-ence, literary theory, and Marxist discourse in the twentieth century, means that circulations of theories of the culture industry are shot through with hesitations, ambivalences, and failures of communication that expose a strong self-consciousness on the part of Japanese theorists about their location and positionality in the face of international (i.e., European) media theoretical discourses.

This chapter turns a microhistorical lens on one notable media theoretical event, the visit of German media theorist Hans Magnus Enzensberger to Japan in 1973 (he had written "Constituents of a Theory of the Media" in 1970). Enzensberger had articulated an influential argument about the potential and energy of media as an activating and organizing force; even within a critique of media, he saw alternative production as a space of cultural enfranchisement. A two-day symposium brought together—on stage and in their written responses—many of the major art critics, artists, and writers of media theory of the time. This event and its impact, although at times painfully symptomatic of the unilateral narration of media theory in Japan as a matter of influence and reception, in actuality provides a highly disjunctive occasion for a renewed and more whimsical mapping of the development of leftist media theory in Japan and internationally. I argue that the reactions of Japanese leftists are part of this paradigm shift in leftist thought and strategy around the possibilities and limits in media practice. The Enzensberger moment provides an opportunity for a close-up view of a network of media and theorists as well as a unique chance to understand the stakes in these discourses at a moment of profound transformation in leftist thought.

These critics understood that the media played a key role in the control and forms of culture across a range of scales, from politics and institutions to the most personal experience of the everyday: from wars, economic transformations, and policies to social, cultural, and urban infrastructures and protests, to the vicissitudes and framings of emotional and familial life, like the feelings of boredom and shame Everyman expressed in Okamoto Kihachi's film. The changing media landscape made a difference to the experience of time (understandings of history, the contemporary moment, and the future), and yet it was a challenge to think and articulate, as well as participate in, the movement of media forms in a way that could feel relevant and not just get swallowed up in the tides. The critics took up aspects of the critiques of mass culture from the 1930s and beyond, attempting to understand what constituted and what could energize and empower those masses. Some critics advocated looking deeply to ideas of movement, mobilization, and materiality to try to understand a potential for self-organizing the masses without necessity for or capitulation to homogenization—allowing for movement and shift within, between, and among individual bodies. Others reacted to the seemingly optimistic potentiality these former critics named with a clear sense that a profound refusal and negation was the only option: mobilizing the im-potentiality or blockage or silences offered the only real possibility available in an overwhelming system.

Perhaps, affectively, it is true that the situation in Japan did not lend itself to much optimism in 1973: the rise of the corporate structures and the managed society seemed almost impenetrable to many Japanese artists and critics writing at the time. The body itself, as they well knew, and the structures of embodiment and feeling were shot through with the investments and pervasiveness of the corporate management culture and the visible and the invisible infrastructures of capital. This problem has continued to occupy theorists and critics of the globalized media system, as Asia and Japan's place within this system becomes ever more central. Returning to the moment of the early 1970s, when many aspects of our current media system began to appear, gives a historical perspective that can also help us to resituate the axis of persistently presentist, Eurocentric theories that continue to vacillate between more utopian, deeply critical, and more ambivalent perspectives on media culture.

Media Theory, Culture Industries, and the
Enzensberger Moment

Hans Magnus Enzensberger (1929–) is a prominent media theorist, part of a network of leftist intellectuals in Europe that includes Jürgen Habermas (also born in 1929), following in the lineage of Walter Benjamin, Herbert Marcuse, Siegfried Kracauer, Ernst Bloch, and to some extent Georg Lukacs and Bertolt Brecht, among others. Enzensberger's "Constituents of a Theory of the Media" made a splash when it was published in Japanese in August 1971 in the journal *Bungei*.[5] Media theorists and artists gathered in force when the German Cultural Center and the publisher Film-Art Company (Firumu-āto-sha) invited him to appear in a two-day symposium at Asahi Hall in Tokyo on January 22–23, 1973 (figure 3.1). It was an event filled with promise: two days of conversation bringing together the most prominent artists and critics of the day.

The leading filmmaker Kawanaka Nobuhiro, known for his role in spearheading the personal film movement, staged the event as a producer, putting monitors down the center of the auditorium so that it was reflexively mediated/mediatized in its very moment of occurrence.[6] On the first day, the symposium included Tōno Yoshiaki, one of the so-called Big Three art critics of the day, who also wrote critical essays on television and had done his own closed-circuit television performances; Terayama Shūji, the theater director, poet, filmmaker, and writer who was also active in radio and television; TV/radio/film scenario writer, editor of *Kiroku Eiga* (Documentary

FIGURE 3.1 Auditorium mediatized at the Enzensberger symposium, Asahi Hall (1973).

film), producer, and activist Sasaki Mamoru; architect Hara Hiroshi; and, as moderator, the television producer, director, writer, and activist Konno Tsutomu (Ben), who had founded the first independent TV production company along with directors Hagimoto Haruhiko and Muraki Yoshihiko (TV Man Union/Terebiman yunion) after their break from Tokyo Broadcasting System over labor disputes in 1970 (figure 3.2).[7] On the second day, the symposium featured art critic Hariu Ichirō, another of the Big Three; photographer/theorist Nakahira Takuma; and radical Left critic Tsumura Takashi. In various publications, a flurry of reflections and responses, reactions, and—as we shall see—passionate rejections ensued.

Why invite Enzensberger—clearly a media star in his own right—to stand at the center of this Japanese debate on media and its relation to capitalism at this particular moment? Enzensberger and many other American and European theorists had been read and translated extensively throughout the 1960s and early 1970s, and ultimately, the Japanese theorists would both draw on and push against the models they provided. Enzensberger's essay is by no means univocal in its optimism but is usually cited for its "linking of media critique with a systematic plan for alternative production, together placed in the service of cultural empowerment."[8] Indeed, the essay functions—among its many caveats and reservations—as a call to arms for alternative modes of production, as his closing sentence signals. In the process of "bringing the liberating factors in the media . . . to fruition," the author/artist must "work as an agent of the masses. He can lose himself in them only when they themselves become authors, the authors of history."[9] While Enzensberger articulated one of the most persuasive summaries of the contradictions involved in such a process and the many false forms of feedback—meaningless or empty

FIGURE 3.2 Symposium participants, Day 1: *from right*, Konno, Sasaki, Hara, Enzensberger, translator (name unknown), Tōno, Terayama.

participation—that can be constructed in the media, he ultimately lands on an argument for an inherent power and potentiality of the media as a participatory and mobilizing force. Such an argument, J. T. Caldwell rightly notes, "prefigures digi-speak," referring to the utopian discourses around the digital.[10]

In the end, both Enzensberger and Jean Baudrillard in his retort to Enzensberger, "Requiem for the Media," agree that the media need a fundamental destructuring and reorganization to realize whatever potentiality they may have; and they agree that there are many false directions and impasses. Yet the emphasis of Baudrillard's retort here is part of a deeper and more widespread doubt, shared and newly extended in many of the Japanese theorists' writings, about the way the superstructure (within which we find semiosis, discourse, and representation) should be understood in relation to infrastructure (base, economic production)—a strong critique of the Marxist tendency to read both as responding to the same dialectical progression.[11] This Marxist debate forms part of the backdrop for the wider—transnational—scale of leftist discourse in which Matsuda, most strikingly, but also Taki, Nakahira, and Tsumura Takashi are key participants.

Today, when we read Enzensberger's "Constituents of a Theory of the Media," it is striking how many aspects of his writing still resonate for contemporary discussions of electronic media. We may note the very speed of circulation of these theoretical works, along with the speed and ease of circulation of persons (with the rise of affordable airline tickets), as well as the powerful extensiveness of what Enzensberger was calling "new media" in 1970. Among the prior twenty years of "new media" he referred to in 1970, he included news satellites, color television, cable-relay television, videotape recorders, videophones, stereophony, laser techniques, electrostatic reproduction processes (copy machines), electronic high-speed printing, time-sharing computers, and data banks.[12] The issue of telephone tapping that he discusses and the impossibility of monitoring all phone lines, which he claims is unfeasible because it would require a monitoring system larger than the entire telephone network, resonates with today's questions around the corporate use of search-result algorithms and the surveillance of email and texts as well as searches and site visits (yet, as Matsuda says in his response to Enzensberger, "*my* phone is tapped").[13] Enzensberger's analysis of the situation of media and empowerment draws on Fanon, Lefebvre, Benjamin, Lissitzky, and Adorno—all of whom were available to Japanese media theorists to differing degrees in translation or through citation by other Japanese media theorists—and also includes critiques of Georg Lukács and a trenchant dismissal, especially of McLuhan, the latter having just a few years earlier enjoyed great influence in Japanese art-critical circles.[14]

While Adorno's work was introduced in Japan in the mid-1950s primarily under the rubric of music theory, by the late 1960s there was a more abundant focus on his critical theory; Krakauer was known and taken up particularly by film critics with the translation of *From Caligari to Hitler* in 1970–71 (published by Misuzu shobō). Yet for Japanese readers then (and those of us today) who might not be as familiar with Enzensberger's work and its impact in Japan, Musashino University professor Nagai Kiyohiko summarized his reception in the May 1973 issue of *Sekai*: "Recently, Hans Magnus Enzensberger rushed through Japan in a flurry. Enzensberger is perhaps even better known in Japan than the recent Nobel prize-winning German writer Heinrich Böll. Most of his major works are available in Japanese translation. . . . He has been judged the only writer who could appropriately be called a successor to Bertolt Brecht, and with each of his works he brews a storm of controversy."[15]

Nagai writes of the quieting down of student movements in both Germany and Japan, and how Enzensberger "[around 1972] was still as cheerful and optimistic in his viewpoint [as he had been in 1968]. Instead of being

aimlessly crushed and succumbing to defeat, he learned from defeat, and was overflowing with confidence in the certainty of victory in the long run. Perhaps it has something to do with his being from south Germany. An ordinary German, affable and vivacious [*yōki*] in a way that one can hardly imagine in a radical left fighter."[16] The image of the south seems to figure in Nagai's identification of/with Enzensberger to place him in a more flexible and marginal position in relation to the power of German culture as a whole. (He too is other, Nagai seems to say—like us—and at the same time he is idealized as someone who performs this role as a confident, optimistic leader.) The identification with Enzensberger is then reversed (mirrored) in his recognition of a cheerful Japanese leftist: upon speaking with the new leftist critic and activist Iida Momo (sometimes spelled Iita, 1926–2011), founding member of the Beheiren (Citizens' Coalition for Peace in Vietnam), Enzensberger "looked at Iida steadily and said to me [Nagai]: 'It is a pleasure to speak with such a cheerful [*yōki*] revolutionary. It is rare to find a leftist who laughs out loud and doesn't have any gloomy (melancholy) side. Wherever one goes, so many on the Left have sunken cheeks and seem to be grieving. [Iida] seems to be different.'"[17]

The affective dimension of this encounter, brought on by the layers of identification and (mirroring) investment in the figure of Enzensberger, turned out to be a telling component of the dialogue with Japanese media critics. Enzensberger himself famously characterized the symposium during Day 1 as "four pessimists and one optimist." Nagai Kiyohiko attempted to explain this by pointing out differences in the situation of West Germany and Japan: "In general, the very fact that Enzensberger, a 'dangerous person' with revolution on his lips, can be sent into Japan by a public institution/organization from West Germany, eloquently expresses the difference from the current situation in Japan."[18] Nagai argues that the overall positive support of work like Enzensberger's by German TV and radio—some of it was sponsored by state-owned West German television, for example, though it was also restricted from some print media—might have contributed to his alleged optimism about these media. By contrast, within the symposium, Nakahira refers to the anti-NHK war, the struggle by part of the general public and labor unions against the conservative political ties and authoritarian management of Japanese public television; Nakahira affirms the need to destroy rather than reform the bureaucratic media structure.[19]

Enzensberger's theoretical writings relentlessly look for spaces of what he calls "leakiness"—the "leaky nexus of the media"—and yet he also advocates "utilizing" the contradictions within media while remaining aware of

the propensity for absorption of contradictory opinions within the liberal/reformist frame. In "Constituents of a Theory of the Media," his optimism consists especially in a critique of the leftist sense of impotence and the oversimplifying oppositional logic that views the media as pure manipulation of the masses, a view he links to the 1960s New Left.

The range of responses to Enzensberger within and after the symposium develops a picture of Japanese leftist critical theory as it existed in the early 1970s. We can delve into this moment as a transitional place in the movement, for example, in radical leftist thinker Matsuda Masao's work, from landscape theory toward a theory of media, as I discuss further on. Marxist critic Tsumura Takashi responded with a discussion of network theory—invoking Lefevbre's 1966 *Le Langage et la Société* (Language and society)—with a reading of the "urban information environment" that would include labor unions and other organizational elements as part of the urban media ecology and thus extend the discussion of environment beyond electronic media. As we have seen in chapter 1, issues around environment and urban control were central to cultural innovations at the time, ranging from intermedia arts to metabolist architecture to Expo '70 and its aftermath. In his article, Tsumura proposes the formation of a field of "informational environment studies."[20]

Given the securitization of urban space and the palpable atmosphere of defeat of the student movements, it makes sense that Enzensberger's optimism struck an odd note in 1973 Tokyo. As Tsumura points out, one of the central experiences of the symposium for many participants was of a "difficulty of communication" or the sense of not understanding or being understood, "not getting through" (*tsūjinai*).[21] This issue of incommensurability of discourses rises to the level of a transcultural reflection on media, an irony that Tsumura points out, since the topic is itself "communications" and access to communication, the ecology of media.

Media-ron, media theory, had also developed in part out of the field of communications theory or *masu-komi-ron*. Indeed, the mediation of a translator is a key and rarely remarked fact: and further, Nakahira mentions in his essay that the translator was translating via English.[22]

Tsumura strikingly points out:

> [To borrow Enzensberger's words] what I [Enzensberger and Tsumura] felt at that time was that [the Japanese panelists] began with a critical attack on currently existing things—pointing a finger at the world—rather than starting from the possible, or even from elucidating the basis of

contradictions and the conditions of their manifestation: he said that he encountered this intellectual model (pattern) in Japan wherever he went. . . . The four theorists on the Japanese side, in any case, [seemed to think that] to begin by declaring definitively that "it's all no good" [*dame da*] was the more intellectual posture/attitude to take."[23]

The issue of intellectual posturing and models points to a self-consciousness about relative valuation as a tactical move—the "Japanese side" critics' awareness of their act of producing mediated cultural material as a "media act" situated within the very media forms they are discussing—and their awareness of that mediated act in relation to the relative cultural situations/power of Germany versus Japan.

Matsuda Masao puts it more strongly in fairy tale–like but also critically racialized terms: while Sasaki Mamoru is "repeating, like a magical incantation, that 'television is fascism,'" the "happy Prince Hans, coming from the country of the Grimm Brothers," describes the future positive possibilities of television and media: "I recall now distinctly that as he made these remarks those above as well as those below the speakers' platform, or in other words the whole house, were taken aback and chilled by his words. At that time Piotr Kropotkin's famous 'free agreement theory' reflexively came to my mind, and I couldn't help glaring at the white [naive] face [*hakumen*] of Prince Hans and thinking, 'This irredeemable optimist!'"[24] The ideo-affective stances become signals of the theorists' positioning and tactics within the transcultural workings of media theory, and they create an opening for those critics' strong interventions around the possibility and impasses in the workings of the culture industries. These specific elaborations, with their affective resonances relevant both in the personal (micro) interactions and for the broader cast of media culture, grapple at the middle range of agency with how change might be envisioned in the wake of a loss of hope, in the midst of the need for new approaches, within changing relations to overwhelming infrastructural realities and media's pervasive presence in everyday life.

Matsuda's Critique: A New Axis for Media Theory

Matsuda opens his May 1973 *Bijutsu techō* article in full (negative) critical mode. He compares Enzensberger's statement that "television, like the telephone before it, should come to be used effectively, free of the 'oppressive uses of media'" with Kropotkin's writing in *The Conquest of Bread* that the

railroad network was an example of a "free agreement" that foreshadowed the dying away of the state.[25] Matsuda explains the sleight-of-hand that allows Enzensberger to misperceive TV as mobility and therefore potential freedom: "The first concrete example that Kropotkin raised of his free agreement was none other than the *railroad network*. In other words (not to sound too much like Tsumura Takashi, but) every problem of power must actually begin with a problem of communication."[26] Enzensberger accounts for many of the possible counterarguments to his theses in his own writings, and does so compellingly. Matsuda thus mobilizes the critic's own language to attack his "unbearable" optimism, citing Enzensberger's own *The Consciousness Industry* to diagnose such thinking as a form of false consciousness: "What is abolished [writes Enzensberger/Matsuda] is therefore not exploitation but the consciousness of exploitation. . . . I should declare that precisely on account of the existence of the 'free agreement,' the cunning [*kōchi*] of history has enabled the state to maintain its full force" (53–54).

Matsuda thus criticizes the panelists and Enzensberger, not for their pursuit of incommensurability or the delving into chaos at its deepest level (as Kobayashi Hideo might have put it in another context), but for the fact that they establish and end up standing too much on common ground, Enzensberger and Sasaki resembling each other, Matsuda says, "like two acorns." Both hold either absolute or relativized oppositions between a "we" and a "they," "our media" and "their media." The commonality establishes the use of binary oppositional axes—they/we or theirs/mine (*"yatsura" to "ore"*)—or in other cases plays itself out in a dichotomy between idealist/conceptualist (Terayama) versus realist (Enzensberger).

Matsuda argues that it is necessary to shift the ground from such a series of binary oppositions, framed in the symposium around the issue of "access," to another directionality or vector ("axis"):

Today, what media theory needs is to rotate fundamentally what appears as an existing given, the axis between "them" and "us" or of "them" and "me" [*ore*]. Instead of debates about access [*akusesu*], what is needed is to reset the axis [*akushisu*] itself. . . . [To say it in Enzensberger's words,] "It would be impossible without the self-organization [institutionalization] of the participants. This is itself the political crux of the problem of media." Exactly so: the axis for media revolution should be set in a direction, to speak metaphorically, where the question is by what circuits [paths] the lonely "I" [*ore*] before the television set will organize himself toward a "we," and only in this direction. (56)

Here Matsuda once again speaks alongside Enzensberger. His citational performance takes on without mirroring Enzensberger's meaning, or takes it farther, in a sense performing the redirecting axis shift that he is advocating: he reorganizes an altered collectivizing theoretical mode that figures a version of the lonely "I" redirecting itself toward a "we." Matsuda effectively asks: how can discourses—say, media theory—themselves dependent on the media for circulation, reorganize the relation of the individual to media? Through what forms of movement can the individual pass (circulate, circuit) to be organized as part of a collective of some kind, and what kind of collectivity?

Matsuda's statement about this shift in relation is highly striking, because issues of communication/commensurability, as well as comparability/correspondence, are themselves key problems for Marxist media theory as a whole, where at stake is precisely the relation that should obtain between the vanguard thinkers and the masses, as well as between thought and movement. In Matsuda's own past essays, he had written in terms of a "spontaneous harmony" between intellectuals and the masses, a kind of unmediated direct access, but in this essay he criticizes his own earlier position; here he shows the *ore* (I, marked as male) itself as multiply constituted over time by its own language and transmission, such that the issue of the external network has to relate also to a so-called internal network discussed by some symposium panelists, especially Terayama and Nakahira.[27]

Matsuda realizes that he had depended on an idea of one unconscious or subconscious directly and instantly connecting to (another)—a kind of "correspondence replacing communication" (as Matsuda points out Leopold Sédar Senghor had put it), *kōkan* (empathy) instead of *dentatsu* (transmission).[28] Here again he uses *furigana* for *corespandansu* (correspondence, or more deeply the Baudelairian *correspondances*) to double the physical feeling, the affective experience of *kōkan*, empathy (correspondence as an affective mode of feeling with, to replace the more media-based transmission of information = *dentatsu* as communication), but at that time he had still been within a frame of binary thinking, what he calls the "demon of dichotomy" (*nibunhō no oni*). Matsuda had earlier framed the communication model of *dentatsu*, the transmission of a message from producer to receiver, as a model that needed to be transcended and ruptured to give way to a more direct, unmediated relation. However, here repudiating his Senghorian framework (as many came to do), he instead articulates a new and alternative view of mobility and mobilization, and of gestures, one by which he reframes the whole question of media theory, saying, "The only thing that could organize the

frenzied heat of the overwhelming majority of the 'masses' was the media/ mediation of the unconscious power that spurted out [*funshutsu*] all at once [instantaneously] from within the 'masses,' in other words, 'what was not words/language'" (59).

His writing in this moment thus traces a shift between media and mediation (*baitai*, 媒体), where he has superimposed on the word *baitai* (mediation) with the *katakana* reading "media" filled in.[29] Media in this passage is seen not as something external but something that has a bodily quality, something like blood, that spurts out all in an instant not from an individual body but from a collective, the masses, not in the form of language but in the form of an unconscious power that has the capacity precisely to organize passion, affect, and frenzied heat into a *soshiki* (an institution, formation, or organization). In this formulation, media is not itself the system or organization, but media is the mediating force that can organize the unconscious power of the masses. The member of the masses, "only by performing revolution in this way, was able to transform himself into one of the innumerable nameless people who slashed open history, so that he could mobilize [*dōin*] himself in the true sense of the word, like a dancer, a football player, a guerilla" (59).[30] It is in this way that Matsuda argues for directing the vector (or axis) of media theory toward the question of how the individual comes to relate to the broader organization, and how the person can "mobilize himself" not via language but via a corporeal movement (in some sense beyond consciousness or language). At the same time, he inhabits Enzensberger's language of mobility, moves within Enzensberger's theory and redirects it toward this spurting, this tearing, this organization of affect, the mobilization of an organization that emerges in an instant, the media/mediation of the power of the masses' emergent unconscious.

Matsuda then concludes, "The Kropotkian inversion [*tentō*/overturning] extends far beyond the 'symposium with Enzensberger' to cover [conceal/hang over] not only the theory of violence but also the entire sphere of the theory of media" (60). Theory of violence, theory of media—for Matsuda, these whole realms contain the problem he had named with Kropotkin: the sense of a freedom or free will that conceals an infrastructural network underlying and conditioning them. The unconscious gesture, and the affective mood, become crucial pathways and potentialities within Matsuda's concluding call to continue to "dig ever deeper" (into what he ironically calls the "Unconsciousness industry"), as he aims to do in part through his own "brute semiotic" practice of theory writing and trenchant critique.

Paradigm Shift of the New Left: Tsumura Takashi and Nakahira Takuma

To understand more fully the significance of Matsuda's intervention in cultural media theory, it is worth taking a moment to understand the ideas of voice/parole and the complex assertions about mediation other theorists made at the time. The voice or parole, *nikusei*, can more literally mean natural voice, human voice, or true voice, live voice, yet it is also the translation of the semiotic term popularized in Japan through translation of Roland Barthes and others as *parole* in opposition to *langue*. In that sense, the term *parole* (in French it can mean word or speech) stands as the term for a specific momentary intervention, a moment of speech that takes its place in the larger, systematized structures of language that, via structuralist linguistics, are mapped onto the term *langue* (language). An understanding of the symbolic systems of signs and representations was a key element in the paradigm shift of the New Left toward the "war of maneuver." Two writers, Tsumura Takashi and photographer Nakahira Takuma, hold a key place in theorizing the way these systems work and in opening and figuring the problem of the affective scale for media theory, the intermediate range of agency in which it is understood that media condition the rhythms, temporalities, and structures of everyday life. Thus any intervention one could make is already entering a given system and infrastructure (parole exists in the system of langue), and yet it is necessary to continue to search for ways to intervene critically and transform the terms of the system itself. For Nakahira, that is a multistep process that involves the transformation of self in relation to and as a sort of system; the understanding or research into the realm of the social; the interruption of that system's workings; and thus, ideally, the dismantling of the reality as it currently exists. Working within larger groups and political movements and reflecting on those movements, however, there is a key question of energies and motivation as well as public perception in engaging the solidarity of activists: the writings of Tsumura Takashi and their reception are an intriguing case study for considering the way that affective-ideological movement makes a difference in the potentialities and energies of such interventions in a broader framework.

In the postscript to the 2012 republication of the writings of Tsumura Takashi, Suga Hidemi suggestively situates Tsumura as a pivotal player in the paradigm shift of the New Left in the late 1960s to early 1970s discussed above. Tsumura, who (as mentioned above) in the early 1980s abandoned

this form of political writing to launch a career as a new age qigong prac-
titioner and writer about Asian health practices, had been a prolific critic
and journalist on topics including anti–nuclear power theory, ecology, third-
world issues, and urban space. He was known as an activist protest orga-
nizer around immigration issues and Koreans and Chinese living in Japan,
and his "discrimination theory" (*sabetsuron*) made him a central player in the
important *7.7 Kaseitō kokuhatsu* incident. Tsumura's discrimination theory had
inspired a group known as the Overseas Chinese Youth Strike Committee
(Kaseitō) to accuse Japanese new leftists of harboring nationalism/narcissism
in their thought and policies, at a meeting on July 7, 1970, commemorating the
thirty-third anniversary of the Marco Polo Bridge (Rokōkyō) incident (a key
trigger for the Sino-Japanese War). The Chinese Youth Strike group was pro-
testing Japan's immigration-control policy and the way the current student
movement ignored issues of race, ethnicity, and discrimination. Later leftists
thought that this shift in focus and the sudden doubt instilled in activists—
the shock of that moment—through Tsumura's writings and this incident
ultimately contributed to lessening leftists' "resolve" (determination) to move
toward true and violent revolution, instead shifting toward a more tepid re-
form that would work within the structures of existing capitalism. Suga argues
that this episode, in which Tsumura's writings on discrimination played a key
role, "can easily be considered one of the most important events in postwar
ideology." "To date," Suga writes, "we are not able to free ourselves completely
from the paradigm which this event created."[31]

In parallel with the early formulations of cultural studies and postcolonial-
ism debates, Tsumura (along with Matsuda, Taki, and Nakahira) gave us a pierc-
ing analysis of the intersecting constructs of race, class, and (to a lesser extent)
gender. Suga contends that Tsumura's arguments have a concreteness and
practicality often missing in what Suga sees as the "politically correct" con-
sensus of some later versions of postcolonial critique, cultural studies, and
feminist thought as received in Japan's academic world.[32] In the more subtle
"war of position" that emerged at this time, struggles turned to questions of
buraku (social minorities traditionally considered outcasts), feminism, race,
immigration, nuclear power, rural residents' struggles, and the "minorities as
a potential subject of revolution."[33] Suga argues for the necessity of revisit-
ing Tsumura's writings today, and in the extended wake of 3–11, to examine
his theories as part of knowing the histories and stances of the earlier anti-
nuclear movements.

Tsumura worked within the frameworks of broader protest movements
and had a key role in tracking and shifting the energies of those movements

(though, as Suga points out, Tsumura's work was strongly criticized by influential theorists like Yoshimoto Takaaki at the time and has been largely forgotten in the intervening years). The question of energy and collective affect—the way groups mobilize toward refusal and negotiate conflicting claims—and hence the very definition of the political opens in a new and striking way in relation to the intervention that Tsumura's writings made in their moment. Energy and affect operate in a different way in the more artistically inclined, radical vision of a politics of refusal framed by photographer Nakahira Takuma in his trenchant leftist theoretical critique. His works as a theorist, which negotiated and theorized the place of the individual within larger systems, existed alongside his correspondingly innovative and rigorous photographic practice.

Nakahira's newspaper reflection on the Enzensberger symposium focuses on this issue of the voice or parole, *nikusei* as a metaphor for the problem of agency in relation to existing discursive/mass media systems.[34] Nakahira dismisses the utopian view of electronic media (such as video communication) that believes in its "'egalitarian'" possibility for "gaining a new language" partly because it reminds him of the rhetoric of sexual liberation. Free media, free sex: both views oversimplify the difficulty of breaking free of these systems, closing them off from the rest of the social sphere and viewing them in isolation when in fact they "cannot be cut off from the totality [*sōtai*] of our lived history." (We will see how gender as system/infrastructure comes to be negotiated by another photographer, Ishiuchi Miyako, in chapter 4.) Utopian views of media and sexuality thus "lack the opportunity for a *total refusal* of existing reality." The alternative, however, Nakahira describes in the negative, as that without which there will be no fundamental change but that can barely be articulated under its own sign: nothing will change fundamentally, he states, unless there is "the concrete and realistic opportunity to completely deny and dismantle the dominant reality," a possibility he describes as *undōron* (theories of movement/a kinetics).[35]

The framework of Nakahira's criticism reflects his embeddedness in structuralist (and emergent post-structuralist) theoretical modes. He captures the idea that the continual focus on the new—what he calls "the theory of hope/ expectation for new media" (*taibō*, expectant waiting)—is nothing but a "reflection in reverse of capitalistic innovation by the people." Works and art included in the video production system come to be framed as personal "expressions" or personal "works" (*sakuhin*) that—and in a quite derogatory sense—become the "toys of the masses" with bourgeois sensibility "transplanted artificially" into them. What he opposes to these "toys" conveyed

through the media is framed in the problem of the "voice": the real voice, as it were, and the question of "how the voice we should convey can be captured" or, in fact, "whether we possess a voice which can be conveyed."[36]

The problem of voice in his writing then transitions into a problem of rhythm: as Yoshimi Shunya has written, rhythm or structures of temporality are a central aspect that television came to regulate with its rise in popularity and its entrance into the home in the 1960s. For Nakahira, too, it does not matter what the content is, what are the "expressions" or "works" conveyed on television, so long as the television broadcasts "preserve a rhythm of programmed harmony so that the world continues as it is."[37] In other words, TV kept the status quo, no matter what the content, swallowing everything into its "fixed rhythms" whose "enforcement was television's political role."[38] The body's movements, the pace of a day—nothing could interrupt that rhythm. Even the Asama-sansō jiken, the Asama-sansō hostage crisis so broadly televised in real time, soon was restored into this rhythm, like an "8AM soap opera" program. For Nakahira, the rhythm of media, the corporeal and affective rhythm, is the problem that makes it impossible to dismantle existing television from within. Instead, he returns again to the problem of the voice. The voice, then, figures the interruption of this rhythm, in the sense that it has "nothing to convey—it is just our silence directed toward the dismantlement of all existing things. That is what our paradoxical language is."

The key problem of langue versus parole (structured system versus intervention of a momentary instance selected from within it) structures Nakahira's response to Enzensberger. Nakahira calls for a "kinetics," and it is in this way that his search for speech/voice/parole (nikusei) parallels Matsuda's interest in gesture and mobility. In order, shall we say, to "claim expression," or to "respond" at all, to "take on the role of the manipulator" (in Enzensberger's words), it would be necessary from Nakahira's point of view first of all to invent a new way to be in/amid media, to be a photographing/media-involved subject. In his writing on Enzensberger and media theory, then, Nakahira evokes the voice (parole/nikusei) as a collective: "What exactly is our voice? It is something which has rather nothing to convey."[39] In relation to a hegemonic and engulfing homogenization, as well as the futility and battering of the world, it is his own "silence," then—his time bomb—as another side of parole, that Nakahira feels goes unnoticed in all this hypersaturated discourse on culture industries and media.

Nakahira's roughly contemporaneous writings on the homogenization of landscape (fūkeiron), developed alongside Matsuda's, bring the power regulation of landscape and infrastructure as well as image and perception into

the realm of media critique. It is not only, as Nakahira claims in his response to Enzensberger, the "political role" of media such as television to "enforce a certain rhythm throughout everything, a rhythm of preestablished harmony so the world can continue as it is."[40] As he wrote in the same essay, not only do the dominant media "squeeze our senses into molds and regulate our senses on a daily basis," which he calls "the only and biggest political role of existing media," in essence flattening time (alongside landscape); but beyond those roles of media, the problem is that the landscapes both of Japan and of the rest of the world have come to seem flattened, frozen, and immutable. This has happened not only within images or representations, but within our own perceptions or ability to apprehend. "Like the flattened 'landscape' of Japan," argues Nakahira, "the worldwide relationships between exploiter-exploited, oppressor-oppressed have been snugly enveloped within a landscape like a beautiful picture postcard, a landscape which to me appears to lack even a single crack, or a single indication that perhaps the beauty and stability of this landscape will one day be overturned."[41] Addressing the complicity of the individual subject within these larger systems was a key goal of his photographic projects: as Nakahira put it in his writing on one of his projects, *Circulation: Date, Place, Events*, discussed further in chapter 6, "from the midst of everyday existence I took up the camera as a means of immediately recording and then discarding the bias arising from the process of continually eroding, transforming, and violating my self by subjecting it to the world."[42]

Nakahira Takuma had contributed that project to the Seventh Paris Biennale, one part of which focused on the theme of interventions (along the continuum of concerns about response and interactivity contemporaneously addressed by Matsuda and Taki). Nakahira had spent each day of his time at the exhibition running around Paris taking photographs/documents, developing and printing them on that same day in the darkroom, and then circulating those fragments, or what art critic Yasumi Akihito calls "remnants," back into the landscape of Paris in the space of the Biennale—rumpled, tacked up, piled on the floor, barely dry, including some photos of the exhibition itself. Although Nakahira was extremely critical or even dismissive of the Biennale event and encountered many difficulties in the process of participation, Yasumi has argued nonetheless for the importance of Nakahira's contribution, writing that *Circulation: Date, Place, Events* functioned to "cut up the continually moving world and its homogeneous flow of time: a history is buried within this cutting process itself, like a time bomb."[43] In chapter 6 we return to look more closely at the impact of this

photographic event and its theorizations of contemporary art as it relates to questions of community and collectivity.

The problem of co-optation had long occupied Nakahira. He had seen it with his own work in *Provoke*, a movement that aimed to "capture a fragment of reality" and thus in one possible sense to escape or sidestep the media system (though much of that work was also first published in journals). In any case, Nakahira kept noticing that all that could be done in that regard was provisional, momentary, and was quickly reabsorbed by the media system as a style/fashion. He noticed how his own interest in darkness and the monochrome paradoxically reinscribed the "touch of the hands" and hence his own emotion into a photograph that was trying to be impersonal/anonymous and devoid of sentimentality, and he later wrote of this problem in terms of a failure of *Provoke*'s project.

In Nakahira's writings, and in his response to Enzensberger, there is an interest in the space between language(s)—one that we might argue deconstructive theory later explored in a very different way, here seen and felt also as a relation to materiality. This body is not exactly my body, not exactly a subject's body: for Nakahira, the idea of transforming oneself into the *dentatsu shutai* (the prevailing translation of a term of Enzensberger's theory, the "subject of communication") rings utopian, too, and so he criticizes this concept of Enzensberger's. It is not from the point of view of the *shutai* (subject, agent) that, for Nakahira, any significant developments are going to arise. Instead, what is necessary is to see how the media are "squeezing our senses into molds and regulating our senses on a daily basis" and then to find a space of negativity, which here too, strikingly, has the paradoxical structuration of an institutionality. That is, the words of Enzensberger's that Nakahira uses here, like Matsuda, are *jiko-soshiki-ka* (self-organization) as well as *shakai-teki gakushū* (study of the social). These are key steps in moving toward that space of negativity, that refusal that takes the form of an interruption, a silence that would be collective: first an intervention on the level precisely between the self and the larger institutions, between the first and third persons—turning oneself into an organization, organizing or reorganizing the self, understanding the self as a complex and ephemeral construct, and grasping and transforming the social/technical as well as personal apparatus of the self. This process would take place, not in order to engage in a process of self-disciplining into the social, but in some other imagined way or alternative scale, one that engages affect, that transforms precisely that self into an instance, an instant, of reframing an intermediate space of self and infrastructural/sociocultural system.

It would be on the basis of a paradoxical transformation of the self into an alternate (*alternate* is my word) institution/organization and through an understanding of the social, through an interruption in the body rhythms of media that takes place through a silence, and through the very process of dismantling reality itself, that the beginning of Nakahira's imagination of parole can arise. If the private, in other words, is already pervaded by the political and by the rhythms of corporatized media, what Nakahira imagines instead is a voice without pregiven content—it is a silence aimed at the "dismantlement of all"; it is a nihilistic voice. And there is an importance here in the idea of research, of study; theory and study hold a crucial role in this potential dismantling. Of course, it might be easy to associate the aphasia and memory loss that Nakahira fell into from 1977 (through illness) metaphorically or allegorically with this call, just a few years earlier, for silence.[44] But perhaps we can also read the fleshliness of this *nikusei*/parole that is neither fully individual nor collective as an evocation of the paradoxically embodied quality of what theorists understood as the continually dematerializing (and rematerializing) electronic media rhythm in daily life. Other leftist critics also draw on this idea of the parole and questions of embodiment to theorize these problems of agency and dematerialization in the electronic media realm. Theorists like Nakahira and the *Provoke* photojournal cofounder and art critic Taki Kōji frame their ideas of the struggles within and via media systems through these images of finding a space for intervention. In Nakahira's case, the key would be to work toward a refusal and dismantling, while in Taki's case, what is required may already be underway: a reversal or overturning of the gaze, which would take the form of another kind of parole, and lead to an ambivalent but valuable opening toward freedom. Like Tsumura, who liberated an energy of transformation that on the one hand galvanized and on the other introduced a new complexity into (or even divided) the leftist struggles, Taki focuses on power differentials, (post)coloniality, and the potentiality of resilient excluded voices to transform the terms of the media debates.

Inverted Eyes

For *Provoke* photo journal cofounder Taki Kōji, Nakahira's paradoxical parole joins with questions of postcoloniality, the third world, and the gaze in photography. For Taki, too, media takes the form of a hegemonic system/force, a veritable "monument." His response to Enzensberger takes the occasion of the "death of *Life*" (*Life* magazine had temporarily ceased publication

in 1972) to reflect on the gaze constructed by this monolithic and homogenizing media structure. The emergence of parole (*nikusei*) would involve an overturning of the intensely homogenizing logic of media.

For Taki, *Life* magazine's "visual logic" requires analysis because this media "gaze" is the "productive force of media itself."[45] Note that Matsumoto Toshio's *Ishi no uta* (*The Song of Stone*), discussed in chapter 1, was also a remediation of *Life* photography that aimed to reframe and critique *Life*'s mode of documentation/representation. Taki argues that *Life*'s journalism—including Farm Security Administration photographers such as Walker Evans, Margaret Bourke-White, and Dorothea Lange—had participated in the spirit of the New Deal by making "objective reports" that were also aesthetic and emotional in their effects. In his view, a shift happened around the Vietnam War from the reporting that had happened earlier in *Life* on the New Deal and US foreign policies in the Spanish Civil War, World War II, and the Korean War, a shift that concerned the structure of the "public" (*taishū*). In the *Life* version of the document, Taki tells us, what is photographed becomes an exhibition or exemplary display (*chinretsu*, Taki writes, following Lefebvre) and monument (Foucault). "*Life*, while making every document into a monument, has also come to confirm itself as a new monument, or in other words, as media" (47), he writes.

To understand what needs to change (and is changing), Taki cites Ortega y Gasset in the 1930s, who wrote of the masses as an "image" that emerges precisely with the reproduction of media but is "a group/mass that has neither a specific culture nor its own voice [*nikusei*]." What is needed is "to look into technological media from the other side of words [*kotoba no acchi*], through inverted eyes [*sakasa no me*]" (48). For Taki, the "eyes of America" represent an ethnocentric gaze historically based in European imperiality, capital, and metaphysics. He identifies the beginning of the postcolonial era as the moment when the unified myth that he calls in quotation marks the "eyes of America" and the concept of document or record that was *Life* magazine come to be exposed to the danger of dissolution because "the eyes looking back from the third world [which he also calls the 'historical eye of the oppressed'] began to be understood by part of the US public" (44), although those "eyes of America" continue to have a disconcerting resilience.

For Taki, there is nonetheless a gap opened by the (ultimately momentary) death of *Life*: "At the same time that *Life* brought to the surface an image of the masses, it absorbed the consciousness of the masses, and made them one part of its own story. The fact that *Life* was abandoned [*haihinka*, made junk] as a medium is political, and this happened [this junk media/abandonment was

born, as it were] when the masses began to have their own voice. . . . This potential for the acquisition of a voice is precisely what is indicated, as a photographic negative, in *Life*'s death" (49). Taki hovers intriguingly between the metaphors of voice/parole and those of the photographic logic of the negative, just as above he conceptualized the other side of words alongside the inverted eyes. In another mixed metaphor, like Matsuda with a figure of burrowing, he envisions the conditions of possibility for "digging out the voice."

As Benjamin and other Frankfurt School theorists also argued, it is through mass media and technological reproducibility that the idea of the mass comes into its own, even as it is, in some fundamental way, objectified or managed through these same media. Taki extends his own analysis of the concept of the masses:

> Until very recently there was a deep-rooted perception of the masses as a floating thing that was easy to manipulate as a whole. However, whether it has a voice or not, whether this voice is only internal or external, individual or collective cannot be decided. On both of these sides, both of these faces, [the problem of speech/parole] is correlated with "freedom," and moreover, concrete and real freedom itself can have a metaphysical meaning. For as long as they are split by class, neither the exclusive and internal intellectual bourgeoisie nor the regulated masses has a voice. *Freedom* itself is (just) a *word*, but no one yet has this *word*. (48)

The subtlety of Taki's point emerges in his attempts to transcend the "demon of binary" that haunts the very language and analysis of freedom and voice. Metaphysics and materiality meld; there is an "ambivalence of media" in that it holds to a place of having and not having a voice, "opening up and closing down" possibility. He goes so far as to suspend temporarily the question of having or not having a voice (parole): realizing this opportunity depends on the transcendence of class divisions, the division between individual and collective, as well as between materiality and metaphysics.

Examining the paradigm shift of the New Left at this (transnational) scale, we see how the concept of parole takes on a central role: it opens a promise for imagining (mediated) immediacy, response, and interaction, overturning or breaking through the homogenizing structures of time and space. Though the theory of the last thirty years has taught us to find even tempered calls for immediacy suspect, we can nonetheless respond to these articulations of a movement that would aim to be both practical and theoretical at once—a dismantling and trenchant analysis of critical impasses, which these theorists offer for problems that extend only deeper in today's new media theory and

utopian/antiutopian dialectics of digi-speak.[46] For Taki, the ambivalence of the media is that it "opens up *and* closes down political possibilities" at each stage of advancement. Nakahira (quoting Georges Sorel on the disheartened optimist) says that a "pessimist's glory" is to "stay in this reality and to crush it," representing his own kind of positive negativity.[47] Each media theorist carefully evades the naive optimism of unqualified agency or subjectivity, as well as a reified or essentialized notion of embodiment. Instead, they focus on the ideas of movement, liminality, and affective irruptions, trying to frame a critique that will allow for a grasp or handhold on the pervasive system of media. While this system of media in its own way will come to absorb those very interventions themselves, or perhaps redeem them, cash them in, by turning both Enzensberger and their own responses to him precisely into a media event, our hesitation and slowed-down look at these ideas of the potentiality of parole may reclaim the force of these ideas for understanding ways of navigating critically from within transforming media environments.

The Future of Media

The moderator of the Enzensberger symposium, Konno Tsutomu (Ben), insightfully summarizes the problems and approaches to media that emerged from the culture-industry debates at the time with an eye toward the increased prominence of electronic media and future changes in the media system. Konno, of the independent television production company TV Man Union mentioned above, along with his colleagues Hagimoto Haruhiko and Muraki Yoshihiko, proposes a mode of thought from within the "concrete, everyday labor process" of working in television production, as a "broadcast laborer" (*hōsō rōdōsha*).[48] Some critics in Japan, like film scholar Hirasawa Gō, would point out that there should be a **very dark line** drawn between theorists like Matsuda Masao/Tsumura Takashi/Nakahira Takuma | (there it is) and Konno Ben and his TV Man Union group. Matsuda, with his entirely unflinching critique of capitalist structures, was expelled from France on suspicion of plotting guerilla activities with Japan's Red Army and continued to support escalated armed resistance from within Japan. People like Konno were, from Hirasawa's perspective, entirely aligned, or (depending on your stance) absorbed or colluding, or at the very least believed it was possible to work from within the established TV system.[49] The problem, then, according to Konno (citing Tsumura), is how the "two attitudes and two battle fronts"— the critical spirit of the radical militant Left and the "proposals of the possible" that work within the media production process like his own—can "be

mediated synthetically (strategically)."[50] As we saw above, Tsumura rejected the stance of radical negativity of the Japanese leftist intellectuals and urged them to move toward thinking "what is possible," or at least to explicate the base and conditions of the existing contradictions. Yet Matsuda and Nakahira also emerged into their own forms of radical practice and continually rethought their relation to the larger media systems. In their 1969 book, Konno and his colleagues had attempted a praxis-based theory of television based on a potentiality of television's "present" time:

> If "power" is that which has the right to restructure time politically as a matter of course and then present it as "history," then the existence of television, which tries to present the "present" [*genzai*] **as it is** would be something difficult for power to allow. If "art" is that which selects and internalizes "time" and presents it as a "work," then television, only by *pursuing time and thus trying to possess its own specific expression*, will lack the essence of art in its primary sense. Not desiring to be restructured either by power or by art, but only by *creating/developing the present* can television determine its own future. And that which can do so is of course not the functionality of television itself but the new expressive person who has taken part in television: the TV man.[51]

There is more to say about the idea of capturing the present as it is (he writes the words in English as well as paraphrasing them, *aru ga mama*) and its odd parallel with and differences from theories of photography and document in the same period, even those of the (dark line separated) Nakahira in his *Circulation* project, who "cuts up the flow of time" and "buries history within it . . . like a time bomb." Yet Konno, along with his colleagues and contemporary critic/artists like Tōno Yoshiaki, in this heightened moment of television broadcast, is most interested in the potentiality of TV's live broadcast qualities. He understands that it is easy to mistake a theory of media for a "theory of the future"—a superficial optimism and opportunism. Konno begins his discussion of the Enzensberger symposium with his group's manifesto from the book in order to attempt to aggregate the more possibility-inclined position (although he refutes the position of optimist for himself and Kawanaka Nobuhiro, producers of the event in its media form) with the more purely negatively dialectical critical stance of leftist theorists who, like Matsuda, find themselves "dumbfounded and taken aback" by Enzensberger's position. While Matsuda attempts to move beyond the binary, Konno tries to envision—and he again turns to the framework of mediation, a term worth further inquiry here—some way to mediate and/or synthesize these

seemingly opposed frames and hence to come to a kind of "organization" that would be strategic. Thus he returns to the problems of mobilization that Matsuda also left us with, but with a very different tactical approach.

Konno thus allows us to see clearly one wing of a transition that was taking place in this historical moment, from approaches to photography and document with their theories of matter/materiality toward thinking about electronic media/television (he calls it *chūkei no shisō*—relay-thought) as a site of emergent media theory. The disparate media theorists who gathered to engage in these culture-industry debates give us a fuller picture of the possibilities and contradictions that opened in this key era of the development of electronic media, problems that persist unresolved and in many ways remain caught in similar impasses in today's critical writings on capitalism, globalization, and digital media.

How, that is, can one mobilize in a world where so many things are already (and increasingly) mobile without really changing? What does it mean to move (affectively)? To intervene at the affective scale, taking into account paradoxes that are not only linguistic but also material, mobilizing relays, resonances, and gestures both for the infrastructure as subject and for the mediated, embodied subject as apparatus? Nakahira, Matsuda, and Tsumura offer highly incisive analyses of the media system within the rubric of a "total media" (*sōgō media*) and a broad comprehension of urban media geographies. Tsumura, for example, writes in 1971, "When the computer line and television are combined, and albeit a somewhat radical hypothesis, if NHK and Nippon Telegraph and Telephone Public Corporation were to merge, this net will perhaps possess power equivalent to the former imperial state [*kokutai*] system."[52] We might note that the term *sōgō* (total, synthetic) is the same word that Hanada Kiyoteru used to talk about emergent intermedia as a synthesis/composite, in the theoretical work that became a precursor to intermedia arts and expanded cinema. While Taki sees reason for a qualified hope in the death of *Life* and the activated return of the gaze of the third world, Tsumura (and Konno) ask in different ways how to mediate between two seemingly opposed strategies or, more pertinently, to transcend (shift their axis of) opposition. Tsumura quotes his own statement from the end of the symposium to open precisely this question:

> It *is real* to say that there is nothing to be done except struggle persistently within the system, however unstylish that position may be; and it *is real* to say that the only way to proceed is by complete personal refusal. Each approach grounds itself on one side of the extreme polarity of

bourgeois society which continues its "flight toward the future." Neither approach can therefore smash through its own *limits*—which are the limits of this society. The problem, then, is none other than this: how is it possible to *mediate* [*baikai*] synthetically [strategically] these two attitudes, these two battle fronts, one that is the display of the possible, the other that is leftist criticism?[53]

Tsumura goes on to develop his concept and practice of "limit criticism" (*genkai hihyō*) as a response to his own question. Reflections on media, that is, require a larger grasp of "dominant urban media" as environment within a broader biopolitics—what Tsumura calls "supermedia."[54] This idea of supermedia opens the idea of media to include aspects of the flow of information such as finance capital (credit), the logistical distribution and transport systems for moving objects through urban space, and political/social organizations: he thus opens media to an even further encompassing, and prescient, understanding of where the culture industries were heading, and the breadth of perspective that would be necessary in order to begin to challenge them.

Rereading 1970s media critique and culture-industry debates thus takes us to a moment when globalization was imminent and perceptible, 1968 was vivid in recent memory, and a new battle of position—the slower battle of significations—was taking a new form. An understanding of urban infrastructure and social forms as part of the media system continued to open leftist thought and energy to new critiques of the workings of class and racial power. These critiques led to challenging efforts to act within and to break through existing frames, to harness and activate the potentialities of media forms. In chapter 4, we will see how visual media can open up the subtleties of affect and embodiment, the apparatus of social networks, and the ambivalent place of the subject or individual within these frames. In that work, photography refigures gender politics and layered historical temporalities. Yet already in the early 1970s, the feeling of a pressing need for present action, combined with a profound sense of theory's necessary relation to all of these forms of daily practice, found one compelling transnational articulation in a way it has seldom touched since.

The Afterlife of Art in Japan

A Feminist Phenomenology of Media

Ishiuchi Miyako

I am not photographing the past. I am taking the present moment, the time of the now, when these remnants are here, together with me.—ISHIUCHI MIYAKO, interview, July 11, 2014

The broad cultural debates of the early 1970s represented a key realignment in artistic and political emphasis by New Left artists and activists. From a strategy of attempting to change social space through "battle," direct violence or protest—what the artists, citing Gramsci, called a "war of maneuver"—artists and activists shifted toward a "war of position" (*jinchisen*), a battle waged on the field of cultural representation.[1] With a heightened focus on class, race, and cultural power structures, they debated the role of mass media in carrying forward that battle for transformed cultural values. Radical landscape theorists such as Matsuda Masao and photographer Nakahira Takuma argued that nothing short of a complete overhaul in the structures of the culture industries would enable true change. Others, like Tsumura Takashi and his industrial research group, and collectives like TV Man Union (Terebi-man Union) tried to invent more interactive forms of television production that would disrupt the existing top-down models and mobilize broadcast TV's specific temporality. Some of TV Man Union's experiments

presage utopian writings about the interactivity of the internet or of fan culture (anyone can be a producer).

In each case, reading and analyzing the workings of these changes at both the technological/social and personal/micro levels, these artist-theorists grapple at an intermediate scale with the larger structures of media. For some writers, the shifting media ecologies could open new potentialities in structures of feeling, either to disrupt the existing rhythms of sociocultural life as they pulsed through individual bodies and urban spaces, or to evoke liminal movements of the unexpected. For others it was a question of calling for a radical block and disruption, in the form of breaking the relentless cycles of productivity, through a trenchant refusal and silence of the parole (voice)—bringing to mind what Ann Smock, in another context, called "a voice that was not just bereft of, but also preserved from, all ability and capability," that "no relief, no consolation whatsoever—mars."[2] These varying routes offer evocative possibilities whose force is most apparent when, at the affective scale, we trace the transition between first-person perception and larger systemic frameworks, those anonymous frames that overload and condition the life of subjects.

Expanding on the insights these theoretical shifts offer, this chapter turns our focus to the afterlives of these media theories and practices in more contemporary art. Recent works embody a critical extension of the earlier theories and make visible in new ways the intermediate or middle range of agency on the affective scale. Further refracting the vacillation between critical and reparative approaches through the lens of gender, the works in this part of the book highlight a structure that has been implicit already throughout the work on intermedia, animation, and theories of the culture industry thus far: the foreboding of disaster and survival in the aftermath of loss. As we saw in intermedia art, a sense of overwhelm underscored the vulnerability of the sensorium and of the individual subject within larger social structures. Animation refracted the violence of social upheaval via its resonances with student and worker protests of its time. Reflections on the Vietnam War—along with problems of colonial domination and the eventfulness of the Red Army's rise—played a central role in theories of the culture industries and reflections on media's potentialities and impasses. In the more recent artworks I study here, those larger structures—technological, institutional, mediatic, sociopolitical—include a picture of time's fragmentation within the force of historically significant events of loss: war, occupation, and the aftermath of the earthquake, tsunami, and

nuclear meltdown of 3–11. Absorbing and realigning earlier moments of loss, the later works bring aftermaths, afterlives, and vulnerabilities to prominence on an alternate horizon. The critical modality and the inventiveness of navigating among people, institutions, and systems are brought to bear in a new way in this more recent art, to mobilize a critique of the infrastructures of gender and to generate a renewed understanding of the workings of collectivity.

Ishiuchi Miyako, the photographer who is the subject of this chapter, forms something of a bridge between the 1960s–70s in part I, and the 2000s (roughly 2002–14) in part II of this book, given that her career began in the 1970s, as do the intervening works from the 1980s–90s that I consider before turning to the early 2000s. Though she came to fuller international prominence within the last twenty years or so, Ishiuchi's early career began concurrently with the *Provoke* photographers' work and the rise of intermedia art, through photographs that explore landscapes and bodies, textured surfaces, and temporal dislocations. Her works give politically charged spaces (Yokosuka, location of the US military base where she grew up) and historical events (such as the bombing of Hiroshima) an alternative structuration in relation to the problems of media, affect, and infrastructure. Inspired by recent feminist philosophy that allows issues of gender in their broader perturbations to revise perspectives on a wide spectrum of cultural categories, this chapter considers how the problems of infrastructure and media have (always already) had a gendered history, in ways that philosophical thinking can help us see.

Roughly concurrent with the rise of *Provoke* photography and intermedia art, and throughout the culture-industry debates discussed in chapter 3, Ishiuchi studied textiles/weaving at Tama Art University, where she started in 1966, joined a film study group, made an 8 mm experimental film (*Rabu mainasu zero*, Love minus zero), and cofounded a group called Thought Group Existence. She also joined the all-campus barricade of Tama Art University in January 1969 at the age of twenty-two. Though her early work and formation overlaps in time with much of what I have considered in part I, her first photographs were shown in an exhibition in 1975, and it was 1979 when she received the fourth Kimura Ihei Award for photography, a recognition that, as Gunhild Borggreen notes, had the dual role of valorizing the work of individual photographers and further valorizing photography's role as a legitimate art form beyond its utility in journalism or its place in photo-specific journals.[3]

Ishiuchi herself has at times resisted the use of gendered criteria as a central factor for evaluating her work, calling that element trivial or claiming that such issues have "nothing to do with the photographs." In my view, the photographs do present or lift elements of gender into phenomenological view—that is, into visibility as textures, surfaces, ruptures, and seams at the level of the material, of matter—and I argue that this phenomenology makes gender visible/perceptible in its specificity as an infrastructure of the social. Whereas intermedia works render visible the semi-unseen infrastructures of the urban and social systems within the media and bring the power regulations of the urban environment into overt media critique, Ishiuchi's photographs bring the social role of gender—the power landscape of gender—into palpable and sensible, affectively moving form. Through her different series discussed in this chapter, that power structure also ultimately comes to entail a meditation, indirect or direct, on loss, disaster, and paradoxical temporality, in ways that become central also in later works of contemporary art post-3–11, both those that allusively evoke and others that more directly call upon the aftermath of that triple disaster. Beginning with this chapter, the second part of the book, then, unlocks the legacies and "retroactivation" of the media theoretical discourses of the earlier chapters, thus to understand the highly differentiated approaches of a selection of contemporary artists in the representation of media and infrastructure, loss and historical disaster at the affective scale of inquiry.

This chapter turns back chronologically to Ishiuchi's earlier emblematic work that takes the city of Yokosuka as a framework and then introduces her work from the point of view of her more recent reception. By her focus on textures and her medium of the photographic grain, she realizes and makes visible the intermediate, affective scale of perception in the Yokosuka landscape (1976–79). The historical and personal circumstances of Yokosuka take on a new and yet more pointed valence in her less-known Polaroid series *Dōkyūsei* (*Classmates*, 1984), where we see the infrastructures of gender play out in an ambivalent yet performative way, visible yet remaining partially outside of awareness. The chapter closes with Ishiuchi's multilayered and multidirectional reflection on loss in her *mother's* (2002) and ひろしま/*hiroshima* (2007) series. While reading her work as hovering between the personal and the broader historical frameworks is not new, a closer reading of them opens up more precisely how she evokes that affective edge, the methods and processes she uses for her own media theoretical interventions as an extension of postwar media practices and as a bridge between those concerns and more contemporary visual arts.

Gender as Infrastructure

Looking back to the 1950s, under the banner of a certain realism, the photographer Tokiwa Toyoko had shown in her photographs how strata of time constructed Yokohama and Yokosuka not as unique instances but as part of an explicitly layered historical imaginary. Tokiwa's photographic works had been little recognized and considered mainly as documents of Yokohama history up until the 2019–20 Bombas Gens Centre d'Art exhibition *La Mirada de las Cosas/The Gaze of Things*.[4] In her work, Tokiwa captured the power and presence of Oroku, whose "emotionless expression" in her hut in the red light district of Yokosuka flashes viewers back to the 1920s–30s when Oroku began her work in Yokohama's red light district. Tokiwa's vision introduces a temporal layering that traverses the prewar and postwar incarnations of those places and traces the lives of working women of her era.

Two decades later, Ishiuchi became known for her photographs of an alternate Yokosuka, one that shifted the frame from the more expected political discourses of her time about that site toward a focus on surfaces and textures as refractions of the infrastructures of gender. In a way that one could consider an extension of her work on Yokosuka, in 1984 Ishiuchi took Polaroids of the women in her own high school class in a park across from Yokosuka Naval Base.[5] She asked the women to come in *ichiban ki ni itteiru yōfuku* (the clothes that appeal to you most), a move that would seem to highlight the women's particular subjectivity. However, the individuality of each face, each carefully selected purse, each gaze into the camera press against the force of the collective they construct. The photographs frame these respectable-looking women in their moment, with a backdrop of both Yokosuka's history and normative social roles (figure 4.1). By contrast, Ishiuchi herself has more of a punk-looking haircut and attitude, standing thin in her jeans and casual red shirt, one hand in her jeans pocket and the other holding the shutter release cable to the Polaroid camera (figure 4.2).

Ishiuchi's 1984 Polaroid series *Dōkyūsei* (*Classmates*) thus begins to capture one view of what it was possible to become as a woman of her generation and cultural location: her gaze is compassionate yet unflinching, relentless in its pursuit of the moment of contact (Polaroid as the embodiment of the momentary) that will transform what is in some ways an ordinary photo into one that touches the politically charged, broader scale of the affective.[6] The fusion of the documentary framing in each photo with the personal and specific case can touch and disorient the viewer. There is the opportunity for connection, intimacy, and a close-up view combined

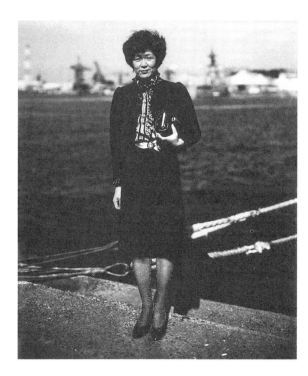

FIGURE 4.1 © Ishiu-
chi Miyako, *Dōkyūsei
#6* (*Classmates #6*,
1984). Courtesy of the
artist and The Third
Gallery Aya.

with a distance and objectivity created by the precisely repeated framing and matched composition across the fifty women photographed.

"I was too busy taking photos to get dressed up," Ishiuchi laughed in an interview.[7] Resisting a reductive political message, Ishiuchi's words tell us what many of her photos tell us: "This could have been me; I could have been this." Still, Ishiuchi's incisive gaze in 1984 at Yokosuka cracks open a world of imaginative labor and creative pleasure, an alternative range of possibilities she would choose, so unlike that suggested by the appearances of the other women. As a set, the photos speak to the strength of her contemporaries and their survival, both hers and theirs, in different ways. They also clearly mark her departure from the usual options open to women upon graduation from Yokosuka Second City High School.

These classmates are about thirty-seven years old in these photos, so about twenty years after graduation. Normative social values would have them engaged in the type of social reproduction expected for women of that generation—they would present themselves as wives and mothers, with a certain degree of wealthy-bourgeois respectability—a prettiness still present but marked no longer by the extreme youthfulness of a *kawaii* (cute)

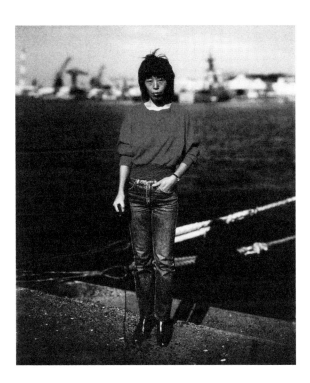

FIGURE 4.2 Ishiuchi herself in the *Dōkyūsei* series. © Ishiuchi Miyako, *Dōkyūsei #14* (*Classmates #14*, 1984). Courtesy of the artist and The Third Gallery Aya.

aesthetic. While the provisionality and instantaneity of the Polaroid might imply a spontaneity or sudden impulse, the women stand—"framed up"—on a precise spot, the ropes of the port on the diagonal behind their knees, the dark blue of the port's water framing the backdrop to their clothing, the opposite side's Yokosuka Naval Base out of focus beginning around shoulder height. The women cast their shadow in bright sunlight against the concrete wall that marks the edge of the water—backed up against the chain-metal ropes that block the women, one might say, from tipping backward into it.

In one photo (figure 4.1) we see a woman with relatively short hair, black low-heeled pumps, and black stockings with a knee-length black skirt. The texture and properness of the tights contrast with the raw infrastructure of the concrete and metal chain ropes, partaking of very different universes: the ropes could form part of one kind of reflection on Yokosuka's naval base, its place in the history of Japan's high-growth economics, while the clothing speaks to modalities of gender—the role of the woman and her labor, as she forms both a pillar of the community and in many ways is tasked with being its invisible supporting ropes. In her left hand this woman grips a black leather purse under her arm—an image that might symbolize her economic

centrality or stability, the very niceness of the purse itself as part of an out-fit of the respectable woman playing out her role. We glimpse the red of a manicured nail. The grip on the purse is active, while her other hand hangs straight to her side, posed. This is not a person passively imprinted with the norms of gender. Instead, she is actively carrying out—with the force of her intelligence, practicality, and sociability implied by her beginning of a half-smile and her gaze into the camera—the emotional as well as physical labor of specific social forms in a given historical moment: the early years of the economic bubble. Based on the frills and stripes of the chic gray-and-white blouse whose collar nearly reaches her chin, the purse, the tailored black jacket with a slight but tactful puff of shoulder visible against the blurred whites of the shipyard, you might have her say, "I've made it." A certain and we now know fleeting attainment of a dream of security and economic prosperity: no longer quite so young, not yet middle aged, the respectable woman of all time, the platonic ideal of the later-thirty-something woman, here in an ambivalent relation with a suspended history, even as the space of Yokosuka, with its violent past, and what we know of the bubble-piercing recession place it contingently (before us) in its moment.

Tsuchiya Seiichi writes of Ishiuchi's photos of the Yokosuka buildings near where she grew up that whereas several famous photographers such as Tōmatsu Shōmei, Moriyama Daidō and Kitai Kazuo had photographed Yokosuka based on the 1960s thought of "resistance" against the US military presence, "when Ishiuchi photographed Yokosuka between 1976 and 1977 (her first Yokosuka series, later published as *Yokosuka Story*) the 'YOKOSUKA' [in roman letters/as Americanization] was perhaps *already over*."[8] The latter YOKOSUKA refers to the vision of that town in the history of postwar photography centered on images of US GIs and English-language signs ("The HONKY TONK," "Draft Beer," "Hotel Sacramento") in which the figure of the *pan-pan* girl plays a prominent role. These earlier photographs focused on young women and prostitutes who could be found in the streets of Yokosuka as a corollary to the US military presence. Their private lives off duty waiting at health clinics as well as their fraught interactions with officers in the streets form key subjects of Tokiwa's intimately captured images as well. Earlier representations thus form another imaginative backdrop for the very different—in fact opposing—later vision of femininity that *Dōkyūsei* offers, mediated through Ishiuchi's own three-part Yokosuka series of landscapes (1977–79). And the repetition formed by the many classmates ruptures yet again with the image of Ishiuchi herself.

To make the bridge between the forms of infrastructure and mediatic potentiality discussed earlier in this volume and the works of contemporary art that make up this last part, we might return to the questions of bodies and systems in the discussion between Tōno Yoshiaki and Isozaki Arata in their conversation in 1966 in *Bijutsu techō* about *From Space to Environment*. There, Isozaki claimed, "We can no longer grasp architecture without looking at the scale of the body of its assembly or even a city into which such assembled bodies are systematized. . . . Something personal, or something like the smell of a person, is unavoidably washed away first, and then only systems that have become abstract can survive."[9] He recognizes the put-together nature of architectural space as a kind of body; the scale of systematization of these bodies takes place at the level of the larger urban space. What survives are not individual bodies, in this formulation, but larger abstractions and systems. The biomorphic framework is transferred or transformed here into something on the infrastructural scale. Ishiuchi's photos, however, manage through their affective work to bridge these two scales. Her work recognizes the social infrastructure (*dispositif*) alongside the architectural. For Isozaki the individual body is taking place on a different phenomenological plane than those he describes for larger urban systems, such that, with the aggregation of environment, we lose the point of view that could account for the "smell of a person," the "something personal," which gets unavoidably "washed away." Yet both Ishiuchi's Yokosuka photos and her *Classmates* series manage, oddly, in each individual snapshot to retain something like that "smell of a person," even while showing us how the very self-selected or expressive way that the individuals perform themselves also already partakes of the systemic, even symptomatic.

In their Polaroid medium, these images account for a specific moment while in their seriality they create a larger schema. The scale of the body remains uniquely itself while also forming a tiny building block in a much larger structure. Perhaps Taki Kōji, in his essay that came out in the context of the emergence of *Provoke* photography, presciently articulated what would become of the emphasis on materiality in Ishiuchi's work, when he wrote, "A photographer knows that the world surpasses his self. The world lies in the totalization woven by the [interaction of] its super-human structure and the human being that is a bare concreteness."[10] His concept of "bare concreteness" of the photographer interestingly mirrors the performance of Ishiuchi in the context of the *Classmates* series; as a more bare, stripped-down presence lacking the bourgeois trappings of others, she also embodies

an alternative option. So small, thin, almost transparent, her shoulders barely reach the top line of the sea where the Yokosuka base frames the backdrop; her legs so thin that the sun in the space between them separates their two distinct shadows, while her hair stands up a bit rakishly, like a cowlick. Her eyes are narrowed, and she does not seem to have makeup or a manicure. In place of the purse, we see one hand in her jeans pocket, while her right hand holds the black shutter cord leading out of the shot to the camera itself that will take this picture. Ishiuchi is different, yet, in other ways, she too was formed by this landscape of Yokosuka; she too, while different, is one of them, as they are one of her. She is implicated in the fates of these people, these women, and implicates the viewer as well.

As Tsuchiya Seiichi wrote, in the continuation of his comment on the Yokosuka series, Ishiuchi's "photographs are characterized by her search for the I/me [*watashi*] through visiting Yokosuka, her place of origin. . . . Ishiuchi's I/me does not cling to a unique, inherent ego/self but remains open to multiple and latent possibilities of a plural I/me."[11] Reducing the statement of *Classmates*, or of *1•9•4•7*, another series I discuss in a moment, to a political act of resistance (seeing it only as an opposition to norms) would reduce the force of the act of solidarity that these photographs also ambivalently become. Not an act of shoring up of social systems in the name of reproduction and community, as Iizawa Kōtarō had described the work of the 1990s female photographers,[12] but still, not a fully first-person act of objection either; the correspondence between the women's positionality forms an important substrate of the critique it offers.

Sianne Ngai's description of the differentiation between emotion and affect comes to mind: "Certain kinds of feeling become maximized when we are uncertain if the 'field' of their emergence is most subjective or objective."[13] Ultimately rejecting the affirmation of the binary opposition in favor of a more subtle continuum, she specifies, "At the end of the day, the difference between emotion and affect is still intended to solve the same basic and fundamentally descriptive problem it was coined in psychoanalytic practice to solve: that of distinguishing first-person from third-person feeling, and by extension, feeling that is contained by an identity from feeling that is not."[14] At the end of the day, the affective impact of Ishiuchi's *Classmates* has to do with feelings and material conditions that take place both at the level of the first person—where they seem to originate (just as in some ways this chapter seems to focus biographically on a particular individual)—and at the level of the third person (transcending that individual focus). *Classmates* works in that intermediate realm between what would traditionally be called emotion and

what would be called affect, both of which are folded into/included in the affective scale as articulated in this book, which is particularly interested in the relays and structural navigations between them. *Classmates* allows us to access the level of the third person by its serial structure, the repetition and subtle differences of its framings; the ever so individual yet socially embedded self-expression in the choice of a handbag, the tilt of an arm, the grip of a hand, the determined gazes into the camera; and the work of being a visibly normal member of a social class, a gendered-clothed (seemingly nonqueer) embodiment, a bulwark of a culture in a particular historical moment. Later, Ishiuchi would strip off these clothes, mark ambivalent alliances among the women, and would allow us to see the bare skin of her subjects, as well as the bare garments freed from the burden or constraints conferred by their now-absent owners. But for now, through a seemingly simple device, Ishiuchi staged the occasion to make perceptible, at the affective scale, this picture of larger structures transitioning through images of individuals, structures nonetheless poised to be unraveled, laid bare, or undone.

The Textures of Gendered Labor

"Whether 'photography' or 'language,' all acts of expression [*hyōgen kōi*, all expressive acts] consist in, after all, one's efforts to figure out, by running with his/her own body through the skin of uncertain phenomena, what true being [*jitsuzon*, existence] is."[15] In Taki Kōji's writings on photography, the question of skin became central. The "uncertain phenomena" that are the subjects of the photographs have to be approached, precisely, by bodies—they have to be "run through" with the very fragile and contingent apparatus that is one's "own body" to attempt to figure out—and here he draws on existentialist language—what "true being" (*jitsuzon*) is. "To push it further," he writes, "all expressions lead to an effort to find a *new structure* beyond the structure to which we are exposed on a daily basis."[16] While he is writing of an effort to transcend the everyday apparatus of thought and understanding, to get below or beyond it, his ideas emphasize the key role of bodies and skin in their relation to uncertain phenomena posed by photography. In the wake of her earlier series of textured landscapes, buildings, and clothed, posed bodies, Ishiuchi moves on to attend closely to the traces of time and labor on the skin, through her photographs of hands, feet, and unidentified parts of bodies with scars and wrinkles in various series over the next decades after *Classmates*. Skin becomes another place in her work where time and labor, pain, and survival leave their mark. The work of bridging the specifically

personal and the anonymous, the individual and larger systems, is mediated here through photographs taken directly of skin.

In 1990, for example, Ishiuchi, then forty-three years old, began to take the series of photos that came to be called *1•9•4•7* after the birth years of herself and the other women in the photographs; the captions list not their names or locations but their professions—housewife, hairdresser, pub manager, and so on. The labor of their lives up to this point comes to be visible in the materiality and texture, the light and shadows of their hands and feet. Ishiuchi asks, "Is it not true that those who happened to be born on the same year (as I was) hold a potential to have perhaps *been* me?" (*moshikashitara watashi datta kamo shirenai kanōsei o motteirun ja nai ka*).[17] Again we see the theme of that potential interchangeability, the plural "I," which is not quite the same as a "we" or a community, but rather a recognition of how the "I" can occupy a position between, as it were, the third and first person, can multiply in its situatedness, can bring to visibility—through a concrete, minor detail of foot or hand—a whole structure and system of labor and power, a whole implication of intimate knowledge.

Take a photo of hands, for instance, from *1•9•4•7* (figure 4.3). Later, in works like ひろしま/*hiroshima*, which deal directly with nuclear catastrophe and its aftermath, Tsuchiya Seiichi's concept of the vacillation between the singular and the plural I/me breaks down—as it were, ethically—in the face of a disaster too large to be contained in the concept of either the social or the personal—something that he, like other philosophers of catastrophe, have chosen to name "Absolute Other."[18] Whether one chooses to phrase it in this way or not, the question of otherness could already be said to be inherent in the ontology of photography. Yet looking at *1•9•4•7*, what comes to the fore are questions of time and labor; social, discursive, and historical questions come to be, arise, but then also fall away in the face of the integrity of an individual image's concreteness, its "bare concreteness," as Taki Kōji put it. In this one photograph, we see a monochrome of two hands clasping. The *1•9•4•7* photographs' associated information, not given directly proximate to the images ("hairdresser" or "housewife," "salon assistant") lets us know that in each case these are hands of someone who has engaged in work. The series title reminds us of the parallel with the photographer as well, those hands that press the shutter and hold the camera and will eventually develop this image in chemical fluids—possibly thereby also gaining distance from the ideality of the manicured, well-cared for, leisured feminine hand.

For the captions that say "housewife," we become even more aware of the magnitude of the underrecognized labor these hands have done. If the label

FIGURE 4.3 © Ishiuchi Miyako, *1 · 9 · 4 · 7 #11* (1988–89). Courtesy of the artist and The Third Gallery Aya.

says hairdresser, or manicurist, as in some of the images, we may imagine the leisured feminine hands and heads these rough hands (now forty-three years old) have worked on over the years, in parallel with Ishiuchi's hands. (In 2000, celebrated feminist sociologist Ueno Chizuko would publish *Japan's Misogyny* to record the limitations of professional opportunities still available for women, and the backlash against feminist thought in the 1990s.)[19] Yet in these photographs, we see problems like this sociocultural limit and its lived experience embodied in a very concrete, human, approachable form. One could even say that it's an empathic form—we feel as much as see the labor through our experience of these cracks in the skin, the hardening of the feet. The photographs are also assertive—displayed in a large size, showing the visible traces both of a survival, a life lived at the close, personal microscale, and at the same time marking part of the range of options for gendered labor at this historical moment, in the form of skin's textures. The work that this one woman, these two hands, these ten fingers have done, which the captions help us imagine—to wash the dishes, do the hair, clean the laundry, clean the nails of other, wealthier women, or of children and men—this labor takes the form of something writ large that the eye cannot miss.

A Feminist Phenomenology of Media 153

Ishiuchi points out that the husbands of some subjects requested that she not take these photos, especially the ones of feet, perhaps because they are something shameful, private, not to be out in the open. The feelings of pride or shame reveal the norms of exposure: hands for display, hands you see in the magazines and mass media, of course, do not show age—they are not forty-three-, or fifty-three-, or sixty-three-year-old hands—and they are carefully treated, moisturized, displayed for the sake of products. They are not real hands. Yet the light, coming from the right, or from the side, in many of Ishiuchi's monochrome photos of bodies proceeds softly, giving the skin of the fingers, even the nails, a certain luminosity, almost a holiness. There is a quietness of contemplation. As Yomota Inuhiko wrote about a different series, Ishiuchi "appeals to gaze and contemplation."[20] She has a sculptor's interest in shapes and volumes, the weaver's interest in the textures of living skin, and she likens the photographic process to the gradual dipping and soaking of dye for textiles. Yes, these are hands that worked; yet here, clasped, touching each other in the subject's self-embrace and completion, we think of Eve Sedgwick's or even Irigaray's writing on the auto-touch, the tactile capacity simultaneously to be subject and object of a touch. The camera is catching the roughness of these cuticles in a moment when they are not being maltreated by water, or solvents, or the conditions of their own necessity for survival, or their life projects or care of others, but where they can be nothing but seen, appreciated, or at least recognized. It's a hopeful moment.

At the same time, Ishiuchi inscribes these hands within a system, one that includes feet: the rough, wrinkled bottoms of feet that have traveled far, have been stuck possibly in not terribly comfortable shoes, not just for a short time. Imagining the men who asked Ishiuchi not to photograph their wives' feet, we see and hear the echo of their guilt, their unremarked (if one were to go so far as to put it this way) violence—or the violence of the entire system (heteronormative/economic)—and Ishiuchi's sideways traversing of it in the tenderness of these arches, the callouses, the bumps particularly thick on the balls of the feet near the second and middle toes, or on the inside of the big toes in the case of not even very high heels (figure 4.4). We know that this is what a forty-three-year-old (not particularly upper-class) woman's feet can look like—not the feet of leisure and constant pedicures, but the feet of someone who has stood, walked, and been too busy for certain kinds of luxury. She shows us also the beauty of what it looks like to be living, to have survived.

Yet we catch them in a moment of repose. They evoke the time of the photograph, frozen, eternal (as one essay on Ishiuchi titled it, "The Texture of Time").[21] Simultaneously they highlight the time of labor, of being forty-three,

FIGURE 4.4 © Ishiuchi Miyako, *1 · 9 · 4 · 7 #15* (1988–89). Courtesy of the artist and The Third Gallery Aya.

and time's lack, the sense of being busy and pedaling hard up until now, before this occasional pause. (We might recall Pablo Neruda's poem about a baby's feet being like an apple, not yet knowing what they are for.)[22] These feet know what they are for. Part of what is moving, and for some viewers disconcerting, is the way that "for-ness" (as Watsuji Tetsurō once wrote about the transitivity of objects, not people) is here suspended, released, for the moment of the look.[23]

Ishiuchi writes (in an alternate translation of the citation above), "They hold [or enfold] the possibility of having been me [*Watashi datta kamo shirenai kanōsei wo motteirun ja nai ka*]."[24] The plurality of the self opens as a phenomenological perception of surfaces. In one work, we see the fronts of the hands, bare, flat, exposed in their simple presence, monochrome and slightly radiant against a black background. The pointed tips of the fingers take on a particular shine. It is an image of exposure, or of surrender. Spaces between fingers or at the wrists fade into the shadow of the dark background. It is also the image of potentiality, of what those hands might be able to do, of what they might already have done—stopped, caught between moments of doing. In another work (figure 4.5) the toes of one foot reach out into the foreground of the shot, close up, as if reaching out to touch (or be smelled

FIGURE 4.5 © Ishiuchi Miyako, *1 · 9 · 4 · 7 #9* (Beauty Parlor Assistant, 1988–89). Courtesy of the artist and The Third Gallery Aya.

by) the viewer. Ishiuchi takes a particularly active interest in the installation and placement of her works, as is often noted. Given the relation of the viewer's body to the enlarged, rough extremities in *1•9•4•7*—the toes in this one image have an expressive gesture, and the nails of the fourth and fifth toes look particularly thickened and eroded in places—we see the vulnerability as well as the sensibility of these private toes reaching out into the public sphere.

With that vacillation between third and first person, and between public and private spheres, Ishiuchi presents a historically and visually specific framing of a larger structure, but one that takes the form of particular and individual instances that affectively link the subject, photographer, and viewer. By presenting gendered labor in the form of textures, photographic grains, and skin, these works give a specifically phenomenological presence to the affective scale of media, to the middle range of agency—to phrase it another way, to being caught between doing and being done. Like Uno Akira's stretches of skin, these instances of skin freeze for a moment a temporal continuum of potentiality—past, present, future. Yet they are not doing in this moment; they are harboring the im-potentiality, the aspect of potentiality that is not-doing in the moment, is pausing from doing to show sheer potentiality itself. The infrastructural element so central to this book's themes emerges here through the socially structured and gendered forms of labor

implicit in each crack, wrinkle, and layer of skin and nail. In that sense, it is precisely the affective component of the infrastructural that these photographs convey so vividly, and it is their work at the affective scale, caught between personal and infrastructural, that makes them such apt examples of the version of potentiality this book is exploring. Yet it is only through reading them in relation to the later works of *mother's* and *hiroshima* that we fully understand the dimension of implicit loss—whether it be loss of youth, the temporariness of this strength they now manifest, or the eventual erosion of these very hands into aging. These are brave hands: one set of fingers highlights their public face by sporting lacquer with a high shine. Lingering with them, we can feel the courage and effort of these hands in the face of the situations where they find themselves posed. At the limit, we can even feel the historicity of these hands as a series of individuals located at a particular moment (1990, born in 1947) in a continuum with the gendered hands, similarly constrained, similarly laboring, that came before and those that come after.

From this middle phase of her work, and extending into her later work with the aging body of butō dancer Ohno Kazuo and the photographs of her ill father's hands, feet, and face, eventually leading to her photography of scars on bodies after surgeries, one finds an important dimension of time's imprint on the skin. The problem of loss, however, comes to be realized most explicitly in *mother's*, which includes, first of all, the one photograph of a framed photo of Ishiuchi's mother as a young woman standing by the truck she drove during wartime, and several photographs of her mother's scars or burns as seen on her naked body at age eighty-four. The majority of the photographs of *mother's*, however, consist of Ishiuchi's photos of her mother's clothes after her death; these lead us to the striking conversation that evolves between those photographs and the clothing and remnants of atomic bomb victims that are the central subject of ひろしま/*hiroshima*. Many of the photographs in *1•9•4•7* feature pairs of hands, pairs of feet, like a series of staunch partners, working together, in parallel yet each distinct. The hands form a team—perhaps one appearing as if slightly bigger, one smaller—having lived side by side and having been through these things together. The trope of the plural I/we thus layers upon itself, with the hands or feet already constituting a kind of plural "I" in their pairs, then in their resonance with Ishiuchi's hands working on developing these photos of hands and receiving and passing on the images. With the affective link they form with viewers' hands, the plurality links out into a broader network toward a multiplicatory relation of gendered hands and gazes and labors across time.

From *mother's* to ひろしま/*hiroshima*

The *Classmates* series and *1•9•4•7* render visible the infrastructural space of gender construction, as well as class and social expectations, by the sheer force of their very repetition with differences, their straddling of the worlds of the personal, individual, and contingent with the worlds of the conditioned, constructed, and overdetermined. Discussing *mother's* in an interview, Ishiuchi states something similar about that relation between what is particular or private and that which, by being common or ordinary, opens itself to potential belonging to anyone, to a state of commonality. She says, "What I photograph is common and ordinary, happening to anyone. So it is something personal to me, but also something that belongs to everyone."[25] The interviewer Masaki Motoi attempts to press the matter, describing the moment for the viewer of seeing a "personal remnant" and thinking that he or she has something similar: "it appears in front of the viewer's mind as something that is not private," says Masaki. Ishiuchi performatively holds to the vacillation, however, not acceding to Masaki's statement about this arrival at commonality; she refuses to take it there and thus restores to the viewer that subjective privacy: "That is a matter concerning the viewer, and not a matter I should meddle with."

This tendency to press toward the broader collective meaning for her work symptomatically occurs in another interview when Yonohara Kei asks, "Your photos are records and something personal, but do you acknowledge that it connects with a certain kind of universal thing?"[26] Again Ishiuchi refuses: "I don't think such things. . . . I don't want to say from my own mouth that my work is universal." She steps back from imposing a collectivity on the particular instances and intensities she photographs. Yet in that refusal, we can also see her hold to the space of ambivalence between the first- and third-person possibilities, the space in which the affective intensity can be most keenly felt. It is between the individual (personal, subjective) and the collective (systematic, infrastructural) that the affective potentiality and impact can resonate most overtly.

In the 2005 Japan Pavilion of the Venice Biennale, commissioner Kasahara Michiko presented Ishiuchi's series *mother's* as centrally about structures of gender and the social framing of gendered possibilities. Ishiuchi's work, according to Kasahara, "gives a realistic picture of the great changes that have occurred in the consciousness of contemporary women."[27] She goes on to describe the series as "subtle works of art that deal with the dramatic transformation in women's attitudes taking place today," describing how the photos

seem to "embody the will of the person who wore" the clothing depicted in these photos, such that she sees Ishiuchi's mother as "a forerunner of the independent women of today's Japan."[28]

Mother's emerged in the context of what Gabriella Lukács describes as the height of the boom of photography among young women that evolved during the recessionary 1990s.[29] Lukács's essay on the critical reception of this boom focuses on the interpretation of (predominantly male) critics like Iizawa Kōtarō, who called this 1990s trend "girly photography," a trend he saw dominated by "cute, fantasy-driven, and escapist"[30] aesthetics that, in reproducing cuteness and sweetness in family portraits, he understood to reinforce and help to rebuild ties of community that were frayed in the recession. In such critiques, according to Lukács, a certain expected framework of gender disallows a politically disruptive view of the work and in a sense puts art marked as feminine to a reparative task in a conservative sense; that is, such an interpretation would constrain the meanings of women photographers' work to progressive, nation-building, "forward-looking projects wedded to social reproduction."[31] She argues that the so-called girly photography images become more complex when we consider their mobilization of the seemingly spontaneous, near-at-hand, and intimate everyday along with self-reflexive positioning, temporal reversals, and staged events, including posed photos at family gatherings, which thus highlight performativity as an integral part of the reproduction of family forms/structures. The carefully considered use of either digital or analog—technological deliberateness, conceptual labor—makes these works difficult to situate on either side of these gender-overdetermined debates about normativity or opposition. The marketing materials produced around the works only reinforce this difficulty. The critiques of this popular 1990s photography mark an impasse around the binary rhetorics in which the projects are either reaffirming (in the critics' view) or opposing (in the photographers' own views as well as Lukács's) the expectations of normative femininity, family structures, and the affective forms of community.

The rhetoric of broken community and reparative art found new prominence in the aftermath of 3–11, as I discuss in the following chapters. The dimension of political critique, the arts of memorial, and the arts of building futures interlock in complex ways in Ishiuchi's work as well. It seems that community is perpetually in the process of being frayed or breaking apart, and perpetually in need of representational projects that would reinforce or reconstruct it, project its ideality, and constrain its temporality to a rhetoric of forward-looking progress. Yet alongside that continual demand for

a forward-looking, progressive, and unifying view of community, we find a more difficult framework, visible at the scale and level of affect, where the materialities of bodies and the relationship of individual subjects to larger infrastructures take a more critical and multivalent turn. While Lukács is referring to the three 1990s photographers who won the Kimura Ihei Award, this structure of ambivalence around intimate affective relations persists in Ishiuchi's works of the same period, such as *mother's*, and originates in her Yokosuka series of works depicting landscapes, textures, and historically significant present and absent bodies in urban space.

In her work in general, Ishiuchi draws our interest to bodies, scars, garments, and stains on walls and clothing. We observe time's erosion of skin, objects, and architecture.[32] Writing on *mother's*, Yomota Inuhiko claims that the worn-down objects after Ishiuchi's mother's long life "affirmed [it] just as it was, and no scrutiny was needed beyond that."[33] He sees *mother's* as first of all "a work of private mourning and a sign of reconciliation."[34] As he well knows, Ishiuchi's relationship with her mother was multilayered and complex. Ishiuchi took her name as a photographer—both first and last names—from her mother's maiden name (Ishiuchi herself was born Fujikura Yōko).[35] The substitution extends to her life story. Ishiuchi used to claim to have been born in Kasakake Village, which is in fact her mother's birthplace. The question of substitutability, individuality verging toward plurality, literalized here, holds a key in its very excess to the critical and affective edge of this work. The layering of identities (identifications, projection/introjections, ambivalent and consuming desires and loves) extends across generations and across multiple periods of historical time, such that, as an announcement about Ishiuchi's book *From* ひろしま, issued by publisher Kyūryūdō, claims, rather than the "living mourning the dead" within an unproblematic conception of present time viewing a past safely gone, instead "the dead [are] forever watching over the living," in an openness to a paradoxical overturning that destabilizes time's expected vectors.[36]

In *mother's*, when we look at the pink lipstick lying on its side, or the slip that Ishiuchi photographed hanging in her parents' home in Kanazawa Hakkei (Yokohama) in natural light, its translucency showing the filigree of lace (figure 4.6), we may imagine how it would feel for Ishiuchi to touch her own mother's objects after her death, and we may come into an intimacy with this mother born in 1916. We come close to her slips, her girdles, her blue eyeshadow stick with the texture of the imprint the eyelids left upon it, shaping its curved surface as closely as one can to the touch of her skin. And yet, many of us also cannot but remember the old red lipsticks and girdles, hairpieces

FIGURE 4.6 © Ishiuchi Miyako, *mother's #11* (2001). Courtesy of the artist and The Third Gallery Aya.

and dentures of our own grandmothers, also lost—how many jeans-wearing, gym-commuting women today still keep slips, wear girdles, and own reusable lipstick holders with detailed art deco pedestal bases? The effect accumulates as we look at one microcosm after another. The work of plurality is not a leveling of differences, in the manner of some versions of universalism, but the heightening of specificity until it ruptures from within: a plurality formed of repetition and reproduction, displacement and deferral that opens to the phenomenology of photography itself, the art of the afterimage.[37] In other words, as we see each image, and another, and another, there is an absolute particularity to each item, unique and irreplaceable. And yet they build and layer upon one another, like memory traces on Freud's mystic writing pad, so that each one does not feel single, but sedimented with time and strata of barely visible relationship—the relationship between mother and daughter, between women, between mother and object, between skin and garment, between film negative and paper print. They are singular yet also and inherently plural—like photographs. Their uniqueness cracks open to the world.

Second Skin

Tu n'as rien vu à Hiroshima. Rien. [You saw nothing at Hiroshima. Nothing.]
—MARGUERITE DURAS, *Hiroshima mon amour*

A particular and overly repeated version of the antiwar, antinuclear message had attached itself to so many representations of Hiroshima that Ishiuchi said she had for many years felt it neither possible nor ethically permissible to take photos there. She had not visited the city even once until the publisher Shūeisha commissioned her to produce a book of photographs on Hiroshima following the exhibition of *mother's* at the Tokyo Metropolitan Museum of Photography in 2006. Still, it seemed to her a tenuous project at best. "Many people took pictures of Hiroshima, so I thought everything had been completely exhausted," Ishiuchi recounts. "But in the end, there was a Hiroshima I found it was possible to take."[38]

The ひろしま/*hiroshima* series baffles some critics, while to others it seems a natural extension of Ishiuchi's earlier work in *mother's*. To bring the intimate world into the public sphere has always been part of photography's role, but to weave the public sphere into intimate life is what Ishiuchi's ひろしま/*hiroshima* series accomplishes. It is precisely because of the existence of *mother's* that ひろしま/*hiroshima* comes to be a meditation on personal loss, that the I/me opens to this overdetermined multitude of selves known only

from the database of the Hiroshima Peace Memorial Museum: clinical, flatly lit, against a light box.[39] As many critics have also noted, Tsuchida Hiromi, who has photographed the Hiroshima collection as well as the survivors and the empty streets of Hiroshima in the 1980s, "had to confront Hiroshima in a renewed way when both humanist appeals [Domon Ken] and expressionist attractions [Tōmatsu Shōmei or Kawada Kikuji] had been worn out."[40] The early history of Hiroshima photography is a history of the movement from people to objects, from Domon's photographs of *hibakusha* (A-bomb survivors) to Tōmatsu's and Kawada's inanimate traces, concurrent with the *Provoke* circle's landscape photographs, in full-bleed, dark and grainy photo books. Later the move turns back again, or vacillates between them, with Ishiguro Kenji, Kurosaki Haruo, and Tsuchida.[41] In the end, as Ishiuchi herself has noted, there are strong continuities between Kawada Kikuji's photographic project in *Chizu* (*The Map*) and hers, with their focus on the tactility of visual surfaces and the fissures wrought by time.[42]

The layers of mediation, the fixed message of Hiroshima, had made this site impossible to see, on the one hand, and prohibitive to photograph on the other. Ishiuchi's reflections on this subject might call to mind the originary impulse and impasse of the *Provoke* photographers, who attempted to crack open the realm of the already known, the preconceptualized, media-saturated infrastructures of perception. They did this through their experiments with anonymity and their focus on the labor of the photographer's hands in the darkroom, as well as in their emphasis on the concept of documentation, where photographs might be expected to capture elements of the environment beyond the individual's grasp. In other words, those photographers were already experimenting with issues that later become central for Ishiuchi. Her Yokosuka series focuses on remnants of the invisible power structures of that city, there shot through with a reflection on the gendered and sexualized structures of power. Her documents—"traces of time" on the "skin" (walls, paint, crumbling concrete) of the military base and entertainment districts, including the cinema she photographed in 1979 that now no longer exists—thus fall in a quirky yet direct lineage from the *fūkeiron* discourses and the media theoretical interventions of the late 1960s to early '70s—a time concurrent with others' evolving representations of the spaces of Hiroshima/Nagasaki that her later ひろしま/*hiroshima* series would confront.

Her project ひろしま/*hiroshima* is, Ishiuchi claims, not about the past but about the present moment or the "time of the now" (meant not necessarily with Benjamin in mind but resonating with his constellations nonetheless); and it continued to evolve and develop with her yearly visits to the museum

up until a new publication, *From* ひろしま, was released in 2014. Part of what is striking about Ishiuchi's photographs in ひろしま/*hiroshima* is the absence of narrative, caption, and story associated with such artifacts as usually displayed. In these photographs, taken with a handheld camera and developed and processed in large vats on her darkroom floor, Ishiuchi stages an unexpectedly spacious encounter with remnants of clothing. While she is obliged somewhere to provide the donor's name for permissions, as Kawada Kikuji did in *Chizu* (*The Map*), she moves the information out of the line of sight. She does not include the names or stories directly next to the photos either in her photo books or in the exhibitions but places them elsewhere—to allow for a less encumbered confrontation. While Tsuchida Hiromi's *One Piece* gave us emotionally charged yet simple information about the object's owner and how the owner died after Hiroshima's bombing through a detailed caption displayed below the work, framing the object in the center of the white mat and frame, Ishiuchi's version (figure 4.7) perplexes us by being in some sense the same object, recognizable from these other places, such as Tsuchida's photographs, as part of the history of Hiroshima photography.[43] Yet by a seemingly minor detail—allowing the dress to touch the edges of the frame in every direction, at left and right, bottom and top, with the barest edges of both sleeves—she brings the dress closer, and the ripples and wrinkles appear as if the dress might be moving in the wind.

The work, in today's perspective, tilts forward toward the photographs of clothing in the natural light of the window made by Onodera Yuki, who took the pieces of clothing from Christian Boltanski's work and photographed them one by one against the Paris sky of her window.[44] In Ishiuchi's work, the light shines from behind so the viewer can see every hand-sewn seam, and the color of the same piece Tsuchida photographs becomes not monochrome but an indescribably delicate brown-mauve with a pink, skin-like undertone. She imbues the same filaments with a different spirit. Clothing, for Ishiuchi, is a second skin, so close is its contact with the flesh. The Hiroshima garments are stranded, a second skin without the first, left alone to become records of the event after the living bodies have decayed and disappeared. Speaking about *mother's*, Ishiuchi says that clothing "has the same contact point as the skin. . . . The skin of human flesh is on the inside, and the undergarments are the outermost skin. I feel sorry for the undergarments since they remain without the inner skin."[45] Ishiuchi draws viewers to the textures of organdy, the silks, the flower patterns—and toward the story unfolding today, as new objects are donated each year. Many dresses, chemises, and

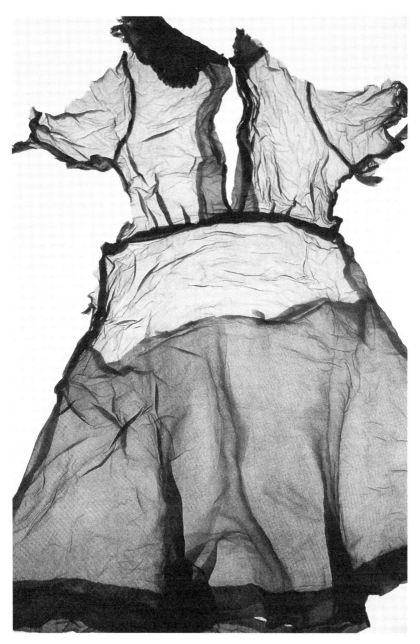

FIGURE 4.7 © Ishiuchi Miyako, ひろしま/*hiroshima* #9 (2007). Donor: Ogawa Ritsu. Courtesy of the artist and The Third Gallery Aya.

blouses stay hidden, folded in white paper in the dark of the museum's basement, until Ishiuchi requests their release into the light.

"If I had been at Hiroshima, I would have worn something like this," Ishiuchi tells us. She began by photographing the objects that came in without proper names, to claim them "as her own."[46] Linda Hoaglund, who made the film *Things Left Behind* about Ishiuchi and the ひろしま/*hiroshima* project, writes that the aim is to "liberate Hiroshima from the weight of its history, so we can imagine ourselves in their fashionable clothes, shoes, and watches, while [we too are] unknowingly imperiled by catastrophe."[47] Ishiuchi recounts, "These photographs are not records or documents (*kiroku*). They are creations (*sōsaku*)."[48] Theirs is a paradoxical, ethically complicated lightness. Writing about the relation between *hiroshima* and *mother's*, Yomota ultimately concludes, "These photographs move in a direction that comes toward, and begins to touch, the mother's artifacts, even while remaining anonymous. . . . They ask of us a direct form of mourning."[49]

Temporality, and the odd reversals that photography can effect in our sense of past and present, forms a key to the work Ishiuchi's photographs of Hiroshima garments perform as, retroactively, we can see they also became for the activation and (re)vivification that she performed with her mother's clothing and objects in the earlier work and with her visions of Yokosuka. This emotional work of giving a (fashionable) subjectivity to lost clothing of Hiroshima, a labor that touches their particularity even within the constitutive anonymity of disaster, thus comes to connect to the overarching project of a gendered phenomenology that, in Kasahara's words, helps to lay a path for "the independent women of today's Japan." While it is clear that the light and transparency self-reflexively evoke the labor and translucence of the art of photography itself, some critics find it troubling and disconcerting that these labors and questions of the structures of the social here change register—without in fact fully changing form—to become reflections on the phenomenology of time more broadly as well as on the temporalities of disaster. For Tsuchiya, the introduction of the framework of disaster, itself a narrative of rupture, fundamentally upturns the reading of her earlier work—just as, as we shall see in chapter 5, the rupture narrative of 3–11 shifts the frame for interpreting the artworks of some of the more recent contemporary artists following those events.

The dress that Ishiuchi calls "Comme des Garçons" takes us back and forth across historical time, as designer Kawakubo Rei's postwar Paris fashion was said to be paradoxically inspired by the blackened and torn garments of the A-bomb; but for Ishiuchi, time flips the other way, when the ripped black

luminous body of the dress stands "here, in the present moment, with me."[50] Rather than Kawakubo referencing and reframing the past of the disaster, here in Ishiuchi's eyes the original object from that past moment works as if to refer forward to Kawakubo's fashion statements of today. The textures of an undergarment and another garment with a burned black pattern convey to viewers a tactile grain through the visual rhythm of their patterns. A blouse curves to the side as if about to fly up and depart the room, while the red-brown stains evoke the larger story, told elsewhere, of a mother holding her newborn to her chest. In the exhibition of her work at the Meguro Museum of Art in 2008, Ishiuchi chose to place the ひろしま/hiroshima photographs high on the walls, "as if they were about to fly upward."[51] Itō Hiromi describes this effect as mythological, the works were so large and elevated, "like a *deus ex machina*" here to save us (who are also lost): "These clothes are alive, not dead: the dark, old objects suddenly had light shining through them, with this sudden impact: now we know—a person was alive."[52] The "distant spacings" enfolded in the lace proffer a sense of aliveness and rich connection between the historical and contemporary women whose touch (and look) awaken these clothes to offer up some of their secrets.

The undergarments hang like those in *mother's*—a mother's hand sewed the air-raid hood or the shirt out of her own kimono. The burning fragments splattered on the hood, marking holes, and the cotton stuffing pokes out. Without a name or date, viewers may imaginatively try on the softness of this silk hood with its blue-and-white lining, or retie the rumpled chinstrap with their own fingers. But this is not a recuperation that would seamlessly tie us back in time or redeem us, just as *mother's* does not make the mother into ourselves, the mother's life into ours. There is, always, the lingering distance of the substitution, the deferral. It is the way these works encompass both an absence or loss—a historically particular inscription with which it is impossible to identify—and a vivacious and disjunctively imaginative forward movement that makes them radical and affectively haunting. Ishiuchi's images hold rigorously to a path of simultaneous resonant connection and specific distance that, after all, could suggest a path through the thicket of precedents for the independent women of today's Japan.

Ishiuchi has always been photographing ひろしま/hiroshima, if by *hiroshima* we mean the discovery in the present of something about contemporary reality that could not otherwise have been seen, in the form of an opportunity for an affective relation to an object (a photograph) linked to the past. And yet, what is so striking in Ishiuchi's trajectory is how one project leads to the next—from the banks of the port of Yokosuka to the scars of her mother's

body to the sewn hems of ひろしま/*hiroshima*—so that in the light of each addition, the meaning of the whole deepens and shifts, like the wrinkles and stained layers of the red-flowered skirt of Yamane Mieko as it makes its way through time to our present. Like the silent edge of Nakahira's parole—in many ways silent, withholding their specific stories—these photographs do nonetheless make a demand of the viewers, an ethical and personal claim in the moment, and they reflect back to us, like blue eyeshadow, an intimate estrangement that asserts itself with uncanny confidence, with a delicate and transparent courage.

Gender Off-Kilter

Moving from the specific case of Ishiuchi to the broader contexts in which her works were viewed, the problems of media's potentiality and infrastructure take us—as if ineluctably—to questions of disaster, the nuclear, and their representations and aftermaths. In chapter 5, on post 3–11 representations, a sudden disaster brings artists to reflect on the political and environmental ecologies that invisibly structured the conditions for such an event, the power differentials and assumed conditions of everyday life that the aftermaths of radical events make apparent. Ishiuchi's work evinces the vacillation between narratable and anti-discursive, linguistically formed and unformed affective states. Among the menagerie of affects, from anxiety to irritation to paranoia, we see here the photographic gaze and the photographed subject (or object) appearing unperturbed while existing alongside the dawning, intense relation that hovers between the viewer and the photograph. We might call this a weak power in its intensities and vacillations, in the ways it frames something other than a direct protest—assembling vectors of feeling, this relation has the effect of shifting off-kilter the expected gendered forms. Borrowing Isozaki's terms, it may bring back a "human scent" while laying bare larger structures, yet still without a fully graspable discursive message. Taki's "running with one's own body through the skin of uncertain phenomena" comes into its own here as a mode for thinking photography. Collecting these moments, bodies, objects, which in each series emerge as a kind of assemblage—as one feminist philosopher puts it, "I am already an assembly, even a general assembly, or an assemblage"[53]—allows each work, image, and object to exercise that weak power by gathering at the border between private and public, first- and third-person affects.

Thanks to this off-kiltering, we cannot fly easily to the transcendent "beauty of ephemerality," though some critics still evoke these terms. Critics find the

development in Ishiuchi's oeuvre now explicitly related to nuclear disaster challenging and problematic (using terms like "absolute other" to name the shift), attempting to name how this newer work transforms and recontextualizes the meanings of her earlier photographs.[54] In the aftermath of 3–11, the next generation of photographers has captured the forms and tones of present day-ness via explicitly networked mediations both of feeling and of social forms. Defying any simple boundary of what should be included in Japanese art in the first place, these younger artists pursue critical reflections on the global that are less tethered to any specific nation's history. Of her series *Scars*, Ishiuchi claims these remnants and sewn bits of skin are a "sign of life"; so the objects of Hiroshima come to join the living present, to participate in the world of the living. Like Uno Akira (Aquirax)'s stretching skin, the skin in Ishiuchi's still photos unfolds a drama of tensile surfaces—more static than those in Uno's *Toi et Moi*, but also more mobile in the layers of time they allow us to imagine, the heavy lightness of meaning that accrues in the cracks and folds of surfaces.

The question of assemblage, to which I return in chapter 6, emerges in the series structure of many of her works, from *Classmates* to *mother's* to ひろしま/*hiroshima*, where the impact then forms, among and in the gathering and differences, the repetitions and deferrals among the photographs in the series. In Ishiuchi's series titled *Body and Air*, each work consists of not a single object or a single photograph of an object, but four or five Polaroids together and the gaps between the images form the image of one person, one woman, one body (figure 4.8). This series confronts the structure and problem of assemblage most subtly: in many instances, we see the eyes and the eyebrows peeking out at us from about the level of the hairline—bangs or a bit of hair sometimes visible, down to the tip or nearly the tip of the nose. In one instance, it could be Itō Hiromi, poet and subject of another series of photos by Ishiuchi, but the women are of varying ages across the series—the nose casts a soft triangular shadow, illuminated from the left, as if looking through a rectangular mask or window—and the Polaroid itself (we return to the Polaroid), mounted on a white backdrop, casts its own shadow by being placed slightly out from the backdrop, emphasizing the materiality and volume not only of the face but also the picture itself. The next photo down shows the skin of the belly and the belly button, but, as in the scar series, Ishiuchi allows the skin to fill the frame, so that we are not able to see where this belly ends. On either side we see hands, but this time separated, fragmented out into two different shots, and below, two feet—this is the structure of many of the works in this series, though some also show the front and back of the feet,

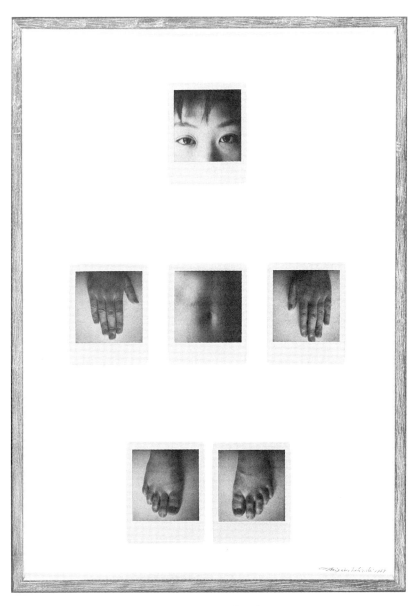

FIGURE 4.8 © Ishiuchi Miyako, *Body and Air #6* (1999). Courtesy of the artist and The Third Gallery Aya.

or the back of a neck or a scarred belly, or two rolls of flesh—at about the height in relation to the face where breasts might be. We have grown used, with *Scars*, to not knowing quite where on the skin of the body a particular mark lies. But here, with the fragmentation and reconstruction of the whole, of the self (the plurality of the self as individual and of the selves here collected), what comes into focus is the work of reconstruction, of recollection from fragments, and the only partial knowability of each of these partially revealed beings that we encounter.

The bright yet elegant pair of red shoes, a photo that has become one of the icons of the *mother's* series, like the other clothing in that series, highlights the absence of the body; we have only what the body left behind, the brave shoes, with only a slight crease around the toes and a slight bend in the back of the heel, a little bit of off-coloration in the off-white beige leather of the interior, revealing that they were ever worn. The shoes cast a reddish shadow, filling the frame, larger than life. Paradoxically, however, when Ishiuchi tells of it, it is again as if they gained life—and even independence—when they traveled to Venice. "Even when I was not there, my mother was in Venice [where she had never been while alive]. . . . It seemed as if the pieces of work were enjoying Venice"[55]—as if the subjectivity of subjects, the objects, and the photos had infused one another.

I linger over these works, emphasizing the movement of affect and movement in time, to highlight the evolution of some central issues at stake in earlier media theory as they enter a more explicitly gendered realm here. The overwhelm of the body in intermedia, the interlocking of multiple gazes in expanded cinema, and the problem of the substitution of the scent of the body and subjectivity by the larger frameworks of urban space take a different route in Ishiuchi's work, where the plural I/we takes on that affective scale of perception so as to lose neither the personal nor the collective, but to pause or freeze in the intermediate space between the two. While not necessarily halting at the personal or collective level, Ishiuchi's hands and feet in *1•9•4•7* reveal, differently from Ichiyanagi and Okuyama's contraption in *From Space to Environment*, the impact of bodies through space and time; rather than flinging back the impulses those bodies offer to the viewers in the form of intermedial sound and light (refracted through other hands), Ishiuchi's photographs hover in that intermedial space by allowing the layers of skin's texture refracted across the time of labor to mirror the layering cracks and layered manual work of photographic development by her own hands. One's own hands and the hands of others frame a collective that does not resolve on the side of either the personal or the infrastructural. The lines

on these hands and the seams of these clothes do not jitter or shake like the horizons in Shirato/Ōshima's work, but they do hold a critical potentiality for their embodiment of the impact of gendered constraints and the historical weight as well as transformative potentiality encapsulated by the sight of these large, vivid hands and feet. Not doing ninja magic, they nonetheless seem to hold the possibility of crossing through time and space. Like Kagemaru, they come one after the other in a multiplicatory serial logic that does not efface but rather emboldens difference and transformation. Ishiuchi's Yokosuka landscapes and the hands carry silences of history and power—like Nakahira's call for a silence of parole—and their off-kiltering of gendered affects may be seen as one potential instance of the shifting of the axis of media and mediation: the *correspondances* that Nakahira called for as a synonym for mediation/media, where it is not a matter of transmission of a particular content but a bursting out of something, some potentiality, contained in and figured as a bodily movement. These bodies hold still, but the affective work that they perform (whether Matsuda would have agreed or not) do revise a gendered axis and organize a collectivity without uniformity, through the media of the body and photography. In all of these senses, Ishiuchi carries forward the work of intermedia, animation, and media theoretical interventions at the affective scale across the phenomenologies of gender and photographic practices.

In recent years, Ishiuchi's work as well as the work of *Provoke* photographers has become better known internationally, and Japanese postwar art has gained more visibility (having its own afterlife) through its curation in exhibitions, catalogs, and gallery shows. Less frequently, the complicated-to-restore works of intermedia, the slow-to-translate media theories, or the more obscure works of film and animation have begun to gain attention as well. While they often thematize afterlives of various kinds, these works gained their own afterlife in reception and attention from curators and the art market. Yet just as affect theories sometimes claim to move past poststructuralist, language-based critiques without ever fully departing from the necessity of close reading, the afterlives of the 1960s–70s artworks I discuss in the following chapters exist in that kind of complex "post-" relation that is both a continuity (or even a doubling, an I/we relationship) and, in subtle ways, also a departure. These works also operate at that affective scale that holds the tension between personal and infrastructural, between subjective feeling and broader affective critique. They take inquiries central to the works of intermedia, animation, and critiques of culture industries and bring a performative reinflection (a sort of afterimage) of some prominent works and

mediatic methods of this period to new relevance for the present moment. Whether it is through their increasingly abstract reflections on the nuclear age in contemporary works of photography and sculpture (chapter 5) or their complex articulations of the potentialities of collectivity (discussed further in chapter 6), these works continue to evoke the potentiality and limits of operating at that liminal scale, that middle range of affective agency in relation to larger social structures. My aim, in part, is thus to trace an afterimage (afterlife) or "post-" for the media critiques discussed in earlier chapters in a doubled structure, a doubling/mirroring resonance, even while attending to their unexpected departures.

5

From Postwar to Contemporary Art

The last ten years or so have seen an enormous wave of interest in postwar Japanese art in the United States and Europe as well as in North and Southeast Asian venues. Although curators and art historians in the US context would rightly point out that the interest builds upon a longer history of important exhibitions through the 1980s and '90s, in the past decade Japanese postwar arts have decidedly entered mainstream narratives of art history.[1] In about 2011–13, a surge of exhibitions in the United States and Europe focused on movements and artists from Japan's "expanded '60s" (roughly 1954–74) with large-scale exhibitions in New York's Museum of Modern Art and Guggenheim Museum, London's Tate Modern, and many other international institutions of modern and contemporary art as well as commercial galleries. With this surge, which curators called either a "planetary alignment" or a "meteor shower," has also come a rise of archival interest in these institutions' own historical connections to Japan.[2]

There are several reasons for this increased interest in postwar Japanese works in the art world now: yet one prominent reason is what might be understood as the close resonance (and also the self-conscious exploration or deployment of resonances) between key concerns of the 1960s–70s art movements and those that concern art practices today. Under the rubric of Asia, curators may bring forward works from Japan's 1960s–70s to parallel

work from other Asian sites that have undergone rapid urbanization and economic development in later periods—a regional economic development that happened in part due to the US Cold War policy in the 1960s of promoting economic exchange between Japan and other Asian countries. Globally, performance art, social practice–based artworks, body-based art, and time-based video art have become more central to art institutions and curation than in earlier decades; as a result, curators have looked to the broader histories of these works and have reevaluated previously ignored precedents in Latin America, Eastern Europe, and Asian art, including Japanese movements beyond Gutai and Mono-ha. Forces within the art market have also played a key role. Curator and collection director Allan Schwartzman describes how interest among US collectors shifted from American abstract expressionism to Italy's Arte Povera and then to Japanese Gutai, and through that process associations in the reception of these movements in relation to one another were solidified.[3] (These associations in fact existed in the original reception of the works in their time but had been forgotten, and are perhaps now overemphasized in the reception of the Japanese works in the United States and Europe.) The shift in the valuation of reenactments of site-specific or performance work from the 1960s or new prints made from an older negative means that the resulting object can be sold as a valuable work on the art market, an option that was not considered acceptable or valued before in the same way. Furthermore, as Alexandra Munroe has bluntly pointed out from her perspective among institutions, collectors, and philanthropists, one could purchase a very important work by an important Japanese artist for "a fraction of what a very bad Jackson Pollock would cost you." Euro-American curators, collectors, philanthropists, and art festival advisors saw this as a "short-lived opportunity" once significant attention had been drawn to the Japanese works.[4] As the interest in site-specific works and ephemeral, process-based work came to new prominence in museums and institutions, and as academic and institutional programs in performance art and departments of performance practice have grown, the works of Japan's 1960s–70s have taken on new value (critically and economically) concurrently with the rise of today's contemporary art in Japan and in Asia.

Postwar artists of the 1950s through the '70s were acutely aware of their position on the periphery of Euro-American-centered narratives of world art history, and art critics such as Nakahara Yūsuke, Haryū (Hariu) Ichirō, and others at the time were at pains to demonstrate and debate the "international contemporaneity" of Japanese *gendai bijutsu* (literally, contemporary art). *Gendai bijutsu* usually now historicizes a period of postwar art to distinguish

it from modern (*kindai*) art that refers to works of the earlier twentieth century (modernisms). More recent works are referred to as *kontenporarī* in Japanese, using the loan word, as an alternative translation of *contemporary*. Reiko Tomii points to the interest in "global contemporary art" as in part a result of globalization and the "precedent of multiculturalism." On the one hand, "despite its notoriety for its homogenizing effects," Tomii claims, globalization "[has allowed us to] see the production of art in multiplicity."[5] Post-structuralist/postcolonial theory also forms part of the reason for the critique of the Eurocentric paradigm, which led to opening narratives of art history beyond a Eurocentric frame—and again it matters whose narratives, and where they are located. The rapid technological changes in the 1960s–70s, the interest of artists such as Matsumoto Toshio and his colleagues in expanded cinema, and intermedia artists' focus on the convergences and overlapping of media in many ways echo the rise of concerns around new media that have brought media art to prominence in recent years. In other words, we see a moment in which 1960s–70s Japanese art has been recognized in new ways, in part for its resonances with current concerns, and in part for economic reasons (their newly increased market value); thus, these (re)discovered works come to have an interesting contemporaneity in another sense, the sense of happening or coming into visibility newly at the same time as new art of the present moment.

The digital age and the era of new media have reawakened interest in questions like cybernetics and computer-based art, questions of the processing of information that artists of the 1960s–70s brought to bear or attempted to contend with in their work. This chapter aims in part to trace vectors of this relation between earlier postwar art (*gendai bijutsu*) and global contemporary art (*kontenporarī āto*). I do so with a focus on the intermediate range of agency as it comes to prominence in these very recent works, exploring the ways artists grapple simultaneously with infrastructural concerns and with the formation and activities of art practice at the level of the personal/subjective—the first and the third person becoming blurred as well in some of these works—and how at times they evoke the potentialities or the silences (the latent or unrealized potentials) of their media in new ways. Though not well known (in most cases) and largely untheorized, some emergent artists today take up the theoretical concerns of those earlier works, embodying unspoken legacies or afterlives of the work done in the 1960s–70s, even while they too evoke an implicit yet powerful intimation of disaster or loss in their reflections on infrastructure. Looking at these works together yields not only a deeper understanding of the two periods but a clarity about the emergent

transhistorical and transnational (cultural, economic) system in which both took part and which shape key concerns of our day.

When participating in conferences on the work of performance or intermedia artists from the 1950s through the '70s, I have often found that the contemporary artists in the audience—those who tend to work in video, installation, or site-specific forms—comment afterward, "These are my artistic ancestors, but I had never heard of most of them before today." The framing of stylistically exciting displays of Japanese art from the 1950s to the '70s in museum and gallery forums runs the risk of detaching them from the ephemeral and locally specific criticality that made the works effective—even when the exhibits include rare documentary footage of the most unusual and least commodifiable of performance groups and actions (such as those by Zero Jigen or Neo-Dada Organizers).[6] Postwar artists tried to understand the impact of the larger capitalist social structures and markets on the meanings and values of their artistic practices, at times claiming a blankly resistant stance toward capitalism and market forces, and at other times recognizing the permeability of their own practices to these structuring conditions. They attempt to confront these conditions while providing images, and intimations, of that ungraspable world system. Confronting art's role in their contemporary age, these artists fold infrastructural concerns into the works, refracting these problems through the works' own labor in relation to viewers in their time.

This chapter takes up the work of a few contemporary artists who, in the era just following the triple disaster, reflect on questions of media, infrastructure, and time, and mobilize them in ways deeply related to the affective scale I have discussed in relation to those earlier works. They reflect on what constitutes reality, and how reality or actuality can be understood and mediated (remediated) in an age of media saturation and overwhelm. I begin with a brief writing on two emergent male artists, Niwa Yoshinori and Arai Takashi, whose work deals quite directly with questions of infrastructure and media; then I move to three women artists—Kazama Sachiko, Kobayashi Fumiko, and Asakai Yōko—who traverse these questions at increasingly abstract and indirect levels that most powerfully evoke the potentialities of art to move at the affective scale, to work in the range of a media of feeling.

Out of Doubt: Arts of the *Kontenporarī*

The exhibition *Out of Doubt: For a Landscape to Come*, the 2013 edition of the triennial *Roppongi Crossing* exhibit at the Mori Art Museum, subtly remapped the edges of Japanese contemporary art by including the work of

artists of Japanese descent who do not practice primarily in the Japanese milieu, many of whom base their work in Australia, Europe, or the United States. *Roppongi Crossing*'s desire to situate contemporary Japanese art in an international context—and the collaboration of two international curators of Japanese art—cannot be situated outside the historical concerns of *gendai bijutsu* in relation to the contemporary. Yet when one looks closely at the productions of the young artists in the exhibition—including Arai Takashi, Niwa Yoshinori, Kazama Sachiko, Kobayashi Fumiko, and Asakai Yōko, all of whom I discuss in this chapter—whatever may be each artist's ambivalent relation to the diasporic imaginary of Japaneseness—we find that there is an important resonance between the work of the postwar avant-gardes and contemporary art, in its so-called post-medium condition.[7] Working at the affective scale in a doubled temporal frame, a kind of afterlife of these concerns (including concerns of loss and survival), these later works, whether self-consciously or more implicitly, generate unexpected approaches to the problems the earlier postwar works approached. Though one could trace resonances with many works in the intermediate period both in Japan and elsewhere, my aim here is to map the affective scale at which they each work, the circulation or doubled feedback loop in which they operate and that they make traceable, in relation to the earlier works and theoretical explorations this book approaches. The theoretical silence surrounding the newer works opens to a new potentiality and resonance with the reading and evocation of that layering.

Roppongi Crossing's 2013 exhibition of (mostly) recent art, in which all the works in this chapter appeared, was subtitled *For a Landscape to Come* in reference to the famous photo book by Nakahira Takuma (*For a Language to Come*) and included a number of works from Nakahira's own more recent *Documentary* series. Nakahira's 1970 book that contains the essay "What Is It to Be Contemporary?" presses hard on the topic of artistic potentiality in an era of mass-mediated image saturation and ideological absorption, questions that are central problems for part I of this book and are key especially in chapter 1, with Matsumoto's reflections on the role of art in the contemporary age. The metaphors of soaking up, immersing, soaking through, and saturation abound in his writings, giving a sense of the inseparability of artistic practice from a larger something, like a medium such as ocean water or air, too enormous for any individual to grasp. Following Marcuse's thought, Nakahira wrote in 1969 of the mechanism in late capitalist society of the commodification and "swallowing whole" (Nakahira's words) of oppositional movements and ideas. Documents of May 1968 in Paris, he

argued, sold well; Che Guevara's life was turned into a Hollywood film; and in Japan, he wrote, "the most sensitive and radical artists of this age have been bought out in their entirety by the stupid festival called Expo '70, *without altering their respective assertions at all.*"[8]

Recent artists have implicitly or explicitly taken up the legacy of Nakahira, of anti-art pioneer Akasegawa Genpei, Mono-ha artist Suga Kishio, or reportage movement painter Nakamura Hiroshi, in particular in the ways these forebears inspire frameworks for reconsidering the problem of reality: how we perceive, convey, visualize, or experience it (including social contradictions) in the digital or new media age. Sometimes in a nostalgic mode, other times through pastiche, irony, or the ambient utopian collective, these contemporary artists reflect on their artistic choices in late industrial capital's image and information saturation, while referencing or reevoking the work of these earlier artists. Back in 1972, Nakahira had already attempted to unpack the consequences of his era's new media and culture industry on the concept or experience of reality:

> Today we are confronted directly, without having any choice about it, with an immense number and enormous output of realities, however fragmented, through countless printed items such as daily wide-distribution newspapers, magazines, flyers, and catalogues, as well as the nearly round-the-clock broadcast of television. In one sense, it is undoubtedly the case that there was never an era in which people lived so thoroughly *soaked through* [*shintō saretsukushite*] by reality. At the very least this is true if one looks at the situation at the level of form. However, it would be a completely different question to ask whether each one of us had truly lived these realities.[9]

Although here this soaking through appears to be a problem preventing the true living through of reality, in the writings for his Seventh Paris Biennale exhibition in 1971, Nakahira expressed that he aimed precisely to allow himself to be soaked through/permeated/infiltrated by the world. In his much more recent photos, such as in his *Documentary* series, through very different techniques, Nakahira returns to photography's "original point" (*genten*) in ways strongly linked to his earlier inquiries. Yasumi Akihito comments thus on Nakahira's recent pieces: "Doesn't the process of spinning forth the bond to an intimate other with his camera—a bond severed by the loss of language and memory—and thus developing (or unfolding) in photographic time the world that had been left dangling in midair, create a gentle shift in the horizon that Nakahira once called the 'battle between "the world" and "myself"'?"[10]

Nakahira's work spans the period of the late 1960s and the very recent past, as Ishiuchi's does, although in Nakahira's case there is a gap of activity separating the two due to his illness. While the question of tracing the continuities and discontinuities between Nakahira's earlier and later work is beyond the scope of this chapter, one issue that Yasumi pointedly raises can be related to the central points of this book: that is, as Yasumi describes it, when Nakahira comments that in some ways it was only by photographing his son as if he were a stranger or an other that he was really able to realize or understand his very existence, in a deeper existential sense (*sonzai sono mono*, his existence itself). This relation between intimacy and alterity resonates with his ongoing political concerns with power relations in Okinawa, where he shot those photographs. Only through the photographing of someone very close to one, one's own son, only by turning what would relate to the personal, the intimate, the closest relation, into something strange/distant, does Nakahira access that middle range of agency that is related to his ability to take photographs at all in an ethical way, either of Okinawa or of his son—a practice also linked to his very survival at that moment, his coming out of his illness—and thus to understand, relate to, or realize that very existence.

In that accessing of reality, a proposition he had earlier questioned (as he had asked "whether each one of us had truly lived these realities"), Nakahira's photographic work becomes an affective practice in the sense that he is truly living or contacting, via the medium, his son, who is both part of self and other, both intimate and stranger, in a way that becomes paradigmatic for his later photographic practice for other subject matters as well, and a way that is crucial to survival as a person and photographer. The fact that he sees these photographs as later being completely or absolutely denied/refuted (*zenhitei*) shows how, as before, this grasp on existence, this understanding of reality, is fleeting, a process rather than a product; the methodology as such works only for a moment, and cannot be counted on or attained indefinitely.

"Developing (or unfolding) the world" (*genzō = tenkai shiteiku*) becomes a way to articulate how the photographic process can be a means for finding the world, or reality, that one has been severed from, or that one has been unable to experience fully. Through photography he could, just barely, "understand the existence in itself" of his own son. One could draw a link here to the younger photographer (who is not Nakahira's son, but who aims to follow in his legacy) Arai Takashi, whose daguerreotype works appeared in the same exhibition. Arai alludes to Nakahira as well as to Walter Benjamin's "Little History of Photography" when he describes his use of the techniques

of daguerreotype: he, too, searches for a way to "[spin] forth with his camera a bond to [an]other" and to "[develop] in photographic time a world that had been left dangling in midair." For Yasumi describing Nakahira, the dangling in air represents a world that lacks the potential for a grounded or solid connection. Arai cites Benjamin's words on early portraits where "the synthetic character of the expression, which was dictated by the length of time the subject had to remain still, . . . produce[s] a more vivid and lasting impression on the beholder than more recent photographs." Benjamin characteristically argues regarding older technologies like the daguerreotype that "the procedure itself caused the subject to focus his life in the moment rather than hurrying on past it."[11] Arai adds, "Not to freeze a moment, but to try to live within an integrated single time. That is, also, to rest motionless before the camera and accept [the fact of] a limited death."[12] For Arai, as for Nakahira, photography becomes a provisional means to attempt a (re)connection with an other and to (re)weave a bond to the world.

Yet Arai's choice to thematize radiation in the post-3–11 period gives a new inflection to these questions of temporality, visibility, and the relation to what is perceptible as the real. That is, Arai's daguerreotypes take on the challenge of Nakahira's work explicitly as another kind of facing of existence, an absorbing of a reality in time, and a creation of a relation to an other through the temporal duration of this older medium. The idea of "developing (or unfolding) the world" that Yasumi formulated as a description of Nakahira's work here takes on an alternative nuance: while for Nakahira the politics of Okinawa played an important role in some of his works, for Arai, problems of visibility and invisibility, cued by radiation fears, and questions of exposure animate his haunting series of daguerreotypes that make reference to nuclear events and spaces across history, as in his *Multiple Monument from Daigo fukuryū-maru (Lucky Dragon)*; his image of Hamaoka Nuclear Power Plant, April 5, 2011; or the series of pictures of people around Fukushima, such as Harada Akira and Maeda Sadahiro, who own Soma pony farm in Minamisoma.[13] Arai exhibits these prints in very small (daguerreotype) format in a dark room, giving viewers an intimate interaction with these high-resolution yet seemingly deteriorating images. As a critique of the forward-moving rhetorics of reconstruction/renewal after the triple disaster, they show living forms that seem to be increasingly precarious, where the edges of the frame darken and disappear in blue or black. In his accompanying image of a Hiroshima piano (which again alludes to earlier postnuclear histories) or of the White Sands missile range in New Mexico, the blue artifact created by the

photographic process mirrors the exposure to invisible radiation; a mark left on the skin of the film invokes the historical relationships between these stories. In the dark, viewers see their own reflections faintly mirrored. Explicitly framing his work in terms of both Nakahira and Benjamin's legacies, Arai's reflections on medium and infrastructure shift the terms into an explicitly post-3–11 terrain, a doubling of layers with an explicit content and political resonance. Still, one of the most powerful aspects of the use of daguerreotype is its solicitation of intimacy, the spaces where the image frays at its edges as a residue of the temporal process of its making, and the requirement, silently, that the viewer draw close, view in detail, see herself mirrored in the daguerreotype's gaze (figure 5.1).

Using much larger and noisier media, performance and video artist Niwa Yoshinori redefines "image as monument" from its negative connotation in Nakahira's work to a positive yet ironic position in his own.[14] For example,

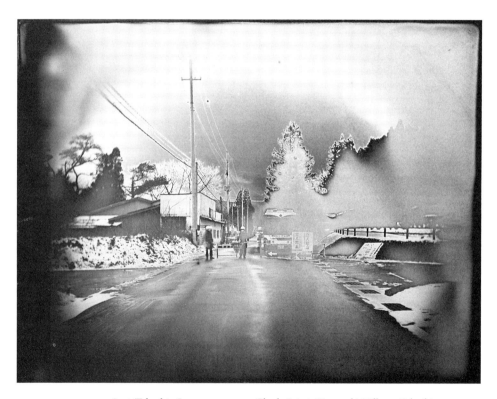

FIGURE 5.1 Arai Takashi, *January 12, 2012, Check Point, Kawauchi Village, Fukushima*. From the series *Here and There—Tomorrows' Islands* (2011–), 25.2 × 19.3 cm, daguerreotype. Courtesy of Tokyo Metropolitan Museum of Photography.

in *Billboard Photos*, a project subtitled *Taking Group Photos in Pusan with No Purpose, Then Joining the Commemorative Photos of Strangers* (2011), Niwa shot random group photos, and also posed himself along with unknown tourists in their commemorative photos, which he then displayed on billboards around the city. Thus, he writes, "We become commemorative monuments of a community/collective."[15] Yet the collective has "no common denominator," is a "false appearance," the "formation, through the photographic medium, of a vessel into which anything may be placed, the vessel of 'we.'"[16] Employing the present-day time redisplayed onsite to those who live in or move through a place, this intervention calls to mind Nakahira's 1971 Paris Biennale contribution, *Circulation: Date, Place, Events*, in which he photographed scenes, moments, images, and objects around Paris and then developed and printed them the same day for hanging in the exhibition, a work that has received more recent attention at *Provoke*-related exhibitions and that I discuss further in chapter 6.

While Nakahira had written despairingly in 1971 of how the entire world seemed to have become like a homogeneous postcard landscape, and that emergent globalization flattened the world so that one only always saw what one expected, Niwa in *Billboard Photos* provides an ironic take on this homogeneity of postcard-like group selfies, turning that formal uniformity into a site of disruption. Critic Ōnishi Wakato traces the link, comparing Niwa's work to *Circulation: Date, Place, Events*, writing, however, that Nakahira "licks all around the surface of the city and the era with his lens" and compares that work's "rough texture" to Niwa's smoother urban interventions, ultimately to ask, "Is the world no longer confronting the individual as much as it was when Nakahira photographed Paris? Is it because in this era the whole world has been homogenized, photographed by an infinite number of cameras, instantaneously connected? Without the need to declare it as Nakahira did, we are already saturated [soaked through] by the world."[17] Both Nakahira and Ōnishi, via his critique of Niwa, are concerned with image saturation shifting the temporality of life experience, and with the momentary relation between an artist and those (s)he photographs (or shoots on video), focusing on experiences of everyday urban reality framed through art. Yet the ultimate impact of the two works differs, even as both emphasize the circulations of images in their present moments: Niwa's ironic and contingent but nonetheless cheerful collective here overwrites the darker critical energy of Nakahira's fragments.

Niwa's interventions into world systems (currency, garbage, outdated historical icons) share the circular quality of Nakahira's same-day set of

circulations. Both link to the central concerns of landscape theory (*fūkeiron*) in its aim to highlight the invisible power infrastructures that condition social space. Theorists of media and art in Japan, as we have seen, engaged in deep reflections on the problems of the material world and the built infrastructures that often go unnoticed but that condition our ways of seeing. How can we grasp and process the stuff of life? The garbage, the left-behind objects, scars on the skin—what gives them meaning? In varying ways, recent art highlights corporate power and consumer culture's wastes and byproducts. One might think of the video and social experiment *Going to San Francisco to Dispose of My Garbage, Tokyo 2006*, also by Niwa, in which he reflects on the infrastructures both of consumer waste and of transnational travel while drawing attention to the materiality of his particular garbage.

The video begins with his wrapping up the kitchen garbage in his home in Tokyo in a translucent plastic bag, locking up, taking his bags, and heading to Narita airport. In the process Niwa's actions make palpable how little time we usually spend with a bag of garbage (and how much we try to minimize this contact, this awareness)—just dropping it outside or on the corner of the road. However, Niwa's bag stays with him through the ticket gate onto the train, back onto the platform, accompanied by the different ambient sounds of each of these spaces. Although we do not get a sense of how it might smell, we follow the garbage as he takes it through baggage check (as it becomes a carry-on), through security—where we see the politeness that is part of social expectation here, so nobody says a word about it, at least from what we can see—and through immigration, all the way by car on the highway to San Francisco Recycling and Disposal Center, where he tosses it and watches it get lifted away by a giant truck. While artists of earlier *gendai bijutsu* such as Akasegawa Genpei, of the group Hi Red Center (whose Shelter Plan is discussed in the introduction), along with his collaborators in anti-art, had "refigure[ed] waste into often obsessional, menacing, or sexualized forms," here, in a different way, viewers experience the materiality of a bag of garbage as a humorous traversal of social spaces and international boundaries.[18]

By taking his garbage through customs, or by disrupting the codified tourist photographs in famous travel cities, Niwa extends the legacies of humorous disruptions that focus our attention on urban, and here transnational, systems—the systems of customs, of the circulation of objects, as well as the movement of value or the valueless across time and space—as they come up for reexamination. The utterly personal—the wastes of daily life—come into the fully infrastructural space of transnational security, recycling trucks, and

garbage compacting, thus hovering deliberately between the personal and the larger structures that, generally, are outside of the individual's grasp, or remain outside of awareness unless one takes a deliberate trip to the garbage dump. In some ways, the earth is "soaked through" and overwhelmed by garbage and waste, some of which we can't see; at other times it is highly visible, like the black bags of nuclear contaminants across Fukushima today. Like Arai's, Niwa's prescient 2006 exploration here has an explicitly environmental angle, in an era when caring for the earth and recycling are part of a prominent and urgent discourse on the individual's contributions to climate change. The feedback loop of Niwa's reframing of Nakahira's model of *Circulation* opens a parallel cyclical process of individual acts as always already imbricated in broader systems.

In chapter 1's discussion of intermedia we saw that artists grappled with a changing media landscape they termed *environment*, attempting to understand what had become invisible, like air, in the institutional, social, and architectural structures around them. The humor of Niwa's garbage event and video lightens the critical load borne by this similar inquiry into environment, framing it as a short, deadpan video that one can watch a bit in the mode of Jim Jarmusch's *Stranger Than Paradise*, where an intimate daily world is slowed down and upturned to provoke an ironic gaze. Niwa, in his own way, approaches the affective scale of agency with his dually personal and infrastructural intervention; yet, as Ōnishi points out, we perhaps no longer have a sense of a "battle between self and world" reflected here in rough textures but rather a smoother version of a quirky, spontaneous temporality for the artwork that can be circulated and consumed in a museum or on the internet with great ease, and perhaps with less resistance or uncertainty. We come to understand and reflect on something about our current reality without the immediate sense of a darkly existential stake of understanding. Cheerful and friendly companions greet Niwa at the airport to drive him through San Francisco for his odd performance, and the world does not seem so hostile a place. Some of the violences of the capitalist world system have gone underground, here, with an irruption of the absurd; but they remain implicit at the edges of the performance.

As the contemporary arts scene tries to come to grips with a more complex picture of the current new media age, there remains a clear problem in that the critical force of these works requires that we attend carefully to their discursive contexts—as they flow seamlessly into (or, perhaps, are saturated by) the commodity circulations and image-information economies of global

capital. Yet the three artists I discuss in the remainder of this chapter find a way to enliven and connect with the earlier concerns of *gendai bijutsu* while retaining an enigmatic and complex relation both with their own mediatic intervention in the present and with the layers of the past they invoke. We will see in the next section how Kazama Sachiko's woodblock prints, like Arai's photographs, perform a political intervention related to current issues of radiation, yet they align with some of the philosophical and visual legacies of reportage artists of the late 1950s such as Nakamura Hiroshi, whose theories of "tableau machine" anticipate Deleuze's writings on technological society. Kazama and Nakamura share an illuminating inquiry into the structures of painting, drawing, and illustration as well as an interest in anachronism and art's social utility. Kazama works in a layered manner with strata of time and text to build an intervention at the affective scale, particularly through her approach to medium.

Kobayashi Fumiko's assemblages, many of which involve outdated consumer objects of daily life, bring to mind the wrap art and junk art of Akasegawa Genpei and Hi Red Center as well as the abandoned infrastructures of the *Thomasson* collective photographs.[19] The impact of her work comes from the intimacy of the objects in daily life and the unexpected ways she mobilizes them as a performative reflection on infrastructure and loss. Photographer Asakai Yōko, with her seemingly empty landscapes—landscapes without human figures or cars, but that nonetheless capture invisible circuits of information—takes us most directly back to the legacy of *fūkeiron*. In her *Northerly Wind* series, each landscape features an electronic bulletin that measures the direction and velocity of the wind in Aomori Prefecture. While their sense of foreboding—as works taken in Tōhoku post-3–11— arises within contemporary concerns about wind-borne radiation, Asakai's works also reenliven the critical reflections on mediation and power to be found within early *Provoke* photography and theory. They operate at the affective level in the sense that they hover between what it is possible to narrate or capture in conceptual frames and what escapes discursive enumeration, between an entrapped vision of power and environment and an energetic vision of the middle range of agency and potentiality. As we shall see, in grappling with their own time, contemporary artists reframe the visual strategies and major impulses of *gendai bijutsu* and thus construct a layered temporality of the contemporary with a new twist on problems of infrastructure and loss. Perhaps it is through the voices of these artists of the contemporary that the critical edge of such earlier works can come more vividly into perspective, even as the next generations continue to redefine the legacy of Japan's postwar.

Women Artists after 3–11: Kazama Sachiko's Layering of the Real

Several recent contemporary artists reinvoke earlier representational practices even as they show an ongoing interest in the materiality of the medium, creating an explicit relation to earlier moments of political art such as the history of reportage painting. Alluding to reportage painting takes us back to the era of the early 1950s, concurrent with the era discussed in chapter 1 with the proto-intermedial works of the collective Jikken Kōbō, like Yamaguchi Katsuhiro's *Vitrine* series, Matsumoto's *Ginrin* (*Silver Wheels*), and the evocative media theories of Hanada Kiyoteru and Matsumoto. As we saw in Matsumoto's writings, the question of grasping reality in media like film was an ongoing problem, and Matsumoto's proposals that the inner and outer worlds both needed to be taken into account in a dialectical way open inquiries into the structures of media like documentary toward the innovations of the avant-garde. Media theorists continued to question forms of photographic realism like *Life* magazine, as we saw in the later reflections of the early 1970s media theories in chapter 3. In the realm of photography there was an ongoing evolution around what would constitute realism or what forms could lay claim to the real, from Domon Ken's powerful ownership and mobilization of that term in his snapshot realist photography work in the early 1950s to later groups like VIVO and *Provoke*, each of which reinterpreted and upturned the definitions of what could be thought of as photography adequate to the changing ideas and forms of the real.[20] While writings on the reportage movement of the 1950s at times focus on its representational realism in political opposition to the American military presence, the use of medium and representational themes are often more complex than some of these interpretations would lead us to believe. The relationship between their innovative formal choices and the idea of realism is rather ambivalent, and the framing and use of medium in the history of reportage painting becomes a useful and unexpected lens through which to view the work of Kazama Sachiko.

Nakamura Hiroshi's oil painting on plywood *The Base*, from 1957, as an example emerging out of the reportage movement, responds to the Gerard incident, the 1957 killing of a Japanese housewife by American soldier William Gerard, when she was scavenging for shell casings at a US shooting range. Nakamura depicts her bent-over posture and distorted feet alongside the skull-like eyeholes of the soldier and the dominant black machine of his gun taking aim. (Nakamura painted another related version called *Gunned Down*

in which the bent-over woman is centered in the composition; figure 5.2.)[21] Although works like *The Base* and *Gunned Down* are in some ways representational and seem to have a direct social commentary, they also contain strong and emotionally powerful abstraction, dark blacks, browns, and whites reminiscent of *Guernica*'s cry of pain through abstracted forms. In that sense, they are a much more complex reflection on Nakamura's explorations of medium, even as his use of plywood as a base reflects the actual conditions of scarcity of the postwar that he shares with the gunned-down gleaner on the American base.

These works thus encompass Nakamura's ongoing questioning of art itself as a human-made thing, his reflections about technology and obsolescence, about bodies and machines, and about the social utility of painting. Later in his career, Nakamura used the concept of a tableau machine to talk about the relation between technology and painting. The quintessential machine that

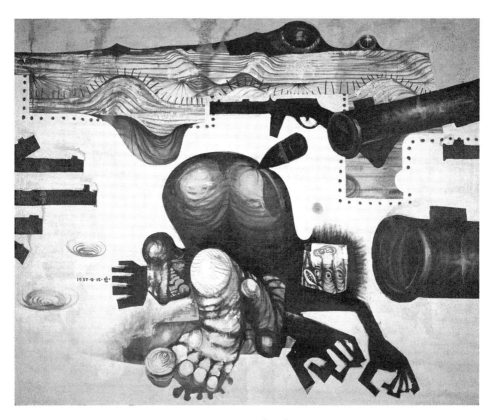

FIGURE 5.2 Nakamura Hiroshi, *Gunned Down* (1957). Courtesy of the artist.

kicked off Nakamura's interest in painting was the steam train, and there are a lot of machines and later kinds of trains in his work, as in his *Civil War Period* (1958) or in his later, post-Ampo work from his red period, *Sightseeing Empire* (1963). His reflections on sightseeing in his collaborations with Tateishi Kōichi (later Tiger Tateishi) compelled works of performance art that critiqued the complicity of Japan's wartime imperial ambitions. He links this critique of wartime complicity with the US military presence in the postwar and, in 1964, with the corporate and profit-driven aspects and nationalisms of the Olympics (for example, in one ironic performance work he can be seen eating five round doughnuts in front of the Olympic stadium for the film *Some Young People* [dir. Nagano Chiaki, 1964]). *Sightseeing Empire*, in deep red, shows a train going off the rails, that, as Namiko Kunimoto writes, "connect[s] the disastrous consequences of imperial Japan's ambitions to the rhetoric of new state power embodied by the postwar emphasis on infrastructure and economic growth."[22]

Nakamura and Tateishi's ironic critique of the "sightseeing empire" (or the process of sightseeing/consuming empire) through performance art illuminates some potentials that are not as explicitly emphasized in some of the work of Niwa, who is more concerned with the creation of unexpected communities of strangers and reflections on image culture. For Nakamura, as for Nakahira, the homogenized landscapes of capitalist urban space, including the manipulation of desire for exotic places through sightseeing, are part of a "disastrous" (Kunimoto's term) network of state power in need of refusal. Yet he mobilizes the unexpected powers of deep red, abstract machines morphing into oddly biomorphic forms, bubbles and stretches of organic shape, to demonstrate that painful reality, to bring to bear a critique at the boundaries between abstraction and realism, between narratability and breaking the bounds of thought's discursive frames.

Art critic Nakahara Yūsuke writes that "the steam train became the moving force that drove Nakamura right into the problem of what painting is."[23] The steam train also raises the problem of the fate of the "man-made thing"—the object or the technology—that is from the start destined to be replaced. So for Nakamura, painting these strangely organic machines (trains, planes) at times in the 1950s and early '60s was at once a direct socially critical reportage of its moment as well as a more layered and affective questioning of the technology and medium of painting, the structure of the gaze, and the juxtaposition of moving parts (like Eisensteinian montage, which Nakamura also alluded to and studied). There is a constantly present awareness of the painting medium as itself somehow potentially outdated, like the steam

train, a technology in the process of being overwritten by photography, film, TV, and other media. While Arai explicitly uses an anachronistic medium (daguerreotype), the use of painting by Nakamura becomes a living reflection on media's obsolescence and renewal and an attempt to mobilize, through melding the political and the abstract, the potentiality of this medium's changing forms and modes of critique of visual regimes.

The curators of *Roppongi Crossing*, self-consciously building the feedback loop of these two eras of contemporary art, placed *Gunned Down* and *The Base* by Nakamura directly across from an overwhelmingly large, almost gigantic black-and-white manga-like woodblock print filled with buildings, billboard writings, and crawling black forms. Aligned in technique and mood, *Jingai kōsaten*, or *Nonhuman Crossing* (figure 5.3), forms Kazama's monumental response to issues of government and police surveillance and contemporary media. Like Nakamura's work, the reflections on infrastructure in Kazama's woodblocks bring together a clear social critique with a complex reflection on their own medium, their temporality of visual forms, and the layers of the real that they both depict and embody. Born in 1972 in Tokyo, Kazama Sachiko is a contemporary artist who makes monochrome woodblock prints with a pointedly conceptual framework. She is quite different from the other two women artists I discuss below, and similar to Nakamura in that

FIGURE 5.3 Kazama Sachiko, *Nonhuman Crossing* (2013), woodcut print (panel, Japanese paper, oil ink). © Kazama Sachiko. Photo: Watanabe Osamu. Courtesy of the artist and Mori Art Museum.

she offers representational and figurative depictions. Yet, while each of these three artists takes a distinct approach, they all address questions of infrastructure, invisibility, and materiality. Kazama engages with the artistic medium of woodblock printing, in a representational and "talkative," information-laden medium tracing a lineage from manga as well as from reportage, ultimately forming a direct critique that aims to make visible—as a network of discourses, structures, and historical facts—the sometimes submerged or forgotten systems of policing and surveillance in contemporary Japanese society. The second artist I consider below, Kobayashi Fumiko, focuses on objects as her medium and therefore forms a critique and reflection on art spaces (museums) as well as loss, time, and urban space. Photographer Asakai Yōko focuses on the issue of invisibility/visibility as well as mediating elements like wind and radiation. All of their careers began well before 3–11—indeed, as emergent artists, being curated into a *Roppongi Crossing* show is a highly visible moment of being taken up in a different kind of agenda of circulation of Japanese contemporary art. But they have come to be interpreted in a new light in the wake of the events of the triple disaster, as part of the afterlife of the strategies of critiquing media and infrastructure that were prominent in *gendai bijutsu*, in the artists of the 1950s–70s, even as each of them reveals the shifting frames for interpreting and relating to the temporal structures that would orient any before and after.

As part of the context for interpreting *Nonhuman Crossing*, it is helpful to consider Kazama's smaller work titled *Prison NUKE FISSION 235* (*Gokumon kakubunretsu 235*), a woodblock print that offers some of the most direct invocations of 3–11 issues (figure 5.4). The work shows the Ministry of Economy, Trade, and Industry (MeTI) building in Kasumigaseki, a ministry that oversees the nuclear power industry. The MeTI building became the focus of many antinuclear protests and an encampment for five years for protestors after 3–11. Kazuma remakes the familiar building here, however, into the character Sunshine from the manga *Kinnikuman*, doing one of his special moves, hell's gate (*jigoku no gaisenmon*), where he transforms into the shape of the Arc de Triomphe, captures his opponents inside the arc, and crushes them. The faces in the nuclei all around him are those of Eisenhower with other government officials surrounding in the form of Dragon Balls. There are buildings surrounding it, such as on the left the National Diet building, on the right the Metropolitan Police Department, the emblem of the Imperial Rule Assistance Association, and the former Ministry of Home Affairs. Behind the arc is the Bravo test mushroom cloud from March 1, 1957, at Bikini Atoll (extensive captioning can be found online on Kazama's website)—all painstakingly

FIGURE 5.4 Kazama Sachiko, *Prison NUKE FISSION 235* (2012), woodcut print (panel, Japanese paper, sumi ink). © Kazama Sachiko. Photo: Miyajima Kei. Courtesy of the artist and MUJIN-TO Production.

rendered in a unique single-exemplar woodblock print through a detailed work of shadows and sumi ink.

Aligned in both technique and mood, *Jingai kōsaten* (*Nonhuman Crossing*) forms Kazama's monumental response to issues of government and police surveillance and contemporary media. According to Kazama's description, she starts out with a manifesto text and then begins to research materials (*neta*) for the image. In the center we see a mystical spell of black birds coming up from the address and emblem of Facebook and 2channel. The black birds are "Twitter birds," and a decontamination squad is picking up their virtual droppings. (In real life, artists such as photographer Akagi Shūji painstakingly documented the work of decontamination squads in the area around the disaster, posting his photos on Twitter; activist writing on the disaster abounded on that platform as well.) The whole image represents Shibuya crossing—according to Kazama, the most-watched place in Japan. Some might also say that Shibuya, as a center of commercial and image culture, is one of the most depoliticized places in Japan, part of the clean image of economic boom times, but Kazama repoliticizes that sparkling neon landscape in a monochrome jungle of allusions. The allusions form a visual and verbal multitude: Tōkyū (department store) becomes Tokkō (special police); a billboard shows a highly censored text from a proletarian novel, *Go Stop*, by Kishi Yamaji, banned in 1930 and then rereleased.[24] Hachikō, the famous dog of Shibuya crossing, here becomes a multiheaded Cerberus hell-hound; and on one building one might recognize the *Engankyō* by Mochizuki Katsura, based on an incident where the Taishō emperor rolled an edict into a telescope and looked at the governing Diet assembly members through it. Mochizuki was an anarchist artist who submitted his work to the *Kokuyō-kai* exhibit (Ōsugi Sakae and Tsuji Jun were also participants), and police ordered it taken down. We find also a ghost of *Kuni no Tate* as depicted by Kobayakawa Shūsei; there are Yatagarasu ravens—ravens who aided Emperor Jimmu on his eastern expedition, as well as (labeled) depictions of Tonarigumi (neighborhood associations mobilized by the Japanese government during World War II), military soldiers with animal faces, alongside people using smartphones, and also a counterespionage poster. In with all this temporally jumbled but thematically unified attention to surveillance and state censorship, one finds loose Shibuya girl socks, and something called "my number people" in reference to the national ID# system that was to be instituted in 2015, soon after the woodblock's unveiling.

Kazama's works, then, are a scramble-crossing of informational signals from many points in history, but one could say that the complexity of all these

events has a more or less unified political message, one that centers on the issue of surveillance and mutual surveillance, and has a manga-like vision of the contemporary corporate-government + military complex as an evil empire. Yet these images' specific material forms proliferate into a broader and denser particularity. The landscape of Shibuya is dark and smoking. In talking about the piece, Kazama makes the link between the Public Security Preservation law passed two years after the Great Japan Earthquake in 1923 to Edward Snowden and then to the 2013 Secret Information Protection Act. Exploring the detailed world of Kazama's work becomes a hypertextual act that involves historical information (that viewers can look up on their smartphones) and metadata in addition to the careful hand drawing and hand carving of the block. It is an abundance, an overabundance of information, almost itchy on the skin, bringing with it the sense of textural and textual overwhelm alongside a certain thematic coherence of violence and darkness. The visual pleasure of the clean black lines contrasts with the dark, smoky (noir-ish) tenor of their cumulative impact, evoking the affective structures of imperiality and governmentality. The juxtapositions are both chaotic and united—perhaps in that sense analogous to Eisenstein's intentions for his montage, which was the basis for Nakamura Hiroshi's earlier version of the tableau machine.

Kazama's are the most explicit or overt examples of post-3–11 political and socially framed reflections among my closing examples in this chapter. By using woodblock print as her medium of choice, with its intense black lines whose potentialities recall Shirato Sanpei and Ōshima Nagisa in chapter 2, Kazama mobilizes a medium that might be considered to be nostalgic, obsolete, analog in relation to the digital world she reflects on. It involves intensive labor for a one-time resulting work (her prints are unique, rather than reproduced) that can only be displayed, at least live, at one location at a time. Concurrently, her work contains a proliferating narrative and digital element; the commentaries and reproductions of the work on the internet give broad access to and participate in the infrastructural world they also critique. The vacillation between the larger infrastructure and the highly narrated aspect of the work as against the more personal, perhaps intimate, unique qualities of the ink on paper create a tension in the work that we could read at the affective scale, the tension between multiple layers of access, both local and transnational at once, that her work puts onto view—that also bring to bear a tension in valuation in contemporary art's circulations. Like Arai in employing a temporally slow, older medium, Kazama brings together a clash or flux of overwhelming information—that flux that is the informational characteristic of the digital age, just as Matsumoto observed it to be central to his

age of technological and social transitions with the rise of television and the high-growth era. Kazama puts the focus on the apparatus, the *dispositif* (both social and technological at once) in a framework that opens a critique of infrastructures and power relations across time, with a special emphasis on the violence, suppressions, and disasters that the historical narrative shows are still very present in ongoing structures and environments of power. Yet she also brings to bear some of the overtones of good and evil genres of the manga form that participate in the circulations of Japan's soft power, the nation-bound connotative history of the woodblock print, the distributive force of Japan's manga universe and fan cultures, which she feeds back into the internet's information database that forms the backdrop of her work's vectors of production and circulation.

While Kazama's work is discursive to the point of overload, Kobayashi Fumiko offers a work, absent of language, that is yet one of the most physically striking in the exhibition, taking an opposing approach to its relation to space, art, and the present moment. The curators of *Roppongi Crossing* also placed near Kazama's woodblock prints a small copy of Akasegawa's satirical poster art, which through manga form in the 1960s made a cutting send-up of the co-optations of the art world of its day. If Kazama in some ways could be said to be following on the heels of that aspect of Akasegawa, in his satirical poster mode—while also evoking Nakamura, in his fantastical reportage mode, and her revival of the old medium of ink on paper print—Kobayashi Fumiko's work relates more closely to a very different side of Akasegawa's and his associates' junk artworks, their use of discarded objects—in a way that also resonates with Akasegawa's *Thomassons*, structures in urban space that no longer have a use. Kazama's evocation of the garrulous world of information in her woodblock operates for the viewer as a layered mirror of the earlier moments in visual and literary culture and helps us to see the performative power of Nakamura's and Akasegawa's works through its striking revision and remaking of their critiques in today's image and with today's problems at their center. Yet the discursive excess, the surveillance, the sense of potential disaster and loss that resonate through her work take a subtle but powerful form in the more silent and structural work of Kobayashi Fumiko.

1000 Feet and the Monumental Afterlife of Objects

The front of the monumental wall is flat; the back has the legs and miscellaneous chair parts sticking out. Viewers stand before a six-meter wall that reaches the ceiling of the very large exhibition space that is the Mori Art

Museum, on the top floor of the very tall skyscraper that is the Mori Build-
ing in Roppongi, Tokyo; or they come up close enough to try to smell the old
clothes and furniture that compose it. Made only of chairs, sweaters, and old
clothing, the assemblage has been constructed out of objects discarded from
hotels around Roppongi Hills and Grand Hyatt Hotel Tokyo, and from around
the artist's neighborhood. The work has the enigmatic title *1000 Feet and the
Fruit of Beginning* (*Sen no ashi to hajimari no kajitsu*, also sometimes trans-
lated *1000 Legs, Cultivating Fruits*), was commissioned for the 2013 *Roppongi
Crossing* exhibition, and is the first work viewers encounter in the exhibition,
a site-specific representation for the curators of the art of the *kontenporarī*,
the art of today in Japan (figure 5.5). If Kazama repoliticizes Shibuya, Ko-
bayashi personalizes the anonymous nightlife world of Roppongi.[25]

Born in Tokyo in 1977, Kobayashi throughout her life (until her unexpected
death in 2016) often made installations with objects, fitting them to particular
spaces. She built *Node Point* (2011), for example, from abandoned bicycles that
floated in air. It was part of a series called *Quiet Attentions: Departures by Women*
and is notably not verbally talkative in comparison to Kazama's work. An-
other installation, consisting of pieces of broken furniture, boxes, and build-
ing materials fitting tightly into a corner space of a museum, filling it from
floor to ceiling, was titled *Island over There: Hiroshima*. Rather than bringing
in captions and the flow of information, like Kazama's work, Kobayashi's se-
ries of installation works focuses on an embodied intervention into a partic-
ular site.[26] She explains, "There are scenes, people, and things that I could
only encounter at that place, and their significances and roles change when
they become part of my work, taken out of their relationship with their origi-
nal location."[27]

Kobayashi Fumiko points out that each of these objects had its owner
and its history—it had a story, a body, a domestic or public context. In the
monumental wall, when one approaches it, one sees that most of the objects
show the signs of wear. While something like the *vide grenier* and *brocante*
(garage sale/flea market) season in Paris displays a much deeper, longer his-
tory of material culture, Kobayashi's wall comes from a relatively thin layer
of the past (like Nakahira's *Circulation*), a relatively recent slice of consumer
objects that speak to the Tokyo custom of quickly discarding those objects
that are no longer completely new. Kobayashi moves around urban spaces of
Roppongi and around her home gathering these, meeting people—the per-
formative element of the work—and then builds them into a form of public
monument, or at least a rather miraculous assemblage in space. The work in
this sense speaks at the same time to a certain precariousness: How do so

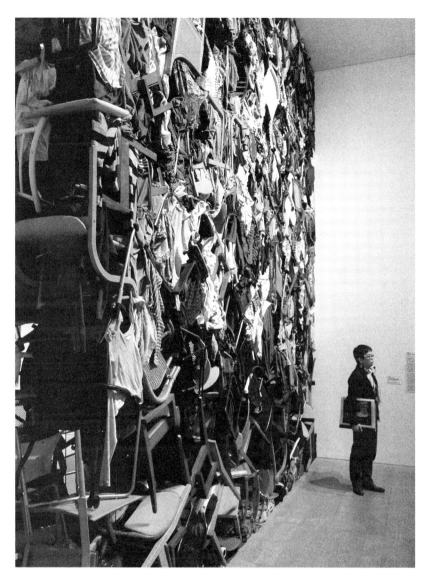

FIGURE 5.5 Kobayashi Fumiko, *1000 Feet and the Fruit of Beginning* (2013; also sometimes translated *1000 Legs, Cultivating Fruits*), installation. "Chairs and Clothes collected from around Roppongi Hills and My House." Photo by the author. Courtesy of the artist's estate.

many small objects at so many odd angles hold? Will they fall? Like Ishiu-chi Miyako's photographs of her mother's clothing, these sweaters and shirts belong to someone absent; they were once close to someone's body, and the chairs were once sat on by someone, or many different someones, and in that sense they are anonymous, far more so than the objects in *mother's* or even those in ひろしま/*hiroshima*. Yet now they take on a new form: they are the monumentality of the lost and abandoned objects of people passing through Roppongi. Viewers passing through the exhibition, walking by and below the wall, are we the active consumers of this exhibition, or are we disposable objects too, eaten up into the doorway and special elevator and spit out by the longer-lasting monument of Mori that will likely outlive us?

Although Kobayashi claimed that when making the work she did not in-tend to allude to the look and footage of the aftermath of the tsunami—she had been making installations of piles of abandoned TVs and chairs and un-used old paper dictionaries and encyclopedias since at least 2005—viewers who came to see *1000 Feet and the Fruit of Beginning* frequently did take it in the context of the disaster footage they had seen, where the contents of houses were spilled out onto the landscape, exposed for all to see: people's clothes, furniture, photo albums, and all the contents of the houses in a jumble of waste on the ground. Particularly the chaotic back of the installa-tion reminded viewers of those images, seen on television and in newspapers for so long, and so recently in 2013 to early 2014 when the installation was displayed. The sense of the missing bodies is palpable here—the sense of a world turned upside down. Because of this, all the more uncanny becomes the impact, in retrospect, of the uniform surface all these objects form on the front side of the enormous wall.

Yet along with these reflections on the infrastructures of the discarded—like Niwa's meditation on garbage—and on the disappearance of the bodies that these objects held, Kobayashi is simultaneously engaged in a conceptual project on a quite different plane, related to the question of what constitutes and constrains the space of art itself, the museum space, and the parameters and limits of art's functioning. This aspect of the work comes to the fore most prominently through an anecdote a curator told me: usually Kobayashi struc-tures her installations purely by balancing all the objects upon one another; thus, the work consists in the dual acts of gathering and of structuring, along with the performative process of moving through a particular social space, possibly meeting the people who owned these objects, asking for the objects that are being discarded from the hotels, meeting administrators or those in charge, and all that may have been part of those acts of gathering. Yet, for the

structuring, the curator stated that Kobayashi, as with her other works, built this six-meter wall completely without attachments. But then the Mori Building's code and safety regulators required her to screw the chairs together to form (what to them appeared to be) a more structurally reinforced object, to avoid a recursive reiteration of a disaster that would harm the work's (anonymous) visitors. This fact thus becomes an unexpected punctum of the piece, when one learns of it. The piece thus comments on the vicissitudes of the object world, treasured items that become urban waste, but it also shows us quite explicitly in its very formal structure the invisible regulatory systems of the museum, and thus of public space itself, in addition to the potential precarity of the viewers' bodies.

These regulatory systems, though here presumably meant in the most protective way for public safety, are linked to what Kazama's work was also making visible in a more overt way. Furthermore, one finds here a reflection on uniqueness in relation to the collective: these products of mass production also retain their specific histories, even in their formation into a somewhat monolithic object. Like the problems that arise when one attempts to discuss disaster, one finds objects and people that are at odds in both being unique and forming part of a plurality, being many and particular—a vacillation between the first and third person like the movement of seriality in Ishiuchi's works, both those relating to and those mostly separated from the epistemologies and thematics of disaster. As we will see in chapter 6, these works also begin a critical appraisal of the problem of forming, maintaining, and working within a collectivity, becoming a place where a more complex notion of collectivity at the affective scale can come into view.

As with Ishiuchi's work, Kobayashi's invites a structure of identification and transference: I think of my own basement, the brevity of use of so many consumer objects now consumed—toys outgrown, too many trips to Target, objects like boxes originally bought to contain other objects—the whole quite hard to get rid of actually, quite labor intensive to repurpose or even to dispose of, that bring one into contact with an awareness of both the built and the landfilled environment. Kobayashi's work opens up all these issues in a quite beautiful way, aesthetically. Still, it is a work, unlike Kazama's, that does not speak, is ultimately not about words and names and the discursive. What would be the media theoretics of this withholding? We might recall Ann Smock's statement about the paradoxical potentiality in being "preserved from" all attempts to articulate in language, one that overturns the expected hierarchies in which productivity, or capability, would be the positive terms, instead seeing the absence of relief and consolation as an alternative route

for being within a space of loss. Like Nakahira's discussion of parole and its paradoxical silence, the lack of discursive overlay here resonates powerfully in the silent impact of a countermonument. Kobayashi explores the cycles of change: productivity itself, both in art and in consumer culture, is brought into question, pulled into an undertow of withdrawal, just as the utility of painting was in question for Nakamura. What does it mean to produce or not to produce? When does one person's garbage become another person's work and for how long? Where does it go, and when does it end? By displacing these objects, bringing them into this new form, or new life as Ishiuchi might say, Kobayashi has given us an odd, displaced portrait of the social infrastructures of consumerism through the microcosms of Roppongi and Tokyo today.

The search and the wandering that echo in Kobayashi's work as part of its process of production come into dialogue with the personal relation that we imagine each owner might have had with the objects she found. Operating at the affective scale, she touches on both the intimately personal, the "smell of a body" as Isozaki named it in describing its apparent disappearance from the realm of art, and the infrastructural frameworks of production and consumption, including those of the institutions of art. She thus provokes an encounter with a multitude, a swarm or crowd or collective of objects that stand together as a model for an ambivalent collective at the site of loss. In a parallel silence or withholding of all but the most ambient of language and sounds, emergent photographer Asakai Yōko captures the mood of a globalized, post-3–11 world in an unexpected temporality of waiting that makes one think also of the ambivalent and layered temporality of Kobayashi's work, as well as of Kazama's. These layers give an altered meaning to the idea of the affective scale of encounter or response, as they blur personal feeling and infrastructural frameworks to evoke the edges of the invisible (like radiation, in Asakai's case). As one review of Asakai states, her work reframes time as she incorporates a sense of "'waiting' for a phenomenon to occur": resonating with the critiques of infrastructure in the landscape theorists of the 1960s–70s, these nearly empty "photographs that are taken by chasing 'air,' which cannot be fixed in two dimensions," evoke an adventurous yet invisible project, "like a road movie in search of 'wind.'"[28]

Asakai Yōko: A Road Movie in Search of Wind

In *Bambi, Berlin*, from 2006, from the series *sight*, we see three figures lying on their stomachs on a mattress or futon on the floor (see figure I.3). On the left a young woman leans her head into a pillow; at the center a younger girl,

head raised, hands crossed, looks to the lower foreground of the photograph. At the right, a young man with short hair and glasses rests his chin on his arm. All three focus their gazes on something that is just outside the frame, but whose bright light illuminates all their faces. In the background we see a yellowish wall, some strewn clothing, and rumpled blankets. The blue of the pillow and blankets cuts across the frame at center, and their bodies fade black in the shadows behind, highlighting their faces.

Bambi, Berlin forms part of a series by photographer Asakai Yōko in which she traveled to nine cities in six different countries to photograph small family groups at home, watching the movie of their choice, on the home medium of their choice (we often don't see what it is, whether a TV screen or a tablet) in their private interior spaces. Born in 1974, raised, and now (at the time of this writing) living in Japan, Asakai Yōko's primary art education comes from the Rhode Island School of Design. She speaks English fluently and travels all over the world to exhibit. In that sense, her works are overtly global and transnational in scope, like her series *sight*, photographs of families ensconced in their domestic spaces, engrossed in watching films like *Bambi*, thematizing and performing the global media space. She thus works with the gaze of the individual or intimate subject, yet one that is already infused with the infrastructures of popular media, where the private meets the iPad, computer, or television viewing-screen space inside the reflective, engrossed temporality of moving-image viewing. She freezes the time of the passing engagement, giving us an intimate glimpse into which we project a sense of the experiential forward motion of these films, as we become an additional layer of gaze into the private worlds of these figures who are also engaged in looking.

I begin with this work among Asakai's series to give a sense of the transnational media space in which Asakai began to work, and her interest in the legacy of that interlocking series of gazes that intermedia artists also aim to capture. Yet my main focus here is her later series *passage*, which comes from her residency at Aoyama Kokushi Geijutsu Center, which happened to fall, though it was planned earlier, in the several months or so just after 3–11. Layering a reflection on post-3–11 radiation with an echo of the "empty landscape" photographs of the *Provoke* era, ones that again mobilize a haunting awareness of infrastructures and vulnerability both within nature and in the built environment, Asakai presents a vision of a contemporary approach to the affective frame that operates in powerful and unexpected ways. With a medium-format camera, soon after the triple disaster, Asakai drove all around Aomori photographing the unique signs she found above the roads that

measure exactly where the wind is going, its direction and speed (figure 5.6). These wind anemometers (*fūkō-fūsokukei*) may be there in case of snow or wind, for drivers to take caution, or for people who work as ship crew. There is also a broadcast three times a day announcing the wind speed and temperature, a soft verbal soundscape that she includes, at a nearly imperceptible volume, as a corner sound projection in the exhibition of *passage*.

Asakai traveled around with a 6×7-inch film camera and photographed these landscapes absent any figures or cars—empty landscapes as it were, part of the quiet legacy of *fūkeiron* discourses about the uniformity and power infrastructures inscribed on the landscape. Like Kobayashi, Asakai also states in an interview that she did not intend this work primarily to refer to issues of radiation contamination; she read it as having more to do with her ongoing preoccupation with making invisible things visible. Wind, the air, fully invisible, was visualized here by text on the electronic monitors above the road within the landscapes themselves. Asakai also presents the work as part of her ongoing interest in "one-timeness" (*ikkaisei*), the passing quality of wind: you have to be there at that moment, and in order to catch all eight points of

FIGURE 5.6 © Asakai Yōko, *North Wind 0m*, from the series *passage* (2011), type-c print, 453 × 560 mm. Courtesy of the artist. The sign reads: North Wind 0 meters [per second].

the compass she had to chase the wind, learn to read the weather maps and prefecture maps, go to city hall to get a list of all the locations, go search for them, and wait for the wind to blow. Parallel to Kobayashi, whose process involved wandering through Roppongi back alleys searching and asking for discarded objects, Asakai rose early and traversed the landscape of Aomori in northern Japan with the aim of catching a certain moment in wind and time. This process orientation rhymes with her series *pace*, where she took photos on a beach in a southern island of Japan, Iriomote Island (in Okinawa Prefecture), from the exact same position at high and low tide. To viewers in the context of the exhibition of *passages*, however, wind direction would have gained an additional and more fearful meaning because of the nuclear reactor meltdown; individuals in that space would remember, in relation to the question of wind direction, the diagrams of wind forecasts shown on television, on the internet, and the mixed and ambivalent information and lies projected at the time about the alleged safety of the air and weather. For example, it was announced that it was safe for children to go to school on a rainy day in north Tokyo, when afterward the radiation content of that rain was shown to be extremely high.

Thus, though the work also deeply integrates other Asakai themes around visibility/invisibility and time, it takes on a particular set of readings in this context; it can even be said to shift the meanings of her other works after the fact, as we saw with Ishiuchi Miyako as well in chapter 4. Seen against Kazama and Kobayashi's works, however, Asakai's *passages* is where the didactic purpose is most attenuated, where what goes unspoken here has the most intense meanings, and a contingent exploration through space and time holds the place of what might elsewhere have been a pedagogic purpose. Having seen *passages*, if one now looks at *pace*, one yet again senses the momentariness and contingency, the passage of unpredictability; it becomes a work about waiting, about watching and chasing and mapping, as well as centrally about human infrastructures in a particular place. The work is both empty and full, visible and revealing the invisible.

The *passage* photographs themselves, and the places they capture, are in some ways nondescript, completely generic for the Japanese countryside yet also somehow a bit beautiful, with big open skies. Each photo in the series contains a common structure: a road, over which we see the overhead wires and the sign with the wind direction and speed; in addition, the frame may contain houses, sidewalks, or the road's edge leading to the beach, with the wires and concrete barrier poles separating the water from the road. It becomes a machine tableau, a wired landscape (figure 5.7). It is nowhere,

anywhere (an anonymous place), and at the same time a specific place and moment in time, captured on film. The relation that photography and landscape cinema had with the topographic mapping version of the world system in the 1960s–70s shifts here, with the focus on wind's temporary presence. But this wind is also shot through with a sense of its interaction with human infrastructures, and, in that sense, those earlier moments also deeply and importantly prefigure Asakai's visions of landscape.

A single body in a car moves through space; she exposes a medium-format film frame, vulnerably traveling through the landscapes so near those that have just been ravaged by the triple disaster. Exposing herself to the wind and weather, she captures the electric signage that links the fishermen with those watching out for radiation exposure, the invisible larger forces of wind that are both part of the natural environment and tied to the sociocultural and economic apparatus of that landscape in myriad ways, from fishing boats to regular drivers looking out for warnings about the weather, to the echoes of the aftermath of recent disasters. She frames the photos from just beside the road, where a single individual might walk, with or without a sidewalk.

FIGURE 5.7 © Asakai Yōko, *Northeast Wind 3m*, from the series *passage* (2011), type-c print, 453 × 560 mm. Courtesy of the artist.

As a singular "I" linked to the "we" that both need and can be eroded or poisoned by these winds, Asakai shows an interlocking web at the affective scale, melding and blurring the personal, singular instance with the multiple, the layered, the overdetermined structure of the local, national, and global power relations that brought this set of wires, cautions, and scientific notices together. All the more, when we remember the critique that landscape theorists and *Provoke* photographers imbued in their silent, empty landscapes, are we able to understand the understated yet incisive layer of perception that these photographs make newly available: not just the aftermath of 3–11 (the specific disaster) but also the broader infrastructural frames and sociomaterial ecologies that underpinned that event and continue to underpin daily life for Asakai and for us. This photograph is then taken up and recirculated in the global art system, recruited to become part of the invisible infrastructures that sustain the idea of Japanese contemporary art, the immaterial labor of art to mediate cultural frames, even while drawing our attention to the various layers of that invisible labor, the winds of those larger systems as well, even chasing the chance to capture them and see them in action.

With varying degrees of explicitness, these three contemporary women artists take up the challenge of making art and responding to 3–11 in creative ways and with three incommensurate approaches: Kazama's careful etchings of a mystical surveillance governmentality, Kobayashi's built remnants of consumer loss and waste and Asakai's visible/invisible wind each reveal something about the urban environment, media practices, and landscape as they are figured today. None of these, one might emphasize, is canonical artwork; all of it is new and may or may not be remembered. There is some emphatic contingency in the practices of making; for example, Asakai worked at a bed and breakfast to make a living while completing the *pace* series about the tides, which also immersed her in the social and economic milieu of the southern island where she photographed. Part of the trend of artists helping to reinvigorate the declining remote/rural areas, the project contains an invisible, struggling social space behind its self-consciously framed reflection on rises and falls, highs and lows. Unlike with the artists of the 1960s–70s that I discussed earlier in this book, there is very little written on Kazama, Kobayashi, and Asakai, and they have written very little about themselves or their works—with the notable exception of Kazama's detailed, prolific blog and a few articles.[29] Thus, we do not have a pregiven discursive apparatus to help us deconstruct or analyze their contributions in the more familiar way. Furthermore, these artists also circulate globally, not only locally—with the exception of Kobayashi's site-specific works—and so their near-silence in

another way becomes an advantage for evading the necessity of translation or allowing multiple (and decontextualized) points of entry.

The Fragmented Contemporary

If we restrict them to that latter international art-market perspective (where too much language is a barrier to circulation), however, we would miss the resonances with the fruitful theoretical evocations in reportage painting theory, the junk art, and the landscape theory of the 1960s–70s, and specifically their continuation of central debates on the subjects of materiality and infrastructure at the affective scale. As part of a wide cohort of artists and writers responding (directly or indirectly) to 3–11, we see them framing their inquiries in a context that destabilizes national frameworks, where so-called disaster becomes a context for works that aim to make us reflect more deeply on the place of "man-made things," including art, in the space and time of media practice today. They aim a critical eye, also affectively, toward the utopian discourses of new media theory that tend to miss the limits of materiality and of infrastructure that these works explore so openly. The artists probe the realms of materiality and infrastructure to more deeply apprehend the movements of media, environment, and landscape as they already existed, half unseen, before the event as it is known (and in part still unknown) today.

The *kontenporarī* fragments into multiple layers of the present, layers that incorporate *gendai bijutsu* of postwar artists, and the new contemporary that is seen to be already part of global art circulation. The art of *gendai bijutsu*, with its new prominence, comes into visibility in parallel with the development of new works by Japanese artists such as Arai's daguerrotypes, Niwa's video and performative send-ups of contemporary culture, Kazama's woodblocks, Kobayashi's monumental wall of personal objects, and Asakai's photography of wind. The works respond to powerful changes on the level of media's social and technological apparatus and grapple at the affective scale with the problems of working in a space where the personal is inherently also infrastructural and larger sociocultural forms overwhelm but also infuse the forms and temporalities of the personal. Generations of artists have explored the potentialities of the spaces between media, and each of these newer artists crosses through that field in her own manner to reawaken the work of earlier artists as well as to posit a survival for those to come.

What in this world produces and what fails to produce? What sustains use and exchange value and what gets cycled, tossed, and recycled? Are our tour-

ist photos of Tokyo at the top of the Mori Building, our cream puffs eaten at the specialty café on the fifty-third floor, more or less important than art triennials, or are they part of the same system? Which is more fun or meaningful? Extending this inquiry into the aftermath of disaster, we might ask, have things returned to normal yet, or is normalcy over? The artists and the frameworks in which they are embedded make us think about what signs of normality of the everyday would be, about what sign we are waiting for. They interrogate how we can navigate the self-conscious cosmopolitan system in which our interventions and presence have a hard time mattering, making a difference. Through various matters and material supports, visible, hypervisible, or invisible like wind, the artists of this chapter manage to navigate, at an intermediate scale, an assertion that the way some of these questions fail to be answerable is itself worthy of note. Such an assertion gives us key information about the feeling of our media environment that also allows us to pull close a new sense of affinity for the artists of the 1960s–70s. Through deploying (overtly, or implicitly) such similarities, they engage in a process of theorizing the larger system (totality) that resists being seen or grasped and give us hints about the workings of those infrastructures (socio-technical and economo-affective) as well as practical modes of theorizing/maneuvering among them.

Caught up in a system that seems at times compelled to comment on itself, the artists of the 2010s explored in this chapter problematize their own relation to various infrastructures—artistic, social, and economic. On the fifty-third floor of the Mori Building, viewers are confronted by an enormous countermonumental wall that references (in spite of itself) the triple disaster, localizes and provincializes the transnational space of Roppongi, and reechoes 1960s junk art. It withholds definitive discursive comment, while its screws and nails wink at you with hints of the very system of public safety whose contradictory messages have brought the precarity of the whole globalized transnational system into view. As viewers, we participate in that system of structured circulation that transcends, overwrites, and reframes our efforts and expressions in the production cycles of its own giant systems. The art world makes use of us, eats us up, and throws us out (viewers and critics and artists alike) in parallel with the discarded garments and cosmopolitan hotel chairs taking a short stay in this space, the global waiting room of mediated desire before we enter the social infrastructures of further mediated desire. The viewer produces circulation along with individual feeling; the dually structured collective of objects and people—the nature and conceptual possibility of that collectivity—is the subject of chapter 6.

Each emergent artist studied in this chapter has worked across multiple media or in forms that can be seen from many angles. Working successfully among the institutions of art, with material objects, in performative relation with the individuals they meet on the way, they begin the process of formulating a more critical notion of collectivity, a term that has been important in framing the role of art in recent years. As we will see in chapter 6, a wave of utopian impulses for art as a repairer of community and a shaper of collaboration has been an important force, particularly since the triple disaster. Yet when we view recent art in the context of the more complex concepts of the potentiality of the masses, traversing ideas of plasmatic multitudes in motion that came out of the arts of the 1950s–70s, we can come to a more nuanced understanding of the workings and conceptualization of collectivity. This more paradoxical perspective brings with it a critical understanding of the movements of feeling and affective energy that also bridges the works of the postwar artists toward those, like Kobayashi, who build personal yet collective monuments in this moment's everyday. By returning, at the start of the chapter, to the late 1950s and then mapping a broader trajectory across the theories and practices of collectivity, we can see more fully how this affective space functions in and through the art of the present day.

6

Moves Like Sand

Community and Collectivity

in Japanese Contemporary Art

Concepts of collectivity and collaboration—not in the darker sense of wartime collaboration, but in a more utopian and communitarian sense—have appeared frequently in the discourses around both art and literature in the wake of the triple disaster of 3–11. As we saw in chapter 5, Arai Takashi's daguerreotypes mobilize an older medium in part to evoke a slowing of time, a being in the present with the subjects of the triple disaster that implies a desire to be with others in a unified and integrated space and time, a "time in which we hold our breaths and gaze at each other" in a way that enacts "cooperation and a trusting relationship" between photographer and photographed.[1] Within a layered presentation and an emphasis on memory, there emerges a metaphysics of presence and an emphasis on creating a collaboration, even a momentary community, for the creation of the work. Niwa's *Billboard Photos* similarly evoke a momentary and unexpected community. From artist collectives like ChimPom to Endō Ichirō's *Mirai e gō bus* (Bus to the future) that he drives around Japan, connecting with and soliciting participation of local community members in art events (that viewers can also track on the internet), or Endō's *Mirai e maru* (Boat to the future), many in a new generation of artists are centrally concerned with the creation of face-to-face human connections and a kind of optimistic if also at times self-reflexive building of community bonds.

These are a few examples of a broader trend in which, in the wake of the triple disaster, art has been called upon, or artists have taken it upon themselves, to work toward restoring a sense of safety, community, and rebuilding through collaboration, in ways that have had an important positive impact on the lives of (at least a subset of) those affected by the disaster.[2] For a broader overview of the importance of the theme of community and collaboration, one could turn for example to the major exhibition *Japanorama* at the Musée Pompidou Metz (2017–18), where the curator, Hasegawa Yōko of the Tokyo Museum of Contemporary Art, launched a thorough review of the contemporary art of Japan from 1970 through the present day. One of the six islands or sections in the archipelago structure of the exhibit is called "Collaboration/Participation/Partage (Sharing)," which the exhibition takes up from Fluxus to the collaborative happening events of the Play Group (Ikemizu Keiichi) through some very contemporary works. In contrast to what might appear to be more personal and subjective interventions in the late 1990s to 2000, such as the work of photographer Yanagi Miwa from her *Grandmother* series (included in the exhibition under the theme "Pop Culture and Neo-Pop"), the recent groups included under the rubric of collaboration, such as WAH (Wow) Project, are engaged in direct interventions that bring in the participation of community members. For example, in one project highlighted in *Japanorama* (Kitayama City, Saitama, 2010), a group of volunteers and local people organized by the WAH (Wow) Project together lifted a two-story house off its foundations. In the footage of the work, we see the hard hat–wearing men and women, including older people and small children, lined up and shouldering wooden beams that are attached to the house at the base. With their collective strength, they lift the house five centimeters into the air (figure 6.1).[3]

Internationally, related projects focused on community formation and intervention are currently being carried out by resourceful activist artists like Lene Noer of the Grasslands Project, Sweden, who goes out into the countryside and works directly with the inhabitants of distant Swedish and Danish towns to stage performative art events and build objects with their help in their villages, enlisting the inhabitants' own ideas to invent the thematics and structure of the works.[4] For example, in one work by Grasslands, the inhabitants of a town said that what they most wanted was a path leading from the waterside to their chateau; so Grasslands organized a twenty-four-hour path-breaking event in which volunteers and locals walked for twenty-four hours between the chateau and the waterside until a clear path had been traced and

FIGURE 6.1 WAH Project, *Lifting House/WAH 47* (2010). Courtesy of the artists Minamigawa Kenji and Masui Hirofumi.

formed between the two (figure 6.2). These works by WAH Project and Lene Noer and Birgitte Ejdrup Kristensen of Grasslands, and others that come up sometimes under the name of popular participation or even the interrogation of democracy, are paradigmatic examples of the concepts of participation and collaboration that have been central in recent years, including some very whimsical and engaging visions of artistic social participation that they practice.

Many recent Japanese artists, with the best of motivations, put forward in their work a quite utopian and implicitly transparent view of what community and collaboration can mean and do. Forming and building community seem almost to be imagined as a seamless process of bringing together people in real time—with a component of the work dependent on social media to gather participants and disseminate results, though the pandemic has attenuated and brought into question the assumed simplicity of live gatherings and increased the prominence of online collaboration. Still, one question these projects raise is what community actually means, how collaboration functions, and what art's role is or should be in forming, repairing, and building these community ties. Like the male critics' interpretation of "girly photography" as implicitly expected to forward the work of social reproduction and community repair, many of these works imply a notion of community that

FIGURE 6.2 Lene Noer and Birgitte Ejdrup Kristensen, *Trampling Marathon* (*Trampe Maraton*), Aasted, Denmark, May 2017. Grasslands Project. Photo by Leo Sagastuy. Courtesy of the artists.

remains pregiven, uninterrogated, taken for granted as simply positive—and thus these very benevolent efforts in the face of disaster can at times leave the meanings and critical potentialities around the idea of community and collaboration unquestioned. Through the trajectory of visions of community and collaboration, this chapter attempts a remapping to add nuance to such views, to mobilize some of the alternative critical possibilities and potentialities around ideas of community and collaboration that have been present in Japanese postwar and contemporary art and theory.

It would be unfair to say that the community-building and social-support art projects do not, at times, evoke a self-reflexive impulse. In their practices they can encounter many forms of conflict that would serve to complicate an idealized notion of community that the works' final presentations nonetheless often imply (and credit to a given artist or group's proper name). The understanding of these projects' value in the art world, however—and some of the structures that fund them—often rely on a relatively utopian, even romantic view of what community action, formation, and building can and should be, in which art becomes "for" the sake of this community building, useful and helpful, so that we lose sight of the complexity of how collaboration, community, and participation can work. By examining works that engage layers of affect and frame a complex assembly of elements, we can explore an intermediate range of agency where assembling takes place below

and above the horizons of subjectivity, between and among human and non-human elements, and thus see more accurately the shifting roles of the individual, the collective, and the larger structures formed around them. Only with a fuller account of these roles and relationships can the potentiality of such media practices—critical conceptions of collectivity as assemblings, disassemblings, and gaps—come into clearer view.

What is the relation between questions of infrastructure that form a key problem in this book and the problems of community and collaboration that have been raised so frequently in recent works and studies? In earlier chapters I noted that artists moved away from models of the individual artistic production of works to open perspectives on infrastructure, on broader systems and their techno-social elements, as well as focusing new attention on the institutions that supported or restricted their practices. They questioned fundamental premises of art making and created works that focused on anonymity instead of individual artistic subjectivity, or on enormous totalities that escaped the grasp of any individual. They asked Marxist-influenced questions about the mobilization of the masses and the role of capitalism and technological change in shaping not only art but also cultural and social space as a whole. These questions formed an important context that shaped painting and proto-intermedia art in the 1950s, the high era of intermedia art in the late 1960s, and theories of the culture industries that circulated alongside them. With relation to the infrastructures of gender, they hold a key place in reading works of photography by Ishiuchi Miyako. These questions also played a vital role in shaping the direction of contemporary (*kontenporarī*) art that reflects on the role of media in the aftermath of the triple disaster. What I examine in this chapter, however, lies between questions of infrastructure and of collaboration and community that are so much more prevalent in art studies today. By expanding and shifting the frame of inquiry, I show how questions of community and participation require us to consider not only the relations between people, but also between things, spaces, and systems (as another face of infrastructure, that some might prefer to term an ecology or a media ecology); the term *collectivity* turns out to help bridge those questions of community to the larger object and system-oriented frameworks of infrastructure.

We begin by considering a provocation by emergent musicologist Miki Kaneda. What follows is a brief four-stop itinerary—itself a return to some of the works and artists visited in the earlier chapters, but from a new angle—across a historical and theoretical landscape of contemporary Japanese art and art theory. Each of these stops offers a different perspective on the forms and

terms of collectivity, community, and ways of being with and relating to others in the context of art. Beginning with the theoretical writings of art critic Hanada Kiyoteru from the late 1950s, we pass through the experimental/intermedia music of composer Mizuno Shūkō and Ichiyanagi Toshi in the 1960s, then we return once more to the site-specific photographic works of Nakahira Takuma and his theoretical interventions, and end with Kobayashi Fumiko's sculptural installation as an instantiation and development of some key points in Nakahira's theories of media around the forms and potentialities of collective practice.

Agencement and the Sand-like Masses: Hanada Kiyoteru

In her writing on Group Ongaku and Sōgetsu Art Center in the late 1960s, Miki Kaneda opens the idea of collectives beyond the concept of an assembly of individual artists or community members: "Intermedia highlights the productive, frictional, and sympathetic encounters that are constantly negotiated in a practice that involves collectives of *people, agencies, ideas, infrastructures, and institutions* coming together in new and unexpected assemblages."[5] She posits the idea that collectives are, first of all, by definition not smooth or uniform, nor even necessarily made up of multiple elements of a uniform type (say, groups of people).[6] Instead, in the context of Japanese contemporary art it is more productive to envision the collective as consisting not only of people-in-relationship but also of people in structured relation to various kinds of things, objects, systems, and even concepts (some of the elements of which we have been considering under the term *infrastructure* in the earlier chapters). Opening the term *collective* to include objects and systems, Kaneda then takes a foray into the related concept of assemblage. Privileging instead the term *agencement* from French critical theory, a term that basically means "layout" or "schema of relations," Kaneda emphasizes the "arrangement of connections, even if they are messy, and multiple" over the objects that are connected. The arrangement (*agencement*), which is also a relation of power, can reshape our theories of collective to focus on the links, separations, and layout over the nodes that are assembled in the process of assemblage.

Lest this all get too abstract, I have drawn a picture (figure 6.3).

In the left image, we see a drawing that would represent the usual idea of an assemblage, involving points or nodes: the assemblage comes from the collectivity that forms between set points. Yet in *agencement*, the little circles (nodes) are not the point, and it is instead a focus on the shape or layout of the

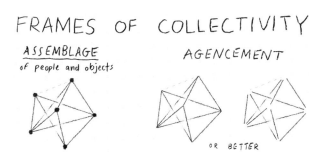

FIGURE 6.3 Diagram by the author, digitally rendered by Alan Johnson.

arrangement—or better yet, without even closing out the points of origin of the vectors, as on the rightmost drawing, we may be left with an open-ended spiderweb of vectors that is the moving and operational logic of the piece thus formed. If it is possible to leave the ends detached, as we'll see in the intermedial music of Ichiyanagi and Mizuno, we still have a formation, structure, or arrangement revealed. When we imagine this *agencement* in motion over time, we might begin to see how vibrant and complex theories of collectivity need to be in order to push against a presumed transparency that can sometimes dominate ideas of community or aspirations toward it. In other words, sometimes we think we know what community is, but these works bring that presumption into question. Hanada Kiyoteru, the Marxist thinker I discussed in chapter 1 in the context of his theories of *sōgō geijutsu* (composite or synthetic art) and for his influence on the theories of dialectics of Matsumoto Toshio in the late 1950s, can help us begin to elaborate the potential social meanings of such an idea of *agencement* and how it might move through time.

For Hanada, it was imperative to reconsider the movement of groups in the context of social change. For many leftists of his time, the movement of masses of people—as potential site for the formation of communities or as a destructive force—was a key question. His work emerged in relation to the so-called mass culture debates, which in the early postwar had focused on an inquiry into the rise of fascism/nationalism in Japan, with a prominently debated disagreement between Yoshimoto Takaaki and Maruyama Masao. Hanada's famous image, taken and reconfigured from critics of mass society such as Maruyama, was of the masses as sand (of the sand-like masses). What makes the sand-like masses move, and what conditions that movement? Hanada imagines the masses as "protean, shape-shifting, and plastic."[7] It is what Yuri Furuhata calls his "fascination with the plastic dimension of form" that

makes the movement of the masses and the plasmaticity of Disney's animation theoretically parallel to one another, in ways that, as we saw in chapter 2, fascinated Eisenstein for similar reasons. Something as plastic as sand is both infinitely malleable, can take any form whatsoever under the sun, and in other times holds an immense power both to destroy and create. Hanada's writing itself is notoriously difficult to grasp and brings in some performativity of sandiness or plasmatic argument being enacted in words; we may be wise not to try to push too hard on concepts that remain somewhat malleable, and yet there is a rigor in the very way that Hanada's language moves and shifts as well.

Art Informel was a movement primarily in postwar painting that encompassed modes of abstraction and gesture as codified in French painter Michel Tapié's writings, which was introduced to Japan in a transnational form (encompassing American abstract expressionism, French Informel with some European counterparts, and Japanese Gutai) in the exhibition *Exposition Internationale de l'art actuel/Sekai konnichi no bijutsu-ten* in 1956, which catalyzed what was known as the Informel Whirlwind in Japan.[8] Although Hanada claims no particular interest in Art Informel itself, he becomes interested in Michel Tapié's writings about Informel for the help they might provide with the theorization of the movement of those sand-like masses. In 1956, Michel Tapié's *Un art autre* was published in Japanese in a translation by surrealist poet and art critic Takiguchi Shūzō, leader of Experimental Workshop (Jikken Kōbō) at that time. Hanada Kiyoteru reads Tapié (perhaps also with Takiguchi's translation in hand), and paraphrases Tapié's *Un art autre* in the following provocative yet quite confusing opposition: "According to Tapié," Hanada writes, "[in-forme (アンフォルム/非定形)] is neither an inert (*shōkyokuteki*, 消極的 quiescent, passive) nor a rigorous (*genmitsu*, 厳密 precise) term, while Informel (アンフォルメル) is a term that anticipates and includes every possible schema (*taikei*, 体系) of forms."[9] Objecting to the image of the masses as a passive material that can be shaped from the outside, or as something that can be defined in limited and precise terms, he nonetheless argues, "As the masses break away from given forms, they might lapse temporarily into the state of 'informe,' and may no longer even be recognizable as such, but precisely because of that, they can envision/imagine every possible form . . . and then choose from among them a form they desire to become."[10] It's an interesting image of potentiality as a plurality that can envision, imagine from out of a state of formlessness, and desire/become/create form.

Hanada's theory of the masses from the 1950s—his imagining of them as plasmatically powerful sand—forms a framework and highly cogent statement we might associate with our image of *agencement* as movement, with a critical relation to social change. The dialectics of fluidity and resistance form a key aspect of his image of a collective movement of political/social transformation.[11] Following Hanada in the subsequent decades, many artists and critics continued to inquire about what kind of self-organization or self-mobilization could be possible for the masses, what their potentialities might be (or what kind of embodied dance they might do). One might think of the writings of Matsuda Masao (as discussed in chapter 3) and the landscape or *fūkeiron* theorists as part of that legacy: whether as a dance, a guerilla action, or a shift of axis, the questions of dialectics and plasmaticity form an incisive model to open up thinking collectivity and/as social transformation, with a critical complexity around the potentialities of such movements of form and medium. Hanada immediately focuses on the importance of mediation for collectivity, a dialectic that transcends the binary of activity (production) and passivity (consumption, being shaped). Instead, introducing an alternation between fluidity and resistance, Hanada raises the problem of the vantage point from which one might gauge the masses, and raises the problematic of locating desire within, among, or beyond those sand-like masses. He also asks what relation might be between form and politics via a plurality of agency encompassing both living and nonliving entities. He moves us far from assumed notions of unified, homogeneous collectivity. But how could such theoretical visions be enacted or deployed?

Collectivity and Intermedia

Moving forward in time to a more concrete example of a form of open-ended collectivity in an extension of this theoretical inquiry, we might look to the enactments of collectivity in 1960s intermedia art. Composer Ichiyanagi Toshi stages musical composition as a matter of process and movement, of open-ended structuration, rather than as a determined final product, such as in his *Music for Electric Metronomes* (1960), whose graphic score and performance consists of a map of starting and ending points that the performers follow in time, with metronome speeds, number of beats, arcs for actions.[12] Ichiyanagi's score maps a series of relationships, a layout of movements across time of several individuals, time signatures, and things. The temporality of the electric metronomes is part of this, as are human actions and

movements—walking, jumping—and some chance objects that may be incorporated. The relations might be imagined here as quite utopian: every element is included and imagined to be of equal importance, though in fact each performance reveals differential strengths in volume and prominence. Only with the participation of everyone—the jumpers and even the spectators— can the piece be accomplished or made. It is a specific (live, open-ended) assemblage in a moment in time, in which all viewers and performers are implicated in the making (figures 6.4 and 6.5).

If one were to draw out an example from the score pictured in figure 6.4, if I were to begin in the upper right (and in actual performance of this piece, which I did in 2012, the "I" could be and was a pair of players working in tandem), I would start at the rather fast 103 beats per minute, and (following the rule of a zigzag arch) for twenty beats would do a number of different actions of my choice with an object (playing a recorder, blowing a whistle, or hitting the floor with a shoe). Then for twenty-four beats I would gradually increase my metronome tempo to 120, then quickly in three beats slow radically down to sixty-four. At this point (say I choose the right fork—I am given two choices) I would for thirty-eight beats, counting all the while, increase to the snappy pace of one hundred beats per minute while, say, walking about among the other performers who are bumping, jumping, accelerating, and decelerating around the space. When I reached one hundred, I could turn inward on the score to the dotted arc for nineteen beats while making any number of actions (clapping, whistling) not using an object. Within about five to seven more such actions (and many choices of route on the score), I would hit a zero, which would signal me to turn the metronome off, and my part in the piece would come to an end.

Am I running the machine or is it running me? I have agency in my choices, but I am also mapped into a spatialized script (graphic score) for my actions through time; my statement gives me freedom, and the range of possibilities is wide open (any physical action counts); but I am told whether it has to be with or without an object and am part of a composed/composited structure of digital/electronic time, a finite time while I am live with others and also mechanically (choosing to) act in concert with others. We are not a mass, and we may well appear chaotic—that chaos, however, depends on a sort of algorithm that those perceiving us may or may not be able to follow.

In some ways, this piece prefigures discussions of the role of algorithm in the digital, a conditioning numeric/electronic frame beyond sensibility, and it also evokes theoretical discussions of control and freedom in the digital age. Ichiyanagi, who spent significant time in New York (he is perhaps well-known

FIGURE 6.4 Ichiyanagi Toshi, *Music for Electric Metronomes* (1960). © 1968 by C. F. Peters Corporation. All rights reserved. Used with permission.

Instructions: larger figure: metronome speed.

Small figure: count the beats of the metronome, while changing the speed gradually to the next large figure.

Line: operate the metronome.

Arc: make a single action (walking, jumping).

Multiple arcs: make two or more different actions (walking, jumping).

Dotted line: make a single physical action (clapping, whistling) without object.

Zigzag line: make a single action using an external object.

Zigzag arch: make any number of actions with external object.

Figure O: turn metronome off.

Number of players: 3–8. Start at any large figure, which has a line only on one side. The performer who chooses a number closest to the edge of the score begins. To end the piece, the performer should get to a large figure zero.

FIGURE 6.5 Participants at UC Berkeley performing the score of Ichiyanagi Toshi's *Music for Electric Metronomes* (1968) at a 2012 event. Photo: Sharon Hayashi. Thanks to Yayoi Uno Everett and JSPS.

also as Yōko Ono's husband before John Lennon) is part of a broader movement for this kind of shift in the arts transnationally (happenings, Fluxus) that highlights the role of contingency in the everyday. It's not just that all parts of this network or imaginary motherboard are connected equally, but depending on how you look at this assemblage you might focus on the one-to-many (Ichiyanagi as composer-performers-audience) or the many-to-many (heterarchical/environmental) element, the constitution of the visible labor that goes into the piece, its techno-social construction as a totality or whole, or the overall mood it creates (of strange, electronically mediated play, jumps and claps and odd object uses in deregulated-seeming combinations of rhythms). For us experimenting with it in 2012, it was also part of a doubled temporal structure in which we were trying to find out what it felt like experientially to move through the music/art of another moment, across the gap in periods considered in this book. And of course the resulting piece is not only sound (though the idea of music foregrounds what one hears) but also movement in space, gestures, interactions with other people, the objects, the world. The audience and other performers bring forward the conventions of musical performance (formal costuming, perhaps; looking at a paper score; the idea of accuracy of tempo/rhythms), along with the lack of an audible melody or a system of organization that the ear can parse. What gets a laugh? What is serious? How is the audience to behave? (The reactions to one YouTube video of a performance range from "Amazing—I wish I were born in Japan at that time," to "To be honest . . . I prefer something with a tune.")[13] What sounds "good" and "bad"? How do you know if it's time to applaud? A more centrally organizing question for our purposes, in the heterarchical network version of the piece that seems to frame or reflect on techno-social infrastructure, would be: How do some elements become more crucial than others in this flat score? Where does it draw attention more to gaps and disjunctures than to conjunctions? What draws attention

(clickbait, as it were)? Long before the digital age, this range of questions forms the core of Ichiyanagi's multifaceted inquiry on collectivity, whose significance touches music but also reaches across to touch key issues for later eras of socio-technical change.

Other members of Group Ongaku continued throughout the 1960s to build on these early experiments, both sonically and in terms of the burgeoning field of electronic music within intermedia art, and hence to work directly and critically with formulating the modes of understanding and practice that could be applied to the ideas of collectivity and collaboration. Mizuno Shūkō, for example, who had been working with the materiality of sound in his pieces since the late 1950s, in 1966 made the following statement in explanation of his piece *Orchestra 1966*, and of the related piano piece *Provisional Color*, which was performed in a CROSS TALK event in 1967. In writing in the CROSS TALK Intermedia program in 1969, he contrasts his compositional method to the more traditional relation between composer, written musical piece, and performance:

> In my recent music, I have employed the idea of "projective units." This can be clarified by a comparison with traditional European music. If (A) is the musical idea (the "tonal form") in the composer's mind, (B) the performer's conception formed on the basis of the score and incidental information, and (C) is the actual sound heard by the audience, we can describe the concert situation in this way: (B) tries to be (A), and (C) is considered to be (A).
>
> In the case of "projections" a different situation exists. (A) is an incomplete ideal, a framework with detail unspecified, (B) projects his own idea based on the framework supplied by (A) or calls on his subconscious in producing something even more personal. In both of these cases, (C) involves *cooperation (conscious and/or unconscious)* of the audience in projecting, with the performer, a joint vision of (A).[14]

Instead of the thing or aim being a musical result, Mizuno proposes an idea that foregrounds the process of projection in a way that, in parallel with Ichiyanagi's framing, upturns and reconfigures the presumed relation between composer, performer, and audience. The composer makes something self-consciously incomplete, (A), something that is in itself a framework with the nodes of production deliberately unspecified. (B)'s job of projection is made explicit, brought to the foreground as creative process. And (C)'s role, that of the audience, becomes definitive. Notable in the case of both (B) and (C) is that they engage not only with conscious intent but also with what

Mizuno calls the unconscious, as a stand-in for what in the psyche is outside control or will. He thus posits a phantasmatic quality that forms the heart of the relationality of collaboration. Mizuno goes on to specify elements of his framework, in which he experiments with the forms of relation that can exist between individuals in a collective. His score for *Orchestra 1966*, for example, rather than consisting of notes, consists of time frames specifying relations that should exist between the players and the sounds they make (figure 6.6).

What is significant for us in this assemblage is the model of relationality it constructs. The thing—the material, pitch, or timbre—is left relatively open-ended; instead, the composition focuses on the kinds of relations, both material and imaginary, between the sound types or between what the players are playing. In one simple example he gives to explain the nature of the relationships, he marks times when the players should be playing similar or dissimilar sounds, and which player should follow which other player (or depart from playing) at which demarcation of time. His composition is both a radically abstract and strikingly concrete meditation on ways of being within a collective, a group practice of making and creating, either separately or together. Thus, as outlined briefly here, both Ichiyanagi and Mizuno allow us to think usefully about a contrasting model coming out of the 1960s of ways of being in collectivity that includes ways of laying out the ever-shifting and plastic forms of community, some of which also involve relations to technological objects.

Mizuno engages with the idea of masses in a quite explicit way: his idea is that if the notes, what he calls the "tadpoles" (the actual pitches) are specified, as he feels they are too often/in too much detail in works like *Pithopratka* by Iannis Xenakis (1955–56) or *Chromamorph* by Takahashi Yūji (1964), then one loses the capacity for this open-ended process to do its work. Instead, he prefers, not that the composer become passive, but that the process highlight what he names an "emotional relation" between performers, listening to one another in performance, using their performance sensibility (*ensō kankaku*) in the moment, their sensibilities of the resonance (*hibiki*) and their ears to work as what he calls a "mass-sound" or a "collective projection," then building tension (*kinchōkan*) through increasing amplitude and tempo so that one has the feeling of "being engulfed in a whirlpool mass of *glissando*."[15] He compares this version of *agencement* or laying out of a musical framework to a kata in kendō, and, in a way somewhat analogous to Nakai Masakazu in his 1930s theories of collective labor in the metaphor of rowing a boat, Mizuno also compares it to swimming.[16] The affective relation of mutuality and

FIGURE 6.6 Mizuno Shūkō, *Orchestra 1966*.

collaborative action of listening and playing, then, becomes an instantiation of his vision of practical collectivity—and he also talks about training performers over time who can listen and collaborate in this way, a specific and new kind of skill base.

In listening to the recorded version of the piece from NHK at the time, one has the sense of a mass of contradictions—the full and enormous power and weight of the Western classical orchestra, of skilled musicians who, it is clear from hearing their individual melody lines when they play alone, could have followed a traditional score to the note, could have infused with their own imaginations a composer's given piece full of set tadpoles (rhythms, tempo, pitches) all the while following a conductor's baton to remain in sync—but instead, here, what remains to be emphasized is primarily the *hibiki* (resonance) of any note, sound form, or melody. This leaves just a sense of

nonrepresentational tension (if you can use the idea of representation here, or its absence for tadpole-less compositions), a building and ebbing and rebuilding but continually evolving tension, whether via a prolonged choice of unison, a pause, or really very much the glissando craziness whirlpool Mizuno described (11′06″). At one point the musicians even shout "Ha!" almost like a *kiai* in martial arts (kendō, for Mizuno). The sense of a continuity (12′35″–12′42″), like an imperfect tense in writing or an ambient sensibility, gets interrupted by a more momentary or eventful sound layered on top of it, and a crashing of waves of percussion that overcome and drown out the notes (13′50″) before ceding to silence.

How can we understand this general feeling of tense overwhelm (like a cityscape on an overloaded traffic day, but formed by the sounds of classical instruments) that Mizuno produces, and how can this mass of sound and its yielding to quiet in the end help us understand the multifaceted potentials of collectivity? He has created a layout of sounds beyond melody, harmony, or counterpoint that works in a nearly purified way with the tension that builds between performers and audience, between sound and sound, between instrument and bow or between drum (or gong) and what strikes it—reflecting in a particularly resonant way on the temporality of development of the sense of collectivity as well as its disruptions, disturbances, phantasmatic projections of hearing and imagining—the eerie mood of its interruption that can devolve into a tense and fraught antirelation (as when performers are directed not to follow one another, to play/move away from the given sound of another performer or the whole). His creation also suggests to me a reflection or rearticulation of the very fact of eventfulness: that is, the way the difficult-to-grasp, ongoing sense of timing of the emergence of something (a sound, a relationship in social-field terms, a form of sexuality, even an ethnicity) can come retroactively to form itself or congeal into a thing, a named framework, even an infrastructural affect, and can come to seem like it was always there as such. In this piece, the ambient defines, determines, and underlies what comes to be seen or felt as the/an event. If the event is a relationship, a framework for identity, or a community (political or otherwise), we need to attend to the temporal framework of its laying out, the process of its retroactive constitution and the coming into awareness of a form—as well as its possibilities for shifting and dissolving in the longer *durée*. Most of all, Mizuno is interested in the practical navigations of the individual and groups, including gaps among them and phantasms/imaginative projections between them, through the fields of larger structures over time.

Reality as Multitude and the Revenge to Come

In stark contrast to Hanada's vision of the masses, or Ichiyanagi/Mizuno's self-reflexively collaborative projects, it might seem counterintuitive to return now to Nakahira's *Circulation* project, usually read as a relatively solo practice. In this work, as we have seen, the frenzied body of Nakahira Takuma ran around Paris shooting images of everyday life with his camera and then developed them in a borrowed darkroom; before they were even fully dry, he hung them at the 1971 Paris Biennale in his section of the exhibition. As we saw earlier, every day he would take a whole series of shots of Paris on that very day, and then add them to the previous day's shots in his exhibition space at the Biennale in real time, until the photos, some still wet, some curled, were starting to rise in waves under the wall and on the floor of the show, upsetting those in charge (figures 6.7 and 6.8). If we were to return to Hanada's image, the photos become like a wave or like sand, accumulating in numbers, 1,500 images in all by the end, challenging the fetish of the individual well-framed image to give way to an accumulation, a tide, a multitude of images of a multitude of only slightly prior moments, near-presents, many of them images of images, like magazine covers, newspapers, streets, coffee shops, cinemas, underexposed and overexposed at times, ripe with texts from street signs—as in one telling quote in one photograph from a newspaper comic: "Have I kept you waiting, Marie? Oh, I am sorry! I didn't notice the time passing! I . . ." ("Est-ce que je vous ai fait attendre, Marie? Oh, je suis désolée! Je n'ai pas vu le temps passer! Je . . .") An assemblage of images and images of images, Nakahira demotivates the framing except to help us to see time passing, or to help us see how the only way to see time passing is with a certain *décalage*, a certain inevitable delay.

Through a repetition of this act of immediacy and slight delay, he creates an assemblage, a layout, an arrangement (somewhat haphazard) of a collectivity of moments that also challenges his own habituated perceptions of the urban environment as well as his conceptions of photography. The viewers then come to look on the floor, to search through the rubble of those moments, for the image they want to look at or the one that strikes them. In Nakahira's own highly critical words, though he was included in a section titled "Interventions," he writes:

> *Intervention(s)*—this word itself has the meaning of "interference" [*kanshō* 干渉] or "intervention" [*kainyū* 介入]. In this case, it denies/negates the static, one-way relationship in which the artist makes the work, exhibits it, and the viewers quietly admire/appreciate it. Instead,

FIGURE 6.7 Nakahira Takuma, *Circulation: Date, Place, Events* (1971), installation view. © Nakahira Gen.

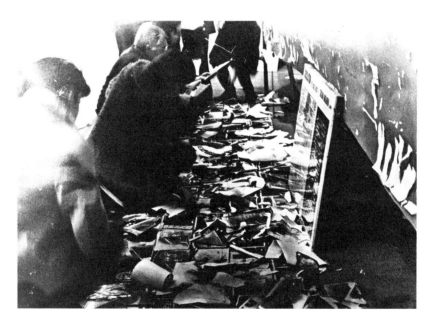

FIGURE 6.8 Nakahira Takuma, *Circulation: Date, Place, Events*, (1971), prints taken down by the artist himself. Photographer unknown. Courtesy of Osiris.

intervention art—close to what for a brief time was known as "environmental art" in the art world—attempts to create a relationship of mutual intervention or interference between the artist and the indefinite multitude of people who see and touch [or are touched by] the work. (263/291)[17]

It is notable in his description that what intervention art would push against, the static relationship, would involve the act of viewing art as an act of admiration, appreciation, as of a decorative object (*kanshō suru*). In the intervention art, it would be a more mutual relationship in which what the multitude of people do is not only to see but also touch the work, come into contact with it.

Yet if this all sounds like a nice ideal, Nakahira devastatingly writes in 1971 that contrary to the concept proposed there, the space was "deserted" (*kansan to shi*): "Not just that it was hushed or empty: it would be more correct to say that so-called 'contemporary art' lay bare (exposed, divulged, *sarakedasu*) the barren wasteland it had reached/arrived at" (263/291). His words and acts, we might argue, set the stage for problems of collectivity in contemporary art since 1971. In "the conditions of contemporary society" he describes, "human beings are torn apart, as individuals cut off from one another, their naked bodies (*ratai*) directly exposed to the iron structures of society like cracked open shellfish" (264/292).

What happens to the collective under conditions of such vulnerability? Instead of continuing to assert the individuality and specific subjectivity of the artists, "Should we not [instead] further drive/propel/push forward that very process of tearing apart, and even disassemble (demolish) the individual itself, preparing for the revenge to come against society and history?" (264/292). He uses the term *kitaru beki fukushū*, the revenge to come, echoing to our ears his now well-known words that became his photo book title *Kitaru beki kotoba no tame ni* (For a language to come, 1970). The revenge, here, is already on its way, and the most effective method for Nakahira, that he is embarking on with this very project, has to do with acts of fragmenting, exploring, propelling, and furthering a tearing apart that is already underway. As we have seen throughout his oeuvre, he highlights a vulnerability, dissolving and dismantling subjecthood that has already been laid bare by the structures of society and the processes of history (infrastructure meets multitude). This is a notable contrast with the more self-assertive creation of works that he sees as prevalent in the contemporary art world's realism.

In writing about *Circulation*, he states, "I negate the idea of exteriorizing my 'thought' and ideas in the form of a work; instead, I am much more drawn to the impact and impulses (the shock/*shōgeki*) that reality has on my thought and ideas, as well as the everyday transformations these shocks produce, and the amplitude of their vibrations" (293/265).

Here, the collectivity takes the form not of individual people who work together in however indeterminate a way, but rather another kind of multitude, another kind of response to social form and historical process in the practice of photography. While the desert of contemporary art is imaged in a multitude of assaults upon the individual artist as ego and subject-source of perspective, a breakdown occurs: the individual work and artist are dissolved and overwhelmed, eroded as it were by a blast of sand particles, by the multitude of (photos/)fragments of reality and their collective of blows. These blows produce "daily transformations," which arrive in the form of a kind of multitude that Nakahira calls "reality." There is still an open-ended/ongoing project that would continue to unpack the full significance of *Circulation* as theoretical intervention, yet we can hold it here for the purposes of this chapter as the facing of a certain kind of despair, violence, and futility in confronting the ideas of community and collective art praxis. At the same time, though, it holds out and embodies a certain hope, liveliness, and unstoppable energy of a particular moment in which Nakahira's photography tries to make present a lived relation to a difficult and precarious social and historical situation.

The sadness and pain mixed with joyous and somewhat tender manifoldness can be seen in a new way in a very contemporary moment; to close this trajectory, I return once again to Kobayashi Fumiko's assemblage, *1000 Feet and the Fruit of Beginning*. A master of assemblage and reconvening of domestic objects in personal and public space—nest building, so to speak—Kobayashi writes that in her projects, "Objects are released and redefined from the certain meaning they are given within the unwritten code of daily life, and from the fixation in people's minds and hearts."[18] By assembling the local objects to form her monumental six-meter wall, and by moving around gathering them and meeting people, she creates a powerful and tactile reflection on the potential impact and presence of collectivity, forming into a massive wall that finally does not fall down, that holds its own mass, weight, and delicate act of construction, even as it also reflects on loss, waste, and the absence of the bodies that used to wear these clothes, sit in these chairs. In her work, individual, flimsy, unneeded things can become a layout, then,

in their powerful and in this case very much tactile and emotionally resonant relation, which forms its own kind of (both) material and theoretical intervention into the idea and potentiality of the collective.

Like Nakahira, Kobayashi is interested in fragments, in specificities, in locations. For Nakahira, illusions of the universal are simply ways that photography, such as journalistic photography, is complicit with the capitalist "consciousness industry" in Enzensberger's sense.[19] It is important to him, as to Kobayashi, to look at the joints, the points of connection, the nodes along which objects join and touch one another in space and time. Though other versions of understanding universality as a philosophical concept have since been proposed, for Nakahira, for example, in his semiotics of a "tree"—tree as the word or signifier, tree as a photograph or image of a tree, another kind of signifier— it still matters crucially, both theoretically and practically, "who saw the tree, and when and where—a pushing against universalizing concepts of perception."[20] For Kobayashi, envisioning who touched the sweater, who sat in the chair, comes to be important in her attentiveness to the specific gravity of the construction, the nodes and spaces in which one chair and one piece of clothing touches and is joined to the next. For both of them, the subject-object relation has the possibility of being reformulated via ideas of materiality (and via specific fragments of matter). Nakahira describes the process that occurs with the image: "Through our gazing scrupulously (meticulously) at a single tree here and 'now' [as an image], slowly the word 'tree' we had as well as its concept = meaning will come to be destroyed."[21]

Matsumoto and others in the late 1960s grappled at the affective scale with the overload of information/data and the paradoxical place of the subject within that larger flow. Both Nakahira and Kobayashi grapple with that larger flow by foregrounding a personal, affective specificity that gathers into a larger multitude. That larger multitude, monument, or series becomes an effective way to track the *agencement* or layout of relations between people, places, and systems by focusing on the movement (circulations) in Nakahira's case, or the nodes of contact, the joints in the building of the wall that link the specific materialities to their larger forms, in Kobayashi's case. Yet this is not a fetishization of presence or a return to an earlier notion of medium specificity either; it traces a delicate balance and paradoxical intermediate movement that can be illuminated in relation to Rosalind Krauss's conception of the post-medium condition, and Nakahira's and Kobayashi's vacillations between an abundance and an absence of language to form an alternative model of collectivity and medium.

Kobayashi's Materialities, Nakahira's Silent Parole, and the Post-medium Condition

Krauss and other art historians trace a profound shift in the idea of medium in art to the emerging hegemony of television in the 1960s.[22] Krauss traces the dissolution or ambivalence of claims to medium specificity, alongside the countervailing force of its reassertions, while other critics describe the process of digital convergence as marking the arrival of this "post-medium condition" by arguing that the digital age has leveled or de-emphasized the materiality of the medium, such that the specific moment of perception gives way to an ideal of a pure flow of data. Other critics reassert the importance of embodied perception, while to some degree abstracting and universalizing, as well as de-historicizing (de-gendering, de-racializing), what might constitute or define the body or the senses that would engage in such perceptions. As we have seen, related issues about the role of the particular body in relation to infinite reproducibility and the flux of mechanically reproduced images preoccupied artists in the 1960s–70s in Japan, leading artists like Yamaguchi Katsuhiro to his *Vitrine* series or others to theorize the "systematization of an interlocking gaze" as a kind of multivalent relationship that blurs the boundaries between individual perceptions and the larger environment and infrastructures. Problems of media transition, information overload, and the phenomenological experience of the image, rendered and articulated by media theorists in Japan such as Matsumoto Toshio and Nakahira Takuma, take form as both theoretical and practical questions. Just as contemporary theorists of the post-medium condition take Benjamin's interwar formulations about photography as crucial to understanding a later digital moment, Nakahira takes up examples not only from German Marxist media theorists but also from contemporaneous French theories of language and sign fragments and film (Godard, Antonioni) to understand the fragmented condition of information and questions pertaining to his photographic practice.

Nakahira uses a moment from Jean-Luc Godard's *Une femme est une femme* (1961) as one touchstone for his discussion of language, media, and reality. Actress Anna Karina, playing a married woman, and Jean-Paul Belmondo, as her husband's best friend, discuss the relationship between truth, belief, and words. Nakahira's impression of Godard's work is as a space where there is a superabundance of words, and he tells of Godard's tactic of linguistic/mediated overload as a viable option for dealing with the condition of language's loss of meaning in this mediatized world: "I have come to think that

in the face of [words' loss of the power of evocation (*kankiryoku*)], the only choices are perhaps either righteously to stop speaking altogether like Tanigawa Gan, or to talk and talk on and on like Godard—or to step into a labyrinth of limitless complexity where one evades asserting what 'is' and instead says 'neither this' 'nor that,' 'nor that.'"[23] Nakahira describes Godard's use of words as a form of "piercing" of the state of the world: "Godard takes a departure right from the middle of what one might call the all-pervasive *state of aphasia* of the world, and by opposition tries to pierce it through with his thorough garrulity [*tetteiteki na jōzetsu de tesshiyō to suru*]."[24] Even before embodied constraints relating to his own aphasia cut off his work as a prolific producer of language and images, Nakahira had been fascinated with loss and rebuilding in language, as in this passage he cites from Alain Robbe-Grillet: "The various meanings that we give to the world around us have already become fragmented, temporary, mutual antinomies [*mujun*], always declaring contradictory meanings. . . . Contemporary novels . . . are quests/pursuits/explorations [*tankyū*], and yet they are pursuits in which we gradually construct our own meanings ourselves, little by little, with our own hands."[25] Yet for Nakahira, it is a matter of working with hands but not necessarily with "meanings"; instead, for him, the abundance of language fragments resonates with and against the proliferation of images in *Circulation*, such that both silence and overly prolific language fragments form vectors or modes that might both "pierce" and "mark a departure from" the current, problematic state of the world.

Kobayashi's nests and walls and structures fall more closely on the side of Nakahira's silence of the parole; the objects rest in larger space with an affective charge relating to loss, absence, and even, in the interpretations of some, the triple disaster, without speaking, without explaining, so unlike Kazama Sachiko's hypermediatized reflections on the history of visual representations with their strong linguistic, historical, and political message—though those, too, in their single-instance woodblock medium complicate the image of mediatized proliferation. Kobayashi's works hold a complex, paradoxical place that sits amid this media-saturated world as the reflection of one woman's walk through specific neighborhoods, specific pieces of clothing and objects. Yet like Nakahira's vision of the building constructed of words by Robbe-Grillet, her work entails a "quest," a pursuit, that takes up the "fragmented, temporary" objects and builds "with her own hands" an astonishing one-time assemblage that just manages to hold. As viewers, our attention is drawn to the nodes of contact between the objects, as well as to the larger structures in which the assemblage takes its place, as a critical form of

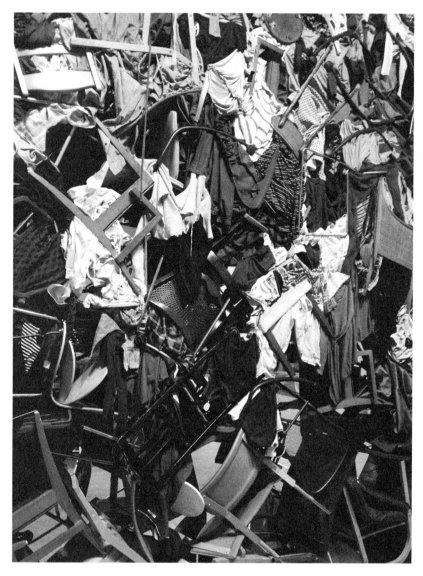

FIGURE 6.9 Kobayashi Fumiko, *1000 Feet and the Fruit of Beginning* (2013; also sometimes translated *1000 Legs, Cultivating Fruits*), installation detail. Photo by the author. Courtesy of the artist's estate.

collectivity and multitude standing within, and accommodating, the larger space of the art institutions and architectural structures of its moment. Her act of (re)building becomes also an act of citation, "requoting" the walls of the building as well as the objects from within their contexts into a new set of contexts, almost as if those objects constituted silent words, a silent yet embodied parole, within a larger system of langue (language), within a larger global system, as urban social/artistic structure.

The metaphors Nakahira uses for the process of creating and gazing at an image illuminate this relation between the object as material quotation and the larger system, as well as the paradoxical relation between the external and internal worlds of the artist and her relation to reality. "The single photograph of a tree," Nakahira writes in elaborating his semiotics, "is open and turned toward each person who looks at it *to requote*, just as the photographer quoted it from reality and allowed his language to be amplified [*zōfuku*] from within himself."[26] In this model, the person who takes the photograph undergoes a process of breakdown and amplification of language (and of fixed concepts/meanings). Photography is a process of quotation from reality, but this recopying, which is also a meticulous gazing, allows a fissure in (and also a peek into) given understandings that, for Nakahira, at the limit, also offer a fissure in capitalist forms of consciousness. Or, rather than fissure, perhaps it takes the form of an amplification that could be a plasmatic metaphor for a shifting shape in the form of sound or visual image. The image that is created can transmit this experience to another person through a process of replication/reproduction once again, a requoting, mirroring, or embodied tracing of the breakdown/amplification process the photographer underwent, now in the linguistic/conceptual and also visual/aural apparatus of the viewer(s). The forms of this tracing echo the way the clothing or the chair might follow and form the shape of the wearer or sitter's body. Amplification then echoes louder, makes perceptible currents in the larger structures in which it also participates.

Nakahira's image resonates against Kobayashi's work as it functions at the middle range of agency, at the affective scale. That is, like Matsumoto, who was concerned with the dialectical relation between the internal and external worlds, between the documentary image and the intrapsychic reality, neither of which should supplant the other but which should function very much like a photograph with a dialectic of negative and positive images, Nakahira's formulation subtly takes into account the way the quotation from reality that is the photograph provokes the revision or reinterpretation of something ambivalently located within—as in the shocks and reverberations

he described in his *Circulation* project. What is within he names "language," a verbal/symbolic infrastructure that is part of the process of subjectivization, a normed set of usages in the system of language, that for Nakahira implies the multifaceted social system that it brings with it. By photographing that reality, mobilizing those paradoxical yet strongly material fragments into a mediatized form, that larger sense of language becomes importantly amplified, transformed, in a way that is crucially sociopolitical and can be requoted/reamplified in viewing the photograph as well, reverberating in a plasmatic movement of potentiality across a larger scale. Kobayashi, in Nakahira's terms, requotes objects from the material world that hover in that space between first and third person, that solicit an affective amplification in the relation to the viewers they construct and the collectivity they imply. This collectivity also structures open spaces, and the quality and provisional intensity of its nodes of joining remain open to question. Falling far closer to the side of silence than to garrulous abundance of words, her *1000 Feet . . .* embodies the kind of breakdown and amplification in real time that Nakahira's theory described for the mediated materiality of the photograph, and hence implies also a kind of already realized futurity, a fruit of beginning, as the work's title suggests.

Nakahira uses concepts and examples from film, such as Godard's "wagered reality," which for Nakahira means a politically inflected, motivated, "pursuit" version of reality that is "subjectified and transfigured by the fact that I am witnessing it."[27] He uses samplings also from television and print journalism (around the Asama Sansō event)[28] to demand that indexicality in photography (the quotation from reality) be inflected by the particular embodied manipulations of the photographer and the effects on language/concepts that then go on to reframe reality for the viewer. He describes this experience in terms of citation both as fragmentation and repetition (two kinds of supplement); the openness to repetition of the photographer's embodied experience then amplifies the viewer's language in a way that is both unique to and echoed in each body. Kobayashi frames the embodied objects—the clothes one wears, the chairs one sits on—as simultaneously objects of the capitalist system of reproduction and consumption and as spaces or environments that hold up within each object an afterimage of the specific bodies that touched them. In that way, as a second skin in Ishiuchi's sense, these objects also afford comfort, accommodating the vulnerability of specific bodies in relation to air's chill (sweaters) or gravity's tiring pull on the muscles (chairs). They gain a historical weight in recalling for viewers the visual images after the tsunami, where houses were upturned and all the internal objects

and furnishings and personal effects sat outside, like trash/debris, exposed to the sun, wind, and radiation of the nuclear spill before being gathered up later into endless black bags that form another kind of wall throughout the landscape. Kobayashi's work at the boundary between private objects and public monument (the wall) exposes the way, seen at the affective scale, those boundaries between internal and external, between private and public space, were already open to ongoing blurring and in uncertain transition before any given event; this openness inherently structures the larger sociocultural system of urban space in which her wandering form then intervenes. She thus stands in the gap between a reparative possibility and a critical place of environmental overwhelm, but her standing there evokes a version or model of collectivity or layout between structures, systems, institutions, and individuals that holds those paradoxical possibilities, phantasms, and disjunctions in productive tension.

The mode of amplification Nakahira describes, in a very Benjaminian image, melds translation (afterlife of language, expansion of the receptor language—but in Nakahira without the stretch toward an idea of pure language) with a subtle shift of given meanings. This shift is figured elsewhere in Nakahira's writings as a crack in the luminous surface of the transparent landscape.[29] Kobayashi, too, in her work emphasizes the cracks and unfilled spaces between the objects, dehomogenizing the landscape, or showing the rough backside of an otherwise partially homogenized surface. She thus gives an afterlife to her objects as citation, translation, and amplification at once, generating ambient feeling in the mode of a reconsideration of the layout and forms, but also of the fundamental disruptions and discontinuities of collectivity.

Nakahira describes his interest in darkness during the *Provoke* era as a fascination with the materiality and texture of urban substance. For him, the urban contingencies and blurs partake more of the aphasic than of the prolix relation to language. They ask us to undergo a process of oscillation between a reading of his theoretical network (his language world, which sometimes also reaches a performative impasse) and the silence, or rather language-interrupting and language-resistant qualities of his images. Of the darkness, he writes that his artistic choices derived from "the very relation between himself and the world" as a means "to create ambiguity in the borders between the objects and myself."[30] Kobayashi too focuses our interest in the ambiguous and changing borders, relations, and points of contact between objects, human beings (artists and viewers), and institutions. Nakahira was concerned, however, that in focusing on this ambiguity in his *Provoke*-era

works, he might risk imposing or projecting his own ideas and feelings on the objects: "I gave up on looking, and as if to fill the blank space that was left I let the humanization qua feeling [*jōcho*] sneak in, even before confirming the unvarnished, naked fact that a thing is a thing by staring fixedly at the world. . . . Things that dissolve [*yōan*, fade out] in 'night,' in 'darkness'—do they not attest to the fact that I had given up looking and closed my eyes to that instant in which things suffice unto themselves [fulfill themselves] as things, or to the gaze of things, that throws back its light [on me]?"[31] This self-criticism of his own feeling processes and ineluctable (embodied/human) limits creates a condition where in some way photography becomes impossible ethically even before it becomes so physically. Yet his formulation is so intense precisely because it does pause to imagine this space, just before the "humanization qua [personal] feeling sneak[s] in," where he posits a "blank space" created by his abandonment of gazing, where the "naked fact that a thing is a thing" gets confirmed, "throwing back its light."

It is worth pausing to note that theories of digitization often seem to hold out (in their emphasis on the so-called post-medium condition) an idea of the radical otherness of the digital, the nonhuman parameters of the data. Yet Nakahira allows us to see the history of the clichés of dealing with the radically other; instead of relying on the binary of the known/unknown, he moves toward a form of "off-reality" "off-known" (and also wagered reality/*kakerareta genjitsu*) that amplifies—a reverberative, citational, also potentially but only partially indexical mode—that vacillates and folds between the linguistic and the imagistic, the theoretical and his own media critical practices. This image making as an amplification of experience opens either to "infecting" or "being requoted" (two alternative figures of transmission, one with a dark underside) from one person's experience to another. Not just embodied affect, then, not just the incommensurate experience of radically self-differing, aggregative media (beyond the human), Nakahira sees the seemingly simple problem Krauss later names otherwise: on the one hand, how certain forms of image making can "reflect and reproduce the universalizing logic of capitalism" (Nakahira); and how the post-medium condition thus fosters a (similarly suspect) "international fashion of installation and intermedia" (Krauss). Nakahira does not like how *Provoke* style—reduced to a fashion—was reread as *poésie*. He retained a special doubt for schemes of reading and appropriation that involve mastering and commodifying incommensurate others (be they stylistics in art or other/colonized populations). Nakahira's formulations and pursuits provide a striking and historically specific counter-

balance to universalizing, presentist, globalizing (as international) theories of new media and the politics of the post-medium condition. Instead of flattening the world to the form of the self or a homogenized commodification, Nakahira and Kobayashi both propose a complex and paradoxical structure of relations with materiality and contemporary realities that evoke a critical collectivity, an *agencement* that cannot simply be presupposed nor held as a given and desired future. Instead, Nakahira questions and reviews the ethical implications of his own gaze and photographic practice; Kobayashi envisions an opening move toward futurity that has already borne fruit ("the fruit of beginning") and that emerges from a multitude of material pasts. Both operate in an interstitial, one might (with Haneda and Matsumoto) say a dialectical space of affective potentiality and ever-uncertain yet rigorous theoretical practice.

From the destructive and creative power of the masses in Hanada's image of sand, then, to the creatively disruptive projections envisioned in the graphic compositions of Ichiyanagi and Mizuno, to the crack of pain reflected in the multitude of blows to ideas and concepts from the barrage of everyday image strikes in the Paris autumn of Nakahira's *Circulation*, to Kobayashi's monument of the *1000 Feet* that may become the beginning of a new formation, contemporary Japanese art and media theory have a lot to teach us in challenging preconceived concepts of community and collectivity in the relations between people, systems, and objects. Rather than claiming seamless or naive continuity as the presumed imaginative structure for community and collectivity (to be formed under the name/sign of a given creator-subject or leader), they visualize and take into account the dark externalities to perceptibility, the complex ethical dilemmas, the unevenness and disruptions, the phantasmatic projections and affective blurrings of scale, materiality, and temporal eventfulness as a fuller perspective on the conditions of possibility for collectivity. These artists have taken up such questions in surprising, contrasting, and profound ways. Bringing this history into the forefront of the conversation, one can begin to leave behind the prevalent, at times historically amnesiac or romantic relation to the idea of future collectivity that has circulated to motivate and justify artistic practices in recent years. In fact, several generations of artists and critics have thoroughly considered these concepts and problems. Writings on anime, post-3–11 art, and representation have drawn new attention to questions of collectivity and community. As we attend to these writers' and artists' theoretically nuanced visions, we can deepen our framework for understanding the relations between people, objects, and distributive

systems, as well as the deeper and more fragmented work of collectives and community, to move us beyond both reified subjectivities and objectified or commodified works of art.

In the space between questions of infrastructure and critiques of collectivity, affect and emotion play a key role. When he discusses the masses, urban space, and the "feeling of the city," Hanada foregrounds questions of energy and sensation. In *The Energy of the Masses* (*Taishū no enerugī*), Hanada asserts repeatedly that "avant-garde art that is separated from or cut off from the masses does not exist"; and further, "just as there is no avant-garde art separated from the masses, avant-garde art is no more than a concentrated expression of *mass energy*."[32] At the end of his essay on the sand-like masses, Hanada concentrates on *jikkan*, direct feeling or sense. Hanada's idea of the plasmatic potentiality of form thus links the sand-like masses to a transformative potentiality that brings together avant-garde artistic movements with leftist social praxis: working at the affective scale, he emphasizes the feeling and energy within urban systems and social groups. With Mizuno, too, that unconscious thing that one puts into a collective process is also a matter of directing the energy and intensity of a group. Mizuno's musical works model the training of a very concrete and material "mass-sound group" that performers can learn to generate, in part by feeling. The sensibilities of assault, impulses, and shock that reality delivers in Nakahira's oeuvre to the artist's conceptual and ideological apparatus evoke what he calls an "amplitude of vibrations" that recalls not just earthquakes but the shivering glissandos of Mizuno's music; in this sense, his project frames a parallel matter and method for demolishing the old forms of individual subjectivity, society, and history through feeling.

In much more contemporary artistic practices, works of collection and assemblage like Kobayashi's, while extremely imposing (like Benjamin's collections), take their objects out of the circuits of everyday use; they are striking instead for their absence of garrulity, their interruptive quiet. Asakai Yōko's landscape photographs have this quality of touching something invisible that lurks among the objects of the landscape, imbued with a desire or a haunting. Like them, the apparent calm of Kobayashi's imposing works—sometimes also harboring an underlying fear, as if it might topple at any moment, or as the afterlife of a world already upturned—can resonate for viewers in the face of her countermonumental and ephemeral vision of collective. Rather than evoking subjective sentiment such as an individual's personal memory or loss, this work instead calls upon a broader affective terrain of sensibility and transmission only obliquely tied to individual feelings. It

is as if all these private feelings have dissolved into and suffused a more public sphere, a third and first, a neither/nor that circulates unevenly between private and public. Even with the direct performative element—the moving around to collect and build all this—Kobayashi's work allows a subtle affect to resonate between people, objects, and larger structures, forming a rigorous concretization of what is also an abstract and ungraspable process.

The works discussed here more broadly thus awaken a sensitivity to that form of community or collectivity where mass energies gain perceptible form, in varying models of the layouts and transformations of both social and historically specific urban space. The politics and criticality of these visions may be far less obvious than those of works of direct collaboration and participation with publics, while even in those more assumed or direct forms of community, more complex forms of synthesis and friction are most certainly taking place behind the scenes of utopian creation. And yet I would argue that these rather more abstract works make visible something crucial about how energies of collectivity do get mobilized and shift, energies that are fundamental, as Hanada so clearly articulated, to any project of reenvisioning the workings of global social and cultural space and historically conditioned urban life.

Feeling Media

I began this book with the work of Yamaguchi Katsuhiro, for whom a work of art should not just be one person's perspective but a combination of multiple perspectives. He made these works as part of Jikken Kōbō, a collective that framed a useful example of the collaborative model of creativity in multiple media. We saw the expanded cinema work of Matsumoto Toshio, where the baffling multiplicity of everyday urban life catalyzed a need for cinema to encompass more than one moving image or layer, and more than a graspable or linear narrative. Composers like Takahashi Yūji, Ichiyanagi Toshi, and Yuasa Jōji, in the early era of electronic music, saw sound itself as analogous to what Hanada formulated as the malleability of sand: while white noise was composed of the combination of all possible frequencies, by adjusting and eliminating certain frequencies in works like Icon for White Noise, something they termed "colored noise" could be created. Electronic music's concept of collective or group encompassed collectivity in terms of the structure of sound, as well as in terms of the relation between composer, performer, and audience. In Mizuno's work, sounds themselves could be structured as "individual" or "mass."[33]

Even Ishiuchi's photographs of clothing, echoing forward to Kobayashi's later work, form in their aggregate a collective and a layering that still highlights the resonance of the individual fragment. The world of intermedia art, the theoretical exploration of culture industries and media theory, and the expanding world of contemporary visual arts thus provide three locations where the problems of a broader—one might call it ecological—structure of systems beyond one's grasp can nonetheless be not only envisioned and materialized, through artistic practices, but can also be grappled with, remodeled, and reframed. While problems of surveillance and hacking, detached/refracted senses of our own subjectivity through digital media, and commodified forms of self-structuring pervade our lives today, our regulated bodies, electronic calendars, and ever-beeping notifications conspire to lure us to forget our finitude, our vulnerability, and the reality of loss.

Yet the artists discussed in this book offer us clues as to how to remember, grapple, and materially reckon with that forgetting, to see the historical situatedness and the fore- and afterlives of our current predicaments. They inspire by their sheer force in language and in making, and they model by their grappling with moments of loss of force or failure. Feeling in the midst of media—media as an alternative term for the affective potentiality of our moment, yet ever so slightly delayed from the pressure of its forward-moving circulations—may offer a glimmer of an imagined, critical collectivity within a recognition of (nonhomogeneous) losses. Feeling media may allow the fragmented, local afterlife of specific theories and practices to take (imaginative and real) form. As we live within these systems and practices and rhythms of our everyday, let us stop to take in the quirks and digressions they offer us, to open out the layers where folds of meaning and feeling might hide. Let us explore the layouts of vectors and crystalline nonlinear architectures where positive and negative images shimmer against one another—where plasmatic hope meets cracked-open shellfish of despair in ways that pose provocations for further thought and artistic practice.

The idea of a critical collectivity, then, viewed across a broader historical trajectory as it has been in this book, might seem to lead us to a place where art holds the answer after all. But part of the effectiveness of the *agencement* these works create is to let us see the space of infrastructure, in which they also play a part, at a more distant remove. Pulling back to think through the circulation and distribution and production of his shocks, Nakahira reminds us to step back and consider the broader trajectories of subjective life within transforming techno-social conditions. The critical collectivity framed in this chapter opens to multiple layers of questioning, as it pictures, refracts, and

gets caught up in broader systems itself. Critical collectivity here frames a disjunctive nonunity where many different parts interact unevenly for a set of flows infused with political consequences. By expanding from individual works to consider these broader concerns across a wider historical scope, I conclude by considering how such an *agencement* locates its power, as well as when that power becomes difficult to locate or visualize. Even within high art we can begin to read, from the Olympic and post-Olympic era of the 1960s to the non-Olympics of 2020 and its problematic delayed enactment, the layers of that invisibility—via the feedback loop and parallax view afforded by this inquiry as a whole, so that we can begin to outline what remains to be traced.

Conclusion

Parallax and Afterlives

As I'm writing this conclusion, we are almost two years into the pandemic, which has given new meaning to what *air* means—what is airborne—as well as to the experience of disruption and normalcy. Infrastructure studies has had as one of its key approaches the consideration of newly visible structures of everyday life at a moment of large-scale disruption. Affect studies, though it has many guises, can sometimes begin with the microtremor of a feeling. Yet the advantage of the concept of affect as it extends out of and challenges narrower definitions of emotion is that it can begin to read for tones and moods that limn larger political and social situations we hold in common. In this, affect theory follows the more encompassing legacy of both feminist and queer studies of feeling, and it connects to media theory's ongoing examination of feeling as structure. Two years into the pandemic, the sheer numbers of Zoom meetings as a form of work, community, and sociality (funeral, bris, committee meeting) have begun to create a certain visceral nausea in this particular individual, but it is also a nausea that many of us hold in common (visceral-affective-social), one that has to do with shifts in the uses of technological media as our schools and universities and workplaces move online, and that has to do with the political situations in our varying locations. These heterogeneous politics bring into view potential destabilizations of region (Asia), even as they enable reinforcement of ideas and structures of nationhood that may have seemed more attenuated in the globalized capitalism of so-called normal times. Whether such normalcy really existed

or was a function of tricks of perception and willful ignoring of crises else-where as well as here, it is nonetheless a moment when reading infrastructures and affects together feels all the more necessary, helpful, even urgent.

This book has taken on what is perhaps an odd task in its structural form: the historical time periods of most intensive focus have been the 1960s–70s—with a brief bridge through the 1980s–90s via the long career of Ishiuchi Miyako—and the first two decades of the twenty-first century. We have studied the movements of boundary-crossing arts in the 1960s–70s from intermedia and expanded cinema to experimental art animation to theories of the culture industry. In part II, we moved to the fraught and generative terrain of more recent Japanese contemporary art, both in its relation to the former works and in its own redefinition of some of the key concerns of those earlier times. What do we gain by studying these two groupings or constellations together—even beyond, I hope, a deeper understanding of each period in itself?

This study constitutes in part a historiographic experiment where the lin-earity of periodizations, with their narratives of progress or regress, yields for a moment to a sense of parallax view, in which one earlier period gains an afterlife by its uptake, its resemblance, its semblance (*schein*), even if il-lusory, and its dissemblance—one might even say its translation with and into another. As the term *schein* would suggest, such a double view brings into the conversation all the contentions and problems of mimesis as something far more complex than a direct mirroring. Perhaps the latter period gains a kind of aura, or inversely, a preimage (as opposed to afterimage, thinking of the shadows and flickers on 1960s expanded cinema, in their split screens). It opens a new possibility of depth in what otherwise seems an irreparable or immobile flat-ness, a relentless heterarchy (a flattening, as opposed to hierarchy). We could see it as a process-oriented sedimentation, a vision of palimpsest. In another way, though, it's an act of performing and deliberately structuring a parallax view, like a split screen, creating a vision across a gap or void. This imagining or construction of resemblance can be approached in numerous ways, some more rigorous than others: for example, via comparison; via linear connec-tion; via air, tone, or atmospheric readings.

Comparison, from the limited purview of one who is looking back across this study, can yield up or suggest various facts. For a start, one could look at the doubling of the Olympic/Expo '70 moments of buildup or renewal: from the rough chronology of Tokyo's transformations in the lead-up to the 1964 Olympics and subsequent 1970 Expo to the urban rebuilding and rhetorics of reconstruction in the wake of 3–11 associated with what became the non-

Olympics of 2020 and the fraught/delayed Olympics of 2021. One could consider the rapid technological change and new-media era for both periods that yielded a need to account for the impacts of changing media forms as well as the image and information overload or overwhelm. Linear connections would focus more on the ways the art and cultural scenes of the 2010s directly and explicitly redeploy images, movements, and thought from the 1960s–70s as newly relevant, whether by revaluing (or newly valuing for the first time) that production in curatorial/art historical circuits or, by extension, placing that earlier art in new configurations by explicitly comparing it with today's contemporary art or with other Asian countries' heterogeneous experiences of the contemporary. Additional linear links take place in moments as concrete and material as the physical exploration by enactment of versions of earlier performance pieces, like Gutai's (Shiraga Kazuo's) *Challenging Mud* or Lee U-fan's breaking of glass/mirrors with local stone for his *Relatum*, formerly *Phenomena and Perception B* (in New York, or in Metz, France, or elsewhere)—that is, creating new twenty-first-century versions of 1960s–70s performative/sculptural works and events. Yet even such direct citations or placing of one period's art into/beside another—like the *Roppongi Crossing* curators' choice in 2013 self-reflexively to display Akasegawa Genpei and Nakamura Hiroshi's 1950s–60s work beside Kazama Sachiko's *Nonhuman Crossing* (2013)—also bring into view disjunctures, including different kinds of institutional support and global agendas of recent artworks in their new and spectacular museum contexts. For a time, many of these contexts went online, making us think differently once again about the materialities of a rock, a glass, and a plane flight to get to see them prior to the periods of sheltering in place. Can even materialities—that which might pose most explicitly as representing what is unreflexive, nondiscursive—change in response to transformed sociocultural circumstances? The answer is blatantly yes, as feminist and queer theory have already taught us; and we saw the differing discursive uptakes of the ideas and practices of the (imagined to be) less discursive ideas of matter (*busshitsu*) and materiality (*busshitsu-sei*) as they came to be defined in newly heightened ways in these two eras when the electronic/virtual felt and feels overwhelming. Yet the very fact of those materialities as well as those image-electronic flows seemed ever more elusive to grasp, partly because of their extensive scale.

Thinking through modes of comparison as well as contingent linear-historical links, with their self-conscious reflexivity, it is important to highlight gaps and internal disjunctures. Taken together, varying modes of multiple projection become promising avenues for conceptualizing a nonlinear, or at least a

more weakly linear, movement across epochs that works via models of parallax, or through concepts like the afterimage or afterlife, where one element comes to be invigorated via its constellated relationship with another or with several others. To return to some of the trajectory we have traversed, we can begin to see how the relaying from intensive to extensive and back—from intrapsychic to extrapsychic (documentary encompassing both), from the individual/personal both inside and outside toward the sociotechnical collectivity—like a form of self-consciously discontinuous zoom (small z), works through the different case studies that this book has brought to bear.

In both the 1960s–70s and more recently, the process and rhetoric of reconstruction and renewal strike different groups of people differently. Studies of the San'ya area of Tokyo point out that those precarious day laborers who lived there in makeshift shelters in the 1960s had a crucial role in building the infrastructures for the 1964 Olympics, and similar politics of labor unfolded around the Osaka Expo in 1970. Activists subsequently mobilized around protecting the space for those disenfranchised by the 1960s bright life in so many ways. Again in 2019–20, San'ya was being recolonized and cleaned up, as a location for low-budget Olympic travelers who might displace the long-term residents, by now-former day laborers.[1] Yet something is different, has become perceptible through the odd passage of the lost decades after the bursting of the economic bubble, through the long-term recession that has led to the palpable presence of economic precarity, through the fading of the prospects and structures of lifetime employment for an increasing segment of the population, with the aging population and the ever-increasing rise of the freeter/precariat.[2] Something is happening, with the aftermath of 3–11 that made so visible the fallibility of existing infrastructures and the absence of trustworthy procedures for taking care of them. The hoarding of safe bottled drinking water in Tokyo is still a relatively recent memory, and the possibility of nuclear fallout's presence in the air, wind, and rain (as well as the soil's contamination) puts into question every bite of a summer tomato. The ambivalent and complex pedagogy of activist documentaries and critical writings from an earlier moment rise again into view, offering to teach us what we newly need to learn.

Textures of Overwhelm

Examining these two eras in parallel creates a pulsation of relationships and flows, allowing us to discover/invent new meanings in past works, and bringing into view a set of networks among individual artists and larger artistic

and cultural systems. In the 1970s and beyond, Shinjuku and Shibuya get built up with skyscrapers, and the *zaibatsu* (large corporate conglomerates) establish these neighborhoods in Tokyo as a regulated colonization of space, a hybrid commercial/shopping/cultural space in a way that seems almost to foreclose political intervention. The Mori Building that houses Mori Art Museum is built "on the concept of becoming a Vertical Garden City," seeming to extend this more or less depoliticized spatial/commercial logic into the twenty-first century—then within it, under its auspices, Kazama Sachiko launches an attempt to repoliticize Shibuya Crossing.[3] Artists from both periods grapple with an awareness that they and their work are deeply imbricated in the structures of capital and art institutions, not always in a comfortable way. Many individual artists and critics remain aware of their fragile and contingent place within the overwhelming economic and cultural tides and infrastructures of a multiply defined and heterogeneous present time.

What does it mean to situate or ground a critical inquiry in the idea/concept of overwhelm, the experience and state of sensory and affective subjugation? What does it mean to study the affordances of tinkering (comfortably or uncomfortably) in a media system that regulates the rhythms of the everyday, maps the potentialities and limits of movement, limns the theories (in Sedgwick's affective sense) that are possible? This book examines media's role in that exploration of a resemblance, the mapping of a relationship between the experiences of overwhelm in these two moments and the potentialities that art and media/mediation had to offer toward a mode of being in those situations. Media may be read as the dual *dispositif* (technics, in some translations) of technology and sociality—of infrastructure read not just as "stuff you can kick" but also as who kicks it and why—or as an ever-evolving ecology or complex of forms within capitalist globalization (at earlier or later stages of pervasiveness in everyday life). Media forms have deeply to do with these fundamental problems of overwhelm that can be approached in materialist/economic analyses of structural factors as well as in the framework of consideration of aesthetic/cultural forms—and, most pertinently for our purposes, through both together. For artists and critics in both periods, part of what gets revealed—or proposed and experimented with—is how practical navigation of each of these versions of the contemporary entails rethinking solitude and collectivity (chapter 6), as well as reimagining sculptural, photographic, painterly possibilities in relation to that situatedness. Facing up to that situation includes confronting the space and agendas of circulation of their own work within an art scene conditioned by its own cultural and economic imperatives and genre-bound or genre-flailing discourses and needs.[4]

When Eve Sedgwick writes of affect theory via Sylvan Tompkins that "affect theories are subject to constant revisions both large and small, based both on prediction and on retrospective resampling and reanalysis," besides engaging the language of cybernetic feedback loops, she opens a way to think of affects themselves as (ever-evolving) theories in ways that could evoke how systematicity comes into play for the artists and critics (of both times).[5] That is, here larger structures become yet another evolving thing (like the data sets, fungibility, and acts of subjugation of our digital age; like frameworks of similarity and difference in this book) that you can stick your elbow into, stick your tongue out at, lick: to experience as a texture among others rather than be erased by. The ways artist/critics of the 1960s–70s did this become a resource to draw on, both overtly and in more unacknowledged ways, for the survival and reassembling that takes place in the 2000s.

Mobilizing the affective scale of thought across this broad historical range does not just relativize the heterogeneous present or the idea of the contemporary but also allows us to upend and transcend imagined binaries of materiality and the immaterial/virtual labor of cultural work. Seen in this broader temporal scope, we can debunk (paranoid position) the obvious agendas of valuation that condition the consumption of Japanese contemporary art (sometimes within emergent regional frames of Asian contemporary art) as an assertion of a kind of national or regional soft power that works in conjunction with movements of pop culture (profit-driven mass entertainments). Both of these would collude to construct an imaginary of regional innovation as a rather blunt reflection of state power.[6] The attempt to countervail or navigate the strange scale of such an overwhelm produces instead an envisioned parallax that shows us anew a media theory of quiet in the face of such a situation (photographer Asakai Yōko, sculptor Kobayashi Fumiko, alongside Nakahira Takuma). Or artist Kazama Sachiko engages directly with the Twittersphere that is a crucial space of circulation both for art and its commentaries as well as for unceasing news on the aftermaths of disaster. She engages with the histories of art and literature in such a moment, lest we forget that in some ways we have already been here, reminding us that the illusion of the new is part of technology's (and advertising's) sleight of hand. Rather than extraordinariness, Asakai and Kobayashi present us with scenes and objects of ordinariness, but each in her own way allows us to reflect on the presence or absence of the "smell of a body" in the omnivorous (art) world system and to experience the potentiality of a personal media feeling, even in the midst of infrastructural forms that exceed us, that process us and surveil our presence, our interventions, our movements.

Coda

In the late 1960s–early '70s, the atmosphere of protest and the advent of a sense of overwhelm and powerlessness in the face of the flattening effects and homogenizing forces of capital and emergent media, all of which would come to colonize space and datify both persons and things, could still be accompanied by a certain hope for maneuver or practical potentiality that we see in the powerful creative and theoretical forays of intermedia. We have seen such a hope in this book in the burgeoning sense of collective possibility around experimental artistic exchange, including animation, and in the prolific critical output of culture theorists in the 1960s and '70s. The artists this study has focused on for more recent times appear more isolated, mostly working with smaller budgets and moving their bodies through urban and rural landscapes like single atoms in a larger, impersonal field. Those who had engaged in the overt political struggles of the 1960s–70s have in many instances turned toward the explicitly ecological or environmental in another sense—experimental filmmaker Ōe Masanori becoming an organic farmer, critic Tsumura Takashi becoming interested in macrobiotics and holistic health, experimental filmmaker Miyai Rikurō pursuing a now long-standing career in Indian meditation and healing practices. Higashi Yoshizumi cultivates small, delicate plants one by one in his own handcrafted ceramics, displaying them along with quirky *obuje* (objects) around his and designer Shōta Kanoko's beautiful, self-designed café Hachiya in Chigasaki, where until the pandemic shut them down she served home-brewed coffee and sake in his earthenware cups, and where he continues printmaking, prose poetry, and other arts. While some of these artists attend to the earth through embodied methods, the next (or later) generation(s) of artists traverse the landscapes in their vulnerability/solitude with their bodies and cameras, picking up the signals of that sometimes hard to visualize chronic infrastructural deterioration that occasionally explodes into terrifying visibility/perceptibility under the title of *disaster*.

In other words, speaking in terms of air or tone, the underlying hopefulness and strong protests of the (dominantly masculine) collective in the 1960s gives way to a deteriorating and more precarious picture by the early 2000s, a picture of isolation and fragmentation that nonetheless brings to mind the desperation of Nakahira's 1971 *Circulation*. Such a dark tone, as with Nakahira's incisive theoretical energy, can nonetheless be intermittently illuminated by sharp critical sparks or can pause to make space for small everyday solaces. Still, or meanwhile, in commercial spaces and national-culture

discourses, the uncertainties of contemporary life are frequently painted over with an enormous amount of glitz and sheen by ongoing rhetorics of the bright life (whose form borrows from the 1960s white-collar visual culture), which is, as we know, underwritten by debt, pollution, and unequal access to its benefits.

Although much of this study has taken up representative artworks and movements as well as key critical moments, the larger intention is to shift the scale of attention beyond any individual work or artist. I have framed an intermediate scale that allows us to look at those works as nodes or points within a larger layout, where they can bring into view from their vantage points, sometimes self-reflexively, sometimes almost unwittingly, what is going on for the complex, open-ended, and contingent set of relationships that bind the perceptual or smaller scales of feeling with the excessive assemblage of objects, institutions, and flows that are beyond the individual's (or the individual work's) capacity to grasp. The contingent workings of that affective scale, both within works and in their relations to/functioning within larger systems across space and time, has been a key focus of this whole book.

While, on the one hand, the word *jōdō* (affect, 情動, not used in everyday conversation in Japanese) simply appears within the sphere of Anglo-American literary studies in Japan (*eibei bungakkai*) mostly as a refraction of a Deleuzian schema, the multitude of terms and approaches to feeling tones proliferates (*kandō*, being moved; *kimochi*, feeling, mostly internal state; *kanji*, a feeling, mostly external; *x to iu ki ga suru*, having a sense or feeling of x; *kanjō*, emotion, with a bit of gushing; *fun'iki*, atmosphere; *tōn*, in katakana as loan word, tone; *mūdo*, in katakana, mood; not to mention the multiplicatory terms and histories of the whole menagerie of specific feelings, major and minor). These terms and approaches become substrata within a long history of critical considerations of sociocultural space as well as of the modes of functioning of media (*media*) and mediation (*baitai*). Yet what strikes me most powerfully looking back at the broader picture here are not just the discursive formulations—ever creative and self-consciously aware as they are of their refractions in relation to the international-contemporary (pre-1980s) or global-contemporary (post-1980s) critical frames—but the ability of the works and artists in this book (via art, language, image) to model modes of maneuvering practically across these complexes of social and sensory relationships at the affective scale.

My own book-length writing over the years has shifted across time periods, from a focus on the avant-gardes in the prewar to the 1960s–70s and then in retroaction forward and back from more recent times. Like the

slippage or blurring moments between emotion and affect, between paranoid and reparative positions, the cross-temporal purview can allow us to attend to seemingly contradictory yet illuminating perspectives of each individual work, group, or movement and can allow them to realize, at least speculatively, a potential afterlife that was not yet visible in the moment of their creation. Further, they can allow us to reframe the temporal locatedness of creation/creativity itself beyond the idea of a given or fixed temporal or geographic origin. In this sense, I follow queer theorists in attending to the heartbeat of contingency and the power of a gesture that seems to be in excess. Beyond that, I aim to show the very distinct and modally contrastive ways that (mostly men) artists of the 1960s–70s and (mostly women) artists of the early 2000s grapple with and potentially countervail the odd and overwhelming feeling of Being in their temporally heterogeneous contemporary ages.

Perhaps this method of accounting for temporal and scalar heterogeneity—we might call it an approach to heteroscalar perceptibility—finds a good figure in one of the works with which we began this study, Yamaguchi Katsuhiro's glass *Vitrine* series, in that it incorporates technological/mediatic innovation while modeling a theoretics of divided perception in concrete/material form. Or perhaps it is the image of the dialectic in the alternation of dark and light figures against gridlike stones (Matsumoto Toshio, chapter 1) that would best encompass the capacity to traverse multiple scales, not by bringing them into an ordered totality but by accounting, in a different vision of totality, for the continuous slippage of what is beyond perception, including larger systems and frames of thought and power structures. Or we could think, with Uno Akira, of modes of visually transforming perception from one time period to the next, as we move away from the imagining of violent revolution (though that still seems necessary at times) to the beginning of an off-kilter, slower, tensile mode of framing a plasmatic notion of potentiality, one that foreshadows the quieter lineages of navigating what so often remains invisible in the 2000s.

The concept/image in Yuasa Jōji's electronic music of a band or zone of sound, generated through inventive filtering—the subtraction of frequencies to generate colored sound from white noise—resonates with the boundary-opening workings of studies of affect that account for spaces of transition and gray scales. It may also provide a good image for the historical spacing in the method of this book with its bands of time and its gaps or skips in time. Yuasa's piece, that is, focuses on what is there when one leaves open broad in-between spaces to structure a work around resonances across overlapping zones or bands

(of sound, in his case). Intermediality itself constructs opportunities to experience media more as divergence than convergence, but it is a divergence that does not congeal, into ideas of medium specificity for example, but continues to circulate and disperse—it puts the border zones into motion. Even the relatively structured and prearranged interventions and agendas of CROSS TALK Intermedia nonetheless mobilize dispersal and contingency in their arrangements across institutions, urban spaces, and crowds.

This study only touches on the actual productions within pop cultural forms such as television and anime; yet the artistic and critical practices studied here express their own theoretically astute view of the life and death cycles of such mass media forms. We saw this in the media theory in chapter 3, with its study of the kinds of personhood and time that the workings of mass media could enable or disable. Broader cultural patterns implicate the developments of gender infrastructures from the 1930s through the '70s to the present (chapter 4), as well as the layered responses to differing forms of disaster (chapters 4 and 5). The mediations of nature as well as blockbuster culture come into play in chapter 5, with the large and small scales of circulation coming into surprising contrast in the self-conscious agendas of artists and curators outlining a landscape to come in the wake of 3–11. There local boundaries come into view even as they are challenged in a contradictory mixture of local, regional, and global-diasporic views of what constitutes Japanese contemporary art.

The ongoing need for collectivity and community (chapter 6) confronts the dispersive and fragmenting effects of globalization and media systems; the framework of collectivity nonetheless returns in alternative form in art viewed across the temporal landscape of this book, where it is framed more as a mode (self-conscious, full of gaps and inconsistencies) than as a result, more a tenuous and self-dissolving process than a specifiable form. Nonetheless, artists experiment with how to do collectivity, to be done and undone within collectivity, where this doing and being done are viewed as waves and processes of dispersal and gathering, use and recycling, a set of questions rather than answers about how to deal with sociotechnical change. If *use* itself as a concept (utility, progress, forward motion) becomes suspect and undoes itself here in this exploration—which is structured around a gap (though not a void) in space-time—we can perhaps nonetheless borrow and recycle some potential here fulfilled in these works' hard-won parallax fore- and afterlives. We can track the conceptual and practical interventions here for the sake of our own potential intercessions in a geopolitical and affective framework that eludes the usual modes of doing, being, protesting, or living.

Thus, I hope we can take away from this study a shifted notion of the ground of media theory and the working of affect and infrastructure, a shifted set of potentialities framed through a consideration of media, as the experiential result of a shifting historiographic possibility for cultural study. Both subjectivity and objectivity, smaller and bigger pictures, remain fallible and full of holes and distortions, compressions, and repressions; yet it remains necessary to track carefully the relays and flows between and among these sometimes incommensurate scales and frameworks. The artists and critics of this book model for us a way, or a number of alternative ways, of lifting to a broader scale without losing specificity and attention to language and form. They have shown us innovative ways of reading tone and air, atmosphere and mood, teaching us new languages of feeling media.

Notes

INTRODUCTION

Japanese names are given in the Japanese order, surname first, unless the writer publishes primarily in English. Japanese terms are given in modified Hepburn romanization.

1 Woolf, *Mrs. Dalloway*, 207.

2 Woolf, *Mrs. Dalloway*, 207.

3 Hua Hsu, "Affect Theory and the New Age of Anxiety," *New Yorker*, March 25, 2019. This was published in a roundup of affect theory well before the pandemic hit, but it encapsulates the vacillation between focusing on what might seem to be personal experiences of affective moods (at the level of "everyday life") and large social media and mass media platforms that both condition and are conditioned by those widely shared moods/tones.

4 *Lossiness* is a term for the prefiltering or alteration of an image or data source for more efficient compression.

5 Hal Foster reads the 1950s–60s as a repetition or "retroaction" of earlier twentieth century avant-gardes (*The Return of the Real*, xiii); also cited in van Hensbergen, "Moving with Words," 13.

6 I'm indebted to Hannah Airriess for introducing me to this film, which she analyzes in depth in chapter 3 of her PhD dissertation ("Staging the Bright Life").

7 Berlant, "Nearly Utopian," 293.

8 See Lamarre's preference for thinking media ecology for its account of the complex assemblage of media instances and their relationships in Lamarre, *The Anime Ecology*, 115, 288; see also Zahtlen, *The End of Japanese Cinema*, 2. For a fuller account of the vicissitudes of this term, see Goddard and Parikka, "Unnatural Ecologies."

9 Berlant, "Genre-Flailing."

10 For the citations above from Parks, see "Media Infrastructures and Affect," also reprinted in Parks, "Introduction," 15. Parks also there makes a convincing argument for the use of differing scales to think infrastructure.

11 For trenchant critiques of area studies and its place in the struggles of the humanities and social sciences within "the quickening conversion of learning into intellectual property and of the university into the global corporation," see Miyoshi and Harootunian, *Learning Places*, 19 (for quote) and passim.

12 Ngai, *Ugly Feelings*, 27.

13 Ngai, *Ugly Feelings*, 28.

14 The North American field of affect theory is a broad one, around which scholars have recently built more durable institutional structures and homes. For an overview of some that inform my approach, see Gregg and Seigworth, *The Affect Theory Reader*. A rougher version of the taxonomy of two key strains of affect theory would sense a divide be-

tween the feminist-affiliated and mostly American-centered work on affect (Sedgwick, Berlant, Ngai, Ahmed) and the more techno-oriented and Deleuze-inspired work of scholars (Massumi is a central figure here) who focus on the virtual and certain strains of Marxist critique. My own work is closer in spirit to the former constellation, while sharing with the latter an explicit interest in media forms and in Marxist-influenced ideas of potentiality. In the context of Japan, affect theory, like most of the rest of the fields important in North American academia (performance studies, queer theory), is generally a subcategory of the discipline/departments of English and American literary studies (*ei-bei-bungaku*), thus rather dramatically putting it in its place.

15 I emphasize "reparative" here because, although she uses the terms almost interchangeably, "depressive" can be confusing to those less familiar.

16 Sedgwick, *Touching Feeling*, 8. Page numbers hereafter given in the text.

17 Matsumoto, "Ekusupandiddo shinema no tenbō," 172.

18 Debarati Sanyal's articulation of necessary complicities and folds becomes useful here; see Sanyal, *Memory and Complicity*, 1–18.

19 Nihon daigaku zengaku kyōtō kaigi shokikyoku, *Nichidai tōsō*. Individual photographs in the book are not credited to individuals, but the afterword credits Shinkai for contributing many photographs while the majority in the book are by the collective.

20 Sasaki studied at Tokyo College of Photography and worked in editing at Nikkatsu and as a photographer; she made the experimental film *To Die Sometime* (30 min., 1974); from 1979 to 1993 she lived in Brazil. See the recent recognition for her work in the exhibition *Japanese Expanded Cinema Revisited*, Tokyo Photographic Art Museum, 2017. In her retrospective photo book of the events, published in 2009, Sasaki claims her camera was a "cheer" for the students, but she often hesitated to press the shutter. (Sasaki, *Nichidai*, 224.)

21 Nakanishi Natsuyuki's courtroom testimony, republished in *Bijutsu techō* (November 1971): 207. Hi Red Center was in contact with Fluxus, and afterward George Macunias made a map of Tokyo that recorded/notated the group's performance events. See the exhibition and catalog: Merewether and Hiro, *Art, Anti-art, Non-art*. Re the 1000-Yen Note Incident, Akasegawa had used monochrome one-sided copies of the 1,000-yen note as invitations and in performances; the police initiated a criminal investigation that led to a long, drawn-out trial, in which many prominent members of the art community testified about art, mimesis, and representation, before his ultimate indictment, three months' incarceration, and one year of probation.

22 See works such as Simondon, *Sur la technique*, more recently translated to English using the word *technics*, and Stiegler, *Technics and Time 1*.

23 Beyond the standard musical direction (meaning moderate/restrained yet singingly/freely, very apt for this piece's play within a highly regulated space), Paik may have been referring to Duras's novel and film of that title, released in Japan in 1961. See Akasegawa, *Tokyo mikisā keikaku*, 135.

24 After a number of cross-media endeavors, Higashi Yoshizumi (b. 1949, Kagoshima) undertook a prolific art practice spanning photography, painting, poetry, film, illustration, music, sculpture, book design, and ceramics. Recent objects and archived writings may be viewed at Higject on the Table: Object and Monologue, accessed October 25, 2020, http://zkkw9223.jugem.jp/.

25 Enbairamento no kai, "Kūkan kara kankyō e' ten shushi," 118. See also Yoshimoto, *"From Space to Environment."*

26 Isozaki and Tōno, "'Kankyō ni tsuite,'" 92.

27 Matsumoto, "Ore tachi wa minna kichigai piero da," 38; Matsumoto Toshio, "Puro-jekushon āto no kadai" (On the challenge of projection art), *Asahi shinbun*, May 28, 1968, repr. in *Eiga no henkaku*, 160.

28 Michael Lucey writes an interesting aside about how the idea of the "anonymity" of discourse in certain strains of French thought (Duras, Blanchot) navigates the question of (desire for) political relevance in *Someone*, 147.

29 For the development of this thought, see works such as Agamben, *The Man without Content*, *Homo Sacer*, and *The Coming Community*; and Negri, "Il Mostro Politico." For a lucid and concise discussion of these debates, see Attell, "Potentiality, Actuality, Constituent Power."

30 For Beauvoir's visit as media event and her influence on Japanese feminism, see Bullock, "Fantasy as Methodology."

31 Taki, "Oboegaki 1," 65.

32 Taki, "Oboegaki 1," 64.

33 Regarding the specific terms *landscape* (*fūkei*) and *environment* (*kankyō*) in these cultural debates: although some critics have posited an opposition between *fūkei* and *kankyō* based on taking the idea of landscape in its more traditional sense (aligned with European landscape painting), as a relatively taken-for-granted "nature," many critics were using both terms in relatively aligned or similar ways to describe the highly medi-ated and technologically infused, structured, often urban world of social, architectural, and politically valenced infrastructures.

34 For a further outline of changing versions of realism in Japanese photography, see Sas, "Conceptualizing Japanese Postwar Photography."

35 *Reportage painting* refers to a left-wing Japanese postwar art movement of the 1950s as-sociated with the work of Nakamura Hiroshi, Ikeda Tatsuo, Yamashita Kikuji, and Ishii Shigeo, with explicit political aims in opposing the American military presence and actions in Japan. For a concise introduction to the movement, see Hoaglund, "Protest Art in 1950s Japan."

CHAPTER 1. THE FEELING OF BEING IN THE CONTEMPORARY AGE

Earlier versions of this chapter were published as "By Other Hands: Environment and Apparatus in 1960s Intermedia," in *The Oxford Handbook of Japanese Cinema*, ed. Daisuke Miyao (New York: Oxford University Press, 2014), 383–415; and *Tokyo 1955–1970: A New Avant-Garde*, ed. Doryun Chong and Nancy Lim (New York: Museum of Modern Art, 2012). Exhibition and catalog.

1 Isozaki Arata coined the phrase "future city as ruins" as part of his architectural theory related to postwar Tokyo. Isozaki and Tōno, "'Kankyō ni tsuite,'" 95.

2 Isozaki and Tōno, "'Kankyō ni tsuite,'" 95.

3 See Yūki, *Kamitsu kasō*, 9, 13, 18, cited in Oguma, *1968*, 36. See also Franz Prichard's *Residual Futures*, especially the provocative first chapter, "Prelude to the Traffic War: Infrastructural Aesthetics of the Cold War," on traffic and Tsuchimoto Noriaki's 1964 film *On the Road: A Document*.

4 This last piece of the definition plays a definitive role in Miki Kaneda's writing on inter-media art in Japan; she links this aspect most strikingly with Shiomi Mieko's work and notes its role in Miyakawa Atsushi's critical writing.

5 Matsumoto, "Ekusupandiddo shinema no tenbō," 172.

6 Daibō Masaki (Waseda University) detailed the use of recorded sound alongside visual images at the advent of cinema in Japan in "Umbilical Links or Discontinuities."

7 Juana María Rodríguez mobilizes these three terms in the legacy of theories of queer *latinidad* to navigate the interstice between imaginings of more utopian sociality (with José Esteban Muñoz) and productive failure (Halberstam) and to find terms for a possibly halt-ing yet meaningful intervention in politico-social fields. See Rodríguez, *Sexual Futures*, 8.

8 See Ross, "Beyond the Frame," for a rigorous historical and archivally based presenta-tion of the emergence of Japanese intermedia and three major events that marked its development (the Runami Gallery event, Intermedia Arts Festival, and CROSS TALK Intermedia). For an excellent review of the term *sōgō geijutsu* and Hanada's interest in it, see Yoshida, "The Undulating Contours of *sōgō geijutsu*."

9 See Satō, *Nihon no Eiga*, 143. Film critic and theorist Imamura Taihei wrote about the *sōgōsei* (composite quality) of film even earlier, in the 1930s; see Imamura, *Eiga geijutsu no keishiki*, 143–51.

10 Hanada, "Eiga to taishū," 48. The artists' collective Jikken Kōbō (Experimental Work-shop) articulated a vision relating to organic synthesis in their statement of aims, and also intended the relation between the arts to implicate a link between art and everyday life. See Takiguchi, *Jikken kōbō to Takiguchi Shūzō*, 102. *Sōgō geijutsu* as a term is often used as the Japanese translation for *Gesamtkunstwerk*, the concept of a "total work of art" as adopted and adapted by the Bauhaus artists and others. *Sōgō* was used to translate the Hegelian concept of synthesis, and writers such as Hanada and Matsu-moto Toshio attempted to retain the term's Hegelian dialectical nuance. A note on the use of the term *janru* (genre) in Japanese discourse: it is often used not to designate what in English one would call genre *within* a medium but to distinguish disciplines or mediums (painting, dance, theater, architecture). This confusion, like the discussions of *sōgō geijutsu*, has bearing on considerations of the so-called post-medium condition in recent media theory.

11 Translations of English terms such as *happening*, *performance art*, and *event* were open to debate in Japanese art journals of the period and were used in confusingly related ways. The close relationships of some Japanese artists (Tone Yasunao and Shiomi Mieko of Group Ongaku, and Akiyama Kuniharu—one of two Japanese organizers of CROSS TALK Intermedia) with New York–based Fluxus artists formed a key node for the development of these experimental practices and the transmission of these terms. See the Museum of Modern Art's Gilbert and Lila Silverman Fluxus Collection for crucial documents on those exchanges. See also many moments in Ross, "Beyond the Frame," that articulate these distinctions; Kaneda, "The Unexpected Collectives," 29n3; and Yoshimoto, *Into Performance*, 30–31. Kaneda draws her distinction between *happening* and *event* especially from Yōko Ono's definitions and performances.

12 For more on the events at Sōgetsu Art Center, see Doryun Chong, "Tokyo, 1955–1970: A New Avant-Garde," in Chong and Lim, *Tokyo 1955–1970*; see "Sōgetsu āto sentā no

kiroku" kankō iinkai, *Kagayake rokujū nendai*; and Kaneda, "The Unexpected Collectives," 29–67; as well as the presentations of Uesaki Sen from the Keio University Art Center on Sōgetsu Art Center.

13 For example, the University of Iowa's still-active Intermedia MFA program was founded in 1968. Samuel Taylor Coleridge coined the term *intermedia* in English in the early nineteenth century, in the singular *intermedium*. See Coleridge, *Biographia Literaria*, 217.

14 For definitive extant studies on intermedia art in Japan written in English, see Kaneda, "The Unexpected Collectives"; Ross, "Beyond the Frame"; Yoshimoto, *Into Performance*; and Yoshimoto, "*From Space to Environment.*"

15 Akasegawa Genpei and happenings artist/Neo Dada Organizers member Kazakura Shō assisted with the screening. For a rigorous historical description of the event, see Ross, "Beyond the Frame," 50–53, and many other moments in that dissertation mentioning work by specific participants.

16 Ishiko, "Geijutsu wa sangyō kyōryoku no tame ni aru no ka," 81–82.

17 Ishiko engaged frequently with the critical function of と (*to*), signifying *and*. Ishiko, "Geijutsu wa sangyō kyōryoku no tame ni aru no ka," 81–82, emphasis added. Julian Ross frames a distinction between artists interested in this concept of totality (such as Tone Yasunao in the Intermedia Arts Festival) and those he associates with CTI interested in the "destruction of boundaries" between media; Tone and others critiqued the latter as too obsessed with newness and technology. See Ross, "Beyond the Frame," 74.

18 Matsumoto, "Ekusupandiddo shinema no tenbō," 172.

19 Mono-ha (School of things) involved a group of artists centered in Tokyo from 1968 through the early '70s who worked with raw natural and industrial materials in ephemeral arrangements to "reveal things as they are." Sekine Nobuo's *Phase Mother Earth* is said to be the initiating work of Mono-ha, and Lee U-fan became its principal philosophical voice as well as a key painter/sculptor in the movement. For more on Mono-ha and these theories, see Mika Yoshitake, "The Language of Things," in Chong and Lim, *Tokyo 1955–1970*; see also Sas, *Experimental Arts in Postwar Japan*, 104–8.

20 Matsumoto reminisces that a famous person like Tsuburaya probably agreed to participate with young artists like Matsumoto to gain more experience with the special effects that could be done with early Kodak color films. Matsumoto, "Eizō hyōgen no jikken," 78.

21 See Tochigi, "Matsumoto Toshio kantoku"; and Sakamoto, "Sengo jikken eizō."

22 The film was shot on Eastman Kodak's early single-strip negative color film (type 5248) and more recently carefully restored. See Tochigi, "Matsumoto Toshio kantoku," 78. For an intriguing historiography of the rhetoric of Mount Fuji in photography, see the book and exhibition by Kohara, *Visions of Mount Fuji*.

23 Matsumoto recalled his intermedia practices in the 1960s at a talk given at Kanagawa Kenritsu Kindai Bijutsukan, Hayama, on March 12, 2006 ("Eizō hyōgen no jikken," 57).

24 As filmmaker Miyai Rikurō puts it, "The Fūgetsu-dō café in Shinjuku, a hippie gathering place that was also full of artists and revolutionaries, was a big school for us. Fūgetsu-dō as a whole was very 'intermedia.' It was a mixed-media chaos. It was a melting pot of media, a chaos from which creativity emerged." Interview with the author, November 23, 2011.

25 Nakahira, "Naze shokubutsu zukan ka," 20. In English see Yoshida, *Ozu's Anti-cinema*.

26 Matsumoto, "Zen'ei kiroku eiga-ron," 51. A full translation of this essay by Michael Raine was published in *Cinema Journal*.

27 Matsumoto, "Zen'ei kiroku eiga-ron," 52–53.

28 An interesting comparative description of the intervention of the body into the "autonomy of the visual" through an aesthetic of pulsation, a lineage of artworks framed through pulsation (via the *Informe* that was also an important intertext for Matsumoto and other critics/artists in the late 1950s in Japan) can be found in Bois and Krauss, *Formless*, 135.

29 See Marx, *Capital*, 165.

30 Matsumoto, "Eiga geijutsu no gendai-teki shiza," 14.

31 Markus Nornes elaborates cogently how the term *taishō*, which can be translated as either *subject* or *object* in English, became a keyword for documentary theory. Nornes discusses subjectivity (*shutaisei*) and the object (*taishō*) in *Forest of Pressure*, 20–30.

32 In Matusumoto, "Eiga geijutsu no gendai-teki shiza," he presents one of his most comprehensive theoretical formulations of the relationship between avant-garde and documentary, and his understanding of the dialectical relationship between subjectivity and the object in these two cinematic modes in his early work. Many of these ideas come through Matsumoto's relation with the critic Hanada Kiyoteru. For discussion of Hanada's theories and fuller discussion of *Ishi no uta* in English, see Furuhata, "Refiguring Actuality."

33 Matsumoto, "Eiga geijutsu no gendai-teki shiza," 17–18.

34 Matsumoto, "Zen'ei kiroku eiga-ron," 52.

35 I use *burn-in* here as an alternate term for the retinal afterimage, which appears in the negative, and thus forms an internalized phenomenal relation between positive and negative, in this case of mechanically reproduced images.

36 For another strong discussion in English, see Furuhata, "Refiguring Actuality," 26, 37–39. In relation to the concrete materiality of these stone-like masses, there is "capital" as "'almost'—the abstract as such." See Gilles Deleuze and Félix Guattari, cited in a discussion of Marxist abstraction and empiricism in Spivak, "From Haverstock Hill Flat," 7.

37 Enbairamento no kai, "'Kūkan kara kankyō e' ten shushi," 118.

38 Enbairamento no kai, "'Kūkan kara kankyō e' ten shushi," 118. For one key analysis of the event, see Yoshimoto, "*From Space to Environment*."

39 Enbairamento no kai, "'Kūkan kara kankyō e' ten shushi," 118.

40 Enbairamento no kai, "'Kūkan kara kankyō e' ten shushi," 118. The manifesto, likely penned largely by Takiguchi, given that his statement in the back of the special issue echoes it nearly verbatim, points out that though the Japanese words *shi'i*, *shūi*, and *ijō*, as well as *kankyō*, can be translated as *environment*, they feel the English term more strongly connotes the active and dynamic interaction they intend.

41 Yamaguchi, "Untitled," 36. For another perspective on the flashing vehicle lights, see Norman, *Turn Signals*.

42 Yamaguchi, "Shikake," 36.

43 Part of the significance of this conversion of wave forms to digital numerical forms and back is captured well in writings on the heteromorphism of the machinic in analyses of fiber optic networks. See Chun, *Control and Freedom*, 16.

44 Roger Reynolds, "From Space to Environment-I," letter to the Institute of Current World Affairs, December 24, 1966, 8, emphasis mine.

45 Although each moment of the *Orchestra* would be unique, depending on the visitors' specific sounds and density, a recorded version can be heard on *Obscure Tape Music of Japan Volume 6: Tape Works of Kuniharu Akiyama* (Edition Omega Point, 2007).

46 Haryū, "Jiko hōkai no shinwa," 12.

47 KuroDalaiJee, *Nikutai no anākizumu*, 216, 149.

48 On this relevant issue of the role of discotheques and underground spaces, see Ross, "Beyond the Frame," especially 211–29.

49 Isozaki and Tōno, "'Kankyō ni tsuite,'" 91–92.

50 For a thorough history and interrogation of the ambient and its genealogies in the art world, see Roquet, *Ambient Media*.

51 Recent work on Sōgetsu Art Center, in the context of Keio University Art Center, and work in the "Visual Underground" conference in September 2011 on Shinjuku Bunka Center and Sasori-za in the space of Shinjuku are part of this broader mapping.

52 Gutai Art Association (1954–72) was a group of radical Japanese artists led by painter Yoshihara Jirō that focused on actions, outdoor exhibitions, and innovative art and painting practices. See Kunimoto, *The Stakes of Exposure*, for reflections on gendered subjectivity in these Gutai works and the importance of the infrastructural changes on the conception of electronic networks refracted in and mediated by these works.

53 Thomas Pepper, "Sound Composers Use Technology to Achieve Art: Films, Lights, Electronics, Theater and Dance Are Used to Create What May or May Not Be Music," *Baltimore Sun*, February 23, 1969, D1.

54 The CTI program box was well designed by musician Karen Reynolds and is fully bilingual. I am grateful for the chance to consult it in the private collection of Roger and Karen Reynolds. See Tōno Yoshiaki, "An Interview with Tange Kenzō," CROSS TALK Intermedia program, 6, 4 (original unpaginated; paginations are my own). Key to the thinking about CTI, since it directly corresponded in time with preparations for Expo '70 in Osaka, were reflections on earlier world expos, such as Brussels (1958) and also Montreal (1967). The Xenakis/Le Corbusier collaboration in Brussels '58 was influential for critics at this time, as (for example) Iannis Xenakis was collaborating with Takemitsu and Takahashi Yūji in compositions for Expo '70; Akiyama Kuniharu published critical writing on Xenakis's "mathematical thinking" in *Bijutsu techō* in 1969.

55 *Thomasson* (also *Tomason*) refers to an obsolete architectural structure—things such as staircases leading to nowhere or ticket windows that had been cemented over while still having their frames. Akasegawa and colleagues invented a form of hyperart in the 1970s, a movement that has continued since, in which individuals who discovered a Thomasson, named after a bad baseball player, would contribute to a collective archive by sending a photo to Akasegawa. For an excellent summary and examples, see Akasegawa, *Hyperart*.

56 There were three CTI events prior to the 1969 one, consisting mostly of new music but with strong overlap in participants and uses of technology with the 1969 intermedia event: November 13, 1967 (CROSS TALK 1, with participation by Takahashi Yūji, Mizuno Shūkō, Yuasa Jōji, and others), January 22, 1968 (CROSS TALK 2, with participation

by Ichiyanagi Toshi, Roger Reynolds, music of Salvatore Martirano, and others), and March 16, 1968 (CROSS TALK 3, with participation by Matsudaira Yoriaki, Iimura Takahiko [film *Shelter 9999*, which had first been presented in 1967 at Filmmakers' Cinematheque in New York], and music of Alvin Lucier, Milton Babbitt, Larry Austin, and others). There were also CROSS TALK numbers 5 and 6, and various separate but associated events, such as a complete performance of Erik Satie's eighteen-hour marathon piano piece *Vexations*, and open rehearsals with a question-and-answer period for other musicians and students.

57 Tōno, "Interview with Tange Kenzō," 3–4.

58 Tōno, "Interview with Tange Kenzō," 4, 5, translated in the program (modified), emphasis added. More fully, "An apparatus that will generate events woven together by people and space." Perhaps this can be compared productively with the more contingent and reflexive "administration" of the crowds in Akiyama's *Environmental Mechanical Orchestra No. 1*. Yuriko Furuhata lucidly discusses the darker side of surveillance cameras and the administration of crowd flows in Expo '70 in "Multimedia Environments and Security Operations."

59 See Dimova, "'Beautiful Colored, Musical Things.'"

60 Ishizaki, "Geijutsu o norikoeru mono," 86.

61 Matsumoto, "Ekusupandiddo shinema no tenbō," 172.

62 Matsumoto, "Ekusupandiddo shinema no tenbō," 175–76. Here he is describing the way VanDerBeek moved around when he was projecting part of the images and linking it also to the way screenings were done in Cage's and Kaprow's happenings.

63 Tōno, "Interview with Tange Kenzō," 2, emphasis added. Such images of skin or "second skin" come into play in a new way in Ishiuchi Miyako's work, discussed in chapter 4.

64 Composer Toda Kunio, in the *Asahi Shinbun* evening edition, February 22, 1969, wrote that the mechanical sound distributors and ring modulators became the star of the show. Ring modulators are electronic devices for combining or multiplying two input signals or wave forms into a single output.

65 See Matsumoto, "Eizō hyōgen no jikken," 62.

66 Yuasa Jōji on *Icon* in "Theater as an Environmental Medium," 197. Luciana Galliano writes of the usefulness for him of having worked in documentary and radio drama, giving Yuasa continuous access to the NHK studios, and she mentions that in this piece he worked on "regrouping different figures to construct a totality" (*The Music of Yuasa Jōji*, 53).

67 See Yuasa's comments in the useful liner notes in *Oto no hajimari o motomete 2: Satō Shigeru Work* (Osaka: Sound 3, 2006), an album that interestingly and in alignment with my own argument structures its framework around the sound engineer rather than focusing on one composer. See also the discussion of this event in Ross, "Beyond the Frame."

68 See Ross, "Beyond the Frame," 70.

69 In his debates with Ōshima Nagisa in the same year, Matsumoto critiques Ōshima's mode of politics (in "Henshin no ronri"): "If it can be an original work of thought first, and then made into a film, it is not a creation, just an imitation." Matsumoto, "Henshin no ronri," 210.

70 Group Ongaku members who contributed to this piece included Mizuno Shūkō, Kosugi Takehisa, and Shiomi Mieko.

71 The CTI program box set contains detailed descriptions of this wide array of ambitious pieces and their conceptual and technological innovations, which then itself becomes a thematization of the relation of information (too much to absorb on the spot) and technologically mediated experience.

72 Roger Reynolds, "Cross-Talk Intermedia I," letter to Richard Nolte of the Institute of Current World Affairs (RR-20: the twentieth letter in the series), 9. Accessed in the collection of Roger and Karen Reynolds.

73 Reynolds, "Cross-Talk Intermedia I," 9. Reynolds concludes, optimistically, that this instance of using these institutions to one's own ends provided a model for Japanese artists of how this could be done.

74 Matsumoto, "Ōshima Nagisa yo, kimi wa machigatteiru," 20.

75 The quote comes from Reynolds's photo caption in "Cross-Talk Intermedia I."

76 Ueno Akira, writing in the *Mainichi Shinbun* evening edition, February 21, 1969, called it a "grand scale . . . migration from Shinjuku to Yoyogi," again somewhat belying the view that would separate political Shinjuku too definitively from corporate-linked intermedia.

77 PING is now partly visible in Ross Karre's short on its restoration process, "PING Migration." See Ross Karre, "PING Migration," YouTube, uploaded June 8, 2011, http://www.youtube.com/watch?v=Q-ZEmodEziQ.

78 Isozaki and Tōno, "'Kankyō ni tsuite,'" 92–93.

79 Roger Reynolds recounted the story of this event in an interview with the author, August 30, 2011.

80 Program for CROSS TALK 1 (November 13, 1967), 7, 8. The next three quotations from Yuasa are also taken from the same source.

81 Tōno, "Interview with Tange Kenzō," 6.

82 See Sianne Ngai on "paranoia" as being about the situation of late capitalism beyond the individual (*Ugly Feelings*, 330).

83 Melley, "Stalked by Love," 95, cited in Ngai, *Ugly Feelings*, 319.

84 These include critics from Fredric Jameson and Gayatri Spivak (on capital) to Sianne Ngai and Jack Halberstam (on paranoia).

85 I call *Ginrin* proto-intermedial for its relationship with/emergence out of Jikken Kōbō collaborations, and *Ishi no uta* because of my argument that the theoretical dialectic it embodies links directly with the vision of environment that intermedia artists attempted to construct through their events. For the citation see Hansen, *New Philosophy for New Media*, 270.

86 Nakahara, "Animēshon firumu no bigaku," 1–2.

87 Matsumoto, "Sannin no animēshon," *Nihon dokusho shinbun*, January 1, 1962, 8, cited in *Kagayake rokujūnendai*, 331.

88 Matsumoto, "Ore tachi wa minna kichigai piero da," 42, also cited in Ridgely, "The 3-D Future versus a 4-D Present at Expo 70"; Ishiko, "Geijutsu wa sangyō kyōryoku no tame ni aru no ka," 81–84.

89 See Sas, *Experimental Arts in Postwar Japan*, 183.

90 Matsumoto, "Ekusupandiddo shinema no tenbō," 172.

An earlier version of this chapter was included in *Mechademia 7, Lines of Sight* (2012).

1 See Loubet, "The Beginnings of Electronic Music in Japan"; and Galliano, *The Music of Jōji Yuasa*, 54–56. Yuasa notably worked on the radio drama *Comet Ikeya* by Te-rayama Shūji.

2 For more on the history and development of what she describes as the unique white-collar visual culture of this period, see Airriess, "Staging the Bright Life."

3 I have written about prewar avant-gardes, as well as their relation with postwar experi-mental arts, in Sas, *Fault Lines* and *Experimental Arts in Postwar Japan*.

4 Citations are from Leslie, *Hollywood Flatlands*, 177, 232–33; see also Ōtsuka, "Disarming Atom"; Ōtsuka, "An Unholy Alliance of Eisenstein and Disney"; and Lamarre, "Specie-sism, Part I." For a more recent study of the wartime works, see chapter 4 of Hori, *Promiscuous Media*.

5 Art Theater Guild, which started as an independent agency distributing foreign films in 1961, in 1967 began producing and (in collaboration with studios) distributing indepen-dent, experimental films; some of these auteurs, from both their studio and poststudio Art Theater Guild days, are now known as the main directors of the Japanese New Wave, though the term *New Wave* in Japan was originally the *Shōchiku nūberu bāgu* (Shōchiku Nouvelle Vague) and thus had started in the context of these directors mak-ing new works within the studio system.

6 He was riffing on *Yunbōgi no nikki* (1965), which used still photos, and in turn on Chris Marker's *La Jettée*, whose script was published in the same issue of *Eiga Hyōron*.

7 The creation of the ASIFA (Association internationale du film d'animation/Interna-tional Animated Film Association), with its Unesco recognition as an international organization, had come in 1960, and the separate Annécy Animation Film Festival runs alongside Cannes to this day.

8 These affective impacts of commercial media continue to form an important subject of debate for those in the legacy of Fiskean cultural studies, as this field extends into fan studies, performance studies, and studies of interactivity in so-called Web 2.0.

9 Takiguchi Shūzō, "Waku yaburu omoshirosa: yashin-teki na sannin no kai no koko-romi," cited in *Kagayake rokujūnendai*, 328–29.

10 Kuri Yōji, Manabe Hiroshi, and Yanagihara Ryōhei, "Atarashī imēji o saguridasu tame ni: 'Animēshon sannin no kai' no manifesuto," *Sōgetsu Art Center News*, November 1960, unpaginated, opening page of special issue on Animēshon sannin no kai.

11 Nakahira, "Dōjidai-teki de aru to wa nani ka," 78. In that essay, it is a matter of finding a way to practice photography in which one does not simply reproduce old or already known meanings and images. Takiguchi Shūzō's comment on Hijikata Tatsumi's mode of being avant-garde focuses on this problem, though Takiguchi, in addition to being a crucial supporter and critic of postwar arts, had also been a prime mover in those earlier avant-garde movements. For the terror of the relation to the object in prewar surrealism and postwar butō, see Sas, *Fault Lines*.

12 Kuri, Manabe, and Yanagihara, "Atarashī imēji o saguridasu tame ni."

13 For a continuation of this claim into the later period of postmodern thought, see Takeu-chi, "Posutomodan ni okeru chi no kansei."

14 Nakahara was a veteran critic and curator, one of the Big Three (which also included Hariu Ichirō and Tōno Yoshiaki). He had a burst of writing in the 1960s–70s, including, in book form, *Nansensu no bigaku* in 1962, *Miru koto no shinwa* and *Ningen to busshitsu no aida* in 1972, and works on Lee U-fan in 1977 as well as Yokoo Tadanori and many others.

15 Yokoo's posters are a veritable who's who of experimental arts of the time, from *Bara-iro dansu* (1965, butō) to Tenjō sajiki's *Aomori-ken no semushi otoko* (1967), to Kara Jūrō and Jōkyō Gekijō's *John Silver* (1967), to Hosoe Eikoh and Hijikata's *Hijikata Tatsumi to nihonjin: Nikutai no hanran* (1968), to Ōshima Nagisa's *Shinjuku dorobō nikki* (1968), to name just some of the most famous events.

16 Nakahara, "Animēshon firumu no bigaku," 1–2.

17 Eisenstein, *Eisenstein on Disney*, 21. Thomas LaMarre in his writings on *Barefoot Gen* also discusses this distinction, using the more mobile term *plastic* rather than *plasmatic* or *protoplasmatic*. LaMarre, "Manga Bomb."

18 Eisenstein, *Eisenstein on Disney*, 21; do Rozario, "Reanimating the Animated," 165.

19 Eisenstein, *Eisenstein on Disney*, 46. Note the relation between the Japanese notion of *eizō* (image) and sensation (embodied in pulsation), a key issue raised here that reso-nates in different ways within Eisenstein's notions of Disney and in Japanese film theory. See also discussion of Hanada's mobilized and plasmatic sand-like masses in chapter 6.

20 All this from Nakahara, "Animēshon firumu no bigaku," 1–2, emphasis added.

21 Matsumoto Toshio, "Sannin no animēshon," *Nihon dokusho shinbun*, January 1, 1962: 8, cited in *Kagayake rokujūnendai*, 331.

22 Matsumoto, SAC Journal, cited in *Kagayake rokujūnendai*, 331.

23 Mori Takuya, "Kātōn to gurafikku anime," in *Animation Festival 65* (brochure publica-tion from Sōgetsu Art Center), 4.

24 Mori, "Kātōn to gurafikku anime," 5.

25 Mori, "Kātōn to gurafikku anime," 5.

26 Fukushima Hideko's *Foam Is Created* (*Minawa wa tsukurareru*), along with other works like Kitadai Shōzō's *Another World* (*Mishiranu sekai no hanashi*); Yamaguchi Katsuhiro's kaleidoscopic *Adventure of the Eyes of Mr. W.S.* and Yuasa Jōji's *Lespugue* (*Resupyūgu*) used the automatic slide projector made by Tokyo Tsūshin Kōgyō (precursor to Sony) to make what these Jikken Kōbō (Experimental Workshop) artists called auto-slide pro-jections. The slides consisted of diverse views of a concrete set of objects (foam bubbles in Fukushima's case; in other cases, constructions made of transparent materials such as plastic) that would shift to the next slide in automated response to a prerecorded soundtrack.

27 Both *Music Inn* (1960–63) and the Contemporary Series (1960–64) were series of events at SAC, the former centering around performance, study, and discussion of jazz, and the latter consisting of a series of concerts.

28 In fact we can see that, for example, as a work of illustrated remediation, the last work of Tezuka's Mushi Pro company (not involving Tezuka), the commercial failure adult film *Kanashimi no beradonna* (*Belladonna of Sadness*, 1973), shares some sensibility with

Uno's work, while one could trace a direct line between Tezuka's extended world and today's globalized anime production. I am grateful to Layla Hazemi for her analysis of this work in an unpublished paper. Uno, thus, is perhaps not far off from at least some of the roots of today's global anime culture.

29 See Nishimura, "'Etosetora to jazu no kai,'" 37–38. These examples are drawn from the April 1960 event of the Jazz etcetera series. The contemporary series itself was a continuation of cinema events that had been organized by Teshigahara Hiroshi and others at Yūrakuchō Prevyū Hall since 1957, as part of the group Cinema 1957 (which changed names each year with the new date). For more details on this history, see the summary in Nishimura, "'Etosetora to jazu no kai,'" as well as full details in *Kagayake rokujū nendai*. Keio University Art Center researchers Uesaki Sen and currently Morishita Takashi—also a crucial researcher of Hijikata Tatsumi's archive—have been central figures in curating, mapping, and conducting research related to the SAC materials in the Center archive.

30 See Wada, "Animēshon no kawagishi o aruku," 64, cited in Nishimura, "'Etosetora to jazu no kai,'" 37. For more on this element in these works, see Sas, *Experimental Arts in Postwar Japan*.

31 To trace the links with popular culture, one could note that the place of the baroque in contemporary anime and in early *shōjo* works forms an important part of the current scholarship on anime. See, for example, Anne McKnight writing on Kamikaze girls and Rose of Versailles in "Princesses and Revolution"; or Kotani Mari on Revolutionary Girl Utena and the trope of the "battling beauty" in "Metamorphosis of the Japanese Girl." Higashi Yōichi, later the director of *Yasashī Nihonjin* (1971), is listed as cooperating on and appearing in Uno's film *Omae to watashi/Toi et Moi*.

32 Benjamin, *Origin of German Tragic Drama*, 178.

33 Uno and Kodai, "Interview." In *Someone*, Michael Lucey elaborates forms of sexuality attached not only or necessarily to particular bodily acts but proceeding through literary language, forming tenuous and fragile intimate publics; here illustration and animation become the medium for a diffuse sensuousness whose connotations in terms of sexualities also remain unfixed, while connoting or interpellating intimate publics.

34 Manabe's piece about a submarine focused on the ripples on the surface of the water, also a shortcut technique like Uno's skin in terms of drawing labor. Uno included a moving image of a drawn cat in the corner like a kind of flip book to allay doubts about whether his work was in fact animation.

35 「ところで、人は言葉に酔う。手当たり次代に誇張する／それからふいと気がつくのだ／現実はそれほどまでではないことに。／お願いだ、わたしの心はほっておこう。お前の心はほっておこう。」 In the original, "Mais on se grise avec les mots, on s'exagère / l'importance de tout, et puis on s'aperçoit / que la réalité n'est pas à la hauteur. / Je t'en supplie, laissons mon Coeur, laissons ton Coeur" (Géraldy, *Toi et Moi*, 23). The Japanese translation by Inoue Isamu was published in 1952; it was never as hugely well known in Japan as it was in France.

36 Kodai Nariko, in the interview with Uno, points out that the poem/book was later retranslated more informally as *Kimi to boku*. To her, Uno's version fit much better with the slightly more formal language of the first version (Uno and Kodai, "Interview").

37 Jōnouchi Motoharu, *Gewaltopia Trailer,* 1968; Hijikata Tatsumi and Ohno [Ōno] Kazuo, performance, *Bara-iro dansu: A La Maison de M. Civesawa* [Shibusawa], 1965; Ōshima Nagisa, *Shinjuku dorobō nikki,* 1969.

38 Still, this reminds me a lot of one of Hijikata's essays about reflexive action, about "when a line comes to resemble a line" without origin. See Sas, *Fault Lines,* 162–63.

39 Uno Akira, "Metamorufōsesu," in *Uno Akira masukareedo* (1982), reprinted in Uno, *Bara no kioku.*

40 See also Natsume Sōseki's extended reflections on the subject of capturing the fleeting and shifting image on canvas or in poetry in *Kusamakura,* 79–83.

41 This is a paraphrase of practice workshops I attended in the mid-1980s, but they were continuations of long held dance practices and rhetorical tropes that he had possibly begun to evoke already in the 1960s.

42 Moriyasu, *Barokku no nihon.*

43 Uno complicates this in his own discourse by evoking the scenes of commercial voyeurism, recalling in his interview that lesbian sex shows in Asakusa were called "white on white," and involved being led to a hidden place where one drew aside a curtain and watched either live or filmed sex acts.

44 Berlant and Greenwald, "Affect in the End Times," 76.

45 For a revealing near-contemporary account of the differences among the factions and the impacts of their actions, including a description of the Haneda events, see Sunada, "The Thought and Behavior of Zengakuren," 466–67.

46 Ōshima, "70-nendai o dō shinu ka," 136–38.

47 Hayashi was a composer who ultimately composed over one hundred film scores, including that year's Ōshima selection, *Nihon shunkakō* (A treatise on Japanese bawdy songs, 1967), and the later *Kōshikei* (Death by hanging, 1968) as well as Yoshida Kijū (Yoshishige)'s *Akitsu onsen* (Affair at Akitsu, 1980), among many others.

48 Jonathan Mark Hall discussed this film in detail in "Gentling Okinawa." An earlier version of this section was presented at that conference, Japanese Arts and Globalizations, in 2010.

49 Ōshima focuses on the ways in which social forms are mediated, such that mass media is inseparable from social form. See the film's pamphlet notes, "Bōken, jikken, kakumei," published in his volume of reviews, *Kaitai to funshutsu,* and reproduced in Ōshima, *Ninja bugeichō,* 4–5.

50 Benjamin, "Critique of Violence," 249. One might imagine reading these terms alongside the "constitutive" (lawmaking) and "constituent" power of the *otaku* movement.

51 Ōshima, "Bōken, jikken, kakumei," 5.

52 Abe Kashō discusses this successive subjectivity of revolution in *Ōshima Nagisa no kokyū,* 20.

53 Benjamin, "Critique of Violence," 252.

54 Benjamin, "Critique of Violence," 250.

55 Benjamin, "Critique of Violence," 250.

56 Abe Kashō links this moment of Kagemaru's "audacious smile" upon beheading not only to numerous instances of beheading and strangulation in Ōshima's films but to a famous line in *Tōkaidō yotsuya kaidan* (Ghost stories at Yotsuya on the Tōkaidō, 1825)

often cited by the film critic Hanada Kiyoteru, who was close to Ōshima. Abe, *Ōshima Nagisa no kokyū*, 19.

57 Ōshima, "Bōken, jikken, kakumei," 136.

58 Sunada, "The Thought and Behavior of Zengakuren," 463.

59 For reframing of the debates, see works like Gaudreault and Marion, *The End of Cinema?* For a nuanced reading of the Japanese case, see Zahlten, *The End of Japanese Cinema*.

60 Taketori, "'Ninja bugeichō kagemaruden' no shōgeki," 15.

61 Ōshima, "Ninja bugeichō seisaku memo," 55–57.

62 Ōshima Nagisa, "Ninja bugeichō no kao" (The faces of *Ninja bugeichō*), in *Ninja bugeichō*, 8.

63 Matsumoto emphasized how Resnais filmed parts of Picasso's famous painting but never the whole, along with a Paul Éluard poem in voice-over. Matsumoto uses this film to illustrate his ideal documentary, saying that it never aspires to explain anything like the realist documentaries of the 1950s that he attacks, but only instead represents what he views as Resnais's inner world. Matsumoto, "Zen'ei kiroku eiga-ron," 49.

64 On trauma, loss, and working through in Kentridge's art and his animation techniques, which involve minutely drawing, photographing, and erasing and redrawing large-scale charcoal drawings, see Hagström-Ståhl, "Mourning as Method," 346; and Hagstrom, "Melancholy Traces."

65 Ōshima's essay "Dokusōteki na, kage ichizoku no kyarakutā" (The original characters of the shadow clan) was first released as an afterword in the ninth volume of *Ninja bugeichō* in 1969 by Shogakkan publisher's Golden Comics series. Reprinted in *Ōshima Nagisa chosakushū*, vol. 4, 128–31.

66 Furuhata draws differing conclusions from another aspect of layering, the movement from manga to film.

67 Ōshima, "Dokusōteki na, kage ichizoku no kyarakutā," 131.

68 Ōshima, "Dokusōteki na, kage ichizoku no kyarakutā," 130.

69 Ōshima, "Dokusōteki na, kage ichizoku no kyarakutā," 130.

70 Ōshima, "Bōken, jikken, kakumei," 4. Noël Burch too links this film, along with *Hakuchū no torima* (*Violence at Noon*, also 1967), with Eisensteinian editing, pointing out that the films contain over two thousand shots, by comparison with 1,500 in *Battleship Potemkin*. See Burch, *To the Distant Observer*, 330. Ōshima claims that it is in fact about four thousand shots, edited down from ten thousand that he originally filmed. Cited in Abe, *Ōshima Nagisa no kokyū*, 22.

71 Abe, *Ōshima Nagisa no kokyū*, 21.

72 Ōshima, "70-nendai o dō shinu ka," 136–38.

73 Abe, *Ōshima Nagisa no kokyū*, 20.

74 Abe, *Ōshima Nagisa no kokyū*, 20.

75 Ōshima, "Bōken, jikken, kakumei," 4.

CHAPTER 3. THE CULTURE INDUSTRIES AND MEDIA THEORY IN JAPAN

An earlier version of this chapter was published as "The Culture Industries and Media Theory in Japan," in *Media Theory in Japan*, ed. Marc Steinberg and Alexander Zahlten (Durham, NC: Duke University Press, 2017), 151–72.

1 Suga, "'1968-nen' to 3.11 ikō o tsunagu shikō," 388. Students occupied the nine-story clock tower at Tokyo University and over the course of two days in January 1969, thousands of police in riot gear with tear gas and high-pressure water broke down the student barricades. Students retaliated with Molotov cocktails, threw flagstones, and used the famous *geba-bō* (*Gewalt* [violence] sticks or pointed wooden sticks). Many were injured on both sides. Neither side used firearms.

2 Suga, "'1968-nen' to 3.11 ikō o tsunagu shikō," 381. Note Barbara Spackman's excellent essay on Machiavelli's resistance to firepower and his advocacy of a warfare of "brute semiosis" (Spackman, "Politics on the Warpath," 180). See also Gramsci, *Prison Notebooks*, vol. 3.

3 Several scholars (Setsu Shigematsu and Chelsea Scheider among them) have studied the way gender discourses played out in this period, including the crucial growth of the women's liberation movement, as well as the "figure of the female activist" as a source and space of projection and imagination in the late 1960s. However, it remains clear that the most prominently recognized voices for this New Left critique are still male. (See also the scathing documentary by Barbara Hammer on Ogawa Productions' women that frames a critique of the gender politics of the daily workings of these leftist movements: Hammer, *Devotion*).

4 For an excellent discussion of *fūkeiron*, see Furuhata, *Cinema of Actuality*, especially chapter 4.

5 The work was originally published in German in *Kursbuch 20* in 1970 (*Baukasten zu einer Theorie der Medien*), in *New Left Review* in English also in 1970, and in Japanese in August 1971 in *Bungei*. See Enzensberger, *Civil Wars*, for a more recently translated collection of his works.

6 Kawanaka, born in 1941, is an experimental filmmaker, founder of Japan Filmmaker's Cooperative, founding member of Image Forum, and a central member of Video Hiroba.

7 For an excellent overview of the TV documentary milieu of this period, see Matsui Shigeru's lecture, "Shuji Terayama's Television Documentaries," presented in London in 2011. See also Matsui's other excellent writings and edited volumes on the history of media art theory.

8 Caldwell, "Introduction," 18.

9 Enzensberger, "Constituents of a Theory of the Media," 36.

10 Caldwell, "Introduction," 18.

11 In this essay, Baudrillard accuses Marxists of homogenizing: thinking infrastructure and superstructure as if they were part of the same substance that could be thought in the same forms. Baudrillard, "Requiem pour les médias," 166, 169.

12 Enzensberger, "Constituents of a Theory of the Media," 13–14.

13 Matsuda, "Media kakumei no tame no akushisu," 53.

14 See Steinberg and Zahlten, *Media Theory in Japan*, on the presentation/dissemination of McLuhan in Japan for advertising executives as a practical and applicable work on how to do things with media; see also Kadobayashi Takeshi's writings on the reception of McLuhan, including "Umesao Tadao's Theory of Information Industry and 1960s Japanese Media Theory," later collected in *Media Theory in Japan*.

15 Nagai, "Kaikaku to handō to," 228.

16 Nagai, "Kaikaku to handō to," 228.

17 Nagai, "Kaikaku to handō to," 228. One might note that Francis Fukuyama takes Enzensberger to task in his more recent work for what Fukuyama sees as too much "pessimism." See Fukuyama's review in the *New York Times Book Review* of Enzensberger's *Civil Wars: From L.A. to Bosnia*, October 9, 1994, 12–13. On the activities of Beheiren (Citizens' League for Peace in Vietnam, a Japanese coalition of groups protesting Japanese assistance to the United States during the Vietnam war), see Avenell, *Making Japanese Citizens*. Recent critical work has highlighted such movements to appropriate the power of media as a legacy of 1970s critical work. Parallel movements in Europe and the United States in television include San Francisco's TVTV in the 1970s and Tony Conrad's Studio of the Streets in Buffalo, New York; in Italy, the Autonomia *Radio Alice* movement (which inspired Félix Guattari) can be linked in the early 2000s to Italy's OrfeoTV and *tv di strada*. I am grateful to Sam Jackson, Rebecca Uliasz, and Brett Kashmere for their thoughtful analyses of these movements.

18 Nagai, "Kaikaku to handō to," 229.

19 The anti-NHK war was a movement against NHK as led by Maeda Yoshinori, famous for his authoritarian management style and his ties to conservative politics and the prime minister (Satō Eisaku). The anti-NHK war involved the labor union and more general public components; for example, Honda Katsuichi published a book, *The Logic of NHK Payment Refusal*, in 1971.

20 Tsumura, "Entsensuberugā 'media ron no tame no tsumiki-bako' shinpojiumu ho'i," 37–38. One might note the Mellon/Berkeley Global Urban Humanities initiative as one among many recent examples of prominent efforts related to digital humanities to address environmental design in connection with the humanities disciplines and problems of urban space.

21 Tsumura, "Entsensuberugā 'media ron no tame no tsumiki-bako' shinpojiumu ho'i," 35.

22 Nakahira, "Nikusei no kakutoku wa kanō ka: Media-ron hihan e mukete," *Nihon dokusho shinbun*, March 19, 1973, 1. On the development of mass communications studies and television studies, see Yoshimi, "Japanese Television."

23 Tsumura, "Entsensuberugā 'media ron no tame no tsumiki-bako' shinpojiumu ho'i," 35.

24 Matsuda, "Media kakumei no tame no akushisu," 51–52.

25 Kropotkin, *Conquest of Bread*.

26 Matsuda, "Media kakumei no tame no akushisu," 53, emphasis in original. Page numbers hereafter cited in the text.

27 For a discussion of the ideal of direct access or nonmediation in Terayama and others, see Sas, *Experimental Arts in Postwar Japan*. Baudrillard, in "Requiem pour les medias," also advocates for an immediacy of response and interaction to transcend or rupture the semiotic models of transmitter-message-receiver, even as a two-way street: he favors a model of reciprocity (170) and "immediate communication process" (182), a contestatory ambivalence of meaning. Baudrillard's emphasis on speech (parole) as intervention parallels that of Taki and Nakahira, discussed below.

28 It is notable here that he had been drawing on the work of Senghor, president of independent Senegal from 1960 to 1980, who was widely criticized for his essentialist version of the idea of Négritude and who held a Bergsonian view of vitalism that informed his

ideas of African culture. The emphasis on the affective dimension (meant here in its more common sense of embodied feeling) thus can rhyme with other racially inflected vitalist views. Matsuda later discredits or disavows these earlier affiliations even while sustaining his interest in a more mediated concept of affect and embodiment.

29 In Japanese, the conventional possibility exists to layer a *kanji* (Chinese) character, like here *baitai* (mediation), with a reading that denotes its sound, usually an equivalent, for example when there is ambiguity about how the character should be read or when it is an obscure character. Here the reading of *mediation* is marked with the *katakana* (foreign loan word alphabet) form of the word *media*. Hence the word itself performs an organization of equivalents within a situation of tension.

30 Here he cites Enzensberger's image: "like a dancer, like a football player, like a guerilla." Enzensberger's English translation: "as free as dancers, as aware as football [soccer] players, as surprising as guerillas" ("Constituents of a Theory of the Media," 14). Discussion of Matsuda's appropriations of Yamaguchi Masao's (and theater historian René Fülöp-Miller's) ideas of gesture remains for another time; this, too, is an example of the generation of movement at an unconscious communicative level and leads him to the formulation cited above. See again Rodríguez, *Sexual Futures*, for a more recent reading of the role of gesture as political intervention. Matsuda uses *butōka* as the word for dancer, as the translation for Enzensberger's dancer, which to my ears has a very specific local ring (think Hijikata); one also thinks of his own later affinity with guerilla fighters, alongside other thinkers like Adachi Masao at that time and soon after.

31 Suga summarizes the Chinese Youth Strike Committee and describes Tsumura's role and others' response to it in his postscript to Tsumura's work. Suga, "'1968-nen' to 3.11 ikō o tsunagu shikō," 381.

32 For an interesting analysis of this problem of political correctness as a détournement of critical feminist and race theory, see Johnson, *The Barbara Johnson Reader*.

33 Suga, "'1968-nen' to 3.11 ikō o tsunagu shikō," 388. Tsumura commented on the limitations of this last position and the "rationalization" it implied.

34 "Is it possible to capture the voice?" his title asks, and he goes on to discuss how deeply the media pervade the current social landscape such that it is no longer possible to "exit" those systems. Nakahira, "Nikusei no kakutoku wa kanō ka," 1.

35 Nakahira, "Nikusei no kakutoku wa kanō ka," 1.

36 Nakahira, "Nikusei no kakutoku wa kanō ka," 1.

37 Programmed or ordered harmony seems to echo/play with a less hopeful reading of the name of today's new era (Reiwa).

38 In other words, even innovative and radical programming is simply absorbed into this fixed rhythm. Television director Muraki Yoshihiko (1935–2008) noted a similar obliviousness to content in television, but with an opposite valence. He wrote about the dominance of process in experimental TV documentaries with a sense of possibility and reality being captured by this specific focus on process and liveness. Muraki, "My Television, or an Advertisement for Television Itself," 11.

39 Nakahira, "Nikusei no kakutoku wa kanō ka," 1.

40 Nakahira, "Nikusei no kakutoku wa kanō ka," 1.

41 Nakahira, *Circulation*, 53.

42 Nakahira, *Circulation*, 45.

43 The photographs from the *Circulation* project have been published in a photo book along with Yasumi's essays and three essays by Nakahira related to the event. Yasumi, "Optical Remnants," 316. An archival version has also been reconstructed and remounted in the exhibitions *Provoke: Between Protest and Performance* (2016–17, Albertina Museum, Fotomuseum Winterthur, LE BAL, and Art Institute of Chicago) and *The Gaze of Things: Japanese Photography in the Context of Provoke* (Bombas Gens Centre d'Art, 2019–20).

44 As early as 1973 he was hospitalized for "sensory abnormalities" due to his use of sleeping pills; alcohol poisoning in 1977 caused linguistic and memory loss.

45 Taki, "Aru media no bohimei," 40; page numbers hereafter cited in the text.

46 From Arlie Hochschild's analysis of emotion work and deep capitalism to Eva Illouz's understanding of the structures of everyday intimacy, the analysis of embodied articulations of capitalist forms and media proceeds in many directions. See Hochschild, *The Managed Heart*; and Illouz, *Consuming the Romantic Utopia*. For a concise summary and reference to recent sources for new media and internet (network) studies on both sides, see Kompare, "Media Studies and the Internet," especially 139–40.

47 Nakahira, "Nikusei no kakutoku wa kanō ka," 1.

48 For an elaboration, see Hagimoto and Muraki, *Omae wa tada no genzai ni suginai*.

49 Hagimoto and Muraki had already been deeply involved in experiments in formally provocative and entertaining television broadcasts such as "Anata wa . . . ?" at Tokyo Broadcasting System. Such programming is part of what Nakahira refers to when he discusses radical programming as still, in spite of its radicality, self-consciously or unwittingly reinforcing television's dominating rhythm.

50 Konno, "Kanōsei no teiji ni mukatte," 96.

51 Konno, "Kanōsei no teiji ni mukatte," 91.

52 From Tsumura Takashi's comment on the Enzensberger symposium, "Toshi = soshikiron to shite no mediaron o kaku to suru jōhō kankyō-gaku e no kōsatsu," 38. The essay was reedited and included in Tsumura's *Media no seiji* (The politics of media) in 1974.

53 Tsumura, "Toshi = soshikiron to shite no mediaron o kaku to suru jōhō kankyō-gaku e no kōsatsu," 36, emphasis mine.

54 Tsumura, "Toshi = soshikiron to shite no mediaron o kaku to suru jōhō kankyō-gaku e no kōsatsu," 37. Tsumura is citing a work by Marxist economist Inomata Tsunao (1889–1942), "The Contemporary Phase of the Urban and the Rural," in which Inomata elaborates a theory of "the media of dominant authority" (i.e., hegemonic media) and "city as media."

CHAPTER 4. A FEMINIST PHENOMENOLOGY OF MEDIA

An earlier version of this chapter appeared in *Ishiuchi Miyako: Postwar Shadows*, ed. Amanda Maddox (Los Angeles: J. Paul Getty Museum, 2015).

1 Versions of this battle extended into the late 1970s and '80s, with activists taking to the courts to fight for release of arrested and imprisoned radicals. Sabu Kohso describes the ongoing efforts and outlines their legacies into the 1990s, with an emphasis on trends that offer possibilities for continued protest today. Kohso, "Angelus Novus," 422.

2 Smock, "Translator's Introduction," xii.

3 See Borggreen, "Gender in Contemporary Japanese Art." Lena Fritsch has written extensively on Japanese photography and on Ishiuchi; in English see, for example, Fritsch, *Body as Screen*.

4 An exception can be found in Okai Teruo, "Tokiwa Toyoko no shashin: Sei fūzoku o tsuikyū shita tokui na joryū shashinka," and in Tokiwa and Okai, *Watashi no naka no Yokohama densetsu*. See also Enguita, *La Mirada de las Cosas*.

5 Ishiuchi gained access to the Polaroid camera/film thanks to Yamagishi Kyōko, wife of *Camera Mainichi* editor Yamagishi Shōji, who also suggested the idea of photographing classmates.

6 *Dōkyūsei: Yokosuka shiritsu daini kōkō 39-nendo sotsugyō 3-nen B-gumi* (Classmates: Yokosuka City Second High School 39th graduating class 3rd year group B), Yokosuka shiei rinkai kōen (Yokosuka Municipal Seaside Park).

7 Ishiuchi, interview with author, July 11, 2014.

8 Tsuchiya, "'Yokosuka,' 'Watashi,' 'Onna,' soshite 'Ishiuchi Miyako,'" 8, emphasis in original.

9 Isozaki and Tōno, "Kankyō ni tsuite," 91–92.

10 Taki, "Shashin ni nani ga kanō ka," 9.

11 Tsuchiya, "'Yokosuka,' 'Watashi,' 'Onna,' soshite 'Ishiuchi Miyako,'" 8.

12 Lukács explores the implications of this kind of critical interpretation of the work of 1990s female photographers in "Unraveling Visions."

13 Ngai, *Ugly Feelings*, 28.

14 Ngai, *Ugly Feelings*, 27.

15 Taki, "Shashin ni nani ga kanō ka," 9.

16 Taki, "Shashin ni nani ga kanō ka," 9, emphasis added.

17 Tsuchiya quotes Ishiuchi on 1•9•4•7 in "'Yokosuka,' 'Watashi,' 'Onna,' soshite 'Ishiuchi Miyako,'" 11.

18 Tsuchiya, "'Yokosuka,' 'Watashi,' 'Onna,' soshite 'Ishiuchi Miyako,'" 14.

19 In 2017, and since, she continued to give talks on Japan's position as 144th out of 153 on the ranking of wage equality among industrialized nations by country, as part of her activist project Women's Action Network and publicizing her film about the history of the women's movement in Japan. Ueno, "After Half a Century of Japanese Women's Lib."

20 Yomota, "Hiroshima no sei veronika," 56.

21 Masuda, "The Texture of Time."

22 Neruda, "To the Foot," 435.

23 Watsuji Tetsurō, in a moment that I read as opening beyond his otherwise conservative politics, attended to the complex ways objects can be for a use, or for themselves. I discuss this in Sas, *Experimental Arts in Postwar Japan*, 100–104.

24 Cited in Tsuchiya, "'Yokosuka,' 'Watashi,' 'Onna,' soshite 'Ishiuchi Miyako,'" 11.

25 Ishiuchi, "Ishiuchi Miyako Interview Series (3)," 28.

26 Ishiuchi, Yonahara, and Masaki, "The Absent Body," 255.

27 Kasahara, "Japan Pavilion at the 51st International Art Exhibition."

28 Kasahara, "Japan Pavilion at the 51st International Art Exhibition."

29 Lukács, *Invisibility by Design*.

30 Lukács, "Unraveling Visions," 171.

31 Lukács, "Unraveling Visions," 176.

32 Louise Wolthers made a similar point in the presentation of the Hasselblad Award, published as the prologue to the Hasselblad exhibition catalog. Wolthers, "Miyako Ishiuchi."

33 Yomota, "Hiroshima no sei veronika," 57.

34 Yomota, "Hiroshima no sei veronika," 57.

35 She claims that her mother's unknown name gave her a certain anonymity, and hence freedom. Later, her mother was proud of her daughter's success under that name. Ishiuchi, interview with author, July 11, 2014.

36 Ishiuchi Miyako, From ひろしま, unpublished book announcement/proposal.

37 Tsuchiya makes a similar claim in "'Yokosuka,' 'Watashi,' 'Onna,' soshite 'Ishiuchi Miyako.'"

38 Ishiuchi, interview with author, July 11, 2014.

39 This description better fits the early days of the database. Today, the display, even online, contains quite vivid color photographs, videos, and extensive descriptions in Japanese and English. See "A-Bomb Artifacts," Hiroshima Peace Memorial Museum Peace Database, accessed August 18, 2020, http://a-bombdb.pcf.city.hiroshima.jp/pdbe/search/col_bombed. Ishiuchi, too, uses the light box in this series, with the effect, according to Louise Wolthers, of making the objects appear to float. See Wolthers and Vujanovic, "Miyako Ishiuchi," 5–7.

40 Yomota, "Hiroshima no sei veronika," 55. It is hard to agree, however, that Kawada's approach in particular has ever worn out.

41 For an excellent summary of this movement by photographer and critic Masafumi Suzuki, see "The Atomized City and the Photograph."

42 Ishiuchi, Yonahara, and Masaki, "The Absent Body," 258.

43 Tsuchida Hiromi, One Piece. The caption states, "Setsuko Ogawa (21 at the time) was participating in morning physical exercise at the fifth army headquarters, 800 meters from the hypocenter. Although she sought refuge at a nearby park, raging fire forced her to flee into a small river. She was then rescued by soldiers and accommodated at an army Headquarters. On August 9, she was transferred to another location, but died on August 11."

44 For Onodera's series Second-Hand Clothes (1994–97), she bought clothing from Christian Boltanski's 1993 exhibition Dispersion (a mound of secondhand clothes for sale to viewers) in Paris and photographed each piece to "symbolically restor[e] them to individual life." Onodera's project resonates strongly with Ishiuchi's work and opens yet other meanings for mother's and ひろしま/hiroshima to be drawn in relation to Boltanski's and Onodera's forms of archive.

45 Ishiuchi, Yonahara, and Masaki, "The Absent Body," 252.

46 Linda Hoaglund, "Behind Things Left Behind: Ishiuchi Miyako," film notes.

47 Hoaglund, "Behind Things Left Behind: Ishiuchi Miyako." Elsewhere Ishiuchi recalls, "The clothes were waiting for me to wear them. It may sound strange. I can't wear it, so instead I photograph it." Ishiuchi, Yonahara, and Masaki, "The Absent Body," 255.

48 Ishiuchi, interview with author, July 11, 2014.

49 Yomota, "Hiroshima no sei veronika," 57.

50 Ishiuchi, interview with author, July 11, 2014.

51 Itō Hiromi, interview with author, May 2, 2014.

52 Itō Hiromi, interview with author, May 2, 2014.

53 Butler, also citing Jasbir Puar, in *Notes toward a Performative Theory*, 68.

54 This relates to the problem of the "unwanted beauty" Brett Kaplan refers to in her writings on representations of the Holocaust, or that other critics like Shoshana Felman refer to in discussing the developments of Celan's poetry. See Kaplan, *Unwanted Beauty*; and Felman and Laub, *Testimony*.

55 Ishiuchi, interview with author, July 11, 2014.

CHAPTER 5. FROM POSTWAR TO CONTEMPORARY ART

1 A key exhibition that prepared the groundwork for this wave was *Japon des Avant-Gardes, 1910–1970* (Centre Georges Pompidou, Beaubourg, 1986–87), curated by Věra Linhartová. In the United States, *Japanese Art after 1945: Scream against the Sky* (1994–95) brought a range of these works to American audiences. Walker Art Center's exhibit in 2008 on Kudō Tetsumi curated by Doryun Chong also played a role.

 C. J. Wanling Wee points out a transition that occurred in the 1980s from regional-international exhibitions (with a face toward the Euro-American art world) to global-regional Asia exhibitions (inter-Asian relationships without immediate reference to Euro-American postwar high modernism). See Wee, "Art Exhibitions and the Synchronized Heterogeneity of the Contemporary," forthcoming. The Mori Art Museum's purpose, as stated in their own publicity, is to straddle the two frameworks, with an intention to lean toward the latter. Mori Art Museum, "Fifth Anniversary of the Opening of the Mori Art Museum," press release, October 17, 2008, https://www.mori.co.jp/en/company/press/release/2008/10/20081017112442000648.html.

2 For the citation, see "Why Japanese Post-war Art Matters Now," transcript of Art Basel Miami panel discussion, December 8, 2012. Many exhibitions could be included in this list, but examples from only these two years in the US context are the New York Museum of Modern Art's *Tokyo: A New Avant-Garde, 1955–1970* (2012) and the accompanying documents *From Postwar to Postmodern: Art in Japan, 1945–1989* (2012); Guggenheim's exhibitions *Lee U-fan: Marking Infinity* (2011) and *Gutai: Splendid Playground* (2012); Blum and Poe gallery in Los Angeles (and Barbara Gladstone in New York City) with *Requiem for the Sun: The Art of Mono-ha* (2012); a series of exhibitions on individual artists at McCaffrey Fine Art in New York; the Dorsky Museum's retrospective of neo-Dada artist Shinohara Ushio (*Shinohara Pops!*, 2012); broader exhibitions with a significant Japanese art component such as the Museum of Contemporary Art, Los Angeles (and MoCA Chicago) exhibition *Destroy the Picture: Painting the Void, 1949–1962* (2012–13). Interest in Kusama Yayoi continues with, for example, a retrospective that toured Madrid, the Pompidou, Tate Modern, and Whitney (2011–13). See also major exhibitions on *Provoke* such as the US and European exhibition *Provoke: Between Protest and Performance* as well as *The Gaze of Things: Japanese Photography in the Context of Provoke* (Bombas Gens Centre d'Art, Valencia, Spain, 2019–20).

3 "Why Japanese Post-war Art Matters Now."

4 "Why Japanese Post-war Art Matters Now."

5 Tomii, "Historicizing Contemporary Art," 612.

6 KuroDalaiJee writes critically of the boom in Mono-ha and Gutai in Japan as well, lamenting that the most ephemeral performance practices and interventionist radical works of the period have not received the attention they deserve because they are not receptive to the commodification of the art market: see KuroDalaiJee, *Nikutai no anākizumu.*

7 For a succinct articulation of the debates around the "post-medium condition," see Krauss, *A Voyage on the North Sea.*

8 Nakahira, "Dōjidai-teki de aru to wa nani ka," 162, emphasis added.

9 Nakahira, "Kiroku to iu gen'ei," originally published in *Bijutsu techō* 357; appearing again in Nakahira, *Naze shokubutsu zukan ka*, reprinted by Chikuma shobō, 43.

10 Yasumi, "Imēji no reido," 136.

11 In the first half of the quotation, Benjamin references Emil Orlik's words. See Benjamin, "Little History of Photography," 514. Arai's citation of this passage appears in Arai, "Kagami no ryōgan de deau koto," unpaginated, paragraph 21.

12 Arai, "Kagami no ryōgan de deau koto." Although he references "The Work of Art in the Age of Mechanical Reproduction," these citations come from Benjamin, "Little History of Photography." These are themselves cited by Benjamin from Orlik, *Kleine Aufsatze*, 38ff.

13 *Lucky Dragon* was a fishing boat contaminated by fallout from the Bikini Atoll nuclear test in 1954.

14 While Niwa also had work in *Roppongi Crossing*, the works I focus on here were displayed elsewhere but better demonstrate the line of inquiry I explore here.

15 See Yoshinori Niwa (website), http://www.niwa-staff.org/news.html.

16 "(East) Asia as a (non)common denominator in tourist and consumer culture," as a spectral formation, is one subject of the symposium "Power, Politics, and Pop Culture" referenced above. See also Huat, *Structure, Audience, and Soft Power.*

17 Ōnishi Wakato, "Nakahira Takuma 'Sākyurēshon: Hizuke, basho, kōi' ten, 'Aidentiti VIII' ten—sekai to jiko no kakunin" [Nakahira Takuma "Circulation: Date, Place, Action" exhibition, "Identity VII" exhibition: Confirming the world and the self], *Asahi shinbun yūkan* [evening edition], July 11, 2012.

18 Marotti, *Money, Trains, and Guillotines*, 153.

19 Akasegawa and his colleagues in the 1960s created junk assemblages that reshaped the waste objects of high-growth capitalism, often into organic or anatomically expressive shapes.

20 For a summary of these transformations see Sas, "Conceptualizing Japanese Postwar Photography."

21 *The Base* and *Gunned Down* were displayed as explicit self-reflexive intertexts in *Roppongi Crossing 2013* alongside the woodblock works of Kazama Sachiko. When we think of this in relation to Ishiuchi's later works having to do with the American military bases, we see how much less explicit the critique is in Ishiuchi's *Yokosuka* series.

22 Kunimoto, "Olympic Dissent," 4. Kazama's work overtly mobilizes a parallel critique of the relation between corporate and state power.

23 Nakahara Yūsuke, "Humetsu no taburō kikai," 11–16.

24 In the text a lot of *xxx*s are included, as if to try to prevent the book from being banned again or to make explicitly visible the act of censorship; the scene is a factory worker being tortured by the police.

25 I am grateful to Frank Feltens for his clear articulation of this thought in our discussion of the work.

26 While Sawaragi Noi frames a key opposition between emphasis on site and internationally facing exhibitions like *Roppongi Crossing*, here we see a site work that is also about the paradoxical ground/materiality of urban spaces, even inside commercialized zones of capital like Mori Hills. See note 1 above.

27 Kataoka, Mami et al., *Out of Doubt*, 151.

28 See NADiff Gallery Archive, *Yoko Asakai: Northerly Wind*, November 2011, http://www.nadiff.com/gallery/asakaiyoko.html.

29 See, among others, Kazama Sachiko's blog post "'Jingai kōsaten' ni tsuite (1)," November 30, 2013, *Kazama Sachiko no sōgai no kuro-geshō* (blog); Okamura, *Hikaku geijutsu annai*, 41–44; Kazama, "Artists' Manifestoes 036"; Kazama, "'Fukusei' shōhi jidai no mokuhanga poppu." See also Asakai Yōko website, https://www.yokoasakai.com; Iida, "Asakai Yōko 'Sight' manazashi no saki ni aru koto"; Kondo, "Asakai Yōko."

CHAPTER 6. MOVES LIKE SAND

1 Arai, "Kagami no ryōgan de deau koto," paragraphs 21–22.

2 Anne Bayard-Sakai raises questions of those parts of the population that are and are not reached and helped by these projects as well as who counts as a *tōjisha* (affected person), a term that runs through antidiscrimination movements and is key in post-3–11 discourses. See Bayard-Sakai and Kimura Saeko's edited volume on literature in the wake of 3–11. Bayard-Sakai and Kimura, *Sekai bungaku to shite no "shinsaigo bungaku."*

3 The artists at the center of WAH Project, Minamigawa Kenji and Masui Hirofumi, have formed a new group with Kōjin Haruka under the title 目 [mé]. See 目 [mé], accessed March 23, 2021, https://mouthplustwo.me.

4 See Lene Noer and Birgitte Ejdrup Kristensen, *Grasslands*, accessed March 23, 2021, https://grasslands.dk/.

5 Kaneda, "The Unexpected Collectives," 4, my emphasis.

6 Judith Butler raises this issue about thinking through the human and non- or beyond human ("a sociality and interdependence that is not reducible to human forms of life") in relation to the collective in *Notes toward a Performative Theory of Assembly*.

7 See the discussion of Ur-sand (like Goethe's Ur-plant) in Furuhata, "Refiguring Actuality," 25.

8 This event led to much interesting critical writing in Japan about Informel as well as what the meaning of the changes in contemporary art might signify; see Miyakawa, "After *Informel*." For an interesting discussion of the "Informel whirlwind" as leading to anti-art in Japan as well as a discussion of Miyakawa's writings, see Tomii, "Historicizing Contemporary Art," 619–23 and passim.

9 Hanada, "Suna no yōna taishū," 477.

10　Hanada, "Suna no yōna taishū," 477. As we saw in chapter 2, this idea of potentially embodying "every possible form" also appears in Eisenstein's reading of Disney's plasmaticity.

11　See the discussion of Catherine Malabou's reading of plasticity through Hegel in relation to Hanada in Furuhata, "Refiguring Actuality," 34.

12　Yayoi Uno Everett has analyzed this piece in her lecture "Toshi Ichiyanagi and the Art of Indeterminacy." Akiyama Kuniharu and Ichiyanagi's catalog of the *Exhibition of World Graphic Scores* in which it was included underlines the theory of indeterminacy that motivates it.

13　See Getty Research Institute, "Ichiyanagi Toshi, *Music for Electric Metronome* (1960)," YouTube, April 27, 2007, https://www.youtube.com/watch?v=kz88H3gfFXA.

14　Mizuno Shūkō, program for CROSS TALK Intermedia, 3, my emphasis. Private collection of Roger and Karen Reynolds.

15　Mizuno Shūkō, "Zoku—Ongunteki sahō e no shikō," 52.

16　"It is not something that must be said, but something that must be tasted by the muscles," Nakai writes. Kitada Akihiro's discussion of philosopher Nakai Masakazu becomes relevant to our view of the affective scale when he writes that for Nakai, at least at certain moments, "the individual and the self are nothing more than terms in the trial-and-error process mediated by technology." Kitada, "An Assault on 'Meaning,'" 90–91.

17　Page numbers here refer to Nakahira, *Circulation*, which contains excellent translations by Franz Prichard (dual page numbers refer to Japanese first followed by his English translations); I use my own translations for slight differences of emphasis. For a thoughtful discussion of this work, see Forbes, "Takuma Nakahira's *Circulation*."

18　Kobayashi Fumiko, "Gendai bijutsu koten: Gallery 2 tenrankai annai, Kobayashi Fumiko 'Mistletoe'-ten" [interview], *Lixil*, July 1, 2011, https://livingculture.lixil.com/archives/gallery/contemporary/detail/d_001961.html.

19　Nakahira, "Kiroku to iu gen'ei," 44.

20　Nakahira, "Shashin wa kotoba o chōhatsu shieta ka," 143. See Butler, Laclau, and Žižek, *Contingency, Hegemony, Universality*.

21　Nakahira, "Shashin wa kotoba o chōhatsu shieta ka," 142.

22　Krauss, "Two Moments from the Post-medium Condition," 55.

23　Tanigawa Gan (1923–1995) was an influential poet, critic, and activist. In 1960, triggered by the (failure of the) Anpo struggles against the renewal of the Japan-US Security Treaty, he withdrew from the Communist Party; in the postscript to his collected poems published that year, he announced that he would no longer write poetry. After 1965, he ceased writing criticism but remained well known as a leftist and education activist. Nakahira, "Riariti no fukken," 327.

24　Nakahira, "Riariti no fukken," 326.

25　Nakahira, "Riariti no fukken," 330, citing Alain Robbe-Grillet, "Pour un nouveau roman." See chronology in Nakahira, *Genten fukki*, 158.

26　Nakahira, "Shashin wa kotoba o chōhatsu shieta ka," 143, my emphasis. Nakahira discusses the idea of the "citation from reality" in terms of Alain Jouffroy's critical writings as well.

27　Nakahira, "Riariti no fukken," 330.

28 The Asama Sansō Incident in 1972 was a hostage crisis known for being the first marathon television broadcast in Japan.

29 See Nakahira, "Fūkei e no hanran."

30 Nakahira, "Naze shokubutsu zuka ka?" 23.

31 Nakahira, "Naze shokubutsu zuka ka?" 24.

32 Hanada Kiyoteru, "Uta no tanjō," 347–48.

33 Mizuno Shūkō, *Provisional Color*, performed in a CROSS TALK event, 1967.

CONCLUSION

1 Airriess discusses the gap between the social realities and the mass media images of the salaryman's "bright life" (*akarui seikatsu*) in the 1960s ("Staging the Bright Life"). For the definitive writing on San'ya, see Fowler, *Sanya Blues*; see also Kohso, "Angelus Novus in Millennial Japan," 420–24, for a brief description of the *yoseba* movement to support day laborers in San'ya (Tokyo), Kamagasaki (Osaka), and others.

2 Gabriella Lukács describes the illusory desires, cruel optimisms, and invisible labor of women in the digital economy in *Invisibility by Design*.

3 For the concept description, see "Fifth Anniversary of the Opening of the Mori Art Museum," October 17, 2008, https://www.mori.co.jp/en/company/press/release/2008/10/20081017112442000648.html.

4 Attempts to show off local regional specificity, conceptual contemporaneity, national meaning, or Asia as a regional construct frame varying agendas of the immaterial labor of the museums and festivals in which such art is housed. Sawaragi Noi comments on the division in Japanese art festivals and bi- or triennials between those framed around the idea of region/land (meaning taking place in and emphasizing sites in rural Japan) and those curated around themes and assertions of international urban contemporaneity. Sawaragi, "Looking Back on 2017."

5 Sedgwick, "Affect Theory and Theory of Mind," 147.

6 This framing was inspired by the discussion of Chua Beng Huat by C. J. Wan-ling Wee, "Power, Politics, and Pop Culture."

Bibliography

Abe Kashō. *Ōshima Nagisa no kokyū, Shirato gekiga no sen* [The breath of Ōshima Nagisa, the line of Shirato's *gekiga*]. Pamphlet in DVD. *Ninja bugeichō*. Tokyo: Kinokuniya, 2008.

Agamben, Giorgio. *The Coming Community*. Translated by Michael Hardt. Minneapolis: University of Minnesota Press, 1993.

Agamben, Giorgio. *Homo Sacer: Sovereign Power and Bare Life*. Translated by Daniel Heller-Roazen. Stanford, CA: Stanford University Press, 1998.

Agamben, Giorgio. *The Man without Content*. Translated by Georgia Albert. Stanford, CA: Stanford University Press, 1995.

Ahmed, Sara. "Afterword: Emotions and Their Objects." In *The Cultural Politics of Emotion*, 204–33. Edinburgh: Edinburgh University Press, 2014.

Airriess, Hannah. "Staging the Bright Life: White-Collar Cinema in Japan's Era of High Economic Growth (1954–1971)." PhD diss., University of California, Berkeley, 2020.

Akasegawa Genpei. *Hyperart: Thomasson*. Translated by Matthew Fargo. New York: Kaya Press, 2009.

Akasegawa Genpei. *Tokyo mikisā keikaku: Hai Reddo Sentā chokusetsu kōdō no kiroku*. Tokyo: Paruko shuppankyoku, 1984.

Arai Takashi. "Kagami no ryōgan de deau koto: Dagereotaipu, imēji no gensho e no tabi." *Shunjū* 1 (January 2011): unpaginated.

Asakai Yōko. Yoko Asakai [website]. Accessed October 27, 2020. http://www.yokoasakai.com/ja/projects/cover-jap/.

Attell, Kevin. "Potentiality, Actuality, Constituent Power." *Diacritics* 39, no. 3; *Contemporary Italian Thought* 1 (fall 2009): 35–53.

Avenell, Simon. *Making Japanese Citizens: Civil Society and the Mythology of Shimin in Postwar Japan*. Berkeley: University of California Press, 2010.

Baudrillard, Jean. "Requiem pour les medias." In *Pour une critique de l'économie politique du signe*, 164–84. Paris: Gallimard, 1972.

Benjamin, Walter. "Critique of Violence." In *Walter Benjamin: Selected Writings*. Vol. 1, *1913–1926*, 236–52. Cambridge, MA: Harvard University Press, 1996.

Benjamin, Walter. "Little History of Photography." In *Walter Benjamin: Selected Writings*. Vol. 2, *1927–1934*, 507–30. Translated by Rodney Livingstone. Cambridge, MA: Harvard University Press, 1999.

Benjamin, Walter. *Origin of German Tragic Drama*. Translated by John Osborne. London: Verso, 1998.

Berlant, Lauren. "Genre-Flailing." *Capacious: Journal for Emerging Affect Inquiry* 1, no. 2 (2018): 156–62.

Berlant, Lauren. "Nearly Utopian, Nearly Normal: Post-Fordist Affect in *La Promesse* and *Rosetta*." *Public Culture* 19, no. 2 (2007): 273–301.

Berlant, Lauren, and Jordan Greenwald. "Affect in the End Times: A Conversation with Lauren Berlant." *Qui Parle* 20, no. 2 (spring/summer 2012): 71–89.

Bois, Yves-Alain, and Rosalind Krauss. *Formless: A User's Guide.* New York: Zone, 1997.

Borggreen, Gunhild. "Gender in Contemporary Japanese Art." In *Gender and Power in the Japanese Visual Field*, 179–200. Honolulu: University of Hawaii Press, 2003.

Bullock, Julia C. "Fantasy as Methodology: Simone de Beauvoir and Postwar Japanese Feminism." *U.S.-Japan Women's Journal* 36 (2009): 73–91.

Burch, Noël. *To the Distant Observer: Form and Meaning in Japanese Cinema.* Berkeley: University of California Press, 1979.

Butler, Judith. *Notes toward a Performative Theory of Assembly.* Cambridge, MA: Harvard University Press, 2018.

Butler, Judith. *Precarious Life: The Powers of Mourning and Violence.* London: Verso, 2004.

Butler, Judith, Ernesto Laclau, and Slavoj Žižek. *Contingency, Hegemony, Universality: Contemporary Dialogues on the Left.* London: Verso, 2000.

Caldwell, John Thornton. "Introduction: Theorizing the Digital Landrush." In *Electronic Media and Technoculture*, edited by J. T. Caldwell, 1–31. New Brunswick, NJ: Rutgers University Press, 2000.

Chong, Doryun, and Nancy Lim, eds. *Tokyo 1955–1970: A New Avant-Garde* [exhibition and catalog]. New York: Museum of Modern Art, 2012.

Chong, Doryun, Allan Schwartzman, and Mika Yoshitake. "Why Japanese Post-war Art Matters Now." Panel discussion moderated by Alexandra Munroe, Art Basel Miami, December 8, 2012.

Chun, Wendy. *Control and Freedom: Power and Paranoia in the Age of Fiber Optics.* Cambridge, MA: MIT Press, 2008.

Coleridge, Samuel Taylor. *Biographia Literaria, or, Biographical Sketches of My Literary Life and Opinions.* New York: Leavitt, Lord, 1834.

Daibō Masaki. "Umbilical Links or Discontinuities: Reconsidering the Early Japanese Sound Cinema in Terms of Phonofilms." Lecture, Cinema across Media Conference, University of California, Berkeley, February 26, 2011.

Dimova, Polina. "'Beautiful Colored, Musical Things': Metaphors and Strategies for Interartistic Exchange in Early European Modernism." PhD diss., University of California, Berkeley, 2010.

do Rozario, Rebecca-Anne. "Reanimating the Animated: Disney's Theatrical Productions." *TDR* 48, no. 1 (spring 2004): 164–77.

Duras, Marguerite. *Hiroshima mon amour: Scénario et dialogue.* Paris: Gallimard, 1960.

Eisenstein, Sergei. *Eisenstein on Disney.* London: Methuen, 1988.

Enbairamento no kai. "'Kūkan kara kankyō e' ten shushi." *Bijutsu techō* 275 (November 1966): 118.

Enguita, Nuria, ed. *La Mirada de las Cosas = The Gaze of Things, Fotografía japonesa en torno a Provoke / Japanese Photography in the Context of Provoke.* Madrid: La Fábrica, 2019.

Enzensberger, Hans Magnus. *Civil Wars: From L.A. to Bosnia.* Translated by Piers Spence and Martin Chalmers. New York: New Press, 1994.

Enzensberger, Hans Magnus. "Constituents of a Theory of the Media." *New Left Review* 64 (November/December 1970): 13–36.

Everett, Yayoi Uno. "Toshi Ichiyanagi and the Art of Indeterminacy." C-MAP Project workshop, Museum of Modern Art, New York, January 2012; Cultural Geographies of 1960s Japan: Film, Music + Arts workshop, Center for Japanese Studies, UC Berkeley, April 27, 2012.

Felman, Shoshana, and Dori Laub. *Testimony: Crises of Witnessing in Literature, Psychoanalysis, and History*. New York: Routledge, 1992.

Foster, Hal. *The Return of the Real: The Avant-Garde at the End of the Century*. Cambridge, MA: MIT Press, 1996.

Forbes, Duncan. "Takuma Nakahira's *Circulation*," keynote speech, Association for Photography in Higher Education Summer Conference, July 19–21, 2017. YouTube video, September 8, 2017. https://www.youtube.com/watch?v=JOmq2ZFzrgQ.

Fowler, Edward. *Sanya Blues: Laboring Life in Contemporary Tokyo*. Ithaca, NY: Cornell University Press, 1996.

Fritsch, Lena. *The Body as Screen: Japanese Art Photography of the 1990s*. Hildesheim, Germany: Georg Olms, 2011.

Furuhata, Yuriko. *Cinema of Actuality: Japanese Avant-Garde Filmmaking in the Season of Image Politics*. Durham, NC: Duke University Press, 2013.

Furuhata, Yuriko. "Multimedia Environments and Security Operations: Expo '70 as a Laboratory of Governance." *Grey Room* 54 (winter 2014): 56–79.

Furuhata, Yuriko. "Refiguring Actuality: Japan's Film Theory and Avant-Garde Documentary Movement." PhD diss., Brown University, 2009.

Galliano, Luciana. *The Music of Jōji Yuasa*. Newcastle upon Tyne, UK: Cambridge Scholars, 2012.

Gaudreault, André, and Philippe Marion. *The End of Cinema? A Medium in Crisis in the Digital Age*. New York: Columbia University Press, 2015.

Géraldy, Paul. *Toi et Moi*. Paris: P.-V. Stock, 1913.

Goddard, Michael, and Jussi Parikka, eds. "Unnatural Ecologies." Special issue, *Fibreculture Journal* 17 (2011).

Gramsci, Antonio. *Prison Notebooks*, vol. 3. New York: Columbia University Press, 2010.

Gregg, Melissa, and Gregory Seigworth. *The Affect Theory Reader*. Durham, NC: Duke University Press, 2010.

Hagimoto Haruhiko and Muraki Yoshihiko. *Omae wa tada no genzai ni suginai: Terebi ni nani ga kanō ka*. Tokyo: Tabata shoten, 1969.

Hagstrom, Kristina. "Melancholy Traces: Performing the Work of Mourning." PhD diss., University of California, Berkeley, 2006.

Hagström-Ståhl, Kristina. "Mourning as Method: William Kentridge's Black Box/Chambre Noire." *Arcadia: International Journal of Literary Culture* 45, no. 2 (April 2011): 339–52.

Hall, Jonathan Mark. "Gentling Okinawa: Walter Benjamin, Higashi Yōichi, and Their Critiques of Violence." Paper presented at Japanese Arts and Globalizations Conference, University of California, Riverside, May 16, 2010.

Hammer, Barbara, dir. *Devotion: A Film about Ogawa Productions*. Barbara Hammer Productions, 2000.

Hanada Kiyoteru. "Eiga to taishū." *Kinema junpō*, November 1, 1957, 47–49.

Hanada Kiyoteru. "Suna no yōna taishū." In *Hanada Kiyoteru zenshū*, vol. 6, 476–85. Tokyo: Kōdansha, 1977.

Hanada Kiyoteru. "Uta no tanjō." In *Hanada Kiyoteru zenshū*, vol. 3, 339–48. Tokyo: Kōdansha, 1977.

Hansen, Mark B. N. *New Philosophy for New Media*. Cambridge, MA: MIT Press, 2004.

Haryū Ichirō. "Jiko hōkai no shinwa—'Kūkan kara kankyō e' ten hihyō." *Dezain hihyō* 2 (March 1967): 12–16.

Hoaglund, Linda. "Behind Things Left Behind: Ishiuchi Miyako." Accessed October 14, 2014. http://lhoaglund.com/behind-things-left-behind-ishiuchi-miyako.

Hoaglund, Linda. "Protest Art in 1950s Japan: The Forgotten Reportage Painters." *MIT Visualizing Cultures*, 2012. https://visualizingcultures.mit.edu/protest_art_50s_japan/anp1_essay02.html.

Hoaglund, Linda, dir. *Things Left Behind*. 2013. 80 min.

Hochschild, Arlie. *The Managed Heart: The Commercialization of Human Feeling*. Berkeley: University of California Press, 1973.

Hori, Hikari. *Promiscuous Media: Film and Visual Culture in Imperial Japan, 1926–1945*. Ithaca, NY: Cornell University Press, 2017.

Huat, Chua Beng. *Structure, Audience, and Soft Power in East Asian Pop Culture*. Hong Kong: Hong Kong University Press, 2012.

Iida Shihoko. "Asakai Yōko 'Sight' manazashi no saki ni aru koto." In *Sight*. Tokyo: Akaaka, 2011, unpaginated.

Illouz, Eva. *Consuming the Romantic Utopia: Love and the Cultural Contradictions of Capitalism*. Berkeley: University of California Press, 1997.

Imamura Taihei. *Eiga geijutsu no keishiki*. Tokyo: Ōshio shorin, 1938.

Ishiko Junzō. "Geijutsu wa sangyō kyōryoku no tame ni aru no ka: Kurosutōku intāmedia sōhyō." *Eiga hyōron*, April 1969, 81–84.

Ishiuchi Miyako, Yonahara Kei, and Masaki Motoi. "The Absent Body—Mother's, Hiroshima, and Yokosuka," interview. In *Hiroshima/Yokosuka: Ishiuchi Miyako ten*, 252–60. Tokyo: Meguro-ku bijutsukan, 2008.

Ishizaki Kōichirō. "Geijutsu o norikoeru mono—busshitsukan kara no kaihō." *Bijutsu techō* 21, no. 311 (April 1969): 75–94.

Isozaki Arata and Tōno Yoshiaki. "'Kankyō ni tsuite': Bijutsu, kenchiku, toshi, kyo." *Bijutsu techō* 18, no. 275 (November 1966): 91–103.

Johnson, Barbara. *The Barbara Johnson Reader: The Surprise of Otherness*. Edited by Melissa Feuerstein, Bill Johnson González, Lili Porten, and Keja L. Valens. Durham, NC: Duke University Press, 2014.

Kadobayashi Takeshi. "Umesao Tadao's Theory of Information Industry and 1960s Japanese Media Theory." Paper presented at Histories of Film Theories in East Asia, conference, University of Michigan, September 29, 2012.

Kaneda, Miki. "The Unexpected Collectives: Intermedia Art in Postwar Japan." PhD diss., University of California, Berkeley, 2012.

Kaplan, Brett. *Unwanted Beauty: Aesthetic Pleasure in Holocaust Representation*. Chicago: University of Illinois Press, 2007.

Kasahara Michiko. "Japan Pavilion at the 51st International Art Exhibition, the Venice Biennale in 2005." Japan Foundation. Accessed October 26, 2020. https://www.jpf.go.jp/e/project/culture/exhibit/international/venezia-biennale/art/51/.

Kazama Sachiko. "Artists' Manifestoes 036: Kazama Sachiko." *Bijutsu techō* 62, no. 937 (June 2010): 58.

Kazama Sachiko. "'Fukusei' shōhi jidai no mokuhanga poppu." *Bijutsu techō* 51, no. 780 (December 1999): 179–82.

Kazama Sachiko. "'Jingai kōsaten' ni tsuite (1)," November 30, 2013, *Kazama Sachiko no sōgai no kuro-geshō* (blog). Accessed October 27, 2020. http://kazamasachiko.com/?p=25.

Kimura Saeko and Anne Bayard-Sakai, eds. *Sekai bungaku to shite no "shinsaigo bungaku."* Tokyo: Akashi shoten, 2021.

Kitada Akihiro. "An Assault on 'Meaning': On Nakai Masakazu's Concept of 'Mediation.'" In *Media Theory in Japan*, edited by Marc Steinberg and Alexander Zahlten, 285–304. Durham, NC: Duke University Press, 2017.

Kobayashi Fumiko. *"Nest": Kobayashi Fumiko sakuhinshū*. Tokyo: Akaaka Publishing, 2016.

Kohara Masashi. *Visions of Mount Fuji: An Incurable Malady of Modern Japan*. Gent: Snoeck, 2012.

Kohso, Sabu. "Angelus Novus in Millennial Japan." In *Japan after Japan*, edited by Tomiko Yoda and Harry Harootunian. Durham, NC: Duke University Press, 2006.

Kompare, Derek. "Media Studies and the Internet." *Jounal of Cinema and Media Studies* 59, no. 1 (fall 2019): 134–41.

Kondō Yuki. "Asakai Yōko: Jikan no arika to monogatari no arika." In *Kansatsu-jutsu to kifuhō*, edited by Okumura Yuki et al., 8–10. Aomori: Aomori Kōritsu daigaku kokusai geijutsu sentā, 2012.

Konno Tsutomu (Ben). "Kanōsei no teiji ni mukatte." *Geijutsu kurabu* (July 1973): 91–96.

Kotani Mari. "Metamorphosis of the Japanese Girl: The Girl, the Hyper-Girl, and the Battling Beauty." *Mechademia* 1 (2006): 162–69.

Krauss, Rosalind. "Two Moments from the Post-medium Condition." *October* 116 (spring 2006): 55–62.

Krauss, Rosalind. *A Voyage on the North Sea: Art in the Age of the Post-medium Condition*. New York: Thames and Hudson, 2000.

Kropotkin, Petr Alekseevich. *The Conquest of Bread and Other Writings*. Edited by Marshall Shatz. Cambridge: Cambridge University Press, 1995.

"Kūkan kara kankyō e." Special issue, *Bijutsu techō* 275 (November 1966).

Kunimoto, Namiko. "Olympic Dissent: Art, Politics, and the Tokyo Olympic Games of 1964 and 2020." *Japan Focus* 16, issue 15, no. 2 (August 2018): 1–8.

Kunimoto, Namiko. *The Stakes of Exposure: Anxious Bodies in Postwar Japanese Art*. Minneapolis: University of Minnesota Press, 2017.

KuroDalaiJee (Kuroda Raiji). *Nikutai no anākizumu = Anarchy of the Body: 1960-nendai nihon bijutsu ni okeru pafōmansu no chika suimyaku*. Tokyo: Guramu bukkusu, 2010.

LaMarre, Thomas. *The Anime Ecology: A Genealogy of Television, Animation, and Game Media*. Minneapolis: University of Minnesota Press, 2018.

LaMarre, Thomas. "Manga Bomb: Between the Lines of *Hadashi no Gen*." Paper presented at Theories of Violence, conference, University of California Riverside, May 14, 2010.

LaMarre, Thomas. "Speciesism, Part I: Translating Races into Animals in Wartime Animation." *Mechademia* 3 (2008): 75–95.

Lee, Haiyan, ed. "Taking It to Heart: Emotion, Modernity, Asia." Special issue, *positions* 16, no. 2 (fall 2008).

Leslie, Esther. *Hollywood Flatlands: Animation, Critical Theory, and the Avant-Garde.* London: Verso, 2004.

Loubet, Emmanuelle. "The Beginnings of Electronic Music in Japan, with a Focus on the NHK Studio: The 1950s and 1960s." *Computer Music Journal* 21, no. 4 (winter 1997): 11–22.

Lucey, Michael. *Someone: The Pragmatics of Misfit Sexualities, from Colette to Hervé Guibert.* Chicago: University of Chicago Press, 2019.

Lukács, Gabriella. *Invisibility by Design.* Durham, NC: Duke University Press, 2020.

Lukács, Gabriella. *Scripted Affects, Branded Selves: Television, Subjectivity, and Capitalism in 1990s Japan.* Durham, NC: Duke University Press, 2010.

Lukács, Gabriella. "Unraveling Visions: Women's Photography in Recessionary Japan." *boundary 2* 42, no. 3 (2015): 171–84.

Marotti, William. *Money, Trains, and Guillotines: Art and Revolution in 1960s Japan.* Durham, NC: Duke University Press, 2013.

Marx, Karl. *Capital: A Critique of Political Economy,* vol. 1. Translated by Ben Fowkes. New York: Penguin, 1978.

Massumi, Brian. *Parables for the Virtual: Movement, Affect, Sensation.* Durham, NC: Duke University Press, 2007.

Masuda, Rei. "The Texture of Time." In *Miyoko Ishiuchi: Time Textured in Monochrome,* 11–15. Tokyo: National Museum of Modern Art, 1999.

Matsuda Masao. "Media kakumei no tame no akushisu." *Bijutsu techō,* May 1973, 51–60.

Matsui Shigeru. "Shūji Terayama's Television Documentaries." Lecture, "Art Theatre Guild of Japan: Spaces for Intercultural and Intermedial Cinemas," Birbeck, University of London, July 31, 2011.

Matsui Shigeru, *Kyozō baiyō geijutsuron: āto to terebijon no sōzōryoku: Art Criticism and 1960s Image Culture.* Tokyo: Firumu āto-sha, 2021.

Matsumoto Toshio. "Eiga geijutsu no gendai-teki shiza." In *Eizō no hakken—avangyarudo to dokyumentari,* 9–46. Tokyo: San'ichi shobō, 1963.

Matsumoto Toshio. *Eiga no henkaku.* Tokyo: San'ichi shobō, 1972.

Matsumoto Toshio. "Eizō hyōgen no jikken: 1950 nendai, rokujū nendai o chūshin ni— Images Experiments in the '50s and '60s." In *Art and Technology in Postwar Japan,* 78. Tokyo: National Museum of Modern Art, 2007. http://home.att.ne.jp/grape/charles/texts/ATT2007.html.

Matsumoto Toshio. *Eizō no hakken—avangyarudo to dokyumentari.* Tokyo: San'ichi shobō, 1963.

Matsumoto Toshio. "Henshin no ronri." *Eiga hyōron* (October/November 1968). Reprinted in *Eizō no hakken—avangyarudo to dokyumentari.* Tokyo: San'ichi shobō, 1963, 206–13.

Matsumoto Toshio. "Ore tachi wa minna kichigai piero da." *Dezain hihyō,* no. 6 (July 1968): 40–46.

Matsumoto Toshio. "Ōshima Nagisa yo, kimi wa machigatteiru." *Eiga hyōron* 25, no. 10 (October 1968): 18–23.

Matsumoto Toshio. "A Theory of Avant-Garde Documentary." Translated by Michael Raine. *Cinema Journal* 51, no. 4 (summer 2012): 148–54.

Matsumoto Toshio. "Vandābīku to sono shūhen—Ekusupandiddo shinema no tenbō." *Bijutsu techō* 316 (August 1969): 70–76; 97–105. Reprinted in *Eiga no henkaku,* 172–76. Tokyo: San'ichi shobō, 1972.

Matsumoto Toshio. "Zen'ei kiroku eiga-ron." In *Eizō no hakken—avangyarudo to dokyumentari*, 47–56. Tokyo: San'ichi shobō, 1963.

McKnight, Anne. "Princesses and Revolution: The European Interfaces to Japanese Subculture, from the 1970s to the Millenium." *Minikomi* 75 (2008): 28–37.

Melley, Timothy. "Stalked by Love: Female Paranoia in the Stalker Novel." *differences* 8, no. 2 (1996): 68–100.

Merewether, Charles, and Rika Iezumi Hiro, eds. *Art, Anti-art, Non-art: Experimentations in the Public Sphere in Postwar Japan, 1950–1970*. Los Angeles: Getty Research Institute, 2007.

Miyakawa Atsushi. "Anforumeru igo." *Bijutsu techō* 23 (May 1963): 89–96.

Miyoshi, Masao, and H. D. Harootunian, eds. *Learning Places: The Afterlives of Area Studies.* Durham, NC: Duke University Press, 2002.

Mizuno Shūkō. "Zoku—Ongunteki sahō e no shikō." *Ongaku Geijutsu* 26, no. 12 (November 1968): 50–53.

Moriyasu Toshihisa. *Barokku no nihon.* Tokyo: Kokusho, 2003.

Muraki Yoshihiko. "My Television, or an Advertisement for Television Itself." *Mita Bungaku* (1967), cited in Matsui Shigeru, "Shūji Terayama's Television Documentaries," lecture delivered at "Art Theatre Guild of Japan: Spaces for Intercultural and Intermedial Cinemas," Birbeck, University of London, July 31, 2011.

Nagai Kiyohiko. "Kaikaku to handō to—Entsensuberugā no rainichi o megutte." *Sekai* (May 1973): 228–31.

Nakahara Yūsuke. "Animēshon firumu no bigaku." *SAC Journal* 21 (December 1961): unpaginated.

Nakahara Yūsuke. "Humetsu no taburō kikai." In *Nakamura Hiroshi zuga jiken 1953–2007*, 11–16. Tokyo: Tokyo shinbun, 2007.

Nakahara Yūsuke. *Miru koto no shinwa.* Tokyo: Firumu āto-sha, 1972.

Nakahara Yūsuke. *Nansensu no bigaku.* Tokyo: Gendai shichōsha, 1962.

Nakahara Yūsuke. *Ningen to busshitsu no aida: Gendai bijutsu no jōkyō.* Tokyo: Tabata shoten, 1972.

Nakahira Takuma. *Circulation: Date, Place, Events.* With translations by Franz Prichard. Tokyo: Osiris, 2012.

Nakahira Takuma. "Dōjidaiteki de aru to wa nani ka." Originally published in *Dezain* (May–August 1969). In *Mitsuzukeru hate ni hi ga . . . : hihyō shūsei 1965–1977*, 55–88. Tokyo: Osiris, 2007.

Nakahira Takuma. "Fūkei e no hanran: Mitsuzukeru hate ni hi ga . . ." In *Kitarubeki kotoba no tame ni* (as "Fūkei"), 183–84. Tokyo: Fūdosha, 1970.

Nakahira Takuma. *Genten fukki—Yokohama/Degree Zero—Yokohama.* Tokyo: Osiris, 2003.

Nakahira Takuma. "Kiroku to iu gen'ei: Dokyumento kara monyumento e." Originally pubished in *Bijutsu techō* 357 (July 1972): 73–87. Collected in Nakahira, *Naze shokubutsu zukan ka: Nakahira Takuma eizō ronshū.* Tokyo: Shōbunsha, 1973. Reprinted by Chikuma shobō, 2007.

Nakahira Takuma. "Naze shokubutsu zuka ka?" In *Naze shokubutsu zukan ka*, 9–37. Tokyo: Chikuma shobō, 1973.

Nakahira Takuma. "Riariti no fukken." Originally published in *Dezain* (January 1969): 52–56. Reprinted and edited in Amano, ed. *Mazu tashikarashisa no sekai o sutero.* Tokyo: Tabata shoten, 1970.

Nakahira Takuma. "Shashin wa kotoba o chōhatsu shieta ka." *Nihon dokusho shinbun*, March 30, 1970. Reprinted in *Naze shokubutsu zukan ka*. Tokyo: Shōbunsha, 1973 (Tokyo: Chikuma shobō, 2007).

Natsume Sōseki, *Kusamakura*. Tokyo: Shinchōsha, 1950.

Negri, Antonio. "Il Mostro Politico: Nudo vita e potenza." In *Desiderio del mostro: Dal circo al laboratorio alla política*, edited by Ubaldo Fadini, Antonio Negri, and Charles T, Wolfe, 179–210. Rome: Manifestolibri, 2001.

Neruda, Pablo. "To the Foot from Its Child." In *The Rattle Bag: An Anthology of Poetry*, edited by Seamus Heaney and Ted Hughes, 435–36. London: Faber and Faber, 1982.

Ngai, Sianne. *Ugly Feelings*. Cambridge, MA: Harvard University Press, 2007.

Nihon daigaku zengaku kyōtō kaigi shokikyoku. *Nichidai tōsō*. Tokyo: Godō sangyō shuppanbu, 1969.

Nishimura Tomohiro. "'Etosetora to jazu no kai' to 'Jazu eiga jikkenshitsu.'" *Nihon jikken eizōshi 18*, in *Aida* 105 (September 2004): 35–46.

Norman, Donald. *Turn Signals Are the Facial Expressions of Automobiles*. New York: Basic Books, 1993.

Nornes, Markus. *Forest of Pressure: Ogawa Shinsuke and Postwar Japanese Documentary*. Minneapolis: University of Minnesota Press, 2007.

Oguma Eiji. *1968: Wakamono tachi no hanran to sono haikei*. Tokyo: Shin'yōsha, 2009.

Okai Teruo. "Tokiwa Toyoko no shashin: Sei fūzoku o tsuikyū shita tokui na joryū shashinka." In Tokiwa and Okai, *Watashi no naka no Yokohama densetsu—Tokiwa Toyoko shashinshū*, 61–62.

Okamura Yukinori. *Hikaku geijutsu annai: Kaku wa dō egakaretekita ka*. Tokyo: Iwanami shoten, 2013.

Orlik, Emil. *Kleine Aufsatze*. Berlin: Propylaen Verlag, 1924.

Ōshima Nagisa. "Bōken, jikken, kakumei." In *Kaitai to funshutsu: Ōshima Nagisa hyōronshū*, 136–38. Tokyo: Haga shoten, 1970.

Ōshima Nagisa. "Dokusōteki na, kage ichizoku no kyarakutā" [The original characters of the shadow clan]. In *Ōshima Nagisa chosakushū*, vol. 4, 128–31. Tokyo: Gendai shichō shinsha, 2008.

Ōshima Nagisa. *Ninja bugeichō*. DVD. Tokyo: Kinokuniya, 2008.

Ōshima Nagisa. "Ninja bugeichō seisaku memo." In *Ōshima Nagisa chosakushū*, vol. 3, 55–57. Tokyo: Gendai shichō shinsha, 2008.

Ōshima Nagisa. "70-nendai o dō shinu ka" [How do we die in the 1970s?—A brief comment on "Tokyo sensō sengo hiwa"]. In *Ōshima Nagisa chosakushū*, vol. 3, 136–38. Tokyo: Gendai shichō shinsha, 2008.

Ōtsuka Eiji. "Disarming Atom: Tezuka Osamu's Manga at War and Peace." Translated by Thomas Lamarre. *Mechademia* 3 (2008): 111–25.

Ōtsuka Eiji. "An Unholy Alliance of Eisenstein and Disney: The Fascist Origins of Otaku Culture." *Mechademia* 8 (2013): 251–77.

Out of Doubt: Roppongi Crossing 2013: Mori Art Museum 10th Anniversary Exhibition. Tokyo: Heibonsha, 2013.

Parks, Lisa, and Nicole Starosielski. "Introduction." In *Signal Traffic: Critical Studies of Media Infrastructures*, edited by Lisa Parks and Nicole Starosielski, 1–27. Urbana: University of Illinois Press, 2015.

Parks, Lisa. "Media Infrastructures and Affect." *Flow*, May 19, 2014. https://www.flowjournal
.org/2014/05/media-infrastructures-and-affect/.

Parks, Lisa. "'Stuff You Can Kick': Toward a Theory of Media Infrastructures." In *Between Humanities and the Digital*, edited by Patrick Svensson and David Theo Goldberg, 355–73. Cambridge, MA: MIT Press, 2015.

Prichard, Franz. *Residual Futures: The Urban Ecologies of Literary and Visual Media from 1960s and 1970s Japan*. New York: Columbia University Press, 2019.

Ridgely, Steven. "The 3-D Future versus a 4-D Present at Expo 70." Unpublished manuscript.

Robbe-Grillet, Alain. *Pour un nouveau roman*. Paris: Minuit, 1963.

Rodríguez, Juana María. *Sexual Futures, Queer Gestures, and Other Latina Longings*. New York: New York University Press, 2014.

Roquet, Paul. *Ambient Media: Japanese Atmospheres of Self*. Minneapolis: University of Minnesota Press, 2016.

Ross, Julian. "Beyond the Frame: Intermedia and Expanded Cinema in 1960s–1970s Japan." PhD diss., University of Leeds, 2014.

Sakamoto Hirofumi. "Sengo jikken eizō: Media āto shi." In *Media āto no sekai: Jikken eizō 1960–2007*, edited by Ina Shinsuke, i–xxvii. Tokyo: Kokusho Kankōkai, 2008.

Sanyal, Debarati. *Memory and Complicity: Migrations of Holocaust Remembrance*. New York: Fordham University Press, 2015.

Sas, Miryam. "Conceptualizing Japanese Postwar Photography: Snap, Movement, Refusal." In *La Mirada de las Cosas = The Gaze of Things, Fotografía japonesa en torno a Provoke / Japanese Photography in the Context of Provoke*, edited by Nuria Enguita, 195–206. Valencia: Fondacio per Amor a l'Art, Bombas Gens Centre d'Art; Madrid: La Fábrica, 2019.

Sas, Miryam. *Experimental Arts in Postwar Japan: Moments of Encounter, Engagement, and Imagined Return*. Cambridge, MA: Harvard University Asia Center, 2010.

Sas, Miryam. *Fault Lines: Cultural Memory and Japanese Surrealism*. Stanford, CA: Stanford University Press, 1999.

Sasaki Michiko, *Nichidai zenkyōtō Sasaki Michiko shashinshū*. Tokyo: Rokusaisha, 2009.

Sasaki Michiko. *Shinjuku gōruden-gai no hitobito*. Tokyo: Shichigatsudō, 2018.

Satō Tadao. *Nihon no Eiga*. Tokyo: San'ichi shobō, 1956.

Sawaragi, Noi. "Looking Back on 2017: Beyond the 'Judging' of Art Festivals." ART iT, February 28, 2018. https://www.art-it.asia/en/u/admin_ed_contri9/sohotpdke5xys7oznq39.

Sedgwick, Eve Kosofsky. "Affect Theory and Theory of Mind." In *The Weather in Proust*, edited by Jonathan Goldberg, 144–65. Durham, NC: Duke University Press, 2011.

Sedgwick, Eve Kosovsky. *Touching Feeling*. Durham, NC: Duke University Press, 2003.

Simondon, Gilbert. *Sur la technique (1953–1983)*. Edited by Nathalie Simondon. Paris: Presses Universitaires de France, 2014.

Smock, Ann. "Translator's Introduction." In *Rue Ordener, Rue Labat*, edited by Sarah Kofman, vii–xiii. Lincoln: University of Nebraska Press, 1996.

"Sōgetsu āto sentā no kiroku" kankō iinkai, ed. *Kagayake rokujū nendai: Sōgetsu āto sentā no zenkiroku*. Tokyo: Firumu āto-sha, 2002.

Spackman, Barbara. "Politics on the Warpath: Machiavelli's *Art of War*." In *Machiavelli and the Discourse of Literature*, edited by Vicky Kahn and Albert Ascoli, 179–93. Ithaca, NY: Cornell University Press, 1993.

Spivak, Gayatri. "From Haverstock Hill Flat to U.S. Classroom." In *What's Left of Theory? New Work on the Politics of Literary Theory*, edited by Judith Butler, John Guillory, and Kendall Thomas, 1–39. London: Routledge, 2000.

Steinberg, Marc, and Alexander Zahlten, eds. *Media Theory in Japan*. Durham, NC: Duke University Press, 2017.

Stiegler, Bernard. *Technics and Time 1*. Stanford, CA: Stanford University Press, 1998.

Suga Hidemi. "'1968-nen' to 3.11 ikō o tsunagu shikō." In *Tsumura Takashi seisen hyōronshū: 1968-nen igo*, edited by Suga Hidemi, 381–92. Tokyo: Ronsōsha, 2012.

Sunada, Ichirō. "The Thought and Behavior of Zengakuren: Trends in the Japanese Student Movement." *Asian Survey* 9, no. 6 (June 1969): 457–74.

Suzuki, Masafumi. "The Atomized City and the Photograph." In *Nagasaki Journey*, edited by Rupert Jenkins, 35–43. San Francisco: Pomegranate Artbooks, 1995.

Taketori Ei. "'Ninja bugeichō kagemaruden' no shōgeki." In Ōshima Nagisa, *Ninja bugeichō*. DVD. Tokyo: Kinokuniya, 2008.

Takeuchi Yoshirō. "Posutomodan ni okeru chi no kansei." *Sekai* 494 (November 1986): 92–114.

Takiguchi Shūzō. *Jikken kōbō to Takiguchi Shūzō*. Edited by Fukuzumi Haruo. Tokyo: Satani Gallery, 1991.

Taki Kōji. "Aru media no bohimei." *Bijutsu techō*, May 1973: 38–50.

Taki Kōji. "Oboegaki 1: Chi no taihai." *Provoke* 1 (1968): 63–68.

Taki Kōji. "Shashin ni nani ga kanō ka—jo ni kaete." In *Mazu tashikarashisa no sekai o sutero: Shashin to gengo no shisō*, 6–11. Tokyo: Tabata shoten, 1970.

Tochigi Akira. "Matsumoto Toshio kantoku, *Ginrin* (1956) no dejitaru fukugen o kataru." *Tokyo kokuritsu kindai bijutsukan kenkyū kiyō* 15 (2011): 74–89.

Tokiwa Toyoko and Okai Teruo. *Watashi no naka no Yokohama densetsu—Tokiwa Toyoko shashinshū*. Yokohama: Tokiwa Toyoko shashin jimusho, 2001.

Tomii, Reiko. "Historicizing Contemporary Art: Some Discursive Practices in *Gendai bijutsu*." *positions* 12, no. 3 (2004): 611–41.

Tōno Yoshiaki. *Kyozō no jidai: Tōno Yoshiaki bijutsu hihyōsen*. Edited by Matsui Shigeru and Imura Yasuko. Tokyo: Kawade shobō shinsha, 2013.

Tsuchiya Seiichi. "'Yokosuka,' 'Watashi,' 'Onna,' soshite 'Ishiuchi Miyako'—Ishiuchi Miyako-ron." In *Hiroshima/Yokosuka: Ishiuchi Miyako ten*, 6–16. Tokyo: Meguro-ku bijutsukan, 2008.

Tsumura Takashi. "Entsensuberugā 'media ron no tame no tsumiki-bako' shinpojiumu ho'i: Toshi-soshiki ron toshite no media-ron o kaku to suru jōhō kankyō-gaku e no kōsatsu." *Hōsō hihyō* 4 (April 1973): 35–41.

Ueno Chizuko. "After Half a Century of Japanese Women's Lib: Have Japanese Women Changed?" Lecture, INALCO, Paris, France, December 4, 2017.

Uno Akira. *Bara no kioku: Uno Akira zen'essei 1968–2000*. Tokyo: Tokyo shoseki, 2000.

Uno Akira and Kodai Nariko. "Interview." *Aquirax Cinema* no. 1, limited edition in DVD, *Aquirax Cinema: Karei na metamorufoshisu*. Broadway, 2002.

van Hensbergen, Rosa. "Moving with Words, 1950s–1980s: Language, Notation, Choreography." PhD diss., Emmanuel College, Cambridge, 2019.

Vujanovic, Dragana, and Louise Wolthers, eds. *Ishiuchi Miyako: Hasselblad Award 2014*. Heidelberg: Kehrer Verlag, 2014.

Wada Makoto. "Animēshon no kawagishi o aruku." *Kikan firumu* (November 1971).

Wee, C. J. Wan-ling. "Art Exhibitions and the Synchronized Heterogeneity of the Contemporary." In *The International East Asian Art Exhibition and the Rise of "Asia."* Unpublished manuscript.

Wee, C. J. Wan-ling. "Power, Politics, and Pop Culture." Inter-Asia Cultural Studies Society Conference, National University of Singapore, July 4, 2013. YouTube video, https://www.youtube.com/watch?v=6uNBVvXdI7g.

Weisenfeld, Gennifer. *Imaging Disaster: Tokyo and the Visual Culture of Japan's Great Earthquake of 1923.* Berkeley: University of California Press, 2012.

Wolthers, Louise. "Miyako Ishiuchi: Weaving the Fabric of Photography." Speech at Hasselblad Award Ceremony, Tokyo, March 6, 2014.

Woolf, Virginia. *Mrs. Dalloway.* London: Collector's Library, 2003.

Yamaguchi Katsuhiro. "Shikake." *Bijutsu techō* 275 (November 1966): 35–36.

Yasumi Akihito. "Imēji no reido—Nakahira Takuma 'Genten fukki—Yokohama.'" In *Nakahira Takuma: Genten fukki Yokohama—Nakahira Takuma: Degree Zero Yokohama*, 137–47. Tokyo: Osiris, 2003.

Yasumi Akihito. "Optical Remnants: Paris, 1971, Takuma Nakahira." In *Sākyurēshon: Hizuke, basho, kōi = Circulation: Date, Place, Events*, by Nakahira Takuma, 283–89; 310–17. Translated by Franz Prichard. Tokyo: Osiris, 2012.

Yomota Inuhiko. "Hiroshima no sei veronika." In *Hiroshima/Yokosuka: Ishiuchi Miyako ten*, 58–62. Tokyo: Meguro-ku bijutsukan, 2008.

Yoshida Kenichi. "The Undulating Contours of *sōgō geijutsu* (Total Work of Art), or Hanada Kiyoteru's Thoughts on Transmedia in Postwar Japan." *Inter-Asia Cultural Studies* 13, no. 1 (2012): 36–54.

Yoshida Kijū. *Ozu's Anti-cinema.* Translated by Daisuke Miyao and Kyoko Hirano. Ann Arbor: University of Michigan Press, 2003.

Yoshimi, Shunya. "Japanese Television: Early Development and Research." In *A Companion to Television*, edited by Janet Wasko, 540–57. Malden, MA: Wiley-Blackwell, 2010.

Yoshimoto, Midori. "*From Space to Environment*: The Origins of Kankyō and the Emergence of Intermedia Art in Japan." *Art Journal* (September 2008): 25–46.

Yoshimoto, Midori. *Into Performance: Japanese Women Artists in New York.* New Brunswick, NJ: Rutgers University Press, 2005.

Yuasa, Jōji. "Theater as an Environmental Medium." *Perspectives of New Music* 31, no. 2 (summer 1993): 192–209.

Yūki Seigo. *Kamitsu kaso.* Tokyo: San'ichi shobō, 1970.

Zahlten, Alexander. *The End of Japanese Cinema: Industrial Genres, National Times, and Media Ecologies.* Durham, NC: Duke University Press, 2017.

Index

Page numbers in italics refer to figures.

editing techniques, 106–7

Egawa Saburō, 61, 65

Eiga hihyō (Film criticism) (journal), 95

Eisenstein, Sergei, 73, 78, 79, 81, 85, 106, 189, 263n19

eizō (mechanically reproduced image), 38, 41, 42, 72, 78, 263n19

Eizō gakkai (Japan Society of Image Arts and Sciences), 75

electronic music, 14, 31–32, 53, 239

The Elegant Life of Mr. Everyman (Okamoto), 4–5, 114

elitism, 86

embodiment, 230, 236

emotion, 2, 7, 8, 19, 150

emptiness, 19

Endō Ichirō, 209

energeia (act), 17

energy, 114, 127

Energy of the Masses (*Taishū no enerugī*) (Hanada), 238

Engankyō (Mochizuki), 193

envelopment, 46, 54, 63, 65

environment (*kankyō*): and affective scale, 110; and art practice, 62, 70; and humans, 44; in Matsumoto's work, 41–42; in Niwa's work, 185; as raw material, 52; in *From Space to Environment*, 44; Tange and Tōno on, 54, 69; and technological/cultural change, 25, 30; use of term, 185, 258n40

environmental design, 44, 49, 53–54

Environmental Mechanical Orchestra No. 1 (Akiyama), 45–47

Environment Society (Kankyō no kai), 15, 44

Enzensberger, Hans Magnus, 18, 122, 131, 134, 268n17, 269n30; symposium in Japan, 114–21, 116, 117, 134

eroticism, 86, 87

ethnocentrism, 132

Etosetera to Jazz no kai (Jazz etcetera), 84

events *versus* happenings, 256n11

everyday life, 125, 220, 240, 247

expanded cinema, 15, 31–32, 33, 49, 70. *See also* Matsumoto Toshio; multiprojection

Experimental Workshop (Jikken Kōbō). *See* Jikken Kōbō

Expo '70 (Osaka International Exposition): and architecture, 120; artists' participation in, 63; commercialism, 62; and expanded cinema,

15; intermedia at, 58–59; reception of, 55; and Tange Kenzō, 54; and urban renewal, 243–44

Expos, 15, 34, 55, 59, 245, 259n54

Expose '68, 15

Exposition Internationale de l'art actuel (exhibition), 216

Fanon, Frantz, 118

Feltens, Frank, 275n25

Film-Art Company (Firumu-āto-sha), 115

film/media studies, 52, 76, 102, 133, 176

film stock, 35, 103, 257n22

finger boxes (Ay-O), 47, 48, 51

flatness, 102, 103, 107, 112, 129, 243

flesh, 83. *See also* skin

Fluxus, 32, 210, 220, 254n21, 256n11

Foam Is Created (Fukushima), 81, 263n26

For a Language to Come (Nakahira), 178, 227

For My Crushed Right Eye (*Tsuburekakatta migime no tame ni*) (Matsumoto), 15

Foster, Hal, 3, 253n5

Foucault, Michel, 132

Foujita Tsuguharu, 87

441.4867—0474.82.2603—712.9374 (Group Ongaku), 60–61

fragmentation, 57, 65–66, 93, 142, 229

Frankfurt School, 73, 133. *See also* culture industries

Freud, Sigmund, 162

From Caligari to Hitler (Krakauer), 118

From Space to Environment (exhibition): critics on, 149; curatorial vision, 15, 42–45, 51; *Environmental Mechanical Orchestra No. 1* (Akiyama), 45–47, 51; images from, 43, 48; reception of, 49–50; works on display, 47–49

From ひろしま (Ishiuchi), 160, 164

Fūgetsu-dō café, 257n24

fūkeiron (landscape theory). *See* landscape theory (*fūkeiron*)

Fukushima, 4, 29, 185

Fukushima Hideko, 81, 263n26

Fukuyama, Francis, 268n17

funding, 61, 212

Furuhata, Yuriko, 74, 94, 215–16

Galliano, Luciana, 260n66

garbage, 184–85, 200. *See also* Niwa Yoshinori

the gaze: in Asakai's work, 201; of the camera, 183; of objects, 37–38, 58; and photographs,

145–46, 154, 168, 233; simple, 90; as tactile, 88; of the Third World, 136

gekiga (long-form dramatic popular manga), 17, 94, 99, 102

gendai bijutsu (contemporary art), 175–76, 178, 184, 186, 191, 206

gender: and affect, 172; and assemblages, 168–69; and bodies, 81; as infrastructure, 145–51; normative views of, 159; and phenomenology, 144, 166; and power, 163; social expectations, 144, 145–46, 148, 151, 154, 158; structures of, 158; as system/infrastructure, 127

genres/conventions, 6, 80, 83, 99, 246

Géraldy, Paul, 87–88, 91

Gesamtkunstwerk, 256n10. See also *sōgō geijutsu*

Gewalt (power), 94, 100. *See also* power relations

Gewaltopia Trailer (Jōnouchi), 88

Ginrin (*Silver Wheels*) (Matsumoto), 33–36, 40, 69, 71, 187, 261n85

global contemporary art (*kontenporarī āto*), 176

globalization, 112, 137, 176, 185–86

Godard, Jean-Luc, 230

Going to San Francisco to Dispose of My Garbage (Niwa), 184–85

Gramsci, Antonio, 111, 141

Grandmother series (Yanagi), 210

graphic design, 78

graphic scores, 218, 219, 220–21

Grasslands Project, 210–11, 212

Group Ongaku, 60, 214, 221, 260n70

Guernica (Picasso), 188

Guernica (Resnais), 103

Guggenheim Museum, 174

Gunned Down (Nakamura), 187–88, 190

Gutai, 52, 175, 244, 259n52, 274n6

Habermas, Jürgen, 115

Hagimoto Haruhiko, 116, 134

Halberstam, Jack, 256n7, 261n84

Hanada Kiyoteru, 31, 136, 215–16, 238, 239, 258n32

happenings, 13, 14, 32, 53, 256n11

haptic qualities, 5, 39, 46, 88. *See also* skin

Harada Akira, 181

Hara Hiroshi, 116, *117*

Haryū (Hariu) Ichirō, 49, 116, 175

Hasegawa Yōko, 210

Hayashi Hikaru, 94, 265n47

Hazemi, Layla, 263n28

heterogeneity, 242, 250

Heya/*The Room* (Kuri), 82, 85

Higashi Yōichi, 90, 95

Higashi Yoshizumi, 14, 248, 254n21

Higgins, Dick, 32

Hijikata Tatsumi, 61, 262n11

Hirasawa Gō, 134

Hi Red Center, 13, 184, 186

Hi Red Center Shelter Plan (Akasegawa). See *Shelter Plan*

Hiroshima, 20, 162, 163, 164, 181

ひろしま/*hiroshima* (Ishiuchi), 144, 162–68; and assemblage, 169; description of work, 157; objects in, 198; pictured, *165*; singular/plural in, 152

historical memory, 11, 145

historiography, 243

Hoaglund, Linda, 166

Hochschild, Arlie, 270n46

Hosoe Eikoh, 84

humans: and environment, 44; and infrastructure, 15, 45; and machines, 69; and plasticity, 41; and subjectivity, 45; and technological images, 69

humor, 80

hyperart, 54, 259n55

hypertext, 194

Ichiyanagi Toshi: biographical details, 218, 220; and collectivity, 221; description of work, 47, 49, 239; *Music for Electric Metronomes*, 217–18, *219*, 220; performances by, 54–55, 260n56; process in work, 217; relationship with Matsumoto, 37

Icon for White Noise (Yuasa), 58–59, 60, 64, 67, 239

identification and affect, 99

Iida Momo, 119

Iimura Takahiko, 260n56

Iizawa Kōtarō, 150, 159

Ikemizu Keiichi, 210

Illouz, Eva, 270n46

image/media saturation, 177, 178–79, 183

Imai Hisae, 84

immediacy, 133, 268n27

imperial discourse, 14

Imperial Hotel, 13

the individual, 14, 123, 124, 133, 158, 224

individual *versus* systems, 30, 33, 158, 253n3

information, 176, 196

information studies, 18, 120

Marxism: and culture industries, 113; and homogeneity, 267n11; Japanese engagement with, 17; and media theory, 24, 123; and Nakahira, 230; and paranoia, 9–10; and potentiality, 17, 254n14; *sōgō geijutsu* (composite/synthetic art), 31; subject/object relations in, 39

Masaki Motoi, 158

mass culture, 92, 114, 215–16

masses, 133, 215–17, 222, 238

mass media, 85, 154, 251

Masumura Yasuzō, 106

material imagination (*busshitsu-teki na sōzōryoku*), 79

materiality: of animation, 79; and deconstruction, 130; and the electronic, 244; of the medium, 187, 230; of objects, 78; and photography, 169; of sound, 221; in *From Space to Environment*, 49; of stones, 258n35; and subject-object relations, 229; of technology, 49; theories of, 136

Matsudaira Yoriaki, 260n56

Matsuda Masao, 136; about work, 112, 135; biographical details, 113; critique by, 121–24; on Enzensberger, 122, 123; quoted, 118, 121

Matsumoto Toshio: art practice of, 33–34, 36–37, 62–63; and dialectics, 31, 71, 233; and expanded cinema, 176, 239; Expo '70, 59; on illustration, 83; and landscape, 41–42, 141; on other artists, 95, 103, 260n69, 266n63; psychic structures in work, 8–9, 41; quoted, 10, 30, 62, 69, 79–80; sound in work, 71–72; on subjectivity, 101; on VanDerBeek, 56–59; visual language of, 15; writings by, 38, 39, 40, 56–57, 187, 258n32, 260n69; writings by, application of by others, 45; works: *Ginrin* (*Silver Wheels*), 33–36, 40, 69, 71, 187, 261n85; *Ishi no uta* (*The Song of Stone*), 37–42, 44, 51, 69, 71–72, 95, 132, 261n85; *For My Crushed Right Eye* (*Tsuburekakatta migime no tame ni*), 15; *Projection for Icon*, 57, 58, 60, 67, 70. See also *eizō*

Matsuya department store, 15, 42

May 1968, 11, 178–79. See also protests

McLuhan, Marshall, 44, 45, 64, 118, 267n14

the mechanical/machines, 57, 79, 80, 189, 258n35

media ecologies, 6, 68, 76, 110. See also distribution; infrastructure

mediation, 5, 16, 124, 163, 217, 269n29

medium specificity, 16, 22, 94, 144, 187, 188, 230

Meguro Museum of Art, 167

memory, 86, 91, 95, 131, 162. See also ひろしま/ hiroshima (Ishiuchi); *mother's* (Ishiuchi)

Memory (1964) (Mushi Pro), *82*, 86

metadata, 194

metonymy, 44, 55–56

mimesis, 44, 56, 60, 243

Minami-sōma, 5, 181

Ministry of Economy Trade and Industry (MeTI) building, 191

Mirai e gō bus (Bus to the future) (Endō), 209

Mirai e maru (Boat to the future) (Endō), 209

Misawa Kenji (Kenzi), 57

Misuzu shobō, 118

Miyai Rikurō, 248, 257n24

Mizuno Shūkō: and CTI events, 259n56; description of work, 238; and materiality of sound, 221, 239; *Orchestra 1966*, 221–24; *Provisional Color*, 221; and structure, 215

mobilization, 63, 114, 136

Mochizuki Katsura, 193

modernism and modern art, 77, 86, 175–76

moe objects, 87

MoMA (Museum of Modern Art), 174

monochrome, 130, 154

Mono-ha (School of things), 33, 78, 257n19, 274n6. See also Suga Kishio

montage, 84, 106, 189

Mori Building, 22, 198–99, 207, 246

Mori Takuya, 80

Moriyama Daidō, 148

Moriyasu Toshihisa, 90

mother's (Ishiuchi), 144, 157, 158–59, 160, *161*, 166, *167*, 169, 171, 198

Mount Fuji, 14, 35

Multiple Monument from Daigo Fukuryū Maru (*Lucky Dragon*) (Arai), 181

multiprojection, 15, 56–67, 221–22

Munari, Bruno, 84

Muñoz, José Esteban, 256n7

Munroe, Alexandra, 175

Muraki Yoshihiko, 116, 134, 269n38

Musée Mécanique (Léger), 79

Musée Pompidou Metz, 210

Mushi Pro, 86, 87, 263n28. See also Tezuka Osamu

music, 81, 215, 217–18, 220–23. See also electronic music; *Environmental Mechanical Orchestra No. 1* (Akiyama); Ichiyanagi Toshi; *Icon for White Noise* (Yuasa); *Ishi no uta* (Matsu-

the organic/organicism, 78–79, 90, 189. *See also* plasmaticity/plasticity

Ortega y Gasset, José, 132

Osaka International Exposition (Expo '70), 15, 34, 245

Ōshima Nagisa: about work, 17; and Art Theater Guild, 91; and commercialism, 62–63, 74; on editing, 106; formal qualities of work, 103; and landscape theory, 112; on politics, 106, 108, 260n69, 265n49; reception of work, 100–101; and revolution, 93, 104; on Shirato, 102–3; writings by, 96; works: *Kōshikei* (*Death by Hanging*), 108; *Nihon no yoru to kiri* (*Night and Fog in Japan*), 93, 94; *Shinjuku dorobō nikki* (*Diary of a Shinjuku thief*), 88; *Tokyo sensō sengo hiwa* (*The Man Who Left His Will on Film*), 94, 107; *Yunbogi no nikki* (*Diary of Yunbogi*), 95, 262n6. *See also Ninja bugeichō* (Ōshima)

otherness, 119, 152

Oto no hajimari o motomete 2: Satō Shigeru Work (album), 260n67

Ōtsuka Eiji, 73, 76

Out of Doubt: For a Landscape to Come (exhibition), 177–78

overwhelm: and affective scale, 229; experience of, 65; and intermedia art, 31, 142, 171; in Kobayashi's work, 235; in music, 224; and technological change, 244; textures of, 245–47

pace series (Asakai), 203, 205

Paik, Nam Jun, 14

painting, 188, 189–90, 216. *See also* reportage painting

paranoia, 9–10, 55, 68, 247, 261n82

paranoid/depressive-reparative position, 9, 10, 16, 22, 34, 62, 247. *See also* Klein, Melanie; Sedgwick, Eve

Paris Biennale, 129, 179, 183, 196, 225

Parks, Lisa, 6

parole. *See* voice/parole

participation, 23–24, 211. *See also* artistic collaborations

passage series (Asakai), 201–6

performance art, 14, 175, 189, 244

performativity, 91, 144

personal films, 115

perspectivalism, 108

Phase Mother Earth (Sekine), 257n19

phenomenology, 6, 86, 144, 162, 166. *See also* gender; Ishiuchi Miyako; photography

photography: affective scale in, 150–51; ambivalence in, 18; in animation, 81; awards for, 143; and collectivity, 225, 227; historical aspects, 159; and intimacy, 180; and landscape, 19, 83, 163, 203–4; Nakahira on, 179; and the real/reality, 19, 180–81, 187, 233, 234; and scale, 153; theories of, 135; viewing of, 158. *See also* Asakai Yōko; *Ishi no uta* (*The Song of Stone*, 1961); Ishiuchi Miyako; Nakahira Takuma; *Provoke* (photography movement); Taki Kōji

PING (Reynolds), 64, 261n77

place, concept of, 42–43, 44

plasmaticity/plasticity: and animation, 75, 78–79, 92; artists' use of, 72; and the body, 81; politics of, 73–74, 215–16; and violence, 96

The Play (group, Ikemizu Keiichi), 210

Polaroids, 145, 147, 149, 169, 271n5. *See also* Ishiuchi Miyako

policing, 67, 94, 100, 190, 193, 254n21

pollution, 83, 193, 202, 245

Ponge, Francis, 38

postcoloniality, 112, 113, 126, 132, 176

post-medium condition, 178, 229, 256n10

post-structuralist/postcolonial theory, 176

postwar media practices, 144, 216

postwar subjectivity debates, 77

potentiality: and animation, 71, 79, 80, 92; in Asakai, 22; and CTI, 68; of feeling, 142; images of, 155; of machines, 79; in Marxist thought, 17; of the masses, 217; Matsumoto, 9; and media, 3–4, 114; and Nakahira, 178; of objects, 72; of painting, 190; and paradox, 199; of plastic line, 73–74; and politics, 92, 97; of surfaces, 88; tactics of, 92; of television, 135; and this study, 2; of voice/parole (*nikusei*), 134

power relations, 135, 163, 168, 180, 214

Prison nuke fission 235 (*Gokumon kakubunretsu 235*) (Kazama), 191, 192, 193

Projection for Icon (Matsumoto), 57, 58, 60, 67, 70

protests, 11–19, 12, 67–68, 93, 126–27, 134

protracted war (*jikyūsen*), 111

Provisional Color (Mizuno), 221

Provoke (photography movement), 18, 33, 130, 163, 172, 235–36. *See also* Nakahira Takuma

public/private space, 132, 156, 158, 162, 235, 238–39

pulsation in artworks, 258n28

puppet films, 75